Foundations of Modern Arab Identity

Copyright 2004 by Stephen Sheehi. This work is licensed under a modified Creative Commons Attribution-Noncommercial-No Derivative Works 3.0 Unported License. To view a copy of this license, visit http://creativecommons.org/licenses/by-nc-nd/3.0/. You are free to electronically copy, distribute, and transmit this work if you attribute authorship. *However, all printing rights are reserved by the University Press of Florida (http://www.upf.com). Please contact UPF for information about how to obtain copies of the work for print distribution.* You must attribute the work in the manner specified by the author or licensor (but not in any way that suggests that they endorse you or your use of the work). For any reuse or distribution, you must make clear to others the license terms of this work. Any of the above conditions can be waived if you get permission from the University Press of Florida. Nothing in this license impairs or restricts the author's moral rights.

UNIVERSITY PRESS OF FLORIDA / STATE UNIVERSITY SYSTEM

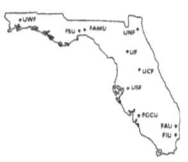

Florida A&M University, Tallahassee
Florida Atlantic University, Boca Raton
Florida Gulf Coast University, Ft. Myers
Florida International University, Miami
Florida State University, Tallahassee
University of Central Florida, Orlando
University of Florida, Gainesville
University of North Florida, Jacksonville
University of South Florida, Tampa
University of West Florida, Pensacola

Foundations of
Modern Arab Identity

Stephen Sheehi

University Press of Florida
Gainesville · Tallahassee · Tampa · Boca Raton
Pensacola · Orlando · Miami · Jacksonville · Ft. Myers

Copyright 2004 by Stephen Sheehi
Printed on acid-free paper
All rights reserved

Library of Congress Cataloging-in-Publication Data
Sheehi, Stephen, 1967–
Foundations of modern Arab identity / Stephen Sheehi.
p. cm.
Includes bibliographical references and index.
ISBN 0-8130-2732-2 (cloth : alk. paper); ISBN 978-1-61610-134-3 (pbk.)_
1. Arab countries–Intellectual life–19th century. 2. Nationalism–Arab countries.
3. Arab countries–Colonization. 4. National characteristics, Arab.
5. Globalization. I. Title.
DS36.88.S55 2004
909'.0974927083–DC22 2004043740

The University Press of Florida is the scholarly publishing agency for the State University System of Florida, comprising Florida A&M University, Florida Atlantic University, Florida Gulf Coast University, Florida International University, Florida State University, University of Central Florida, University of Florida, University of North Florida, University of South Florida, and University of West Florida.

University Press of Florida
15 Northwest 15th Street
Gainesville, FL 32611–2079
http://www.upf.com

To my sublime children, Jad and Shadee

Had I not chanced upon the 1874 copy of the
Lebanese journal *al-Jinan*, I would not have known
that my father had actually been correct in his calculations.

Anton Shammas, *Arabesques*

"Knowledge for its own sake"—that is the last snare of morality:
with that one becomes completely entangled in it once more.

Friedrich Nietzsche, *Beyond Good and Evil*

Contents

Acknowledgments ix

Introduction 1

1. Unpacking the Native Subject 15

2. Inscribing the National Subject 46

3. Desiring Selves, Desiring Others 76

4. The Hybridity of Reform 107

5. The Great Debate 135

6. Doubleness and Duality: Allegories of Becoming 159

Epilogue: Towards an Aesthetic of the Colonial Self 189

Notes 199

Selected Bibliography 223

Index 231

Acknowledgments

The history and motivations of this research are intertwined with my own personal journey and the journey of those I love. Rather than dwell on sentimentality, however, I want to focus our attention on the importance of the current moment. The struggles of those intellectuals in this manuscript are not romanticized or fetishized. They are the foci of this research because we live the effects of their thoughts, work, and experience today, the effects of the dilemmas that they faced if not also participated in creating. If this research is about history's force on the present, then acknowledging the past contributions, attention, loyalty, and affection of those who assisted me in completing this study testifies to my current good fortune.

Therefore, I express my deepest and most profound appreciation to Michael Beard, Muge Gocek, Michelle Hartman, Samir Khalaf, Alexander Knysh, Kristin Koptiuch, Brinkley Messick, Deborah Porter, James Poulton, Lisa Salem, Anton Shammas, Peter Sluglett, Sasson Somekh, and Ruth Tsoffar. My indebtedness to, admiration of, and affinity for them all extends well beyond my communicative abilities.

I want to acknowledge the comradeship of Leo Ching, Abbie Langston, Wahneema Lubiano, Diane Nelson, Senay Ozden, Pam Terterian, Jing Wang, Eric Zakim, and my students, who made my time at Duke fruitful and a pleasure. Likewise, I am grateful to Robert Sikorski and the John Hope Franklin Center at Duke University for their financial assistance in the completion and refinement of this study.

In Lebanon, the administration of the American University of Beirut helped facilitate research while the staff at Jaffet Library and the libraries of the Université de St. Joseph and the Near Eastern Seminar of Theology were most generous in allowing me access to printed and archival materials. Likewise, the Center for Behavioral Studies at AUB supported me throughout this project.

Amy Gorelick and the staff at the University Press of Florida have been most helpful, efficient, patient, and ambitious in publishing this book.

I would like to thank my brothers, comrades, and confidants Kenneth Lang, Walid Rʿad, Walid Sadiq, and Ara Sarafian, for their loyalty, friendship, and advice. Their companionship serves as the richest emotional, intellectual, and political sustenance.

I thank my parents for their continued validation of my work and me. They instilled in me the consciousness and pride that has sustained me in a rewarding but often daunting and discouraging profession. Finally, but not least, my deepest love and gratitude must be expressed to my wife, Marguerite, and our children, Jad and Shadee, who are the inspiration for my everyday life. Their faith and love are the fuel that drives my scholarship, teaching, and convictions. The revelations in this book, as humble as they are, hope to enable them to live contented, fulfilling, loving, undisparaged, and unharassed lives as Arabs, as brown people, and as citizens of the world.

I acknowledge the permission of the following journals for allowing republication of selections from articles that I previously published:

"Desire for the Self, Desire for the West," *Jouvert: Electronic Journal for Postcolonial Studies* 3, no. 3 (1999).

"Doubleness and Duality: Allegories of Becoming in Jurji Zaydan's *Al-Mamluk al-sharid*," in the *Journal of Arabic Literature* (Leiden) 30 (spring 1999).

"Inscribing the Arab Self" in the *British Journal of the Middle East* 27 (spring 2000): 7–24.

Introduction

The Epistemology of an Ideology

Ex Post Facto

> The Arab is backward; his part of the world is underdeveloped. These are cases of fact that no observant person can contest.... Following the war that pushed 1,000,000 of his people into homeless squalor... he has come to appreciate the liability of illiterate farmers and their unproductive farms; he admits the incompatibility of feodary and progress; he has noted the relationship of feudalism to ignorance, poverty to feudalism, foreign control to poverty and ignorance to foreign control.
>
> *Bootstrap: Jordan Valley Development Project*

This quote is taken from a 1953 United Nations Development Program project pamphlet. It associates the dispossession of the Palestinian people in 1948 with their "illiteracy" and "ignorance" and simultaneously negates their historical and territorial identity as Palestinians. So the assumption then goes that they are (only) Arabs whose circumstances must be attributed to their own failure. Although the pamphlet erases the history and politics of their dispossession (that is, Zionist aggression), its intention is "sympathetic" to the plight of the Palestinian people, promoting UNDP's mission to promote education in the camps, where Palestinian refugees happen to end up as "the result of war."

"Feodary," "ignorance," and the absence of "progress"—the passage resonates forcefully with the advent of a new Caesarism of the U.S. State Department following September 11, 2001. In addition to the conquest of Afghanistan, the global "war on terror," and the American invasion of Iraq, the Bush administration eagerly adopted the Likud Party's platform vis-à-vis the Second Intifada and the Palestinian people. Yet the shared political worldview of the Republican and Likud parties, Sharon's courting of President Bush, and Sha-

ransky's seduction of Vice President Dick Cheney can only be given so much credit.[1] Rather, the foreign policies of the United States government concerning the Middle East are embedded in a specific ideological history that is reiterated faithfully as historical fact by a brigade of mainstream political commentators and journalists. Among others, former ambassador Dennis Ross, Daniel Pipes, Bernard Lewis, William Kristol, Charles Krauthammer, Farid Zakaria, and Thomas Friedman, who won a Pulitzer for news commentary in 2001, disseminated the key points on which U.S. foreign policymakers would religiously regurgitate from September 2001 to the present.

While this study does not intend to engage these ideologues or U.S. foreign policy, the vocabulary and formulae upon which their arguments lay are the subject of this study. In brief, they purport that Arabs have failed to develop a significant "civil society," to develop democratic institutions, expand the economic private sector, and permit basic and widespread political and civil rights. In short, Arab states, both "with or against" the United States as George W. Bush might say, have been unable to fully realize "modernity." From this failure, the "Arab peoples" have not enjoyed the benefits of globalization and therefore resent the transformations that it has brought. Consequently, the Arab populace transmute this resentment into an irrational dislike of America, American culture, and "American democracy." Rather than examining American foreign and economic policy, these analysts have faulted the Arab intelligentsia for blaming the West, Zionism, and colonialism for contemporary social ills and political maladies. Hence, Arab intellectuals are complicit with the corruption of their leadership because they refuse to question their own social, political, and cultural prohibitions and irrationalities. Such analysis by post 9/11 American pundits attests to either an ignorance of political history or a strategic omission of historical fact in the service of a political agenda. Even a cursory glance at readily available Arabic and English secondary and primary sources demonstrates that innumerable secular and nonsecular intellectuals, from the left and from the right, have engaged in the issues that these Anglophone commentators have mentioned from democracy to women's rights to economic justice.[2]

In reality, post-1967 Arab intellectuals quite visibly have struggled with the "failure" of their own societies and states, often implicitly agreeing with the developmental discourse found in the assessments of *Bootstrap*. The editorials in English-language dailies such as the *Daily Star, Kuwait Times, Arab News,* or *al-Ahram Weekly,* written by mainstream indigenous intellectuals, analysts, journalists, and activists, confirm such an observation. In fact, the discomfort-

ing verisimilitude between Arab and American criticism reveals the effects of the double colonizing move performed by the very epistemology that will be under examination in this book. Like in *Bootstrap*, intellectuals from Constantine Zurayk, Sadiq Jalal al-'Azm, and Nadim Bitar to Hisham Sharabi and Hazim Saghiyah might agree that the disempowerment of the Arabs cannot be separated from their cultural and political illiteracy. For them, the loss of Palestine in 1948 and the completion of their dispossession in 1967 are manifestations of a deeper and more fundamental failure inherent to modern Arab subjectivity. These tragedies were a result not only of the corruption and authoritarianism of Arab regimes but also the "backwardness" (*takhalluf*) and "ignorance" (*jahl*) of their own societies. More specifically, they conclude that Arab societies failed to break with their traditionalist and conservative tendencies, preventing them from internalizing the spirit of modernity in its most positive, humanistic, and even revolutionary forms.

I have opened this study with the quotation from *Bootstrap* and a discussion of the ideologues of American Caesarism to demonstrate the predominance of the discourse of Arab failure and backwardness in the late modern and postmodern eras. "Failure," "backwardness," "ignorance," "lack of unity," and "the absence of democracy" and how they stand in contrast to Western "progress," "civilization," development, and modernity did not originate with Samuel Huntington or in the analysis of September 11. These terms have existed as key analytical rubrics for sociopolitical phenomena from Operation Desert Storm in 1992 back to the Arabs' self-analysis of King Faisal's loss to the French in Maysaloun, Syria, in 1920; the loss that led to the French Mandate in Syria and Lebanon.

The obsession of Arab and non-Arab thinkers, scholars, journalists, artists, and activists with "failure" is not a coincidence but rather a preoccupation that finds its roots in the very formation of modern Arab subjectivity during the Arab Renaissance or *al-nahdah al-'arabiyah*. These terms predominate because they are an outgrowth of paradigms inherent to modernity and built on the dichotomy of progress and backwardness. This book does more than locate the origins of such a language of binaries. It also reveals that modern subjectivity—the subjectivity underlying Arab nationalist ideologies and their concomitant popular identities—arose out of paradigms of modernity that were generated and reconstituted by intellectuals, literati, and activists of all confessions during the nineteenth century. The epistemology upon which modern identity would rest, I assert, became the very intellectual quicksand for the Arab world's confrontation with Western colonialism and imperialism, capitalist expansion, and individual state formation.

Age of Expansion and Transformations

While this present research is a study of the textual and epistemological roots of modern Arab subjectivity, one must remember that the writings of Muslim, Christian, and Jewish Arab intellectuals during the nineteenth and early twentieth centuries cannot be separated from the radical and vibrant historical transformations and developments of their day. Historians have traditionally marked Napoleon's invasion of Egypt in 1798 as the Arab world's dawn of the modern period. The French invasion, so it is asserted, is responsible for the introduction of the printing press into the Arab world and familiarizing Egyptian intelligentsia and noblemen with French scholars, generals, officers, and bureaucrats. But, moreover, the occupation had brought Egypt and later Greater Syria directly into the rivalry of competing interests between France and England. Discussing the role of competing groups or salons of organic intellectuals in the rise of the proto-bourgeoisie, merchant classes in eighteenth-century Egypt, Peter Gran has forcefully debunked the myth that Napoleon's expedition jolted the Arabo-Islamic world out of a cultural, economic, and social slumber.[3] Likewise, attempts to reorganize various Ottoman institutions as early as the reign of Sultan Selim III (1789–1807) clearly demonstrate that the impetus to "modernize" was an internal, political, and uneven impetus that had preceded intensified European economic, political, and military intervention into the Ottomans' domain.

Even preceding the Crusades, the region was accustomed to doing business with the West. Waxing and waning over centuries, the nature of that commercial and cultural relationship changed by the nineteenth century. A growing number of French, British, Russian, American, and Austrian consular officials began to appear in the Middle East. The majority of these consular representatives simultaneously worked for companies with specific commercial interests in the region. Occasionally weakening the power of the traditional urban merchant classes that Gran discusses, France, Russia, and England began to develop patron-client relationships with minority communities in the Arab world. This policy made confession and ethnicity a prominent socioeconomic issue because it enfranchised some portions of formerly Christian Arab and Armenian peasants in the Empire, while also dispossessing others.

Europeans' economic need determined much of their political policies. France's lack of trading routes into Africa and the Mediterranean motivated them to occupy Algeria in 1830, where they dismantled Ottoman rule and established control well into sub-Saharan Africa. By the 1840s, the migration of

French colons had begun. Direct rule of Tunisia would follow in 1881 and Morocco in 1912. Likewise, Aden in Yemen was occupied by the British in 1839 to facilitate trade to the Subcontinent and secure control of the India Ocean. Their base in Yemen allowed them to gradually assert their influence over the Persian Gulf, which would serve them well in Iraq and Iran at the beginning of the twentieth century. Yet Egypt would be England's dominant entrepôt to the Arab world.

Upon ejecting the French from Egypt, Muhammad Ali, the Ottoman wali of Egypt, gradually gained complete control of Egypt through a program of bureaucratic and military modernization.[4] During the rule of his successors, who would become known as the Khedives, investment such as the cotton industry, the Suez Canal (1869), and the railway entrenched British interests and influence deep into the "semi-autonomous" province. Isma'il Pasha (1862–79) indebted Egypt to such a degree that by the 1870s British and French control of its economy was assumed. In 1882, Great Britain bombarded and occupied Alexandria and established de facto direct rule over Egypt after crushing the 'Urabi Revolt—a rebellion supported by many of the intellectuals under investigation in this study.

While France and Britain successfully commanded North Africa, their influence in the Levant was equally significant, particularly through the intensity of their economic activity. Lebanon's, for example, had been completely transformed with the rise and fall of the silk industry in the nineteenth century. Beirut's growth not only transformed the political economy of its environs but also affected adversely ports and merchant cities such as Sidon, Tripoli, Akka, Tyre, Aleppo, and Damascus. The rapid and drastic economic changes eroded the traditional feudal oligarchy, but also gave rise to a new bourgeoisie and petit-bourgeoisie. These economic changes coincided with, or were responsible for, seminal social and cultural develops in Syria. If the actual implementation of the Tanzimat in the Arab provinces is in question, the ideological effects of this Ottoman reform movement undoubtedly grew deep roots in the soil of Syria, Lebanon, and Palestine. The intellectuals, literati, entrepreneurs, and activists responsible for establishing many of private schools, presses, and industry in Greater Syria, would define an identity and class culture to confront the challenges that modernity seemed to hold.

Though this broad historical overview clues us into the context of the literature and writers under scrutiny in this book, the process of redefining identity vis-à-vis a torrent of local and global changes is not exclusive to the cultures and societies of South West Asia. Similar activities were occurring throughout

much of the world in the like-minded reform, independence, and literary movements of colonial India, Iran, Philippines, China, and Meiji Japan. Speaking of a similar inscription of colonial presence in South Asia, for example, Homi Bhabha reveals how such a process goes beyond an explicitly material dimension that has been examined so rigorously by South Asian subaltern scholars, most notably Ranajit Guha.[5] That is, the "reformation" of self and society during the colonial encounter was an ontological as much as materialist phenomenon. If the discourses of colonialism, progress, and capitalism were hegemonic in their ability to exploit and subjectify, Bhabha shows that these discourses articulated by colonial bureaucrats, metropolitan writers, travelers and missionaries were also anxious and indeterminate, hence vulnerable to subversion. "Colonial presence," he states, "is always ambivalent, split between its appearance as original and authoritative and its articulation as repetition and difference. It is a disjunction produced within the act of enunciation as a specifically colonial articulation of those two disproportionate sites of colonial discourse and power: the colonial scene as the invention of historicity, mastery, mimesis or as the "other scene" of *Entstellung*, displacement, fantasy, psychic defense, and an "open" textuality."[6] More specifically, Bhabha is concerned with how this hegemony is enunciated through the "English book"; how the discourse of the colonizer is riddled with the tensions of its own contradictions and violence, thereby haunted by its own ambivalence. At the same time, the language and form of the book continue to maintain an authority that poses itself as an unquestionable epistemological fact. The insights of Bhabha and other insightful scholars of the colonial condition help our minds grapple with the endless productions of the metropolis. Their efforts uncover the disciplinary practices that enact the metropole's exploitive material control of the colonial subjects but also the discursive hegemony over them.

Returning to Arabic as the primary site for the production of knowledge, this study, in contrast to many scholars of postcoloniality, focuses on how "signs taken for wonders" or signs of mastery were naturalized endemically by a class of intellectuals before direct colonial intervention. We will see how the formation of a new Arab identity was constructed through experimentations in language, rhetoric, and of course literature, that is, through writing practices in the era of capitalist and imperialist expansion. More specifically, I have chosen a handful of prominent literati and reform thinkers whose work simultaneously aims to enact an autonomous Arab subject and society while also producing the discursive terrain that would confirm Western "superiority." The ambivalences and contradictions that consequently appear at the heart of the ideologies of

Arab identity have been subsequently neglected, reconciled, or glossed over by historians.

Historiography of Arab Nationalism and Identity

If the history of the Arab world occupies the quiet background of this study, its historiography stands in its path. The historiography of the Arab world has generally ignored discursive phenomena as a determining historical force in favor of material, political, and ideological developments. Consequently, it approaches modern Arab identity either as a historical fact or an ideologically generated myth. That is, the question of Arab identity has been linked a priori to pan-Arabist national identity and political ideology. Bernard Lewis garnered much popular attention as a scholar of the Middle East. His "scholarly" prescripts differ little ideologically and methodologically from his most recent pedestrian and opportunistic *What Went Wrong*.[7] For example, he asserts that the concept of ethnic identity was alien to the Arabs along with other ethnicities in Southwest Asia during the premodern era: "Descent, language, and habitation were all of secondary importance, and it is only during the last century that, under European influence, the concept of the political nation has begun to make headway. For Muslims, the basic division ... is that of faith, of membership of his religious community."[8]

As Edward Said has shown us, such a statement serves the West's need to articulate a determining set of criteria that aid it to identify and "understand" the Arabo-Islamic world. Like many of his expansive claims, Lewis's assertion lacks evidence in the historical record. In this case, the statement is erroneous not because the concept of an ethnically defined nation-state existed previously. Identity based on nation-states is a modern phenomenon in the East like the West. We do know, however, that the access to power, resources, position, and rule in the classical period was determined by ethnicity, descent, wealth, and local origin as much as faith, as was the case in medieval Europe. That Mamluk rule in Egypt was based on Turkic ethnicity and military pedigree seems to be an explicit example of the role of politics and ethnicity in determining who holds secular power.

A more nuanced example is the Abbasid shu'ubi debate, which pitched Persian and Arab cultures against one another. This debate tells us that local, ethnic, linguistic, and familial pedigree specifically determined selfhood and sociopolitical community precisely in the way that runs contrary to Lewis's supposition. I would propose, furthermore, that the shu'ubi debate was ensconced in

the very notion of Abbasid imperial rule. That is, the first two centuries of Islam were not defined by the coming together of disparate peoples under the banner of one homogenizing faith. Rather, the dynamic period was characterized by the jockeying for political, social, and religious dominance of Islam by various communities, which were informed precisely by ethnicity, locality, and descent if not politics and economy as well.

Lewis's ideologically loaded presupposition is that national identity inevitably manifests itself in a logical if not etiological desire for a nation-state. He is not alone when he conflates the notion of the nation-state with the notion of selfhood. Just as mainstream and state-sponsored historians have projected nationalist enunciations onto premodern Arab history, Lewis unoriginally equates diverse nuances of classical Arab subjectivity anachronistically with modern Arabism. This historical muddying collapses the contradictions and complexities presented to us by several centuries of Arabo-Islamic history that span over an equally diverse land mass and sociocultural environments. While his scholarship retains little weight in the academy, Lewis shares a historical method with countless historians, social scientists, and public policymakers of his generation, who hope to understand the modern Arab "mind." This crudely political understanding of history and identity underlies the historiography of the late Ottoman period in general, which is obsessed with how and when "the Arab street" started to publicly express a collective desire for self-determination. Consequently, the categorizing of all cultural, political, and intellectual acts as pro- or non-Arabist has confused the study of the period to the extent that many researches have been unable to distinguish between primary and secondary scholarship, between constative and performative statements, between polemics and history.

The most prominent example of this is the fact that George Antonius's *Arab Awakening*, which will be briefly discussed in Chapter Two, enframes the study of Arab identity. As the works of C. Ernest Dawn, Sylvia Haim, and Zeine Zeine attest, Antonius's book has served as a catalyst for the revision of the historiography of Arabism.[9] Over time, this revisionist scholarship has been challenged or supported by scholars such as William Cleveland, Rashid Khalidi, Philip Khoury, and Hasan Kayali.[10] All of these scholars have questioned the empirical reliability and veracity of Antonius, calling attention to ideological factors that might have influenced the objectivity of his work and the validity of the historical data that it provides. Responses to Antonius have led scholars to focus on statistical and quantitative data. For example, they have examined the number of participants in nationalist cadres prior to the First World War, such as *al-*

Fatat and *al-'Ahd,* or the number of subscribers to political journals such as Muhammad Kurd Ali's *al-Muqtabas* or 'Abd al-Ghani al-'Uraysi's *al-Mufid.* These historiographical avenues are fascinating but seem to me to be misdirected. Few would disagree that *The Arab Awakening,* despite its weaknesses and explicit political agenda, is an interesting secondary source. With this consensus, the value of Antonius's work should be found not in its trustworthiness as a secondary source but in its eloquence and clarity as a primary source. Albert Hourani recognized this when he stated, "*The Arab Awakening* has a literary merit of a high order. It is written in an excellent narrative style, precise, vivid, highly colored, at times moving."[11]

In *The Emergence of the Modern Middle East,* Hourani provides another valuable but overlooked insight. The analysis of Arabism as an ideology, he states, is missing from examinations of *The Arab Awakening*.[12] The shortcomings of the historiography of Arabism seem to lie here. Antonius's detractors are correct in identifying his work as biased. However, its ideological tenor is the source of its rhetorical power. Therefore, scholars, both Arab and Western, have failed to understand *The Arab Awakening* as a manifesto of selfhood, that is to say, as a metaphysical and epistemological phenomenon. Therefore, I am proposing that Arab nationalism must also be understood as arising from a series of discourses on subjectivity. Seen as a primary source, we appreciate *The Arab Awakening* as a text that *enunciates* the archetypal Arab self-view. In it, Antonius eloquently presents a post-*nahdah* zeitgeist. We understand the text's form and content as replete with the representation that the Arabs hoped to communicate to the Great Powers during a time of Zionist entrenchment in mandatory rule in Palestine. On a less calculating level, *The Arab Awakening* is a final product of an epistemological tradition where competing aspects of national selfhood had been rehashed painstakingly and worked into a coherent sense of modern identity.

By closely examining some of the works from the pantheon that Antonius immortalized, this present work suggests that this epistemology of the national identity, so inspirationally presented in *The Arab Awakening,* is antecedent to the articulation of Arabism as a full-fledged ideology or national movement. This assertion addresses Ernest Dawn's contention that Arab nationalist sentiment, and therefore the modern conception of Arab selfhood, was an exclusive outgrowth of Islamic modernism. Those who deny this, he says, "write of Arab nationalism without Arab nationalists, of a movement without participants."[13] The fiction and nonfiction of these prenational movement intellectuals—Christian, Muslim, and Jewish—will show us that the ideological utterances of

subjectivity inherent to Arabism anticipate the citizen-nation configuration. More simply said, we will see that the possibility, or what Mohammed Arkoun might call *la pensée,* of Arab nationalism is preceded necessarily by a specific epistemology; an organization and regime of knowledge that was shared by "Christian secularists" and "Islamic Modernists," Arab Ottomanists and Egyptian nationalists alike.[14] Nationalism, however, is only one expression of a selfhood that takes form in multiple cultural productions and sites. As the Young Ottoman movement shows us, expressions of national identity did not necessarily mean that this identity aspired exclusively to independent statehood. The selfhood that became the stuff of modern Middle Eastern nationalisms was not ready-made. Nor was it an a priori fact originating in some kernel of authenticity just waiting to be resuscitated by intellectuals and activists. Neither was this selfhood completely contrived or mythical, with no connection to historical materialism or preexisting consciousness that had to be recoded and reinterpreted in the light of the modern era.

Modernity and Authenticity

Contemporary Arab intellectuals such as Abdallah Laroui, Muhammad ʿAbid al-Jabiri, ʿAziz al-ʿAzmah, ʿAli Harb, and George Tarabishi have recognized the tension between the authenticity, modernity, and construct of Arab selfhood.[15] While avoiding many of the pitfalls inherent to questions of Arab identity, many of these brilliant critics have failed to confront the limits of the epistemology of modernity. They state that Arab thinkers rely reverently on their modern intellectual forefathers. This reverence leads them to accept misreadings, which fail to break archaic paradigms of selfhood.[16] As a result, Arab society, they assert, has failed to internalize humanistic notions of modern civil society or to form cultural renewal in its own terms. For example, Hisham Sharabi contends that Arab intellectuals, particularly secular intellectuals, failed to articulate "a genuinely independent critical and analytical discourse in which the problematics of identity, history, and the West could find effective resolution."[17] This reply is predicated, however, on the prevalent assumption that modern Arab identity could be separated from the dominant epistemology that it developed during the colonial era. Or, it presupposes that intellectuals could, in some way, have rejected European hegemony and formulated a sense of self that was separate from the West's domineering presence.

Sharabi is not alone in the pantheon of equally prolific and committed Arab intellectuals who reproduce the myths of modernity. In *Al-Naqd al-dhati* (Self-

critique), written in the wake of the 1967 war, Sadiq Jalal al-'Azm is faithful to this messianic modernity. Arabs have failed, he believes, because they have faltered at the level of thought and practices. Repeating a familiar chant, he states that they have failed "to absorb the fundamentals of modernity, its science, technology, and institutions."[18] He concludes that "the inability to admit that 'you (Arabs) have failed'" indicates the absence of a self-critical nature and will-to-progress that arise from humanistic secularism. This denial of the true principles of modernity led the Arabs to the disastrous defeat in 1967.[19] More insidiously, we find this same prism in the works of Fouad Ajami, particularly *The Arab Predicament*, or Bassam Tibi. Disproving the assertions of the aforementioned Western pundits, Arab critical thinkers, from the right and left, often concur that the Arabs have not progressed because the intellectual and political class never properly internalized modernity's true political and philosophical esprit de corps.[20]

This present study rejects these assertions. Modernity undoubtedly has had uncompromising force in Arab society, polity, and culture because it is inseparable from the very epistemology of its selfhood. A review of works by various turn of the century intellectuals or twentieth-century nationalists will confirm that this epistemology is common to several competing discourses of Arab subjectivity; discourses as various as Islamic Modernism, Christian secularism, Romantic nationalism, to even the Salafiyah movement. Indeed, two generations of intellectuals established an epistemological continuity between the generations of Jurji Zaydan and that of al-'Azm and Sharabi. Salamah Musa is precisely one of those intellectuals whose imprint can be found on Sharabi and 'Azm's generation. As a early secularist and proto-socialist, his belief in modernity is sustained throughout his long intellectual career. For example, in 1962, he opens his memoirs with this vignette.

> I saw the nineteenth century through the eyes of a child. I saw it free of complexities, wearing nothing of the inventions of the twentieth century. ... The traditions of the nineteenth century—if not the many preceding centuries—remained static until the beginning of this very century.... I have ridden on a donkey from the Cairo railway station to 'Aabin and I lived in Zagazig when street lamps were unknown.[21]

Negatively, the imagery is rife with the modern. Musa conjures up a vision that represses signs of modernity. In painting such a portrait, he omits the predominance of radically new forms of communication, transportation, economy, and thought that had reached even the Egyptian countryside. By the late 1880s,

for example, the foreign-dominated cotton industry ran deep into rural Egypt; British troops bombarded Alexandria and occupied Egypt; and the Khedives bankrupted the country through an enormous national debt. Moreover, paging through any 1890s volume of the journal *al-Hilal*, one can find letters from regional towns up and down the Nile. But for Musa, like his intellectual progeny, modernity is conspicuous and proves itself only in the most ostentatious manifestations. That this "proof" did not always exist at an immediate visible level attests, for him, to his culture's "backwardness."

Qualifications and Clarifications

Before proceeding further, lexical and semantic clarifications of the nomenclature of reform (*islah*) are necessary. Reformer and littérateur ʿAbd Allah al-Nadim comments that "if an Arab loses his language, he loses his nation and his religion."[22] This nexus of language, self, and identity interests us as do the problems, ambiguities, and contradictions that this knot presents. The question of language is essential to *al-nahdah* because it creates a specific causal chain that binds the paradigms of reform, a chain upon which reform can be enacted.

Terminology such as cultural success (*najah*), decrepitude (*inhitat*), stagnation (*jumud*), progress (*taqaddum*), and civilization" (*tamaddun*) may be misunderstood. I am not asserting that the Arabs were actually culturally decrepit or socially backwards during or due to the Ottoman era. Nor am I so idealistic as to contend reactively that the Arab world flourished during this period in ways that it previously or subsequently had not. I use the inflammatory terms "decrepit," "native failure" and "lack," "European superiority," and the like, not as terms to describe an a priori, indisputable cultural and social factual condition of the time. These terms are the lexicon that intellectuals used in ascribing the ontological, subjective, cultural crisis that they were diagnosing. Therefore, I do not delimit success/failure, presence/lack, and progress/backward dichotomies because I feel that they accurately represent the true cultural, social, and subjective states of Arab culture. Rather, they are the epistemological condition endemic to the reform platform of the nineteenth century as imagined and envisioned by thinkers, activists, literati, reformers, poets, and merchants of the day. For the intellectuals in question, this lexicon describes cultural facts and serves as antipodes between which the subject must move in his/her journey towards reform.

This study is admitted lopsided. Intellectuals of Lebanese and Egyptian origin based in Beirut and Cairo make up a lion's portion of this research. There

were dynamic reform movements in Algeria, Tunis, and Morocco as well as fascinating intellectual and academic debates in Baghdad, Sanaʻa, Aleppo, Damascus, Haifa, and Jerusalem. While I examine a handful of generally forgotten literati, I have chosen to concentrate on the pantheon of "pioneers" as delimited by the historiographical tradition.

Likewise, many of the literati are Christian Arabs and all, save Labibah Hashim, are male. Indeed, women's journals increased at the turn of the century. Their weighty influence in creating a generation of women intellectuals, writers, editors, educators, and activists cannot be underestimated. While women's rights was central to reform discourses, the national ideal that these male reformers cobbled together was essentially male just as the civil order and public space which they imagined was masculine. I would hope to see further examination of how women's personal and national identities were constructed by writing and artistic practices, but also how these identities were navigated, mediated, or displaced by their male counterparts' vision of modernity.

I anticipate that some might take issue with my choice of the terms "Arab," "native," "indigene," and "subject." First of all, the term "Arab" or "Arab subject" may seem anachronistic or even misplaced to some, considering that intellectuals referred to themselves as Syrians, Egyptians, "Easterners," and Ottoman citizens as often as they identified themselves as Arab. As is the case with using terms like "West," "Western," and "European," I acknowledge that "Arabs" is a generalization that fails to represent the intracultural, interregional, confessional, and class diversity within the Arab world. Despite the pedantic and rhetorical deployment of this terminology, they are not monolithic terms.

My emphasis on the "subject" demands a brief explanation that would help in abating any undue misunderstandings. When I speak of the Arab subject, the native subject, and the national subject, I am speaking not of concrete citizens or stereotypes but of representation of a subjective ideal that these nineteenth-century intellectuals were depicting. If nothing else, this ideal was a yardstick by which reformers set their goals and gauged their failures. If identity represents a synthesis of cultural, historical, and social components, subject includes discursive, ontological, and psychological fields. As Deleuze might say, the subject refers to a conceptualization of an indigenous self who is an assemblage of several competing, often contradictory historical and cultural, religious and secular discourses. In this vein, "Arab subject" represents a typology.

This Nietzschean understanding of typos and tropes underlies the project at hand. The book begins with a meticulous reading of a handful of foundational texts by Butrus al-Bustani and his peers in chapters 1 and 2, in hopes of unfold-

ing the structure, contradictions, and ellipses within epistemological core of competing positivist, secularist, and romantic discourses. The arduous rigors of this reading are fruitful as they lay out the plane upon which this study, and indeed Renaissance itself, transpires. In chapters 3 and 4, the analysis opens up in speed and the number of texts in question. In these chapters, I discuss how literary productions articulated, reformulated, and struggled with the paradigms of reform vis-à-vis the looming cultural and political hegemony of the Western powers in Egypt and the Levant. In this variety of engagements, new schools of thought, aesthetics, and cultural productions were generated. All were bound by the problematics introduced in the first two chapters. In chapter 5, we will see that the Arabo-Muslim competency and rationality had become the dominant cultural issue between East and West, as exemplified by the debates between Ernest Renan and Jamal al-din al-Afghani and Farah Antun and Muhammad ʿAbduh. I reveal how the very criteria of universal reason had become inscribed within the nativist discourses themselves. Finally, the topoi organized through the writing of fiction and fiction appears in their most plastic and popular form, that of the historical novel. In chapter 6, I read the historical novels of Jurji Zaydan to understand how the subject splits, once again, into performative and constative subjects in narrating a vision of the past and present that is both modern and "authentic."

The intellectuals, writers, reformers, activists, and cultural producers under examination in this study are not foundational because their works still resonate in the canon of Arabic literature, culture, and thought. Some have been forgotten, and their works remain obscure. Others exist as often referenced but rarely examined titles and names that form the backdrop for unquestioned literary, political, or intellectual traditions. The texts are foundational because of the language, the discourse, and the episteme that they articulate and represent. The authors in question, as Foucault has said, "produced not only their work, but the possibility and the rules of the formation of other texts."[23] The paradigms that they tumultuously forged served as the basis of the rationalist discourse of Arab subjectivity during the Arab Renaissance and consequently a romantic backlash. But also the epistemology that they animated remains at the unconscious of a variety of subjective positions for Arabs that would be adopted in the following hundred and fifty years.

1

Unpacking the Native Subject

Virtually every intellectual and political discourse has a handful of texts that can be called foundational to their specific tradition. Frantz Fanon's *Wretched of the Earth*, for example, is understood as a foundational text for intellectuals of postcolonial studies; it also influenced those involved in the anticolonial struggle, particularly those actively forging a national culture in response to colonial and/or postcolonial domination. The text is foundational because the study eloquently and systematically replaces essentialist notions of national identity and ethnic authenticity with the central role of praxis and problematics of creating national culture.[1] Therefore, Fanon's work, especially *Wretched of the Earth*, resonates in writing from Amilcar Cabral to Ngugi wa Thiong'o, but moreover it presents a politico-intellectual platform from which all postcolonial must depart.

Yet foundational texts and thinkers often slip into the recesses of our psyche, occupying certain discursive prisms. Al-Muʿallim Butrus al-Bustani can be understood as such a foundational thinker of Arab culture and society. Throughout his life, al-Bustani systematically laid down the fundamental tropes and equations that are found in virtually all Arab reform discourses in later decades and, therefore, demarcated the epistemological boundaries of subsequent debates and theories. While he was not alone in articulating these tropes, the structured manner of the equations point to a clear outline of the epistemology that would inform many "competing" discourses of social reform and national identity from "Islamic modernism" to "Arab secularism" to parochial nationalisms. Just as few discussions of postcolonial theory can proceed without even a cursory reference to Fanon, Arab and Western scholars continue to mention al-Bustani's name in the development of modern Arab intellectual and cultural heritage. However, it is apparent that most of these scholars rely

on secondary sources, particularly Albert Hourani's *Arabic Thought in the Liberal Age,* and have read little, if any, of al-Bustani's original writings.

Growth of an Intellectual

In 1819, Butrus ibn Bulus al-Bustani was born in al-Dibbayah, the ancestral village of the Bustani family located fifteen kilometers south of Beirut in the area of Iqlim al-Khurub. The Bustani family was traditionally known for its ties to the Maronite Church, and it seemed little Butrus would follow a path in the Church blazed by his ancestors. He spent many years studying and then taught languages (Arabic, Syriac, and Italian), theology, rhetoric, and other classical disciplines at the prestigious seminary of ʿAyn Waraqah. The seminary was established by the Maronite clergy in 1789, and it maintained an important place in graduating leaders of the church but also producing secular intellectuals of the Arab Renaissance including Ahmad Faris al-Shidyaq. Al-Muʿallim Butrus's natural ability and family connections made him a perfect candidate to continue his education at the Maronite College in Rome, which would have ensured him a prominent role in the Maronite Church hierarchy, whose political power had expanded significantly since the beginning of the nineteenth century.[2] However, his widowed mother, so the story goes, could not accept the absence of her only son, causing Butrus to forego studies in Rome and turn down an otherwise promising future in the Church.

In 1840, al-Bustani seems to have arrived in Beirut, purportedly to work as a translator for the British army, which had been deployed in the city as a result of a consensus of the Great Powers and the Sublime Porte upon the withdrawal of Ibrahim Pasha from Syria. Abdul Latif Tibawi and John Jandora, however, contend that it is unlikely al-Bustani knew English at this time.[3] We do know for certain that soon after this date he became a tutor and translator for the newly arrived American Protestant missionaries, who made Beirut their base of activities for the next fifty years. Among these missionaries, he met two of his dearest Western friends, the Reverend Eli Smith (d. 1857) and the prodigious Dr. Cornelius Van Dyck (1818–1895).

His interaction with these missionaries resulted in his conversion. While we know little about al-Muʿallim Butrus's conversion to Protestantism itself, it is certain to have been a scandal considering his family's history with the Maronite Church. Cornelius Van Dyck states in "Reminiscences of the Syria Mission, 1839–1850" that in the winter of 1841, al-Bustani "came down . . . desiring to

become a proselyte and be employed." Henry H. Jessup, one of the more vituperative and rabidly anti-Catholic missionaries, suggests that the native convert discovered the "truth" of Protestantism while teaching at the seminary of ʿAyn Waraqah. After this, he states, Eli Smith gave refuge to al-Bustani for two years under fear of retribution by the Maronite Church.[4] The fear was not unfounded. The Patriarch decreed excommunication for anyone associating with the Americans or caught reading missionary literature. He in fact had imprisoned the first Arab convert to Protestantism, Asʿad al-Shidyaq, who died of deprivation in detention at a secluded Maronite monastery. Al-Bustani wrote al-Shidyaq's story.[5] It seems doubtful that al-Muʿallim Butrus al-Bustani solicited conversion while teaching at ʿAyn Waraqah, as Jessup suggests. However, considering his active and leading role in the native Protestant Church, the sincerity of his conversion should not be in doubt or questioned as motivated exclusively by a desire for work, social mobility, or privilege. His role in the American mission and central role in the native church was instrumental from the moment of his induction to them.

By the mid-1840s, al-Muʿallim Butrus al-Bustani taught at the Protestant seminary in the mountain village of ʿAbeih. He married a convert, Sarah, who was teaching in the missionary girls' school of which she was one of its earliest graduates. He was eventually recalled to Beirut for the monumental project of retranslating the Bible into Arabic (1848–56). There, he worked along with Eli Smith and the renowned scholar and poet al-Shaykh Nasif al-Yaziji. Van Dyck and his assistant, al-Shaykh Yusuf al-Asir, completed the Bible translation after Smith died in 1856, but the missionary doctor used most of the finished work of Smith and al-Bustani.

While in Beirut, al-Muʿallim Butrus became the interpreter for the American consul and was active in local intellectual circles. He helped found with his American employers al-Jamʿiyah al-suriyah lil-ʿulum wal-funun (Syrian society for the arts and sciences), a literary-scientific circle, centered around the mission. As secretary, he was responsible for the editing and publication of their proceedings, which we still have today. In the meantime, he had become the most prominent figure in the native Protestant congregation. The native church, in effect led by al-Bustani, broke off from the American mission in protest to their lack of independence and the mission's resistance to allow them to assume roles of leadership in the local church.[6] That is, a running debate between the Beirut mission and Rufus Anderson, secretary of the American Board of Commissioners for Foreign Missions (ABCFM) in Boston, took place

in 1850–51 over whether to ordain a "native minister." As the most erudite and brilliant convert in Lebanon, al-Bustani was an obvious choice. However, the archives of the ABCFM confirm that even Arabophilic expatriate missionaries such as Van Dyck—who would leave the mission out of protest on another matter—resisted an increased role of the converts in the affairs of their church, fearing that the foreign missionaries would become superfluous.[7] This and a series of slights by the American consul encouraged al-Mu'allim Butrus to become more secular and gradually distance himself from the American community.

His secularism developed hand in hand with his nationalism. After the massacres of 1860, he wrote *Nafir suriyah* (Clarion of Syria), eleven patriotic tracts stressing the need for interconfessional unity, which will be discussed extensively in the following chapter. During this period, al-Mu'allim Butrus al-Bustani began to write textbooks on mathematics, Arabic grammar, and the sciences for the missionary schools. The experience would serve him well, as he continued to write pedagogical texts for his own school, al-Madrasah al-wataniyah (National School), which he established in 1863. The first secular school in the Arab world, it was a nationalistic project whose faculty consisted of eminent local intellectuals from various confessions.[8]

His growing intellectual and financial independence allowed him to produce his larger and monumental accomplishments, namely, *Muhit al-muhit* (1869), a comprehensive Arabic dictionary and the groundbreaking journal *al-Jinan* (1870), whose purpose was explicitly to "strengthen, improve, and preserve" knowledge and the Arabic language.[9] The fortnightly and weekly newspapers *al-Jannah* (1870) and *al-Junaynuh* (1871) offered a backdrop to the journal, and his encyclopaedia, *Da'irat al-ma'arif* (The scope of knowledge) (1876–1900), was an unprecedented venture of his day. Al-Mu'allim Butrus al-Bustani died of heart failure in 1883 in Beirut, leaving the encyclopaedia incomplete in the hands of his sons, Salim and Najib, and their cousin, Suleiman al-Bustani, an Ottoman parliamentarian who had translated the *Iliad* into Arabic from the original Greek.[10]

The biography of al-Bustani is important because it testifies to the convergence between his oeuvre and the critical historical developments of his lifetime. For example, as a young adult he witnessed Ibrahim Pasha's challenge to Ottoman power in Greater Syria. He lived through several intersectarian massacres in Lebanon and Syria, witnessed the occupation of Beirut on two occasions by European "peacekeeping" troops, and watched the number of American, British, French, and Russian consuls, merchants, and missionaries increase

in Beirut considerably over forty years. Likewise, the formation of the Mutasarrifiyah in 1860 testified to a new configuration of sectarian power in Lebanon to which his own work would speak, while the silk industry itself would completely transform his country's economy, producing new classes that would be the audience of his intellectual and social project.

Foundational Discourse on Arab Culture

The reform movement in the Ottoman Empire, known as the Tanzimat or Risorgimento, had been officially under way since Sultan Mahmud II's destruction of the Janissaries, which signaled the beginning of bureaucratic reform in 1826. Subsequently, the Palace had begun to adopt new legal, land, and civil codes as well as the Sultan 'Abd al-Majid's Gulhane Hatti-Hamayun in 1839, granting the equal rights to minorities of the Empire. While many of these codes and reforms were not instituted at local levels, it is safe to say that they mark a discursive and political moment that made the time ripe for a new breed of intellectuals. Like their Armenian and Turkish counterparts, Christian and Muslim Arab intellectuals dealt with opposition from conservative religious elements within and outside their own communities. Some of these new intellectuals were linked to the State, and some were independent of it. What is noteworthy is that most of the intellectuals originate in regions most intensely involved in the reforms such as Egypt, Syro-Lebanon, and Tunisia. They found local if not regional audiences, most of whom were positively or adversely affected by the social, political, and economic changes under way in the Empire at that time.

While *Da'irat al-ma'arif* was his magnum opus, al-Bustani's *Khutbah fi adab al-'arab* (Discourse on Arab culture) is the very sort of intellectual production that would speak to the new economic and social classes in "Greater Syria" that were germinating as a result of the reform movement, capital influx because of economic transformations, interregional politics, and international interventions. A commentary on past and present Arab culture, the colophon of the text asserts that the lecture was presented in an abbreviated form to "a well-attended assembly of Westerners (*ifranj*) and Arab sons in Beirut" on 15 February 1859 (40). We can safely assume that this gathering was the Syrian Society for the Arts and Sciences, al-Jam'iyah al-suriyah.[11]

Khutbah is divided into three sections that are indicative of the reformer's vision of scientific progress and the Arabs' historical place in it: "The State of Knowledge ['ulum] among the Arabs before the Advent of Islam," "The State of

Knowledge among the Arabs after the Advent of Islam," and "The State of Knowledge in These Days." These three sections are prefaced by a brief introduction that presents the central propositions of al-Bustani's theory of Arab cultural, social, and subjective regeneration. These propositions delimit the thematic structure of the author's inquiry into the historical and cultural categories.[12] In addition, he prescribes solutions for cultural and social progress that recur in his later works. More important, al-Bustani's introduction presents an epistemological map of the reform project itself, whereby knowledge is central to culture (*adab*) and sociocultural progress (*taqaddum*). The knowledge (*'ulum wa ma'arif*) of which al-Bustani speaks is unambiguous: positivist, empirical, secular, and scientific knowledge. This knowledge, the conditions and techniques of its acquisition, maintenance, and advancement, are understood as the universal element requisite to Arab progress (*taqaddum*), civilization (*tamaddun*), and subjective, social, and political reform (*islah*) (2–3).

This social understanding of knowledge was not new to innovators of reform throughout the Muslim world. The terms *'ulum* and *ma'arif* have resonance and weight in classical Islamic disciplines and Arab rhetoric. Certainly, it had been bandied about quite promiscuously since the beginning of constitutional and political reform in the Ottoman capital precisely because it maintained such currency, which was reproduced by traditional educational systems. Both Michael Chamberlain and George Makdisi have discussed the structure and organization of the "traditional" *madrasah*, which was usually affiliated with the local mosque. The *madrasah* offered a curriculum of the "rational sciences" (*al-'ulum al-'aqliyah*) but stressed religious subjects such as the study of the Quran, Hadith, and Shari'ah as its raison d'être.[13] Christian schools in the Levant had a more diverse curriculum since the sixteenth century, however, as they were fundamentally seminaries or used for producing a small group of *petits fonctionnaires* for local courts and merchant houses. While all of these schools produced their share of great thinkers, prominent administrators, and noteworthy poets, the overall education was based on a conception that knowledge is exclusive and specialized, not universal. The relationship between knowledge and order differed in traditional pedagogical paradigms where the prosperity and the longevity of a society relied on the enlightenment of ruling classes and elites (including the intelligentsia), not the masses. *The Book of Governance* by the Suljuq wazir Nizam al-Mulk makes this clear. Partly an eleventh-century Machiavellian work, partly a guide to elite education, the wazir's famous manuscript aimed to instill princes and the aristocracy with knowledge

necessary for retaining power as well as maintaining political and bureaucratic order.

The nature of knowledge underwent a transfiguration. Its meaning became reified as secular and as the tour de force of progress. In the introduction to his encyclopaedia *Da'irat al-ma'arif,* al-Bustani clearly demonstrates the considerable range that the term had come to encompass in the reform lexicon by the mid-nineteenth century. He states that his encyclopaedia, in fact, is particularly concerned with secular knowledge. The litany is extensive including philosophical and social sciences (*'ilm al-ahaliyah*), theology (*kalam*), and philosophy (*falsafah*); civil and political sciences such as jurisprudence (*fiqh*), and natural, civil, and commercial laws (*al-huquq al-tabi'iyah, 'umumiyah, tijariyah,* and *qanuniyah*); "historical knowledge" (*al-'ulum al-tarikhiyah*) of geography, ancient, modern, and church history, as well as archaeology and Greek mythology; the "educational sciences" of algebra, engineering, accounting; mechanical and chemical sciences, particularly astronomy (*fulk*) and chemistry; the natural sciences of botany, geology, animal and human physiology, and medicine; and the classical disciplines of languages, poetry, composition, and rhetoric as well as literary history. Al-Bustani lists even technical and artistic skills (*fann-wa sina'ah*) such as architecture, inventions, medicine, music, painting, commerce, mining, and printing.[14] Al-Bustani's inventory provides a conceptualization of knowledge's role vis-à-vis society and culture.

> Knowledge (*al-ma'arif*) is the foundation for the mastery of agriculture, industry, and commerce. It is the mother of inventions and discoveries, and the source (*yanbu'*) of prosperity and strength. It is the root of comfort and the preservation of health and the pillar upon which the conditions of society (*al-hay'ah al-ijtima'iyah*), political realities (*haqa'iq al-siyasah*), secular and religious law, and administration rest. It is the means to elevate the mind and the health of governing, and refining character as well as the means to improve customs, pursue religious education, and discover illnesses and their causes. Likewise, knowledge bestows order to business and its management, and so forth.[15]

If in *Da'irat al-ma'arif* he defines knowledge as the keystone to economic health and social order, al-Bustani is explicit and methodical in defining the relationship between knowledge and subjectivity in *Khutbah*. Knowledge, he says, "is not inherited like property and wealth. Rather it demands personal effort (*ijtihad shakhsi*)" (2). It "is like a visitor, establishing itself only with

those who welcome it" (2–3). This unassuming statement lies at the heart of al-Bustani's theory of the subject who is constituted by subjective will. Knowledge must be pursued and cultivated as a personal endeavor, which, in turn, is a critical component to a larger social and a national enterprise. This nexus between individual effort and social necessity is the birth of the modern Arab citizen; an Arab citizen that would be essential in enacting reform on a micro or popular level. While not exclusive to al-Bustani, the interconnectedness of individual and collective knowledge is inlaid in his treatise when he states that the intellect must have the supporting means to acquire knowledge. These means are exterior to the intellect. Among the best of these means are moving and travelling from place to place and the study of books. The existence of instruments without which it is impossible for the senses to perceive what is sought is essential. Also needed is the motivation that makes the intellect attentive and desirous of exemplary behavior and enthusiasm, both of which are naturally intrinsic to humanity. It is obvious that freedom of thought is one of the most important requirements for the recognition of truth and the acquisition of knowledge ('ulum) (3).

Al-Mu'allim Butrus skillfully blends the social and the subjective, the external and internal needs and requirements for cultural regeneration and for being an autonomous subject. His criteria for the accumulation and circulation of knowledge, and therefore progress itself, range from the material (books and technology) to the intellectual (motivations) to the cultural (travel) and to the social (freedom of thought). This weave demonstrates the dialectic nature of *Khutbah*'s criteria for a diagnosis of and prescription for what reformers would identify as the inherent ills of nineteenth-century Arab society.[16]

Allegorical Failure

Perhaps influenced by his missionary colleagues, al-Bustani contends that during "the advent of Islam" (*sadr al-Islam*) as well as the Umayyad dynasty, the Arabs "were not concerned with anything regarding knowledge" ('ulum) "nor did they acknowledge the worth of any books save the Quran" (7). As an example, the author relays an account of the burning of the renowned library of Alexandria. As a lifelong student of Syriac, al-Mu'allim Butrus repeats St. Efram's account. That is, at the command of the Caliph 'Umar ibn al-Khattab, 'Amr ibn al-'As, the conqueror of Egypt, destroyed four hundred thousand books originating from Egypt, Greece, and India because "they differed from the Book of God" (6–7). This belief is no longer held by historians. But the

allegory is clear. "Ignorance" (*jahl*) has the destructive potential to wipe out native and imported learning and thereby prevent cultural progress.

Such an admonition was poignant considering the increasing numbers of students from the Arab and Ottoman world studying in Europe and the subsequent tension between the reforms they would enact and the traditional elites that they would alienate. The example of the library of Alexandria, however, extends beyond sound advice and common sense. It offers a past-present allegory that serves to open the critique of the "state of knowledge" through historical example and consequences. Within this critique, ignorance is the antithesis of a historical-cultural catalyst, exhibiting itself as a negative force and abated only by the will to seek, borrow, and maintain knowledge irrespective of its origins. Along with the opening example in *Bootstrap*, one must only look at communiqués by the nationalist group Hay'at Tahrir (Liberation Society) to understand the term's force and longevity in nationalist, reform, and developmental ideologies.[17]

As in the European countries (*al-buldan al-ifranjiyah*), the "dark ages" fell upon the Arabs in the fourteenth century when they were no longer willing to pursue and maintain the knowledge that had made them great. The decline occurred, al-Bustani states, when the desire (*raghbah*) of Arab royalty and notables for knowledge ceased. Subsequently, the motives for inquiry broke down, impeding the pursuit of the acquisition of knowledge. Texts of knowledge and science were studied but then lost, leaving few vestiges. The "commodities of knowledge" found no market, allowing time (*dahr*) to erode their proprietors. Ignorance forcefully overpowered the people to the degree to which they came to think that the acquisition of knowledge and science themselves were a corrupt affair and a vain endeavor (25). Yet ignorance is more than the simple antithesis of knowledge for al-Bustani, more than a personal tragedy or individual proclivity but a social disease. Easily internalized, he says, the effects of the past manifest themselves in the present because the lack of will for knowledge and progress is the infection of ignorance. Under its sway, learning and knowledge are devalued and find no outlet because the means of knowledge's production and distribution have deteriorated. Moreover, intellectual commodities themselves are seen to have detrimental moral effects. For example, the contents of the library of Alexandria were not only perceived as worthless by these ignorants but also as morally corrupting because, it is implied, it contains secular knowledge. Within this theory, the Umayyad Arab lacked the ability to recognize knowledge as a sign of and a key to what al-Bustani specifically identifies as progress (*taqaddum*) and civilization (*tamaddun*).

We must understand that this historical analysis was by no means an academic effort for al-Bustani but a desperate redress of what he and his peers saw as the root of a cultural, social, and subjective crisis. In declaring Umayyad a failure, al-Muʿallim Butrus refers to its contemporary analogue, the nineteenth-century Arab subject. What binds these two figures—Umayyad and the contemporary subject—is not that they resemble one another but that they are the same subject. Hence, al-Bustani conjures up a transhistorical, imaginary Other who suffers not from maliciousness but from a pathology of ignorance. This pathology in the mind of the Arab critic is that this ignorant Arab Other can only react erroneously because he misrecognizes knowledge as a source of depravity, not productivity. In another context, Jacques Lacan relates to us that "misrecognition represents a certain organization of affirmations and negations, to which the subject is attached. Hence, it cannot be conceived without correlative knowledge."[18] For al-Bustani and his peers, the misrecognition perpetrated by the Arab Other is due to a critical lacunae in psychic and social organization that generates a delusionary world vision.

Al-Bustani's Umayyad schema offers more than a pedantic inversion of the renaissance paradigm proving that ignorance is counterproductive and an agent of social decay. The allegory indicates for al-Bustani that a crisis exists for the Arabs at the most fundamental ontological level because the ignorant subject, whether he is the historical Umayyad or his contemporary analogue, lacks the self-consciousness that makes him a successful social being, let alone civic actor. Such an analytical assertion is certainly not philosophically exclusive to Arab modernity or the Hegelianism that haunts it. The sentiment resonates with the neo-Platonic tradition within the classical rationalist Arabo-Islamic tradition, where knowing and consciousness are bound to ascending several cognitive levels. What is ideologically exclusive to Arab modernity is that the "unknowing subject" is not external to the knowing Arab self. Rather, as the allegory of the Alexandria Library communicated, the Arab Other is endemic to the Arab Self himself.

Nomenclature and Signification

This paradox of Arab otherness and selfhood can only be understood if the ideological language of al-Bustani is naturalized. More precisely, a specific nomenclature is common to virtually all reform narratives throughout the Empire, irrespective of the specific author's confession, ethnicity, geography, or choice of genre of literature. Originating explicitly in the language of modernity,

this nomenclature sets up a linguistic and logical chain or a syntagm of reform. As we will see, this chain is one of signification as much as causality.

The nomenclature of reform is one familiar to most students of the period because it recurs religiously throughout the innumerable and disparate genres of fiction and nonfiction. The terminology forms an equation that provides a causality of progress. The formula and nomenclature intertwine as follows: Contemporary Arab culture was in a state of decay (*inhitat*) and stagnation (*jumud*) by the nineteenth century. If the subject were to reawaken his desire (*raghbah*) for knowledge (*'ulum wa-ma'arif*), then he would be compelled to exert optimum effort (*ijtihad, jahd,* or *sa'y*) to acquire "modern" knowledge. Cultural infrastructure specific to modernity such as presses, printed classical and original books, journals, schools, and libraries is necessary to institutionalize and reproduce these forms of knowledge. The realization of this equation is the logical consequence of reform (*islah*), whose endpoint is modern civilization (*tamaddum* and *hadarah*).

Reform nomenclature provided step-by-step, albeit abstract, nodal points in a chain that leads from an age of backwardness (*t'akhkhur*) to the modern age (*asr al-jadid*). But the terms of the syntagm also provided ready-made binary leitmotifs such as progressive/ ignorant, industrious/indolent, and enlightened /fanatical around which fictional and nonfictional narratives could organize the representation and ideals of the reform. Therefore, for the nineteenth-century critic and reader, the terminology of reform would hold more than a rhetorical value but also a specific signifying power that verifies the naturalness of social development. *Khutbah*'s force is that it concisely articulates this nomenclature in offering its paradigm of cultural vitality.

Ideal-Ego and Discourse Representation

Al-Bustani was not concerned with mapping out a return to past Arab greatness, as was the case with eighteenth century *wahabism* or the conservative *salafiyah* movement at the end of the nineteenth century. Appropriately, he was preoccupied with the progress of the Arabs within a universal context. Like Turkish, Armenian, Persian, and Indian reformers, he searched for the method by which they could "rekindle" the desire for knowledge that would catapult them into the modern era as efficacious cultural producers who would rival the West. This indigenous cultural producer, indeed producer of history, requires a specific consciousness that reaches temporally and geographically beyond the local or confessional self.

If a new sort of consciousness predicates the regeneration of culture, a consciousness that finds its inspiration in universal positivist knowledge, then the question of history becomes paramount. That al-Bustani eagerly takes his allegories largely from history, rather than from literature, religion, art, or science, indicates the centrality of historical consciousness in cultural revitalization. It also makes clear to us that intellectuals were re-creating new historical narratives based on new regimes of knowledge rather than passively inheriting historical facts, traditions, or paradigms.

The representation of cultural and social success and failure is woven together through a historical narrative in *Khutbah*. The negative example of the Umayyads stands in contradistinction to their successors, the Abbasids. In modern scholarship, the Abbasids often are seen as less Arab than Persian, and much has been made of the aforementioned *shuʿubi* debate within Abbasid culture and politics. Al-Bustani, however, saw them as the model of Arabness, perhaps for this very reason of cultural hybridity. Seizing on this trope of the Abbasids is crucial, as it discloses a representational field for reformist thought.

Muhammad ʿAbid al-Jabiri calls attention to the prevalence of this trope in modern Arab writing. In his seminal *Naqd al-ʿaql al-ʿarabi* and *Nahnu wal-turath*, he asserts that modern Arab thinkers, beginning in *al-nahdah*, are enthralled by the master narrative of Abbasid greatness. He identifies three competing "axes" or ideological readings of Arab history (fundamentalist, Marxist, and liberal) that have emerged over the past two centuries. These three "axes" fetishize the Abbasid image. Moreover, they share a slavish loyalty to a method of inquiry (*qiyas* or analogy) that originated in the Abbasid age. While at one point critical and dynamic, al-Jabiri states, this method has become void of "objective" content over time due to the Arabs' deference to its near sacred origins. Replacing reverence for critical inquiry, he concludes, Arabo-Islamic history became mystified and unchallengeable in the modern era, consequently holding "Arab reason" in an epistemological headlock. Despite its innovations and attempts to break with what he sees as the dominant epistemology of Arab thought, al-Jabiri's critique ignores critical and nuanced ideological and discursive differences between the three axes that he puts forth. The rhetorical approach, if not pedantic nature, of his critique forces it into the exact sort of Hegelian dialectics and binaries that his pseudo-Heideggerian critique hopes to avoid.

Contrary to al-Jabiri's dismissal of the rhetorical image, we must approach the deployment of the idealized view of the Abbasids in the sociocultural dis-

courses of al-Bustani to Muhammad ʿAbduh as a historical artifact. Al-Jabiri fails to realize that the form of the paradigm should be the object of historical inquiry, not only its content. By doing so, we can then ask why the image takes on the aura of historical fact in the modern era? Or what are the political conditions that construct the Abbasid image and make its deployment attractive among otherwise critical scholars? Rather than trying to extract indivisible historical truths and separate them from the prejudices of rhetoric as al-Jabiri would have us do, we must understand that the Abbasid trope is part and parcel of larger discursive formations and their concomitant representation.

Modern Arab intellectuals proactively produced these sets of representation, but not as a reflex reaction to a certain set of inherent "problematics," which define Arab-Islamic culture, as al-Jabiri believes. The Abbasid motif, like the vilification of the Umayyads, is a direct and indirect response by organic Arab intellectuals to internally and externally generated social, cultural, and historical conditions of the day, most notably the initial encounters with imperialism, colonialism, and capitalism as well as local nationalisms, class formations and deterioration, and so forth. This response verifies the active agency of the intelligentsia in envisioning a new and even original sense of Arab identity and creating the representation of a subjective ideal or ideal-ego.

The concept of ideal-ego comes from Jacques Lacan's analysis of subject formation. He tells us that "it is in the Other that the subject is constituted as ideal, that he has to regulate the completion of what comes as ego, or ideal-ego ... to constitute himself in his imaginary reality."[19] I would suggest a slight reversal of this definition of self-formation that is more appropriate in the context of the Arab renaissance and that this study will substantiate. That is, the Other to Arab-selfhood, as we have seen in the example of the library of Alexandria, is not singular or unequivocal, nor is it exclusively exterior to the subject, as al-Jabiri suggests in *Masaʾalat al-hawiyah* (The question of identity).[20] Instead, as demonstrated in the historical allegories in *Khutbah* and innumerable texts of Arabic fiction and nonfiction, the Arab subject becomes Other to his own sense of Self. For example, in focusing on *qiyas*, for example, al-Jabiri overlooks the very historical conditions that might make it appeal to Islamic modernists. That is, it is seen as an indigenous method for rational and humanist inquiry as allegedly championed by the Abbasids. It is an answer in the search for an "authentic" Islamic alternative to secular "Western" rationalism. Hence, the internal otherness that we are beginning to see haunt Arab selfhood is instigated by the omnipresence of the West. Therefore, the Arab finds its ideal-

ego in the representation of the third term, in this case the European humanist, rationalist self or Self-Same.[21]

It is important that I reiterate that if a Western sameness serves as a masterlogos for Arab subjectivity, this does not mean that Arab cultural producers, reformers, and intellectuals were not actively struggling with this logos in an attempt to claim that standard for themselves and as their own. This would account for how similar tropes, such as that of the "successful Abbasids," were deployed by thinkers as diverse as al-Muʿallim Butrus, al-Tahtawi, Muhammad Abduh, Farah Antun, Tahir al-Qassimi, and Jurji Zaydan. While al-Bustani's conceptualization of these "venerable forefathers" is purely secular, it corresponds to a common ideal among secular and nonsecular reformers because they represent an authentic subject who possesses the desire for learning, the will to pursue and acquire knowledge, and the competency and agency to master it.

Past Presence: The Topos of Abbasid Success

Now that we understand that the representational nature of historical narrative is as much an object of inquiry as the content of history, let us return to *Khutbah*. In it, al-Bustani is methodical in laying out the evidence that the precedent for Arab cultural and social progress had been set centuries earlier. He states in unquestionable language that the ancients are praiseworthy and that "no scholar should ever . . . deny that we have the right to take pride in the fact that our ancestors reached the highest level of knowledge even if we ourselves have not" (4). For al-Bustani, the determination (*ʿazm*) of these forerunners created "the golden age of Arab knowledge" (*jil al-ʿulum al-ʿarabiyah al-dhahabi*). Intellectuals prospered at this time. Their work was patronized while schools and libraries, by which knowledge is produced and reproduced, flourished (8). As an intervention into universal history, the example of a successful historical Arab represents a subjective presence that translates into a historical presence. Not coincidentally, this success is attributed to the interdependence of knowledge, desire, and external cultural stimuli.

At this point, al-Muʿallim Butrus provides us with an additional historical allegory involving another caliph, the second of the Abbasid dynasty, Jʿafar al-Mansur. Al-Mansur was known, the author states, for his learning in jurisprudence, philosophy, and astronomy and is remembered as the very builder of Baghdad. As the story goes, the Caliph was suffering from a stomach ailment that no doctor could cure. A "foreign" doctor, a Christian by the name of Jirjius

Ibn Bakhtishuʿ al-Nishapuri, known to be the best in his profession, was recommended. Al-Bustani continues,

> Al-Mansur summoned him to Baghdad. The doctor cured him, taking good care of him until he recovered from his malady. The Caliph was exceedingly happy with him. The doctor had brought with him his student ʿIsa ibn Shahlata. He too resided at [the court of] al-Mansur until Ibn Bakhtishuʿ became ill. When his illness worsened, he asked if he could leave for his own country. The Commander of the Faithful said to him, "Since I have known you, I myself have found repose from illness." Ibn Bakhtishuʿ said, "I commend to the care of the Leader of the Faithful my student ʿIsa as my successor. He is skilful." The Caliph paid Ibn Bakhtishuʿ ten thousand dinars and allowed him to leave. He commanded an audience with ʿIsa ibn Shahlata. When ʿIsa was received by him, al-Mansur questioned him and found him skilful and took him as his doctor. (9)

Al-Mansur's behavior is in direct contrast to the Umayyad's incapacity to appreciate foreign knowledge. Al-Muʿallim Butrus shows that the profession of medicine, one of the most sophisticated disciplines of classical Arab learning, was advanced by foreigners (ʿajm) in the empire at the invitation of the Commander of the Faithful himself. The anecdote can be extended beyond an allusion to the historical precedent for the import of foreign knowledge. In a time when native sons were returning from study in Europe, massive state-sponsored translations were under way, and founding of and the enrollment in "modern" schools was growing, the allegory exhibits that this infusion of foreign knowledge can cure directly the maladies of the Arabs' cultural condition.

The example of al-Mansur is built upon by his successors. The legendary Harun al-Rashid, al-Bustani praises, was "famous in his desire (*raghbah*), zeal (*himmah*), and energy (*nashat*) for his beloved sciences and literature," which "he disseminated throughout his vast kingdom." The poet-king, "himself proficient in poetry and music, was enamoured by these two elegant arts" (9). Like his son, M'mun, and grandson, Mustansir, he patronized Muslim and non-Muslim poets and scholars. He gathered books, built libraries, established schools, and sponsored innumerable translations (10–13). Sponsoring the import of non-Muslim, notably Eastern Christian, intellectuals to manage and train native academics and administrators, Harun established a bureau of schools. "The first director of sciences for advanced schools in Harun al-Rashid's kingdom," al-Muʿallim Butrus states, "was a Nestorian Christian Da-

mascene whose name was Yuhanna ibn Masuyah." It was he who set intellectual standards of excellence in the empire (9–10).

Harun al-Rashid, Ma'mun, and Mustansir, like their predecessor al-Mansur, actively searched for scientific and humanist knowledge among neighboring Byzantines, Syrians, Chaldeans, Persians, and Armenians. Each caliph built and improved on the cultural infrastructure left by his predecessor. Al-Bustani is clear in illustrating that each caliph had an ambitious "appetite" (*shahwah*) for knowledge and possessed the "desire" (*raghbah*) to satiate the need to perpetuate cultural success. These accomplishments provide more than the cultural and intellectual infrastructure that facilitates the dissemination and maintenance of the arts and sciences. They mark a productive arch in the theory of the reformer. They offer the historical evidence of the ability of the subject to possess and command knowledge.

The question of competency lies at the foundation of Arab reformers' theories of native progress. Thus we understand why al-Bustani might have awkwardly placed an extended passage from the life of the great rationalist philosopher and physician Ibn Sina (Avicenna) after his discussion of the exemplary Abbasid caliphs. The story is apparently taken from Ibn Sina's autobiography, *Sirat al-shaykh al-ra'is*. In the account, Ibn Sina narrates his own quest for knowledge in the first person. He relates how he mastered the Quran and literature at an early age, learned accounting from a vegetable merchant, and studied philosophy, logic, the natural sciences, and medicine. He would read every book four times until he memorized it. He bought one of these books for three dirhams from a peddler who did not appreciate its true value (24–25). By choosing to use Ibn Sina's own first-person narrative, al-Muʿallim Butrus animates the historical evidence and cultural representation of a willing subject actively pursuing knowledge. This subject is then contrasted ironically with a native book peddler who "thought that there is no worth in this knowledge" (25).

Cultural borrowing thematically underlies the story of Ibn Sina who was heavily influenced by classical Greek knowledge, particularly the work of Aristotle. In the historical schema of al-Bustani, Ibn Sina is the logical product of the efforts of the Abbasid caliphs to gather and domesticate non-Arab scholarship. The venerated philosopher's appearance reinforces the model of a willful native intellectual who has mastered foreign knowledge. The movement from ideal leader to exemplary citizen should not be overlooked.

If we reduce al-Bustani's theory to an epistemological syntagm, we see that, within the Abbasid topos, cultural success is highly contingent. Success is the

result of a causal relationship between recognition, will, desire, effort, ability, and mastery. *Khutbah* presents an etiology of progress first through its invocation of historical consciousness. The ideal Arab, as represented by Abbasid caliphs and intellectuals, expresses this consciousness when he recognizes his intellectual lack and cultural need. Pursuing, acquiring, and developing secular knowledge to redress this lacunae, the ideal Arab consequently translates will and knowledge into subjective and historical presence. The scenario evinces the activity of the native subject. Al-Bustani shows that the historical intellectual received and translated nonindigenous knowledge not passively but as an active cultural producer, allowing the Arabs to enter into the rationalist tradition and a Hegelian concept of universal history, where history belongs to those who affect change and development.[22]

Slippage in the Mastery of the Sign

The topoi and leitmotifs provided by al-Bustani's narrative show us that cultural success and subjective presence emerge as an eschatology where knowledge is a sociocultural catalyst, handled only by the competent. Consequently, the universal endpoint is "progress and civilization." In addition to presenting the evidence of Arab mastery, al-Bustani reassures the native readers of their place in a universal history:

> Science and literature (*al-'ulum wal-adab*) were in danger of disappearing ... from the Western world due to war, conflict, and civil upheavals. They found refuge in the schools of the Arabs.... The Arabs preserved the middle link in the chain of knowledge that binds ancient knowledge to modern knowledge. Without the existence of this link you would see a vast emptiness between new and old sciences. (17)

Repeating his earlier statement, al-Mu'allim Butrus goes on to say that knowledge reached the borders of Europe under the "patronage and protection of the Muslim crescent," and that, steeped in medieval ignorance, Europe relied on Arab schools to "awaken them from their indifference" (17). The leitmotif of borrowing is switched from the Abbasids borrowing from their neighbors to Europeans borrowing from the Arabs. In Andalusia, al-Bustani contends, the Arabs reached an unprecedented level of cultural development as characterized by their numerous libraries and schools and their prolific translations (13–15). Arab Spain represents an exemplary nexus. It was a borrower and trans-

lator of texts from antiquity and also a cultural model, an entrepôt to medieval Europe where, after the decline of the Arabs, learning returned to flourish (26).

The repetition of the borrowing leitmotif serves more than an allegorical purpose. On the political level, the examples of intellectual import justify the technical, administrative, and civil projects well on the way by the 1850s not only in Egypt and the Ottoman capital but also on local levels in Lebanon, Syria, Tunis, and Morocco. Moreover, the allegory has discursive force. It underscores that rationalism and secular knowledge are the authoritative signs which signify the ontological fullness of its possessor in a universal context. For al-Muʿallim Butrus, Andalusia provides another lucid example of the historic and inherent ability of the Arabs to master that sign, which is critical for the justification of the pursuit of the "new sciences" of his day (17).

However, for native subjects at the advent of European imperialism in the Middle East, there are dangers in arguing for a culture based on the mastery of scientific and positivist knowledge. Indeed, this is a trap that ensnared al-Bustani and others. Through historical example, he works hard to substantiate the Arabs' claim in universal history. While empowering for al-Bustani, the universal referent is also an erasing and displacing referent. By focusing on the syntagm of reform, we discover a paradox rooted within al-Bustani's paradigm of cultural and social renewal. The paradox is that the Arab subject's regeneration depends on the recognition of a lack, but this recognition forces an acknowledgment that the lack is an inherent feature to his very subjectivity. *Khutbah* is riddled with this ontological paradox and discursive irony.

For example, al-Bustani figuratively refers to the Arabs and Europeans as biblical cousins, in particular descendants of the sons of Noah. Despite his own religious pedigree as convert and sermonizer in the native church, the biblical example is ironic considering his emphasis on secular society and secular knowledge. However, the genealogy is an important metaphor because the family displaces the difference between Arabs and the West by placing both in a relationship that is located within the larger causality of historical progress. In this causal chain, the West and East lay equal claim to cultural progress. However, this assumption is undermined by al-Bustani's own narrative:

> The tribe of Shem (bani Sam) was happy because their [paternal] cousins, the tribe of Japheth (bani Yafath), had begun to return to them with what they had originally taken from them. . . . This original knowledge

had grown over four hundred years and the tribe of Japheth's subsequent discoveries have been an equal benefit. However, it is loathsome ... [that] some of our aforementioned cousins are arrogant and haughty towards our Eastern race and hold us in contempt.... We handed them knowledge (*sallamna al-ʿulum*) with our right hand and they accepted it with their left hand and returned it to us in a variety of other ways. (27)

Al-Muʿallim Butrus presents us with an etiology of the relationship between bani Yafath and bani Sam, or Europe and the Arabs, respectively. He lays claim to knowledge by positioning the Arabs as its original possessors and rebukes their Western cousins for their prejudice. But this posturing and the assertion that knowledge is returning to the Arabs from bani Yafath serves as a veil.

In Derrida's terms, the veil affirms the ontologies of both the Self-Same and its episteme. It affirms the identity and logic of the unchangeable and indivisible self that stands in opposition to the Other. What the veil hides then is not lack itself but the necessity of lack for the epistemology of the subject and the Other to appear coherent.[23] In other words, this veil disguises *Khutbah*'s repeated acknowledgment of a contemporary lack of will, desire, competency, and knowledge in the subject as well as what becomes an a posteriori realization of the West's primary relationship to knowledge.

Yet, after acknowledging European antagonism for the Arabs, the veil is necessary to naturalize al-Bustani's appeal to universal history for the validation of their potential. In accepting the lack of the subject, the veil functions as an essential mechanism to produce a universal subject of consciousness, indeed, a subject of modernity. After all, al-Bustani's outline aims for autogenetic rejuvenation that needs to arise from the subject himself. Since contemporary cultural and subjective reform are caused by the will and desire for self-improvement, this veil permits the possibilities of regeneration. The historical examples of Arab success both reveal and disguise the fact that criteria of "progress," "civilization," and modernity are based on European predominance and mastery. Within this eschatology of progress, the author tells us that "knowledge has moved from the West to the East coming from the direction of the North and returned with numerous profits from the East to the West from the direction of the South" (26). Stealthily if not inadvertently, the example of Europe's borrowing is transformed into their cultural presence.

This reversal is made explicit by a number of historical examples provided by al-Muʿallim Butrus. Charlemagne patronized the translation and importation of Arab knowledge, and al-Bustani likens him to the Caliph Ma'mun, who

had done the same with Greek learning. Subsequently, the reign of Muhammad 'Ali in Egypt (1805–49) is paralleled with that of Charlemagne because the Ottoman governor of Egypt sponsored the translation of European books into Arabic as well as the printing of classical Arabic texts. The movement of knowledge between Charlemagne, al-Ma'mun, and Muhammad 'Ali mirrors al-Bustani's earlier assertions that knowledge travels from West to East and back again. As we have seen, knowledge, the sine qua non of cultural success—something similar to the Kantian noumenon—is passed between those who possess it and those who lack it. Subjective, social, and cultural reform depends on the recognition of the mastery of the former by the latter. In other words, as al-M'amun recognized the value of Greek learning, Charlemagne acknowledged the value of Arab learning, and in turn Muhammad 'Ali recognized the importance of European learning to redress the social lacunae within his realm.

My earlier allusion to a Hegelian conception of history and subject was no coincidence. The veil of equivocality—the reciprocity of exchanging knowledge between East and West—facilitates the immersion of the precolonial subject into this sense of universal history. I invoke Hegel not out of any belief that his definition of history holds the weight of universal truth. Rather, I want to draw attention to the fact that his paradigm of history and the dialectic of the subject are a profound preliminary effect of the colonial encounter within but not exclusive to the Arab world. In other words, the notion of universal history centered on progress is the same notion on which colonialism finds its "civilizing" justification. Therefore, if the equivalence of the exchange of knowledge confirms the presence of the Arabs in a Hegelian universal history, it also reveals that a Hegelian dialectic of Self formation is under way in cultural and social "rebirth." This dialectic of Self-formation is inherent within the process of colonialism, as it is structured on a Self-Other binary. Not unlike the philanthropy offered by *Bootstrap*, the colonial encounter extends an invitation to the colonized to judge his own cultural present in contrast to the West, who is now waiting on the doorstep to intervene with its overwhelming political, economic, and military power and "goodwill."

With the obfuscating yet enabling function of the veil at play, one understands why scholars, activists, and intellectuals have incorrectly asserted that Arab identity came unto itself through the negative image of the West as Other. Contrary to al-Jabiri's assertion, for example, that they defined themselves vis-à-vis their Turkish and European others, the Arab intellectual of the nineteenth century began to conceptualize his selfhood in terms of his own otherness to

Europe. This assertion is substantiated by examples throughout *Khutbah*. The previous quote, which stated that the Arabs maintained Hellenic and Roman knowledge during Europe's Middle Ages, places them as a depository for knowledge that was originally Western. Veiled by the author's affirmative intent, the effect of his statement is that the Arabs were only a way station between "old and new sciences" instead of actual producers of knowledge. They serve as an interlocutor where al-M'amun and Muhammad 'Ali borrow from and return knowledge to the West. The menacing discursive effect is that Arab cultural success is a "middle link" to European progress. Likewise, their presence in universal history is only the "middle link" for the contemporary Western presence that calls attention to Arab lack and otherness. This otherness is not a temporary condition exclusive to the deficient nineteenth-century subject, however. Rather, it is an epistemological condition essential to the Arab subjectivity that al-Bustani enacts.

In other words, the examples of Andalusia, Shem and Japheth, and Charlemagne, al-M'amun, and Muhammad 'Ali ironically confirm the authority of the West as the primary custodian of knowledge. Such an assertion is implicitly reinforced by additional examples of Arab failure. For example, al-Mu'allim Butrus is astonished that even the Abbasids failed to imitate the quality and force of the Western literary canon. "What is strange," he asserts, "is that with the existence of the poems of Homer, Virgil, and other famous Greek and Latin poets, nothing is found of its kind, no adoption from them, in the poetry of the Arabs" (15).

This comment raises again the question of competency and ability within a Hegelian universal of cultural production. Suleiman al-Bustani's translation of the *Iliad*, for example, suggests that his elder cousin's assertion will haunt the very conceptualization of Arab culture for decades. Consequently, we see that al-Bustani's *nahdah* discourse articulates a subject who perpetually recognizes a master of knowledge that precludes himself. Or, as Hegel might say, the subject develops a self-consciousness that exists for itself but is "determined" through the European Self and apart from the Arab Self.[24] Hegel explains that consciousness is the "middle term," which serves as the link necessary for subjective recognition and subjective presence.[25] Therefore, it may be more helpful to think of identity as René Girard suggests. Girard might say that, since the Arab subject's own self is constructed as Other where the European Self mediates the relationship between knowledge and Arab Selfhood, only the supplemental mediation of the European Self can bestow knowledge, and thereby mastery and subjective presence, to the modern Arab.

This is the essence of identity's struggle in the colonial condition, where identifications and their constituent desires find their power in the activity and efficacy of the master. In case of the nineteenth-century Arab world, the Arab-as-middle-link confers several things upon its own subjectivity. While it inducts them into a universal history, it assigns them the role of facilitators, not the creators, producers, or masters of that history. Thus the self-reflection and self-criticism of intellectuals, of which there was plenty despite the allegations to the contrary, constructed several syllogistic paradigms to veil the unconscious realization that they had arranged selfhood around an unbridgeable gap at the core of its being.

It would be imprudent to adhere too dogmatically to a proposition that understands Hegel's theory of subjective formation as exclusive or hegemonic. Fanon, Memmi, and others have successfully shown the interdependency between colonizer-Self and colonized-Other. Fanon, for example, communicates to us how the violence inherent in this intersubjective relationship results from the play of recognition between otherness and selfhood. This play involves the identification of mastery and the recognition of its preeminence, which extends beyond physical coercion to the naturalization of modes of thought, expression, and even resistance.[26]

Paradox at the Heart of the Inscription

"So where were the Arabs and where are they now? The generation of their golden culture (*jil adabihim al-dhahabi*) has passed and the generation of darkness reigns" (26). Changing his tone to one of rhetorical inquiry, the historical and contemporary domains of al-Bustani's allegories unite. In the following passage, he draws his reader into two coinciding temporal realms that maintain and are bound by a singular coherent and universal field of signification, that of *adab al-ʿarab* or "high Arab culture."

> Where are the poets, the doctors, and the orators? Where are the schools and the libraries? Where are the philosophers, the engineers, the historians, the astronomers? Where are the books on these subjects? Where are the inquiring scholars and the precise intellectuals? Yes, there remains in each community and sect some knowledge.... But what is this in comparison to the ocean of true knowledge? Where is the glory of Baghdad, the pride of Aleppo, the ornateness of Alexandria, the splendor of Andalusia, and the magnificence of Damascus? Where are the Caliphs Ma'mun

and al-Mustansir? Where are the poets al-Mutanabbi and Abu al-Fida'? (26–27)

Attesting to its rhetorical force, this passage reemerges almost verbatim in al-Bustani's journal, *al-Jinan,* some ten years later. In "Man Nahnu?" (Who are we?), the author first praises and notes the historical success of the Arabs in commanding knowledge and justice only to ask where these Arab cultural producers and products have gone.[27] This kind of invocation is consistent with the *khitab* or lecture genre, which permits the force of the text's highly rhetorical tone to override adherence to the author's own narrative organization. Despite the rhetorical nature of these questions regarding the disappearance of high culture, al-Bustani has already supplied an equally rhetorical and powerful reply earlier in his narrative, replying, "It is said that one can find more than two hundred authors in the Royal Library of Paris on the craft of Arabic grammar alone" (15).

He proceeds to recite a litany of famous Arabic works from the "golden age," along with their corresponding disciplines, whose works are found in the Paris Library. For al-Bustani, this litany signifies a loss. The Arabs find themselves at a critical juncture where they must regain the title of their own intellectual history, which they have now lost. The crisis of loss is more serious than a vain desire to regain past achievement or glory. The author makes apparent how the crisis arises from a fissure that separates the ideal (past fullness) from current decadence (present lack). The fissure is ontological as much as cultural or temporal. Al-Bustani's invocation of the trope of the golden age would be repeated by innumerable thinkers and literati, from al-Tahtawi and Khayr al-din al-Tunisi to 'Abduh, Muhammad Kurd 'Ali, Zaydan, and Shakib Arslan. Instead of a return, Beirut's leading intellectual hoped to reinstitute the subjective efficacy that the golden age represented but that the West now possessed (e.g., Arab knowledge in the Royal Library of Paris).

Al-Bustani's questions seem desperate for the very reason that they indicate that the current and ontological crisis is transhistorical, existing in both the present and the past. The topos of the Abbasids that refers to an Arab ideal begins to implode when the question of consciousness is pursued. *Khutbah's* narrative undermines the subjective referent that it previously advanced. Al-Bustani confesses that

> the culture (*adab*) of the ancients contained many blemishes and the manner in which they disseminated it was imperfect. They relied on

stylistic embellishment (*t'aqid*) in the whole of their literature (*tasanif*), while myths (*khurafat*) entered into most of their arts. They built much on the philosophic principles of Greece whose creators drew them from a mythical world (*'alam al-wahm*). The Arab ancients had pretensions of knowing the causes of everything. Due to this, their sophistry increased and their errors and delusions (*awham*) multiplied. If we confront their knowledge, literature, medicine, their natural sciences, and so forth, the sons of this age would realize that the difference between modern and ancient knowledge would be as evident to us as the appearance of the midday sun. Those who hinder the Arabs' pursuit of European knowledge and literature (*'ulum al-ifranj wa tasanifihim*) consider themselves to be gods of industry (*alihat al-sina'ah*). They act as though they are in control. But he who faces the truth cannot deny that the Europeans too are the gods of knowledge (*alihat al-'ulum*), and that the mind (*'aql*) in their heads is like our own. (29–30)

Certainly, al-Bustani's assessment refers to the consciousness of the forefathers and implicates the degree to which they actually mastered knowledge. The flaws in the very episteme of the Arab critical tradition, the critic implies, prevents universal consciousness, but more important in the age of colonialism, they create a conspicuous material-cultural gap when contrasted to the West's massive cultural tradition. Consequently, *Khutbah*'s desire to create a critical tradition is an attempt itself to create a subjective consciousness while simultaneously generating a new convention to defend against colonial designs. Therefore, al-Mu'allim Butrus al-Bustani should not be seen either as self-hating or as a Europhile. He was keenly aware of Western political power, but also protested in writing against the increase domination of the commodities market by European goods.[28] Nonetheless, al-Bustani and others like him will testify that modern European culture is superior to their own because it not only masters secular knowledge but translates it into social and culture order and progress. The European "gods" of knowledge haunt the Arab ideal, as a specter whose presence is always felt even when it is not visible.

Functional Veil

While al-Bustani never uses the words "superior" or "inferior," his assessment of the condition of Arab culture is unambiguous. "The stagnation of the commodities of knowledge among the Arabs and the lack of marketability" is crippling and exists "among their public and especially their notables," he states (31).

The economic metaphor is relevant because the value of these commodities is determined by their relationship to a universal market of positivist knowledge. We will examine later how a similar process of valuation functions similarly in the "debate" between the Ernest Renan and Jamal al-din al-Afghani regarding the issue of Arab rationality. For now, it is important to call attention to how the process of valuation is inlaid within paradigms of subjectivity and social reform from early on.

Despite his conclusion that "culture (*adab*) among the Arabs is in a condition of total decrepitude (*inhitat*)" and their cultural productions have no market value, al-Muʿallim Butrus refuses to acknowledge the decadence of their intellect (32). The knot of the paradox that he is narrating becomes tighter as it is difficult for the author to escape his own conclusions:

> While we think that the Arabs of today are the descendants of the ancient Arabs, we do not see in them the perseverance and effort of those Arabs who previously struggled (*mujahidun*) in the field of knowledge (*ʿulum*). We are not willing to admit that their descendants have become corrupt. ... This is the consequence of many conditions and there are several reasons for it. We would have loved, if time had permitted, to make them evident, so as to vindicate our flesh and blood from the real blame put upon them by the foreigners who, we do not doubt, could have reached a state of deterioration such as our own if fate had kept them in similar conditions. (31)

We again witness the reappearance of the discursive veil in the form of al-Bustani's decadent-but-not-corrupt assertion. The formula camouflages a paradox. The Arab's natural "inclinations" for knowledge and the foibles of fate veil the unbridgeable gap that rests in the heart of the subject. The gap is the distance between the Arab Self and the transcendental Kantian noumenon of knowledge, between the cultural presence of the accusatory West and the intrinsic potential for Arab absence. So if Derrida is correct, the veil produced by the decadent-but-not-corrupt paradigm allows the subject to borrow without immediately disclosing this distance. The veil then keeps alive the possibility of reform.

The process is continually repeated. For example, al-Bustani discusses the history and quality of confessional schools in Lebanon. He praises his alma mater, the Maronite college of ʿAyn Waraqah, and the Greek Catholic schools of Dayr al-Mukhlis and ʿAyn Tarraz, as well as Greek Orthodox, Syriac Catholic, and Armenian schools and the Lazarite and Jesuit schools (26–28). The founders

of these schools and seminaries, usually clerics, are among the few contemporary natives whom al-Bustani praises in his "lecture." However, there is room in all these aforementioned schools for reform, he says, and "reform must enter ever so slowly with the advancement of this age (*jil*)" (38). The patrimony, propensities, and success of the local educators continue to reestablish the Arab as a potentially masterful subject. Yet their cultural achievements are haunted by the need for reform. The veil is the composite assertion that the schools are good but could become better. It enables a modern Arab subjectivity to be imaginable by permitting the possibility of its presence, while also endlessly deferring this very presence. Consequently, subjectivity is rooted in a proleptic ideal of reform, recognizable but not realizable, a perpetual state that Homi Bhabha might call "almost but not quite."[29]

Having versus Being

The constant reminders of European competency as represented not only by their science but also by their political power makes it imperative that the contemporary native subject transform his will into praxis. As in the case of native schools, al-Muʿallim Butrus locates examples of indigenous endeavors that abate the slippage in his decadent-but-not-corrupt formula. His chief example is his son-in-law, Khalil al-Khuri (1836–1907), an accomplished poet whose *Al-ʿAsr al-jadid* "pours classical poetry into a new mold, clear in intended meaning" (35). Khalil al-Khuri's true accomplishments were *Hadiqat al-akhbar* (The garden of news, 1858), one of the earliest Arabic newspapers, and his Syrian press, al-Matbaʿah al-suriyah. His mastery of "the means for civilization" sets an example for his compatriots. Al-Bustani states:

> Undoubtedly, journals (*jurnalat*) are among the best means for the civilization of the masses (*jumhur*) and can increase the number of their readers if they are used properly. There is hope that this young girl (al-Matbaʿah al-suriyah), the first Arabic press specializing in journals, will grow in strength and that the struggles of her owner and dear director, Khalil Effendi al-Khuri, will be crowned by success. Among the sons of the nation (*abnaʾ al-watan*), his reputation remains as a conqueror of a strong fortress whose advantages even the forefathers neglected. (35)

Stylistically innovative while remaining faithful to classical standards, Khuri's Arabic is lucid and "clear in intent." Moreover, he displays the will and ability to master the foreign technology of the press and, with it, disseminate knowledge

requisite for "civilization" (*tamaddun*). His example redresses the failure and "neglect" of even the venerable forefathers, providing momentarily the proof of competence.

If Khalil Effendi's example is to be reproduced en masse, then it must be preceded by the coming together of all of the criteria of progress. Therefore, al-Bustani's praise of Sultan ʿAbd al-Majid, who was the chief advocate of the empirewide risorgimento, differs from the stock praise offered by every book of the period. The author states:

> It is obvious that ʿAbd al-Majid's efforts, along with the commerce among the Arabs, their mixing with civilized peoples, and the increase in the number of presses and schools, will restore to the nation its role as wet-nurse to culture. Likewise, the organization of salons (*majalis*) and assemblies (*mahafil*), the proficiency in knowledge of governmental officials, the art of writing (*inshaʾ*) and oration (*khutub*), as well as cultural, religious, and political dialogue, will facilitate, one hopes, such a return. Freeing the reins of the intellect and the bridle of will (*iradah*) and paying attention to the education of women, especially in this city, Beirut, which in previous ages was the wet-nurse to the study of law, will ensure this in the future. (40)

This passage nicely demonstrates how al-Bustani constructs an etiology of success by linking cultural infrastructure, subjective will, and cultural practice (e.g., cultural mixing or *ikhtilat*) but also how this combination is irreducible from its civil context. Local presses, libraries, and schools are the infrastructure that benefits "the masses in general regarding culture (*adab*) and civilization (*tamaddun*)" and actually "can enrich the sons of the Arabs with books and libraries within a short period" (34). The model of Khalil Effendi brings to a head the issue of the native's will and ability to transcend cultural decadence and master the instruments of subjective presence, both on the individual and collective levels. His example compounded by that of ʿAbd al-Majid's vision and efforts demonstrate the causality between will, knowledge, infrastructure, and what al-Bustani and innumerable other intellectuals of the day called sociocultural "success" (*najah*).

One prominent example of this causality is seen in *Khutbah*'s discussion of the Bulaq, press of Egypt.[30] Instituted by Muhammad ʿAli in Egypt in 1821, Bulaq set the standard even for al-Matbaʿah al-suriyah. Its products were influential and prolific. More important for al-Bustani, they established the priority of Arabic as a means to disseminate "modern knowledge." He comments that

> the press that most deserves mention and that has enriched the Arab race with multifarious books is Bulaq. We are guided by the excellence of the organization of this press and the greatness of the benefits reaped from the many books, originals and translations, it has published.... The supervisors of this press avoided as much as possible the use of foreign terms when they translated from European languages (*al-lughat al-ifranjiyah*). Although... when the press was in its infancy, they used many Western terms despite the existence in Arabic of equivalent terms. (35)

Reflecting the importance of ability, the press's supervisors were challenged to properly find the Arabic equivalent to European vocabulary. Despite their initial failure to do so, the example expresses the opportunity to dress new "knowledge in Arabic garments." In fact, one might argue that Bulaq's maturation from using foreign vocabulary to their Arabic equivalents indicates the capabilities of contemporary reformers to recognize and articulate modern knowledge within an existing semantic system of Arabic. However, I would argue that the shift from using imported to Arabic terminology evinces the depth to which European authority is inscribed within the Arabic language itself. Moreover, only the ability to express this knowledge in one's native tongue inducts his society into the Hegelian ontological superstructure where history is progress and mastery.

Let us return to al-Bustani's evaluation of native libraries, presses, and academic, literary, and vocational disciplines, remembering they have a double contrary function. They act as the signs of failure and cultural success between which the proleptic subject vacillates. One passage concerning cultural infrastructure and competency seems to capture the paradox at hand.

> Although one finds many private libraries in this country, we see, on the one side, the cheapness of their book-buyers or curators, and, on the other side, the lack of good faith of the borrowers of the books. Both curators and borrowers lock iron doors on their libraries, leaving them to the mercy of bookworms and making them sanctuary for dust. So what is the benefit from the increase of books if there is no one to read them? (35–36)

The passage confirms that the question of competency is a symbolic matter, a matter of being, not just having. The assessment of the state of nineteenth-century private libraries discloses that knowledge exists among the Arabs and is desired by them. But the failure of indigenous culture, the borrower's lack of trustworthiness, and the lender's greed reflect the inability of the native

subject to command the sign apparently at his disposal. The inherent decrepitude of the subject erects an interdictory bar (literally, the iron doors) between the native and the ontological stuff (the noumenon) of subjective presence and cultural success. The metaphors of the moth and dust illustrate more than active and passive types of decay. They are the return of time harbingers. Progress literally eats up the possibility of transcendental presence, leaving not only an anomic Arab subject but the actual absence of the native (reading) subject.

All of the ironies of *nahdah* discourse as advanced in *Khutbah* burst out. Al-Bustani's discussion of native competency, that of Khalil Effendi, his press, Sultan ʿAbd al-Majid, and Bulaq are narratively lodged between the Arabs' indebtedness to the activities of the American missionaries and foreign-based Orientalist presses.[31] The effect is poignant. Al-Bustani tell us:

> It is obvious that the Arabic presses are more numerous in Europe and America than in this country. If not for the care of these presses, no trace of precious Arabic literature (*tasanif*) would have remained. Thus, we see many of our Arabic books returning to us, after a long absence, printed in beautiful letters. If only we were able to say that they were returning in perfect grammatical correctness and accuracy. (35)

As we have witnessed the looping quality of the veil, the last sentence utters an equivocality, signaling the author's own discomfort with what might otherwise be an inescapable European hegemony of knowledge. In the form of modern print, the Arab subject comes upon his own tradition, finding it preserved but affected by the West. The knowing subject recognizes this reproduced artifact (the printed Arabic text) as replete with the errors of European redactors. Undoubtedly, al-Bustani's critical eye implicates European mastery. His recognition of grammatical errors transfers failure to the masterful Europeans and asserts the privilege of cultural difference and authenticity. Certainly, this final sentence might be interpreted as "resistance" to the hegemony of the epistemology that I have tried to map out in this chapter. Indeed, theorist Samir Amin has posited a general interpretation of the Arab Renaissance.[32] I replace the term "resistance" with "struggle" because of the intimate degree of complicity that reformers had in this epistemology's naturalization. This said, the above statement is uttered in the context of the return not of "secular, positivist knowledge" but of Arab cultural production, which might otherwise have been lost had it not been preserved by the competent West.

Vocative Conclusions

The author's discussion of cultural infrastructure, contemporary competency, and intellectual need can be tedious. Yet this tone points to al-Bustani's "objective" intent. In the conclusion, the narrative tone and address of *Khutbah* changes drastically. The text was most likely written one year later than the original presentation of the lecture to the Syrian Society for Arts and Sciences. It was published in 1860, the year of fierce intercommunal violence that had left thousands dead in Mount Lebanon and Damascus. Al-Bustani issues a rousing appeal to his compatriots in the conclusion, whose tenor and vocabulary match his "nationalistic" writings.

> Oh sons of the nation (*ya abna' al-watan*)! The pinnacle of those of excellence, and the grandchildren of fellow Syriacs and proud Greeks! The camel's hump of this nineteenth century is that it is the century of knowledge and light (*jil al-ma'rifah wal-nur*). It is the century of inventions and discoveries, the century of culture and humanist knowledge (*jil al-adab wal-ma'arif*), and the century of industry and arts. Arise! Be alert! Awaken! Roll up the sleeves of determination. Culture, waiting at your gates, knocks asking entrance to your beautiful lofty mountains, valleys, plains, and deserts with which nature has adorned your country in all of its glorious beauty. Throw out your fanaticism, your partisanship, and your psychological prejudices (*aghradakum al-nafsaniyah*). Offer one hand to the study of culture. Open the doors to this old box that has come back to you after a long absence. Welcome this treasure and meet it in all happiness and joy so that your country is filled with comfort and leisure, and so that you can dress it in splendor and pride. Undoubtedly, the continual progress of this country in the last few years strengthens the resolution of all those who have the desire and zeal (*ghirah*) for awakening the Arab race from its fallen state. The toils that they undergo and the long years spent by both sons of the nation and foreigners in introducing culture and civilization to the Arabs will be crowned with success. (39–40)

This passage explicitly shows that the reform project is a national project and a project of consciousness. All the themes and motifs that we have seen throughout the text come together in the invocation of the subjective ideal, a national ideal which should blossom with the arrival of the modern age. Desire, will, culture, civilization, and progress conjoin in opposition to sectarian bias, decay,

and fanaticism. The West emerges as a naturalized element of native progress. The correlation between native sons and foreigners corresponds to the relationship between Syriacs and Greeks and Arab ancestors, similar to the biblical metaphor of the children of Noah. Al-Muʿallim Butrus is addressing the Self as much as his compatriots. He is addressing a decrepit-but-not-corrupt subject, who is decadent but able to recognize the need for reform. The call to awake, to become conscious of one's identity, one's place in history, and the necessities of modernity explodes at the end of the lecture but indeed, as we will see in the following chapter, underlies the reform project. Al-Bustani's critical analysis of culture has gracefully shed its cumbersome paradoxes and transformed into the seamless poetics of nationalistic enunciations, anticipating *Nafir suriyah* and his national project.

2

Inscribing the National Subject

In *Khutbah fi adab al-'arab*, we have seen how a semantic nomenclature structured the formula by which nineteenth-century Arabs aimed to institute reform and achieve "progress and civilization." Focusing on the role of this nomenclature leads to the understanding that subjectivity is a process of signification. If, therefore, identity is a signification system, then the countless logical and ontological leaps between signifiers points to the very impossibility of subjective reform. These ellipses are not arbitrary but are predicated on the Hegelian concept of history and the Master-Slave dialectic that arises from the colonial condition. Acknowledging that the writings of intellectuals such as al-Bustani inscribed a lack into the heart of modern identity itself, we also realize that this writing functions as a cultural praxis of political struggle against imperialism. Written over a monumental period of civil unrest, the book *Nafir suriyah* (The clarion of Syria) is a succinct example of Renaissance writing as a political practice. The text is a local but not parochial endeavor, striving to construct subjective consciousness as a national consciousness, while also revealing how the West informs this consciousness.

The aim of this chapter is not to prefigure an identity that anticipates the inevitable foundation of a nation. My assertions do not presuppose that the Arab subject's place is naturally within the confines of a prefabricated nation-state. In the case of *Nafir*, al-Bustani is more concerned with Lebanon within the context of Ottoman Syria than he is concerned with what would become known as the "pan-Arab nation."[1] Nor do I examine the processes by which national subjectivity is constructed through requisite social, cultural, and political apparatuses as Benedict Anderson and others have shown us.[2] Rather, this study shows how a specific discursive developmentalism is naturalized as to facilitate these apparatuses as the "logical" and necessary step in any mod-

ern national project. Consequently, we discover that the subject—exemplified by the Syro-Lebanese context—is an effect of modernity itself because it is produced by a rupture that is synchronic and simultaneous with the colonial encounter.

At the request of his family, Mikha'il Mishaqah wrote a chronicle-memoir of nineteenth-century Syria and Lebanon, entitled *Al-Jawab 'ala iqtirah al-ahbab* (Reply to the suggestion of loved ones).[3] In the process, he provided an account of the interconfessional violence or "civil war" of 1860 in Mount Lebanon and Damascus.[4] Mishaqah, born into a Greek Catholic (Melkite) family, had converted to Protestantism and maintained close relations with the American missionary community. As a physician, he resided in Damascus but was also a member of the Beirut-based al-Jam'iyah al-suriyah lil-'ulum wal-funun (Syrian Society for Arts and Sciences), to which al-Bustani had presented *Khutbah*.[5] To this observer, the violence in Mount Lebanon was clearly one-sided. Christian houses were burned, churches and monasteries were destroyed, property was looted, and monks, priests, and civilians were massacred.[6] Despite this inequity, the physician attributed the violence not only to Muslim "fanaticism" but also to "special causes that grew out of the conduct of ignorant Christians when the intelligent among them were no longer able to curb them."[7] This analysis of the "events of 1860" (*ahdath* 1860) and its causes is not original but was lifted from Butrus al-Bustani *Nafir suriyah*.[8]

Nafir suriyah

Nafir suriyah consisted of eleven patriotic broadsheets, which al-Bustani called *wataniyat*. While the Egyptian sheikh Rifa'ah Rafi' al-Tahtawi had used this term to describe his patriotic panegyric poems about Egypt, al-Bustani's wataniyat could be called, as Kamal Salibi suggests, "advice sheets" suggesting the best path to domestic peace, civil order, and social reform.[9] The first wataniyah was published in September 1860 and the last in April 1861. The span of time between broadsheets ranged from ten days to two months. This erratic dissemination of the wataniyat mirrors their diversity, varying in length, theme, and rhetorical tenor. Despite the variation, the series of bulletins, or *nasharat*, is bound by a stylistic and ideological uniformity that is punctuated by each wataniyah's opening address, *Ya abna' al-watan* (O sons of the nation!).

For Arab nationalist George Antonius, *Nafir* was a watershed for

modern cultural production and social thought. In *The Arab Awakening*, he describes al-Bustani's series as "a small weekly publication... the first political journal ever published in the country, [which] was mainly devoted to the preaching of concord between the different creeds and of union in the pursuit of knowledge. For knowledge, he argued week after week in the earnest columns of his paper, leads to enlightenment; and enlightenment, to the death of fanaticism and birth of ideals held in common."[10] In the introduction, I discussed the problems of relying on *The Arab Awakening* as a historical source. Indeed, Antonius is incorrect in describing *Nafir* as a journal or newspaper, let alone as the first published in Syria.[11] Stylistically compelling, however, *The Arab Awakening* reiterates three-quarters of a century later almost verbatim *Nafir*'s blueprint for cultural and social renewal, where interconfessional fraternity and positivist knowledge lie as the cornerstones of patriotism and enlightenment and hence "progress and civilization." Al-Bustani's outline of Ottoman Syria's national identity and cultural history translates smoothly and seamlessly into Antonius's vision of the Arab nation. This blurry transition testifies to the power and effectiveness of this foundational discourse. Just as Hourani adjures us to understand *The Arab Awakening* as an ideological manifesto, the present chapter reveals how *Nafir* contains a foundational but ever-present "enunciative series" essential to the articulation of a modern national identity.[12]

This series of dependent concepts circumscribes al-Bustani's model of the modern citizen. The move from a transgeographical and transhistorical discussion of culture in *Khutbah* to a local or national discussion of Syro-Lebanese society in *Nafir* is important because it highlights how the reform equation takes on increased significance in the wake of the intersectarian bloodshed in Mount Lebanon and the anti-Christian pogrom in Damascus. It also shows how these reformers wrote in ways that spoke to both local and Ottoman contexts. While maintaining the semantic nomenclature found in *Khutbah*, *Nafir* emerges as a true product of the Tanzimat. If the former offers an equation for subjective reform vis-à-vis cultural reform, then the latter offers a formula for subjective rebirth vis-à-vis the reform of political or civil society. Expanding on "the economy of discursive constellation" presented in *Khutbah*, al-Bustani declares in *Nafir* that the desire (*raghbah*) for knowledge creates cultural prosperity but also begets "concord and unity" (*ulfah wa ittihad*), a popular Tanzimat concept that took on resonance during Greek and, later,

Balkan independence movements.[13] Foucault's insights help elucidate that, while the grammar of reform as expressed by *Nafir* was ubiquitous in the empire, al-Bustani's translation and transcription of the concepts fundamental to the Tanzimat maintained a forceful timbre even after the Renaissance as evinced by *The Arab Awakening*. For example, in his article entitled "Ittihad wa ulfah" (Unity and concord), As'ad Trad restates the exact idiom presented by al-Bustani in his article on civil order.[14] The endpoint in al-Mu'llim Butrus's schemata of national progress is that unity and harmony institute civil order (*madaniyah*), produce the conditions for societal reform, and thereby lead "progress and civilization." The syntagm would underlie the nationalist ideologies that would arise over the next several decades throughout the region. For example, Hussein al-Marsafi wrote *Risalat al-kalim al-thaman* (Epistolary of eight words) following the 'Urabi revolt.[15] The book expressed a nomenclature similar to al-Bustani's including essays on the nation, governing, justice, and education. As an educator himself, al-Marsafi outlines through this language the vision of an independent Egypt, but the text also functions as an ideological manifesto naturalizing the desires, logic, principles, and language of this vision.

Currency of Civil Order

Contemporary scholars have discussed *Nafir*, mostly focusing on its call for secularism in matters of political administration and social-civil protocol. 'Abd al-Latif al-Tibawi, for example, notes that al-Bustani inserted non-Christian references, such as Quranic quotes and *hijri* years, to display the pluralistic nature of his patriotic platform. Consequently, al-Tibawi asserts that this was a means by which al-Bustani disassociated himself from missionary and/or sectarian politics.[16] Youssef Choueiri insists, however, that al-Bustani's secular subject effaces the specifically Islamic motifs of Arab history, pointing out the author's neglect of significant Muslim historical events, most noticeably the central historical role of the prophet Muhammad and the "righteous Caliphs" (*al-khulafa' al-rashidun*).[17] The gesture may be a secularizing move, or perhaps Albert Hourani is correct. He states that al-Mu'allim Butrus's patriotic works are written "as a Christian to Christians" in hope of fostering secularism among them.[18] The argument is valid considering his biblical references and the rise of new sectarian politics. However, elsewhere Hourani refers to al-Bustani's extended discussion of Abu Bakr in the first volume of *Da'irat al-ma'arif*.[19] These

divergent observations indicate the degree of indeterminacy of al-Bustani's writings. Despite the disagreement on the nature of secularism in reform dogma, scholars agree on its centrality in imagining modern Arab society and identity.

Civil society, al-Bustani argues, should be governed by a system of laws and governance based on merit. Valuing collective welfare over personal and confessional interests, the interest of the people should determine social order.[20] Religion, while bestowing moral legitimacy to the civil order, should be confined to the private spaces of personal ethics (VIII, 43). Asserting the primacy of a secularism, al-Bustani states:

> It is obvious to anyone who has looked at the histories of confessional communities and peoples [al-milal wal-shuʿub] that damages are affiliated with the people and religions [al-nas wal-adyan] who have meddled in political matters, and who mix religious with civil matters. There is an inherent great distance between the two. (VII, 38)

Speaking to the sectarian politics that gained currency over the preceding two decades, al-Bustani insists that the political and religious spheres must be separate where public and private spaces are each assigned their appropriate social roles. What is urgent about secularism after the 1860 violence is that, for the reformer, it establishes civil order where law is the sole mediator between the subject and sovereign (the Sultan) but also between equal subjects themselves. Foucault has shown that the issue of law is essential to the social order of modernity, essential in the shift from a feudal economy of power to the diffusion of power into newly divided public and private spaces. Secularism is a tenet of such an order cutting across civic and subjective realms with a social unity. Just as Foucault helps us understand the mechanics of this dissemination of power, Slovo Zizek's committed Hegelianism bears witness to the nexus between law, order, and the subject. Lacan, he states, draws "a line of demarcation between the two facets of law: on the one hand, law qua symbolic Ego-Ideal—i.e., law in its pacifying function, law qua guarantee of the social pact, qua the intermediating Third which dissolves the impasse of imaginary aggressivity; on the other hand, law in its superego dimension—i.e., law qua "irrational" pressure, the force of culpabilization totally incommensurable with our actual responsibility, the agency in whose eyes we are a priori guilty."[21]

If a Syro-Lebanese citizen is to enact a truly secular society and secular identity, then the law is the governing factor in facilitating their realization. However, as Zizek explains, the duality of the law is its coexistence as both

symbolic for the ego and performative as the superego. This duality emphasizes the prolepsis of reform, because the secular code is self-exacting and in need of exterior enforcement. This paradox highlights the need for a tertiary, intervening authority, which will become clear in *Nafir*'s paradigm for "concord and unity."

Before we arrive at this intervention, we need to understand how the concepts of unity and concord existed throughout the works of *nahdah* intellectuals. For example, the concepts are prominent in the Egyptian independence movement, particularly the writings of the nationalist leader Mustafa Kamal.[22] Some decades earlier, al-Bustani explains how concord, unity, and even secularism maintain a crucial and essential role in the project of social reform:

> There have been a few dubious gains, which the nation has won as a consequence of the civil violence. Principally, native sons now have the knowledge that their public welfare, and consequently personal welfare, requires the bonds of unity, virtuous concord, and love to exist between themselves and their communities.... Syria and its peoples reached these states of decrepitude, humiliation, and backwardness only by demonstrating their lack of unity and the paucity of mutual love. They have exhibited a lack of concern for the welfare of their country and its children, and surrendered themselves to foolishness and ignorance, as well as submitted to the power and strength of sectarian, confessional, and familial prejudice and fanaticism. (IX, 48)

Later, in the same wataniyah he continues:

> We call the attention of the nation's sons to two issues. The first issue is that the reform of their overall condition and their country is dependent on unity, which is accomplished only through personal effort. This is because relying on fate to reform them is like a hungry man relying on feeling filled if his friend or companion has eaten. Hoping for things to get better on their own is like an ignorant man hoping to become a philosopher if his neighbor or coreligionist has studied.... Secondly, the demonstration of intercommunal hate... is very detrimental. It induces the cessation or prevention of unity and concord, upon which the success of both the people and the country depend. (IX, 54)

Over and over again, al-Bustani stresses the centrality of concord and unity. This is "the currency of the nation" that facilitates economic and social reproduction. He insists that the principles are also directly involved in the struggle

against "ignorance" and "fanaticism" (*Nafir*, VII, 35). While concord and unity are central in the taxonomy of political reform, I am not discussing the concepts in hopes of tracing the history of liberal or humanist political thought in the Arab world. Rather, the notions of secularism, interconfessional harmony, and national unity are moral and collective starting points for civilization and progress. But the ideals also illustrate the communal vision that reformers strove for during the Ottoman period, which became urgent in the wake of civil bloodshed and contentious with the institutionalization of sectarian identity.[23] However, certain narrative and discursive processes functionalized this vision.

The Enacting of You

Al-Bustani's *Khutbah* is similar to al-Tahtawi's *Manahij al-albab al-misriyah* and Khayr al-din al-Tunisi's *Aqwam al-masalik* in that it identifies and analyzes the contemporary sociocultural state of the nation and offers prescriptions for reform. One need only look at al-Tahtawi's own formula for national progress and civilization methodically laid out in *Manahij*'s introduction to see how much these two intellectuals were of the same mind.[24] What distinguishes *Nafir* from the works of al-Tahtawi and Khayr al-din, however, is its rhetorical tone and form of address. The broadsheets are a direct appeal to the people of Greater Syria, rather than a diagnosis and a prescription for reform. That is, *Khutbah fi adab al-'arab* is both descriptive and prescriptive. It presents a series of constative statements regarding the "objective" conditions of the nation's state of decrepitude and strategies for their redress. According to J. L. S. Austin, constative statements are fundamentally factual and objective truths. They are autonomous utterances, comprehensible even without a specific context. Performative statements, on the other hand, are circumstantial and bound to their context for meaning and intelligibility. In other words, performative statements are contingent on exterior reference for coherent signification.[25]

Characterized by a narrative and rhetorical shift, *Nafir* stands in contradiction to *Khutbah*'s intended constative statements. Directly addressing al-Bustani's compatriots, the wataniyat function as performative invocations meant to incite intercommunal reconciliation and subjective reform. This distinction may seem arbitrary. On a theoretical level, Jacques Derrida recognizes that constative statements also function within an index of meaning and context. Therefore, they too are subtle ideological utterances that find significance in the same semantic ambiguities as performative statements.[26] Austin calls into question the "felicity" or "happiness" of constative statements when he recog-

nizes how they are contingent on tributaries of signification.[27] In fact, he explicitly shows how the "truth or falsity of a statement," the constative utterance, "depends not merely on the meanings of the words," particularly in relation to fact, "but on what act you were performing in what circumstances."[28] Irrespective of this acknowledgment, Derrida reveals that Austin still does not relinquish the objective nature of constative statements. This is because Austin believes that any ambiguities that may exist within the constative arise from the process of interpretation, not the enunciation itself. Chapter 1 demonstrated that *Khutbah* is very much an ideological text, and hence we agree with Derrida. However, its intent as a historical and cultural review allows us to understand in good faith that the text *assumes* a critical impartiality. This positionality of empiricism should be taken, if only pedantically, as the sum of a series of constative statements.

On the other hand, *Nafir* is a series of illocutionary and perlocutionary acts, a rhetorical address meant to induce its reader to take action. Therefore, as a political intervention but also defining a "procedure of intervention" into reconceptualizing the sociopolitical realities of the day, *Nafir* can be understood as performative.[29] This assertion is important narratively because it underscores the move from *Khutbah*'s denotative and analytical narrative and method to *Nafir*'s connotative and rhetorical stance. For example, notice the address and impassioned tenor of al-Bustani's appeal:

> How often have we heard you talking about this ruinous event [*khirbah*], the third of its kind in a span of less than twenty years? You have tried civil war time after time. You have weighed its pros and cons. But what have you gained? Has any of you become a king, an advisor [*mushir*], or a minister [*wazir*]? Have you risen in status and position? Have you increased your reputation or wealth? What has been the consequence of violence? Widowhood, orphanhood, and poverty? Degradation [*safalah*], earthly and spiritual destruction, and humiliation? Belittlement of native sons in the eyes of rational men and foreigners?... Now then, isn't it more suitable to your welfare that you exchange your blind prejudice—which is nothing but a kind name for excessive self-love—with love for the nation and interconfessional friendship (*mawaddah*)? The success of the country [*najah al-bilad*] is achieved only through concord and unity. With them, you can vex reviled Satan, extend the carpet of valor, remember past harmony [*ulfah*]. By them, you can strive to alleviate these calamities and make restitution for this destruction. You are all one hand in

our nation's interest, and you must realize that some of you are a shield, not an enemy, to the others. (V, 27–28)

The rhetorical tone of this excerpt contrasts with much of *Khutbah* as well as the previously cited wataniyat. The "we" speaks to the compatriot "you" (*antum*, pl.) as opposed to *Khutbah*'s reference to "the sons of the nation" in the third person. The pervasiveness of the "we" and "you" usage in the broadsheets indicates more than a shift to familiar language for rhetorical purposes. Rather, the "sons of the nation," who previously represented a unified national citizenry in *Nafir*'s initial wataniyat, are now differentiated.

The movement between "you" and "we" calls attention to the essential place that narrative occupies in the formation of any discourse of selfhood. Mikhail Bakhtin's insights are of some importance here. He has taught us to recognize the diversity of linguistic and discursive relationships within narrative itself. This interplay is more than a literary adornment but is ensconced in the politically charged correlations between language, narrative form and content, and the ontological mechanics of the Self. Specifically, the relationship between "the discourse of the other and the discourse of the I," he states, is the same as the relationship between "utterances" within a language, a narrative, and/or a singular discourse. These relationships "are analogues of (but not certainly identical with) the relations between the exchange of a dialogue."[30] This dialogue is detectable in *Nafir* when, in attempting to form a familiar national self, the narrative switches from you to we. Mirroring the tension between his performative and constative statements, the internal dialogue within al-Bustani's narrative discloses the complexities in representing a "clean" subjective ideal that is able to enact national unity.[31] If Bakhtin shows us that a word can be dialogic, that it has competing meanings and pedigrees within the unity of a singular utterance, then the split in subjectivity (you/we) does not represent two separate subjects but one. Resonant of the *Khutbah*'s historical subject, this unified subject exists in two states, that of knowing and that of ignorance. Consequently, the you-plural of *Nafir* vacillates between a term of accusation and a rhetorical term that enacts a singular national identity. This "you" is one of commonalities. It is the "you" of a shared culture, history, and language. The earliest wataniyah evinces this assertion when al-Bustani pleads, "You all drink one water, breathe one air. Your language which you speak, your earth on which you walk, your welfare and your customs are all one" (I, 9).

The poetics of the entreaty communicates much. "You" transforms the native into a performative subject who acts out the eschatology of his failure.

Simultaneously, it represents the very potential to overcome this failure because "you" links the individual to a collective and a shared communal culture, language, and history. These processes of association and organization are explicitly the mechanics by which subjective identifications are assembled, ideal-egos are forged, and national identity is imagined. Herein rests the psycho-ontological platform that underlies al-Bustani's schemata of national order and its moral economy, which naturalizes his vision of a secular, civil society. That is, by forming identification between the individual and the collective, a national subject is born. Empowered by collective will and compelled by communal welfare, this national subject is performative, constituted by his deeds or misdeeds. The national subject, whose identity reaches beyond citizenry, literally enacts the nation, using his selfhood to realize concord, unity, and a successful civil society. In other words, *Nafir* surpasses the generic descriptions and prescriptions of *Khutbah, Manahij,* and *Aqwam al-masalik* because it summons the subject to become a citizen, to intervene in his own social and political milieu by forsaking local and confessional identities for a preexisting collective identity. Bridging the gap between collective and confessional identities, *antum* unifies metaphysical, ideal Arabs (those who recognize the fraternity and welfare of the nation) with material natives (those who participated in fanaticism and violence), tethering them to "the nation" (*al-watan*).

Love of the Nation

In *Nafir*, a process of identification between the individual and the community facilitates the leap from confessional to national identity. Al-Bustani is not saying that confessional predates national identity, only that fanaticism to sectarianism is contrary to the recovery of national success. In addition to you-plural, the correlation between the nation and its subject is reinforced through another powerful association—the relationship between the members of a family. This idea looms large in al-Bustani's narrative, which states that the relationship between the citizen and the nation "is like [the relationship between] members of a family, its father the nation, its mother the land, its one creator God, and its members from one soil" (VII, 38). Rather than subordinating the family to the nation or supplanting the primacy of the family in the reproduction of society, *Nafir* forms a complementary bond between the two through an associative parallelism. For example, al-Bustani casts the effects of the cultural infrastructure in terms of this familial metaphor, when he states, "The means of acquiring culture, such as through schools, presses, journals,

commerce, and the like, tend to increase the mutual attachment [*ittisal*] and the closeness of the people, making them as one family" (XI, 69). The metaphor allows the nation to co-opt the bonds of the family without displacing it.

The most compelling of these bonds is love, the force that binds the family. As the central theme of the wataniyat, "love of the nation" (*hubb al-watan*) is the transcendental motive that links the subject to the nation, the performative to the constative, and the metaphysical to the material. The political, social, emotional, and semantic nexus that this platitude exemplifies is clear in the following passage:

> The people of the nation [*ahl al-watan*] have a right to their nation just as the nation has duties to its people. Among these rights ... and most important of them, is security for their life, goods, and wealth. Likewise, freedom of civil, cultural, and religious rights is important, particularly freedom of conscience in confessional matters. In fact, many nations have sacrificed martyrs for this freedom. The sons of the nation love their nation more when they realize that the country [*balad*] is their country; that their happiness is in its construction and comfort; and that misery is in its ruin and misfortunes. A desire for the nation's success and enthusiasm for its progress grows in the sons of the nation only if they have a hand in its deeds and participate in its welfare. The more the responsibilities in question are put upon them, the more these feelings are strengthened and become resolute. Among the duties that the sons of the nation have for their nation is love. It is mentioned in the Hadith that "love of the nation is from faith" [*hubb al-watan min al-iman*]. Many are those who spend their lives and all their money out of love for their nation. There are those who exchange the love of their country for sectarian fanaticism and sacrifice the good of their country for personal interest. They do not deserve to be considered members of the nation but are enemies of it. Those who do not exert themselves to prevent the realization of the motives which cause harm to the nation and those who do not exert themselves to ameliorate [the situation] after these terrible actions transpire are also enemies of the nation. How few are those sons of this nation who demonstrate love for their nation in these trying days! (IV, 22)

"Love of the nation" is the central element in the social and psychological process by which the self becomes a national subject. The anonymous article "Hubb al-watan min al-iman" is clearly al-Bustani. While not the originator of this ideological platform, he methodically marks out in this article that pro-

cess of identification between citizen, nation, knowledge, and civilization that would be adopted by innumerable other intellectuals.[32] As we have seen, this process is one of identification and association where the subject forms a cathexis with the nation, which in turn becomes subjectivity's raison d'être. Similar to the effects of you-plural, love bestows propriety and the rights of the nation on its subject, making him responsible for its success or failure. Al-Bustani himself acts out this relationship by signing every evocative wataniyah as *muhibb al-watan* "(lover of the nation)."

The maxim of "love of the nation is from faith" is a linchpin in the subject's investment in what al-Bustani determines as "the national welfare." The aphorism links the social (the nation) to the spiritual (faith). Such a correlation is relevant, as it was the motto for the constitutionalist movement in the Ottoman Empire.[33] In addition, "love of the nation" was central, for example, to al-Tahtawi's platform for cultural reform. Yet for him, national love was a religious dictate and a fundamental rule of good civil conduct set by the Caliph 'Umar ibn al-Khattab.[34] Furthermore, the idiom remains central to nationalist writing from Sati' al-Husri to Michel 'Aflaq and beyond.[35] In the wake of civil war, however, "love of the nation" provides al-Bustani with a moral, emotional, and rhetorical bridge that crosses contradictory cultural and social leitmotifs and priorities, providing a bridge between warring communities themselves. Secularism becomes a rational component in social development at this enunciative level. That is, empowered by love, the subject surrenders not his confessional affiliation but his confessional antagonism and prejudice, recognizing the sameness of his cross-sectarian brethren. If concord and unity are the foundational starting points for national progress, then we see, following Foucault's guidance, how the discursive force of "love of the nation" serves as a "referential" nodal point in the syntagmatic logic that naturalizes this vision.[36]

Over the Camel's Hump

The love-axiom supplies a motivation for accepting the primacy of a national identity while also containing a solipsism, which assumes that if one shoulders additional national duties, then one's love of the nation will increase. Until this point, the "felicity," as Austin would say, of *Nafir*'s formula seems fundamentally intact. However, al-Bustani inlays critical gaps in the process by which a shattered nation becomes unified and rejuvenated. The question then looms: What is to be done if the native subject cannot muster the initiative to seek knowledge, to recognize commonalities, or to make the leap from faith and family to nation

and the collective? To redress this lacuna, al-Muʿallim Butrus provides a supplemental factor in his equation for reform, one who is extra-subjective. This supplement is a qualified and responsible ruler.

The necessity of just and prudent rulers is not strange to Arab intellectuals' formulae for reform. They are prominent throughout al-Tahtawi's *Manahij* and Khayr al-din al-Tunisi's *Aqwam al-masalik*. Francis Marrash, Farah Antun, Adib Ishaq, al-Kawakabi, and others will offer allegories and commentaries in imagining the ideal ruler. Some years later, Muhammad al-Muwaylihi dedicates a chapter to many of the same notable leaders that al-Bustani had named in *Khutbah*, including Muhammad ʿAli and the Caliph Mansur.[37] Yet, for al-Bustani, the enlightened leader is pivotal for the realization of national unity and success, as the following passage illustrates:

> Among the greatest losses resulting from the violence is the loss of confidence between the leaders and their followers or between the citizens [*raʿaya*] and their government. It is well known that the ruler's confidence in the people depends considerably on the people's confidence in the rulers and vice versa. Therefore, effort [*ijtihad*] on both sides is necessary for the return of confidence and the strengthening of its foundation. On the one hand, the hope is that the rulers' wisdom, the quality of their administration, the reform of their behavior towards, and the demonstration of their consideration for the people will dispel the vile effects of the past events. On the other hand, we hope that the people's knowledge [*maʿrifah*] concerning their welfare, their forbearance, and their avoidance of extremism in seeking a pardon or punishment for what is politically, religiously, culturally, and customarily prohibited will dissipate these effects, because these two groups share past bonds such as customs, tastes, dispositions, and degree of civilization. . . . The social wheel will turn in the long run along its former axis. (VIII, 45)

In this passage, al-Bustani's conceptualization of a wise ruler cannot be separated from progress. The ruler's intervention is necessary to assist the debilitated and scarred subject "over the camel's hump" of recent history and decadence towards the establishment of a civilized society (X, 60). The ruler's intercession is the catalyst for the will of the citizen, making "love of the nation" and "concord and unity" possible. Therefore, the return of a peaceful and productive civil society, where there are familial bonds and love between confessions, depends primarily on the competency of an egalitarian-spirited leader who supplies guidance for the general population, thereby aiding them to rec-

ognize and work for national interests. Structurally, then, the leader functions as a third term, imported to bridge the gap between the decrepit subject and his current subjective state.

Al-Bustani's paradigm of unity and progress is interesting because its coherency or, to use Austin's term, its happiness wavers even after the introduction of "love of the nation," because the axiom's effectiveness requires the arbitration of a term exterior to the subject-nation relationship. The following passage demonstrates the necessity for the intervention of the leader (as a third term) for progress:

> We think that two matters, which we have mentioned several times in our past patriotic tracts [*wataniyat*], are essential in these days for the civilization of the sons of the nation, the people of Syria. The first of them is the existence of concord between individuals and groups, and particularly civil concord whose existence or the lack thereof depends on the strength, ardor, and will of the rulers. These rulers must rely on the desires and multiple interests of the people. However, we do not doubt the difficulty, or perhaps impossibility, of heartfelt and faithful concord after what has happened. What we have witnessed is the intrusion of death into the nation's religions and laws, and we are not pleased by it.
>
> The second matter is love of the nation and preference of its welfare to self-interest, whether it be personal or confessional. As long as the sons of our nation do not feel that the nation is theirs, love of the nation and concern for its general welfare cannot be hoped for. Rather, the native sons are always disunited, each one of them searching for what he imagines to be most advantageous to his own person or group. It is well known that when any house or piece of property is divided up, the result is necessarily its destruction. For this reason, if one hopes that the reform of the conditions in Syria will come from the ideas and opinions of its people, then that is to hope to accomplish an impossible feat. It is like asking a sick person to treat himself. (XI, 69)

These paragraphs present the kernel of al-Bustani's discourse of subjective and social reform, expressing not only the interrelations of the nationalistic leitmotifs and semantic nomenclature but ambiguities and contradictions endemic to his discourse. The first paragraph suggests that both the ruler and the subject cooperate to restore intersectarian harmony and social stability. The former brings the will and know-how while the latter brings the desire and authenticity. The second paragraph, however, proposes that the native is virtu-

ally incapacitated by his own shortcomings and the weight of the grievous events; hence the nation requires the intervention of a leader. This enlightened leader possesses an analogue, the doctor, whose intervention on behalf of the sick reflects the patient's inability to cure himself. With this metaphor in mind, Derrida's theory of the subjective and ontological supplement sheds light on the architecture of self-formation in the colonial era. He states, "The supplement adds itself, it is a surplus, a plenitude enriching another plenitude, the fullest measure of presence. It cumulates and accumulates presence.... But the supplement supplements. It adds only to replace. It intervenes or insinuates itself in-the-place-of; if it fills, it is as if one fills a void."[38] Just as Zizek reminds us of Lacan's description of the role of law as the mediating third term between social order and its subjects, Derrida problematizes the Hegelian schema by directing us to see how the leader's intervention serves as the supplement for the intrinsic subjective lack, not least of which is the native's inability to recognize his own greater welfare. The introduction of the ruler as an exterior term in al-Bustani's formula for progress and national unity conjures doubts about the Arab subject's ability for autogenetic reform. That is, on a political level, the leader's intervention is necessary to ameliorate intercommunal antagonism. Therefore, when al-Bustani asserts, "You are as just as he who rules over you," we understand that the subject-nation configuration depends on the intervention of a mediating leader who is both external and internal to the subject.

Al-Bustani says that good leadership is synonymous with good government. Inherent to the concept of the nation is the dialectical relationship between subject and government. The government serves as one material configuration of the nation, drawing in the subject as a component in the economy of its rule. But government also serves as the endpoint of identity's signification and acts as a sign of the subject's cultural and political state of affairs. In other words, good government reflects subjective presence. Without it, true progress cannot be realized.[39] My intention is not to mock the ideological platform of al-Bustani's admirable national enterprise. Nor is this analysis merely a poststructuralist version of a classical Arabic rhetorical exercise revealing how al-Bustani's argument may rest on irrelevant conclusions (*ignoratio elenchi*) or how it structurally begs the question (*petitio principii*) of cultural success. On the contrary, I would like to demonstrate how the solipsistic jumps and incongruencies between rhetorical tropes are representative of the very leaps that are made in the process of signifying national subjectivity. With this in mind, then, we can understand how the relationship of governed, governor, and gov-

ernment sets up a circuit of deferred guilt that camouflages the impossibility of subjective and social reform.

Displaced Failure

We have seen that, for al-Bustani, the fruition of national progress cannot be achieved without the good governance of a competent ruler. Since national rulers are responsible for national unity, intersectarian concord, and imbibing love of the nation, then the lack of competent governance and an effective governor has egregious legal, social, and moral effects. Al-Bustani explicitly develops this relationship:

> The lack of the existence of good government and the scorn for laws are both among the greatest evils for a country whatever the stage of its civilization and success. Government and laws resemble good health. That is, you do not know their worth except in their absence. This lack causes the sons of the nation to transgress the boundaries of humanity and justice, and makes them blameworthy in the eyes of the whole world. (IX, 52)

The process of transferring the responsibility for failure—in this case, passing it from "corrupt native sons" to leaders—structures al-Bustani's paradigm for national unity. The case of governance, however, is a very real issue in 1860. Despite the rhetorical passion with which al-Muʿallim Butrus speaks during and after the sectarian violence, dispossessions, and massacres between Christians and Muslims, he is remarkably silent in assigning specific and focused blame to perpetrators, provocateurs, or local and government officials. Likewise, his broadsheets are surprisingly generic, absent of names of political, religious, or sectarian leaders, dates, places, and statistics about the massacres, chronological and political developments, and potential motivations of the combatants other than their "ignorance" and "fanaticism." However, al-Bustani asserts that the events of the year incriminated the office of reform-minded Fuad Pasha, the Ottoman-appointed Mutassarif. Here, his recrimination has its most palatable political effect because the readership is confronted by the evidence that the "absence of good governance and laws" leads to chaos. This said, al-Bustani does not exonerate Syro-Lebanese citizenry from culpability in the year's violence. If the deficiencies of national leaders are responsible for the disorder, the native sons of Greater Syria, particularly al-Bustani's fellow intelligentsia and men of reason ('uqala'), must accept blame as well.

[T]he blame, loss, and responsibility in such and such deeds in the end falls on rational men and the wealthy. Thus, they are aware that their foremost interest is, at all times and places, the prevention of ignorance. They must educate by means of example and instruction, affecting peace, concord, and friendship.... If the rational men of Syria had taken into account the results of ignorance and disunity, and if they knew that these matters would lead them to the state in which some of them find themselves and that many more of them will experience, then, by their own intelligence, they would have been the first to throw out the delusions sent by Satan or extremists. They would have been the first to have hastened to extinguish the spark made by the hand of ignorance and foolishness, that spark created by a vicious mentality hiding in Syria's deepest forests and arid ravines. Or, if they were old, they could at least have gone outside in the midst of the ignorance and turmoil of the war and made it clear to the entire world that they did not have a hand in these ugly deeds.... [T]hey should have made clear that these deeds are, in truth, against their wishes, interests, and will. (X, 51)

Mikha'il Mishaqah would echo this analysis some years later. Indeed, the proactive role of a politically conscious and socially conscientious subject is crucial in creating conceptually a national citizen who is invested in communal welfare as well as responsible for it. The concept of modern civil society relies on a citizen of ability, indeed action. Therefore, al-Bustani rebukes "rational men and the wealthy" for their unwillingness or inability to act meaningfully and prevent the violence. He castigates them for failing to perform as effective, even exemplary, national subjects. If this weren't bad enough, the failure of enlightened natives speaks to those in the West who indict the Arabs for backwardness. Such a fear relates to us that, always present within the process of self-analysis, the reformer submits his culture, history, and society to an ever-present exterior judge, or what I have chosen to call the specter of the West.

The Specter of the West

Through voluminous social and political commentaries, fiction, and poetry, Arabic writers throughout the Empire struggled to make sense of the radically new social and political conditions of the second half of the nineteenth century. The dialectic between the political and economic dominance of Europe and the internal responses to it were responsible for sweeping changes in virtually every

corner of society. Makdisi, Khater, Smilianskaya, Harik, Fawaz, Chevallier, and others have shown us how these transformations—generated by local, Ottoman, and Western factors—were at the root of the civil instability and political formations within Lebanon during the nineteenth century.[40] Al-Bustani, however, approached the causes of the civil unrest conceptually, not materially. In sum, he posited that the failure of rational compatriots and rulers in 1860–the absence of will, good governance, and good citizenry—resulted in mass killing and dispossession, social disorder, and political uncertainty. A crucial assertion of *Nafir* is that these shortfalls also resulted in foreign military occupation, which dealt a blow to any aspirations of national sovereignty as well as complicating the Arabs' march towards progress. That is, to reestablish civil order, the Great Powers in conjunction with the Sublime Porte agreed to deploy Austrian-British troops in Beirut and the Mount Lebanon. From the very first wataniyah, al-Bustani pays special attention to the existence of these troops in Lebanon (I, 10). He states that "the transgression of boundaries of humanity and justice" by "the sons of the nation . . . made necessary the intervention of a foreign hand in their country's affairs. . . . We are firm in the conviction that intervention by a foreign hand in the politics of any nation . . . is harmful to the country even though it may provide some temporary benefit" (X, 52). As a thinker, al-Bustani insisted that the reform of his nation must be carried out by his compatriots themselves, starting at the most ontological level and ending at the state and society. The necessity of European intervention, then, indicated more than a complete breakdown in civil society. It confirmed that everyone in Greater Syria, from peasants to clergy to intellectuals to rulers, were "blameworthy in front of the whole world" (X, 52).

Nafir sums up the catch-22 of the postmassacre predicament. As soon as the author rejects foreign intervention, al-Bustani endorses European military and political entry into Lebanon. For example, he claims that the foreign powers "came for the protection of human rights and the enforcement of the principles of justice and restraint" (IX, 52).

> This time, foreign intervention was beneficial to all native groups. It was necessary to stop the continuation of hostilities and destruction, which were like infectious diseases spreading from place to place with complete determination and speed. . . .
>
> We hope that this assistance from foreigners, combined with an agreement on Syria's well being, will last until the bases of justice and security are established and strengthened. We hope it closes the door to the fear of

crime, treachery, and the actions of the corrupt and their associates, who are the vilest of people and perpetrators of these savage acts. (IX, 53)

The metaphor of contagion evokes the earlier simile that casts the ruler as a doctor figure. If asking the corrupt to reform their conditions is like expecting a sick person to cure himself, then European intervention in Lebanon is the only means to restore the social order that had broken down under the care of native rulers and intelligentsia. This patriarchal sentiment is profound because it revisits colonized peoples as the justification for colonial and mandate rule in the ensuing decades. Yet the proposition is voiced not only by colonial bureaucrats, Western travelers, missionaries, and Orientalists but reiterated by many Lebanese and Egyptian intellectuals throughout the century. For example, Butrus's son, Salim, would write articles considering the beneficial effects of direct British intervention in Egypt and their cooperative relationship with the Khedive. Yaʿqub Sarruf would enthusiastically endorse colonial rule in Egypt, and even nationalists like Muhammad ʿAbduh collaborated with the notorious Lord Cromer.[41] Likewise, the Young Tunisians, a cadre of intellectuals active at the end of the century, continually petitioned through *Le Tunisien* for a leading role in the affairs of state for the mutual benefit of both the Tunisians and the French.[42] However, the French made it clear in their reply that the Tunisians were not equals because of their backward ways. In most cases, these intellectuals were not traitorous or antinationalistic but hoped that foreign presence would lead to cooperation, not control, collaboration among partners, not dominance of one by the other. They expected that the West would guide torpid Eastern nations to realize a modern political and social order and increase economic and cultural productivity.

This conflict is ironic because the critic desires Europe to intervene to facilitate his society's autonomy, because autogenic reform relies on a jumpstart from the West. The contradiction originates in the reformer's vision of a changing world. That is, a century and a half before the full effects of "globalization," al-Bustani conveys a sense that Beirut, Mount Lebanon, and Syria must be important participants in a rapidly shrinking world if it is not to be dominated by it. He insists that the sons of the nation must realize that "they are not alone in this world. On the contrary, they are a link in a great global chain. This link is not at the end of the chain. Rather, it exists in its middle, its heart, and its political and religious center, and is very important. It therefore connects and separates the Eastern and Western worlds. . . . In this century, the links of this great chain, by means of the steamship, telegraph, and other things, have be-

come very much closer than in past generations and the bonds and connections they form are stronger" (IX, 50–51).

Al-Bustani insists that his compatriots must acknowledge that they are members of a universal cultural and economic market. The world is now bound by an economic and political dialectic, held together by new forms of technology, transportation, and communication. Greater Syria and particularly Beirut are links that bind the global chain, making the Arabs global actors. The paradigm effortlessly arises out of the same discourse that communicates the universality of history and selfhood in *Khutbah*. However, the Hegelian current undercutting al-Bustani's unstated theory of historical agency and subjective success debilitates the national subject. That is, if Western knowledge assists in the reform of Arab culture in *Khutbah*, the political and military intercession of Europe into the affairs of Syria could serve as an authoritative catalyst for citizens and rulers to reach social and political "concord and unity."

Scornful Gaze

The analysis of al-Bustani may be indeterminate or naïve, as it seems to assume the fundamental goodwill of the West in helping the Arabs to achieve progress and civilization. After all, he commends American and European missionaries in their efforts to educate the nation's sons and daughters. This assertion would be more tenable if the antagonism between Europe and the East were not so clearly illustrated in the anxieties and concerns of the reformer. Al-Bustani has told us that rulers, intellectuals, and the masses themselves were all "blameworthy" if not "savage" in the eyes of the West. Al-Bustani was acutely aware of the scornful gaze of the West, bemoaning that "the lover of the nation lowers his gaze to the earth. [He is embarrassed] particularly in these days when foreigners have opened an investigation into the causes of the violence. [We bow our heads] not out of cowardice nor fear, but out of shame and disgrace" (VIII, 41). This shame is peppered throughout the text and reveals the anxiety caused by the simultaneous recognition of the West's advancement and the need for their intervention, on the one hand, and their ill intention and political opportunism, on the other (see *Nafir*, X, 56). This anxiety is not subtle and expresses fears that the recent events will validate foreign disdain for the Arabs. As a result, the direct address communicates an urgency as well as culpability when al-Bustani asks, "O sons of the nation, what excuse should we make for the sons of our country in front of the foreigners, who are neither stupid nor lacking in civilization, who impugn the strength of the Arab intellect?" (V, 26).

The effects of this self-reproach emerge from the depths of the process of identity formation in the colonial era. The shame and guilt that haunt the consciousness of the native are not independently generated. Rather, it confirms that there is a Hegelian Master-Slave struggle under way, a struggle for recognition. René Girard offers a nuanced explanation of this residue of shame and antagonism. Amending Hegel, he identifies a similar process of self-directed resentment originating in the triangle of the Self, his desire, and the Other, a theory that echoes Lacan. In the case of the nineteenth-century subject, Girard guides us to realize that the Arab subject coterminously identifies with European ontological and political presence while also resenting it because he must, in fact, rely on it for success. Shame, then, is the by-product of this process. Thus, in responding to his compatriots, al-Bustani's passion discloses a defensive reaction that is fueled by an acknowledgment of European contempt for the Arabs. In Girardian terms, the effectual and legitimate native subject feels contempt for his ineffectual Other—an Other, as we have seen, which is not exterior but interior to his own subjectivity.[43]

The anxiety inspired by the Western gaze cannot be separated from the anxiety that arises from the split in the native subject between progress Self and decrepit Other. The tension underlies al-Bustani's visions of progress and communal regeneration. It haunts his very imagination. He visualizes a time of reconstruction and productivity, but fear and angst creep into this picture of normalcy. For example, he narrates, "Yes, we see, over there, a house being built and the land being cultivated. But we are also anxious that every time a particular roof is built, a public shrine is simultaneously demolished" (VIII, 44). This vignette is representative of the split between the "you" and "we" form of address. The productive subject is separated from the destructive subject. In fact, the anxiety between the two emerges in his later writing, for example, when al-Bustani condemns rebellions, revolutions, and perennial indigence that have worked contrary to their previous mastery of knowledge.[44] Yet we recall that al-Bustani is talking not of two subjects but of one national subject in two states. Therefore, the author assumes the role forcefully of an intellectual who makes his voice audible to his compatriots and to the West. His recrimination, therefore, is a political reply that is morally necessary to the West's righteousness.

The West's scorn is by no means unambiguous. At one point, we hear an anonymous foreign voice articulate this incrimination: "One of our losses is that of truthfulness and credibility. I have heard foreigners declare: 'How re-

markable! ... Did the sons of this nation have truthfulness before the current events? Is what they say true that they had it before but now, for whatever reason, they've lost it?'" (VIII, 42). Without a doubt, the possibility of reform remains alive in this statement, recalling the previous existence of Arab integrity. However, the fact that such a statement is put in the mouths of foreigners verifies al-Bustani's anxiety. The danger as perceived by al-Bustani is that the recent violence may confirm European prejudice. Consequently, this prejudice relegates the Arabs to a disadvantageous political and cultural position vis-à-vis their Western counterparts. It morally impugns the native, his bad faith extracts him from history, and the prejudice justifies indefinite colonial rule.

On a theoretical level, al-Bustani's overarching concern for the West's appraisal divulges that the Arabs are striving for the recognition of their Selfhood. The struggle within this process is one of identifications as much as it is a struggle with the politics of European imperialism in the nineteenth century. The political struggle and reifications of identifications should not be seen as separate from the nationalistic reformer's narrative, however. Together they demonstrate al-Bustani's cognizance of the ideological platforms historically used to justify colonialism. This assertion is substantiated when he inserts into his narrative an extended commentary in the form of a reported dialogue between himself and a generic foreign accuser. Here, as an intellectual who represents Syrian citizenry to the West, al-Bustani acts as the national defender.

> That same day I had spoken with a man who was defaming the Arab race and slandering the Arabs as being, without exception, cheating liars with no conscience. My Arab blood stirred. Rebutting the maliciousness of his speech, I fervently told him ... that lying and cheating are two natural propensities found in all peoples and races. As proof of my case I adduced the saying of the Prophet. "All people are liars." But I was not happy with this response. So I followed it up by saying that the lies of the Arab are perhaps more numerous and frequent than the lies of other races. This is because they lie casually, without deliberation, and unknowingly, as is their habit [*da'buhum*] in the rest of their actions. As for the lies of other races, perhaps they are greater than the lies of the Arabs in terms of importance and quality. This is because they do not lie except with deliberation and cognizance and for a purpose and profit. If their lies are skillful, so too are their actions. (VIII, 42)

At this point in *Nafir*, the author directly confronts the accusations of a judg-

mental "foreigner." This confrontation has several key discursive effects. First of all, by contesting foreign indictments of his compatriots' integrity, al-Bustani enacts reform himself. He performs the same prescriptions that he had faulted his fellow "rational natives" for lacking during the fratricidal violence of the previous year. In addition to demonstrating competency in rebuking recriminations of his culture, al-Bustani successfully illustrates the actions of an exemplary native.

Another discursive effect is more ambiguous. It is not by chance that the rhetorical form of al-Bustani's defense is enclosed in a dialogue. The dialogue form discloses the subject in a dialectic of recognition with the West. Al-Bustani tries to level the playing field by appealing to universalism. All nations have had corrupt people and degenerate tendencies, he states (e.g., *Nafir*, X, 56). Such a reply is not surprising when one remembers that intellectuals of *al-nahdah* worked to redefine the Arabs' place and relevance in a universal historical and cultural continuum. Therefore, it is curious that al-Bustani amends his defense in midstream. He simultaneously confesses and rationalizes collective guilt, but apparently turns this admission into an indictment of the West's calculating dishonesty. This indictment of the West's character, the gravity of their dishonesty, could certainly be seen as a comment on Western policies in the Middle East during the nineteenth century.

By amending his defense and engaging foreign accusations of Arab inferiority, al-Bustani accepts the gauntlet thrown down by his foreign accuser, thereby instantly entering into a Hegelian dialogue with the West. In his *Khitab fil-hay'ah al-ijtima'iyah wal-muqabalah bayn al-'awa'id al-'arabiyah wal-ifranjiyah* (Discourse on society and the comparisons between Arab and European customs) written some ten years later, al-Bustani struggles within this same dialogue. While demonstrating the virtue of his culture, the author's honest and self-critical nature forces him to recognize the "superiority" of the West in relation to the deficiencies of the Arabs. In *Nafir*, the last sentence of this passage has the same effect of reconfirming Western mastery. Even their actions as liars evince the fullness of Westerners. Stated otherwise, the forceful performance of their calculating lies demonstrates their competence and willingness, which are contrasted with Arab indifference and indigence. By presenting his dubious innocence as ignorance, the subject reaffirms his own otherness in relation to the European Self-Same. Recognizing that there is the Hegelian dialogue at hand discloses that it is this European Self which serves as a subjective referent for progress in the writings of al-Bustani and his peers.

Universalism and Relativity

As we have seen, al-Bustani understood reform to mean the process by which the Arabs can reintroduce themselves into a universal history of progress. However, to reclaim the historical endpoint of civilization and modernity, al-Bustani uses the sameness of humankind, particularly human and familial bonds, to unite the Arabs and the West. This appeal to the commonalities of Man draws al-Bustani deeper into a Hegelian juggernaut. Questioning Kant as much as Hegel, Michel Foucault called attention to this universalism. In "What Is Enlightenment?" he ponders the question of who the "mankind" is in Kant's formulation of Enlightenment. He asks, "Are we to understand that the entire human race is caught up in the process of Enlightenment? . . . Or are we to understand that [Enlightenment] involves a change affecting what constitutes the humanity of human beings?"[45] In asking such questions, Foucault calls attention to the criteria used to define man but never specifically mentions the effects of the application of such criteria to non-Western peoples. Tsenay Serequeberhan picks out this very passage as an introduction to his powerful critique of Kant's race theories, which are found not only in his earlier anthropological works but in *Critique of Pure Reason* as well.[46] Nevertheless, neither Serequeberhan nor Foucault raises the issue of how the criteria that constitute Man or Enlightenment become naturalized in the psyche and self-views of colonized peoples. This notion of a universal Man—Man as a secular subject of knowledge, a producer of history, and a creator of culture—is inscribed into Arab identity and world vision during the Arab renaissance. For reform-minded intellectuals such as al-Bustani, the notion of the enlightenment of Man is certainly androcentric and erects a patriarchal, universalizing discourse that displaces cultural as well as gender difference. The generalizing catchall represents for al-Bustani and his peers an identification with the harbingers of modernity, signs that are full of unease and indeterminacy. The texts discussed thus far have revealed the tension and anxiety within the relationship between the East and West, particularly the national projects of identify formation and social reform.

In *Khitab fil-hay'ah al-ijtima'iyah wal-muqabalah bayna al-'awa'id al-'arabiyah wal-ifranjiyah,* al-Bustani continues to culturally and historically locate the Arab world in a Hegelian universalism by defining a clear and linear map of social evolution.[47] He asserts that the contemporary Arab sociocultural state mirrors the Dark Ages of Europe (*al-Hay'ah,* 174). The West has blazed the path of historical progress while the Arabs "are around four hundred years

behind the Europeans" (*al-Hayʿah*, 183). With such an antagonism, it is understandable, therefore, that al-Bustani returns in *al-Hayʿah* to the genealogy of sameness, once again proposing Franks and Arabs as descendants of Japheth and Shem (*al-Hayʿah*, 184). If both sides would acknowledge their commonalties as the sons of Noah and the children of Adam, he reasons, their cultural differences would disappear. They would act in love and friendship, which are, of course, the principal sentiments that bind the nation (*al-Hayʿah*, 185).

The invocation of Man, let alone the familiar bonds between the Arabs and Europeans, allows al-Bustani to enter the Arab subject into a universal social continuum without surrendering the cultural authenticity of the Arabs. This authenticity is essential in the project of cultural, social, and subjective reform. Authenticity, for al-Muʿallim Butrus, defines a community where ethnographic culture and social norms are relative to place, community, and time. This specificity of culture is important. He states that, despite their qualities and their mastery of modernity, the customs of *al-ifranj* may not be appropriate for the Arabs and Arab society. Neither culture, however, "has the right to blame or hate the other because he is not satisfied with his own customs and does not adhere to them" (*al-Hayʿah*, 173). So if Arab culture can be placed within a universal sociohistory, relativism has a precise and purposeful function. It allows native society to exist within such a continuum without specifically mimicking the West.

What is interesting, however, is that al-Bustani's theory allows not only for the retention but also for the shedding of "traditional culture." That is, the relativism that the author presents is transposed into a justification for the disposal of indigenous, outmoded customs. He states, "It is not appropriate that we are slaves to custom. Rather, in freedom, we should treat custom as our slave, and leave her when we wish" (*al-Hayʿah*, 173). As in *Nafir,* al-Bustani says that just as the Arabs should not blindly adopt Western customs, so too should they be discriminating in the conservation of arcane indigenous customs. The Arabs should hold onto their venerable customs for their intrinsic worth and utility, not revere and maintain them exclusively because of their antiquity as is the habit. Al-Bustani anticipates the likes of Sharabi and al-Jabiri when he concludes that his society's cultural narcissism is debilitating and the lack of self-criticism prevents it from progressing with the rest of the world (*al-Hayʿah*, 183). In stating this, he sets up the justification for his life's work as cultural producer as well as social and cultural critic.[48] But this tact also has a very powerful political effect. He deploys cultural relativism to maintain a sense of

cultural authenticity. Endorsing the release of "traditional" social modes allows society, in his view, to recast itself into a universal mold.

Winding Road of Comparison

From this position of relativism, al-Bustani posits that culture, customs, and tastes vary from place to place and account for different directions in social development (*al-Hay'ah,* 172–73). Here, he demonstrates himself as a social theorist and comes closest to mirroring al-Tahtawi's famous chronicle of French society.[49] He recites a litany of cultural differences between the Europeans and the Arabs including food, eating habits, hairstyles, facial hair, clothing, hats, and mannerisms (*al-Hay'ah,* 171, 174–76). However, his comparison of manners and practices is not just descriptive. He notes that they are indicative of the specific disposition of their cultures and peoples. For example, European food, he states, is designed for its health benefits and pragmatism because Europeans value practicality over taste and pleasure (*al-Hay'ah,* 177). Arabs, however, dine on sumptuous foods while sitting on the floor around a large tray. The commentator states that this social practice, while less sanitary than using forks and eating at tables, strengthens social and familial bonds (*al-Hay'ah,* 177). In regard to hospitality, if a visitor arrives during mealtime, the Arabs insist that the guest join them and eat, while Europeans leave the table to sit with the guest.

Al-Bustani gradually and tactfully transforms this relativistic commentary to judgments that are informed by a utilitarian and protestant criterion that is less favorable to Arab culture. For example, the critic asserts that the generosity of the Arabs, for which they are lauded, is only the veneer of ostentatious display. In contrast, European hospitality may seem sparing, but it is representative of directness and candor (*al-Hay'ah,* 178). As customs reflect those who practice them, al-Bustani insists that Arab customs by nature are superficial in comparison with Western utility. If, he states, "the greetings of Arabs are long and without benefit," European greetings stand in contradistinction to Arab verbosity for their concision and sincerity (*al-Hay'ah,* 181). The customs of Europeans reflect a crucial identification in the subject-ideal for al-Bustani: They are precise, economical, and essentially effective.

Al-Mu'allim Butrus's belief is that one must only reverse Arab customs if one wants to know their Western equivalent (*al-Hay'ah,* 174). The assertion assumes more grave social and cultural consequences, which are particularly important to reformers. His previous comment regarding the role of the critic as well as the

necessity to disregard outmoded ways bulldozes its way through the narrative. The implication throughout is that one must only look at the West for guidance. Ancient legal codes, for example, have been discarded and renewed so that now they serve even craftsmen and peasants. That "the Europeans do not hold onto their customs blindly" permits them to change for the better (*al-Hay'ah*, 182). Anticipating later modernist intellectuals from the left and right, al-Bustani continues to assert that Arabs, on the other hand, suffer from cultural narcissism, which disallows the jettisoning of outmoded customs; thus the possibilities for progress stagnate.

Like his stance on secularism, al-Bustani's view of European culture is contentious. Youssef Choueiri, for example, maintains that al-Mu'allim Butrus used Europe as a cultural model, insisting on an unconditional adoption of European knowledge lest the Arabs have it thrust upon them violently.[50] On the other hand, Albert Hourani believed that al-Bustani and his oeuvre suggest more than simply borrowing from or imitating the West. Rightly, Hourani recognized that the Arab critic was continually on guard for the bad effects of blind imitation. However, arguing the point would be an attempt to reconcile the very ambiguities and slippage found within al-Bustani's life work. In fact, virtually all secondary literature on the period washes over these contradictions, tensions, and hiccups within the discourse of reform in assigning them a specific pedigree in preordained ideological, political, and intellectual traditions. In fact, the venerable Hourani's research is certainly the most renowned in spelling out coherent ideological platforms for al-Bustani and his peers.[51] However, because of these inconsistencies, only through intertextually weaving *Khutbah, Nafir,* and *al-Hay'ah* can he represent a clear master narrative of the history of modern liberal Arab thought.

This study attempts the contrary by focusing on the tensions endemic to this intellectual and cultural tradition. While al-Shidyaq's and al-Tahtawi's commentaries and comparisons with the West are brilliantly perceptive and exceedingly humorous and ironic at times, *al-Hay'ah* seems concisely and theoretically to represent these very tensions. Despite his earlier attempts in *Khutbah* and *Nafir* to lessen the cultural antagonism between the Arabs and the West, for example, by invoking a familiar genealogy (sons of Noah), the author categorically marks an ontological and social opposition between his cultural milieu and the Europeans. The effect produces an unambiguous dichotomy between masterful, efficient, and orderly West and undisciplined, superficial, and ineffectual East.

Reading *Hay'ah* will eviscerate any doubt that *Nafīr* and *Khutbah* do not offer the topology of the reform movement's ego-ideal and that this topology inscribed otherness into Arab subjectivity. The comparison repeats the very methodology, movement, referents, and psychosocial processes found in al-Bustani's earlier works but also in innumerable cultural comparisons written by Arabs. *Al-Hay'ah*'s cultural critique migrates between the discursive binaries that the author has established for us (progressive/backward, efficient/ineffectual, precise/excessive). As we have seen, this vacillation makes his prescriptive and descriptive statements both ironic and paradoxical. Their happiness, to use Austin's term, is never established, because their discursive content continually doubles back on itself, inscribing not an effectual or authentic subject but strengthening identifications with the Western Self. The similarity between the texts shows that there is a logic to the reformers' analysis, a logic that is structured by a specific modern epistemology of the production of subjects. Consequently, this episteme makes the ideological content and effects of the logic invisible.

This is the process of mystification, reification, and naturalization, whether one is talking about money and capital, labor and value, or subjective ideals and identity. The procedures by which this transpires are complicated, trapped in the dialectic vortexes generated and then identified by comparative cultural exegeses. For example, after praising the efficiency of European social organization, al-Bustani notes that current Arab manners are not authentic but contaminated. In this manner, the Christian Arab author anticipates the critique of his clerical Muslim counterparts, such as ʿAbduh and Kawakabi, who claim that authentic Arabo-Islamic social practice has been corrupted by outside influences (e.g., Turkish cultural practices, popular folk religion, etc.). This stance is fundamentally one of attack. Therefore, al-Bustani insists on the Arabs' ability to defend themselves against the onslaught of "armies of *ifranj* customs attacking Arab customs with much strength and determination" (*al-Hayʿah*, 185). This nationalistic posture punctuates *al-Hay'ah*'s conclusion where the author reiterates the mantra of "love of the nation," adding to it the strength of ʿ*asabiyah* to provide the most formidable defense of native culture.[52]

The conflict between emulation and authenticity is endemic to the discourse of cultural, social, and political reform during the nineteenth century, and it comes to an unavoidable endpoint in *al-Hay'ah*. However, despite this intense antagonism and struggle, al-Bustani's texts should not be understood as a deterministic identification with the Western Self-Same. They are, in fact, a pri-

mary location and medium for the resolution of the very conflicts that they produce through their narration. That is, as an earnest critic, al-Bustani, like so many of his fellow intellectuals, writes to redress the flaws and problems, which he defines and impregnates with value. It is important, however, to comprehend how the terms of the questions that al-Bustani and his peers ask, the analytical prisms that they use, and the answers that they formulate were already places where colonial hegemony rooted itself.

Conclusion

In the opening pages of *The Nation and Its Fragments,* Partha Chatterjee objects to Benedict Anderson's much cited argument regarding the formation of national identities by colonized peoples:

> If nationalisms in the rest of the world have to choose their imagined community from certain "modular" forms already made available to them by Europe and the Americas, what do they have left to imagine? Europe and the Americas, the only true subjects of history, have thought out on our behalf not only the script of colonial enlightenment and exploitation, but also that of our anticolonial resistance.... I object [to this argument] because I cannot reconcile it with the evidence of anticolonial nationalism. (5)

Chatterjee shows how, during the independence struggle, Indians not only "imagined" a national selfhood and enacted statehood but also resisted colonialist discourses within these very processes.

Chapters 1 and 2 have attempted to reveal that, at one basic level, the imagination or, as Muhammad Arkoun suggests in *Lectures du Coran, la pensée* of how the Arab intelligentsia conceptualized its Self was affected by the presence of the West. This presence manifested itself in every realm of thought, culture, economy, and politics. This is not to say that the discourses of national resistance or selfhood were passively formed by a master logos dictated by the West. Rather, I have tried to map out the epistemology of national unity and social progress. This has shown that the possibilities for national success and autogenetic reform existed in the minds of native activists. However, by highlighting how failure is deflected from a split, popular subject to national leaders, and back to intellectuals, I have exposed the syllogistic progression in the formulation of "unity and progress" and how this equation posits contemporary disunity as the effect of an inherent lack of national will and competency.

If lack was a defining feature of modern Arab identity as conceptualized by reformers, al-Bustani's opus is a testimony to the notion that the culture's past success implied possibilities for the future.[53] Along with the productive force of this lack, the epistemological prism through which reformers envisioned and deployed this past success adversely affected their conclusions. If the native imagination has not been colonized, as Chatterjee suggests, this inquiry demonstrates that the discursive and performative process by which the modern native conceptualizes himself was informed by exterior as much as interior forces. In the Hegelian view, the existence of a Western presence in al-Bustani's writings attests to a dialectic of self-formation, where lack is produced by an episteme that is enacted by narrative and where the West becomes inextricable from modern Arab subjectivity.

3

Desiring Selves, Desiring Others

> Through the effects of speech, the subject always realizes himself more in the Other, but he is already pursuing there more than half of himself. He will simply find his desire ever more divided, pulverized, in the circumscribable metonymy of speech.
>
> Lacan, *The Four Fundamental Concepts of Psycho-Analysis*

Along with al-Tahtawi, Khayr al-din, al-Shidyaq, and the pantheon of formative thinkers Hourani discusses in *Arab Thought in the Liberal Age*, Butrus al-Bustani's writing and life practice articulated the epistemological foundation that structured several subsequent discourses of social and political reform. Indeed, their work in general was the starting point of generations of cultural producers, activists, and thinkers throughout the Arab world who would follow. The subsequent generations would expand on the terms of reform. Many would further embrace French enlightenment ideals or scientific positivism. Some anchored modern humanist ideals in a new platform of Islam modernism, socialism, or free market capitalism. One does not have to look far or wait long to find a profound thinker whose fiction and nonfiction seem to embody many of these ideologies, whose oeuvre as a whole reflects the changes and struggles of his time.

The son of Butrus al-Bustani, Salim al-Bustani (1848–84) was a prolific thinker. He studied at his father's al-Madrasah al-wataniyah and was taught by legendary native literati and reformers such as Nasif al-Yaziji (1800–1871) and al-Shaykh Yusuf al-Asir (1815–90). He was the consummate Arab Renaissance man. At fourteen, Salim was the dragoman to the American consul in Beirut and, shortly afterwards, he taught English and French at the National School. During his short life he wrote eight romance and historical novels, experi-

mented with short stories, apparently wrote plays (which are now lost), and translated several French and English novels, mostly pulp and Gothic, that deserve attention. In addition to his literary output, he penned innumerable articles on the current affairs of the Ottoman Empire and Europe, new discoveries, and biographies.[1] In fact, at a young age, it seems that he became the principal editor of *al-Jinan* after the inaugural year.

As we have seen, *al-Jinan* set the model for the explosion of journals throughout the Arab world, featuring scientific, literary, historical, technical, and social topics. It was the prototype for journals such as *al-Muqtataf* (edited by Francis Nimr and Yaʿqub Sarruf), *al-Hilal* (Jurji Zaydan), and *al-Manar* (Muhammad ʿAbduh and Rashid Ridaʾ), all of which would enjoy a considerable readership throughout North Africa, Southwest Asia, and the Americas. Within its pages, intellectuals and readers from Iraq to Egypt would contribute articles, editorials, short stories, novels, histories, and ethnographies as well as questions to the editors. Butrus, Salim, and his brothers fielded these questions, discussed new scientific discoveries, and printed current events. The journal was published fortnightly, and at the end of the year it was bound and sold separately throughout the Arab world. Salim, the social and political commentator, however, took the leading role in the journal and opened every issue with an editorial, entitled "al-Islah" (Reform). This editorial touched on every imaginable aspect of social, cultural, political, and economic reform and current affairs throughout the Empire.[2]

Salim was a tireless litterateur and deep thinker who represented the quintessence of *al-nahdah al-ʿarabiyah*. He was influenced by the theories of culture and society that had been laid out by his predecessors. Like al-Tahtawi, the Tunisian reformer Khayr al-din, and his father, Salim had concluded early in his career that the reason for the social and cultural stagnation (*jumud*) in Egypt, Tunisia, and Syria, was that the Arabs had lost the will (*iradah*) and desire (*raghbah*) to acquire and master rational knowledge (*al-ʿulum wal-maʿarif*). These men all agreed on a formula for social, cultural, and political renewal. If they could reawaken the Arabs' passion for knowledge and build schools, printing presses, and libraries to foster its mastery, then Arabs would reproduce their "love of the nation" (*hubb al-watan*). This national love would create communal "unity and concord" (*ulfah wa ittihad*) and usher in a new era of national "progress and civilization" (*taqaddum wa tamaddun*). Furthermore, they concurred that the method by which reform would be achieved was by selectively borrowing intellectual, cultural, and technical innovations from the West,

while simultaneously resurrecting rationalist methodologies and democratic principles endemic to the Arabo-Islamic tradition. The paradigm was disseminated through the graduates of new state-sponsored and private schools, journals, salons, and societies such as the Syrian Scientific Society (al-Jam'iyah al-'ilmiyah al-suriyah) in Beirut and the Society of Knowledge for the Dissemination of Useful Books (Jam'iyat al-ma'arif li-nashr al-kutub al-nafi'ah). The former was a fully native-run offspring of the Syrian Society for Arts and Sciences (al-Jam'iyah al-suriyah lil-'ulum wal-funun) headed by Salim, and the latter seems like an early version of the book-of-the-month club founded by Muhammad 'Arif in 1868.[3]

As we have seen, a tension exists in this formula, a tension between the need to maintain cultural authenticity and the need (*hajah*) to assimilate Western positivist knowledge and social principles.[4] It is the argument of this study that the genesis of new narratives, genres, and styles in Arabic literature was a product of this tension. As the first Arabic romance, Salim al-Bustani's *Al-Huyam fi jinan al-Sham* (Love in a Damascene garden) presents a narrative that struggles with the very reform paradigm that he was simultaneously putting forward in his journal. The narrative's foibles and essence produce the native subject that is haunted by the very presence and absences that structure the author's father's work.

In 1870, at the age of twenty-two, Salim serialized *Al-Huyam fi jinan al-Sham* in his new scientific-political-literary journal, *al-Jinan*. This story could be described as the first attempt at a novel written in Arabic. While not his best novel in literary terms, *Al-Huyam* is noteworthy because it laid down many of the stock leitmotifs, character topoi, and narrative structure common to subsequent Arabic romance and historical novels. For example, Salim's contemporary, Nu'man al-Qasatli (1854–1920), lifted characters and plot structure right out of Salim's novels and short stories. Later, Jurji Zaydan (1861–1914) published twenty-four historical novels and romances in his immensely popular journal *al-Hilal*. While far more sophisticated and refined than Salim's literary opus, Zaydan's novels deploy similar motifs, character sketches, and techniques. For example, Zaydan provides almost invariably in every story a denouement that relies on concealment and disclosure of information, besieged valorous protagonists, or the reunion of a fractured family or lovers.

Salim's fiction, in general, was original in terms of plot, style, and language, but it also drew on many popular and classical literary tropes that are contrary to the style, structure, and spirit of the novel. Most of Salim's long fiction begins

with a preface (*tamhid*) and is peppered with classical poetic verse and the traditional rhymed prose (*saj'*) that is found in almost all Arab prose including al-maqamah, a genre that will be discussed in the following chapter. Many of his plots turn on happenstance or coincidence, reminiscent of high and low literature from *The Story of 'Antarah*, the maqamat genre, and al-Tanukhi's *Faraj b'ad al-shiddah* (Happiness after hardship) to *The Epic of Beni Hilal*, *A Thousand and One Nights*, or even *karakuz*, the popular shadow-puppet plays.[5] In fact, many scholars such as Sabry Hafez have faulted Salim's original fiction for lacking stylistic and generic coherency.[6] However, in *The Dialogic Imagination*, Mikhail Bakhtin has shown us that the novel itself as a genre was created partly out of the "raw material" of older, even outdated, genres. Fredric Jameson expands Bakhtin's theory in essence when he states that "the novel..., whose outer form, secreted like a shell or exoskeleton, continues to emit its ideological message long after the extinction of its host."[7] While translations had been under way for some time, I would argue for the originality of Salim's novels, as they are the trailblazers of their genre.[8] The "incoherencies" of his novels point less to the author's unfamiliarity with the complexities of the European genre and more to an understanding that his texts were an attempt to produce a new form of Arabic narrative. This said, as Foucault has shown us, it would be inaccurate to credit the author and his novels, particularly in the case of *Al-Huyam*, with a "spontaneity" of brilliance or transcendent insight. Rather, the "author-function" is a projection of the psyche of the author's culture, politic, and society, but one that cannot be seen as an indivisible unity or empirical fact.[9] Hence, the leitmotifs, language, characters, and plot in Salim's work are manifest in all of the political, cultural, and intellectual struggles of the Arab renaissance. Salim is important because his life and his life's praxis were specifically political, functioning not only as experimentation but also as intervention. His writing, even more than that of his father, was an intricate performance of reform ideals and values. This realization confirms Hayden White's contention that form is content and that narratology is expressly related to ideology.[10] With this in mind, this chapter marks the effects of the different narrative shifts in Salim's fiction, shifts which have profound consequences.

The Struggles of a Native Son

Al-Huyam fi jinan al-Sham narrates the story of a progressive and educated native son, Suleiman Khalil, who has returned from a long sojourn in Europe

and has decided to tour Greater Syria. The tour allows Suleiman to wax about the beauty of Lebanon and to assess the cultural and social state of rural and urban Syria in general. On his way, the hero is captivated by a Damascene girl, Wardah, and the remainder of the story is a search for union with her. During his tour, Suleiman befriends a group of French tourists in Damascus who commit themselves to visit the ruins of Palmyra, despite warnings about the treacherous road. The group is ambushed en route by an infamous Bedouin tribe, who demanded a ransom for their lives. Suleiman and his companions debate on whether to fight or pay the ransom. Junly, one of the two European women of the party, passionately refuses to succumb to extortion, saying "precious death is preferable to living under oppression and in slavery."[11] However, Monsieur Bellerose, the patriarch of the group, is reticent to engage the Bedouin in battle because he distrusts the group's Arab entourage. He states that

> Our guide and his men will leave us when things get dangerous because the manners of Eastern peoples [*shu'ub al-sharq*] are unpredictable and cowardly. They fear disasters, calamities, and hardship. This is because they have a natural disposition for apathy and laziness, and are used to oppression and slavery [*dhull wa 'ubudiyah*]. (254)

During this precolonial period, Salim al-Bustani was cognizant of the Western colonialist designs.[12] The subtext of Junly's comments reinforces Bellerose's view that the Arabs are cowardly, apathetic, passive, and unconcerned with freedom. Suleiman, too, is aware of Western prejudice. In the first pages of the story, his local guide, in concert with a disreputable innkeeper, tries to cheat him. Suleiman horsewhips the two to "teach them a lesson" before they swindle any European tourists. Mindful of the violence of his actions, Suleiman finds no other means to counter the conduct that would otherwise confirm the West's "prejudice that judges us as savage and barbarians" (28)

Bellerose's accusatory tenor sounds throughout the text and finds its full resonance in the relationship between the hero and Dr. Boeuf. Their discussions invariably debate the Arabs' competence to progress beyond their "backwardness." Wherever the physician presents a disparaging analysis of Arab society, Suleiman provides an explanation, apology, defense, or counterattack. For example, Dr. Boeuf belittles Eastern medicine as little more than shamanism. In reply, Suleiman turns the ethical tables on him by exposing the self-serving intent of European doctors. He impugns European physicians for coming to and

residing in the East for long periods of time. Then, at the sunset of their lives, they return to their own country after earning much wealth. Now I say that you are the opportunists in this case while we are being taken advantage of. May we ask God to grant success to those native sons who have begun to learn medicine, first and foremost, so as to relieve us from such arrogance, oppression, and opportunism.... As for me, I prefer to die by national treatment than to live by foreign medicine (123).

Suleiman's censure is not one of parochial or national chauvinism. It divulges the tension at the heart of the modernizing project. If progress and the adoption of modern knowledge entail the exploitation and humiliation of his compatriots, Suleiman believes that the Arabs can do without it.

Ironically, Suleiman then expresses a desire to study medicine. He asks Dr. Boeuf to accept him as an apprentice. This request is not unconditional; he says, "I am dependent on you to teach me but only for a price" (125). The relationship between Suleiman and Boeuf parallels that between the Arabs and Europeans. The relationship is certainly one of power, asymmetry, and tension. However, the political and economic realities of the empire as well as the plethora of reformers throughout the Arab world showed that the relationship was necessary. If the relationship was to be functional, it could not be one of unvarnished antagonism just as it must not be one of blind imitation. Therefore, the association takes the form of a begrudging apprenticeship. Like the veils we have seen in al-Bustani the senior's work, the teacher-student relationship is a veil. It is a veil that presumes a pedagogical necessity for Suleiman and one that is likened to a father-son relationship (126).

The protagonist insists on paying a fee, however, which undercuts Boeuf's authoritative position. That is, for Suleiman, the payment destroys the doctor's monopoly on specialized knowledge. Like the commodity in an exchange economy, the fee commodifies knowledge and severs it from its producer. The gesture is one of self-consciousness and allows the protagonist to possess specifically modern knowledge with no encumbering bonds of gratitude or debt. This struggle for proprietorship and mastery of knowledge is allegorical of the relationship between the East and the West. The rivalry is embodied by the affiliation between Boeuf and Suleiman, with each taking a proactive posture. For example, the protagonist carries on a crusade against the evils of smoking. The degree and passion to which Suleiman attacks the habit suggests a longtime concern for it as a social and medical issue. He rebukes the doctor for his chronic habit, especially because a man of medicine should know how harmful it is

(122–23). Smoking offers the protagonist an opportunity to confront Dr. Boeuf on an issue where the hero holds the social and scientific high ground.[13]

The trope of smoking cigarettes was an emblematic instance used by contemporaneous intellectuals to illustrate the dangers of uncritically importing Western ways. Salim was among the earliest reformers to attack smoking along with ʿAbd Allah al-Nadim, Muhammad ʿAbduh, Rashid Rida', and al-Manfaluti. In addition to an article against the addictive nature of smoking, perhaps the first of its kind in Arabic, the habit was a popular feature even in his short stories.[14] For example, in "Najib wa-Latifah," smoking cigarettes is one means by which we are informed that the Western and modern ways of the antiheroine Latifah are not real progress but only superficial and cosmetic.[15] The incident between Suleiman and Boeuf permits the hero to demonstrate the native's intellectual competency and his understanding of the spirit of the scientific age and its relation to daily praxis. Moreover, his comments represent his ability to act as a critical and autonomous Arab son who is involved in an unequal power relationship with Boeuf.

The mentorship thinly conceals the antagonism between the two. Suleiman finds himself defending his compatriots against an onslaught of Western indictments. For example, under the apprenticeship of the doctor, Suleiman accompanies him on a call, coincidentally to the house of the heroine, Wardah, who has been poked in the eye by a twig. After Suleiman suggests a shortcut to the patient's house, the doctor compliments him for appreciating the value of time. Boeuf goes on to say that the Arabs are ordinarily lethargic and inefficient. Suleiman concurs and explains that he learned to manage time during his sojourn in Europe. However, he attributes his countrymen's indolence to the warm climate of the Middle East and the efficiency of the West to its temperate climate (124). Al-Bustani's exemplary character recognizes European civility as the standard for normative and productive behavior. However, this admission does not preclude a defense for why Arabs may fall short of this standard.

This is the predicament of the enlightened native Suleiman, who finds himself between the captious remarks of his French friends and the unacceptable behavior of his fellow countrymen. An excellent example is when Suleiman and his traveling party of European tourists arrive in Palmyra and visit the village sheikh. In welcoming them, the sheikh rudely orders his wife to bring their guests water. In a manner reminiscent of Suleiman's censure of his guide and the innkeeper at the beginning of *Al-Huyam*, the hero reprimands the village chieftain for his poor treatment of his wife, saying, "He who is generous to his wife

is generous to himself" (222). He insists that the mistreatment of women is an acquired behavior, handed down from father to son. This abuse is a leading impediment to inculcating native children with character and refinement. However, on an optimistic note, Suleiman asserts that the attitudes towards women in Syria have improved: "I know many people of the East who are contemptuous of women but since I returned from the Europe (*al-bilad al-afranjiyah*) I have not heard of anything of this sort in Beirut, Damascus or any other Syrian city" (222).

The protagonist's statements reflect the centrality of women's rights on the social platform of reformers. In fact, while Qasim Amin (1863–1908) is credited as the intellectual founder of the Arab women's rights movement, several earlier intellectuals and *udaba'*, including Salim and his father, were writing on women's education and emancipation well before the publication of *Tahrir al-mar'ah* (Women's liberation).[16] Perhaps the earliest developed argument for women's education and emancipation was written in 1849 by Butrus al-Bustani in his article "Khitab fi t'alim al-nisa'" (Discourse on the education of women).[17] Soon after in Tunis, Ahmad Ibn Abi al-Diyaf (1802–74) wrote "Risalah fil-mar'ah" (Essay on woman) in 1856.[18] He was the secretary to the famed reform-oriented *wali* of Tunis, Ahmad Bey, and friend of Khayr al-din. Overlooked by the Lebanese- and Egyptian-centered academy, this text is the most comprehensive, progressive, and self-critical text on women's role in society written before Qasim Amin and certainly less pedantic. Among others, al-Tahtawi, al-Shidyaq, and Salim's contemporary Ishaq Adib held the topic as a spearhead point of their social commentaries. As was the case with Salim, the freedom of women, particularly to love and marry, maintained centrality in the fiction of Nu'man al-Qasatli, Ya'qub Sannu', al-Nadim, 'Aishah Taymuriyah, Ahmad Shawqi, and Labibah Hashim. While Salim never dedicated an article exclusively to women's rights, the topic maintained a strong presence in his reform editorials.[19] Despite its prominence as an issue of reform, the women's cause was not a radical crusade for civil liberties. Rather, it was a bourgeois phenomenon that perceived women's education and freedom as one of several necessities to the improvement of national society. This tenet held that an educated and happy mother produces educated and happy boys who will institute progress and girls who will become wholesome, refined wives and mothers.

In *Al-Huyam,* Suleiman's assertions of women's rights have a two-pronged discursive effect. He admits native shortcomings regarding the rights of women, and through his admonishment he actually enacts reform. Simulta-

neously, he affirms the progress of native urbanity, shoring up Arab culture and society against the accusations by his traveling companions that progress and culture are incompatible. This self-consciousness and social monitoring lies plainly on the surface of the text and in Suleiman's behavior. We witness his awareness of the Europeans' judgmental gaze when they beckon him back to their table. After he rejoins them, Junly asks about his discussion with the sheikh. He intentionally misrepresents their conversation:

> I did not want to tell Junly about anything that would demonstrate our backwardness in the realm of culture [*'ala ta'khkhurina fil-adab*]. For it is culture that is the most basic foundation of society and the source of this generation's enlightenment [*tahdhib al-jil*]. So I preferred to lie in response, saying to her, "We were talking about some of the causes of cultural refinement [*tahdhib*]." (222)

Despite his identification with "Western civilization" and cultural progress, Suleiman refuses to disclose the actual conversation to his European friends for fear of confirming their prejudices. The paradox of native reform revisits the reader. Caught between the need to cultivate a progressive mind-set (*'aql*) and the need, literally, to speak to contemporary shortcomings, the native's self-awareness treads lightly on his culture's vulnerability to Western judgment.

Suleiman's apologies are not awkward but a sign of his conviction and enlightenment. He is an exemplary subject who establishes his positive character through action, in contrast to the negative example of Dr. Boeuf. The physician, although educated, is weak-willed and an unabashed coward. Contrary to Monsieur Bellerose's reservations regarding the native retinue, Suleiman and his countrymen distinguish themselves in the battle with the Bedouin. In contrast, Dr. Boeuf presses the group to pay the ransom and avoid the conflict, and he attends to the wounded rather than taking part in the battle. The doctor's cowardice repels his love interest, Junly, and suggests that progress involves not only the mastery of scientific knowledge but also a code of behavior, in this case, one similar to the classical Arab *muruwwah*, or manly chivalry. The effect of the contrast between virtuous native and educated but cowardly European wrenches away from the West any hereditary propriety of rationalist, modern knowledge and reconfigures the criteria for what progress actually entails.

We should not be concerned whether or not Salim intentionally created Dr. Boeuf as a model of *'ilm* (knowledge) without *akhlaq* (character). Undoubtedly, the doctor functions as a caricature of the self-serving European who,

despite his advancement, is an example of the negative effects of modernity. The importance of an allegorical reading is its relational effect. The doctor's cowardice makes visible Suleiman's valor. Dr. Boeuf's willingness to sacrifice freedom and dignity for safety exactly contradicts and therefore accentuates Junly's credo that life is not worth living under oppression. Furthermore, Dr. Boeuf's actions resemble Bellerose's preconceptions of Arab obsequiousness and infidelity. Suleiman dispels and even reverses Western cultural stereotypes, making them ironic. The emphasis on intellect and virtue serves a poignant function. It bestows authority on the Eastern subject that permits the enlightened native to enter into an otherwise inequitable yet necessary pedagogical, and therefore power, relationship with the West.

From Desire to Love

The binary character portraiture of Salim's fiction, as well as much of the early fiction of modern Arabic literature, has been easy prey for contemporary scholars, who have stated that the author's characters and plots are contrived and one-dimensional.[20] However, the deployment of binary characters, facile as they may or may not be, reveals to the theoretical reader the identifications within the psyche of reformist discourse. Since these flat characters correspond to types, it is helpful to remember Lacan's perception that where there is typology there is desire. These desires are constituent of the subject.[21]

Specular desire serves as an impetus for much of *Al-Huyam*'s plot but also for a progress of the native subject. Suleiman's search for, and reunion with, Wardah commences with his spying. He watches her in a Damascene garden, where he is immediately enamored by her beauty and refinement. The Eve-like representation of Wardah, stressing her purity, is reinforced by the hero's subsequent dream of her. During his first meeting with her, acting as Dr. Boeuf's assistant, Suleiman is virtually dumbstruck. At her house in Damascus he manages only to whisper to her, "I wish it were my eye that was injured, not yours" (126). They exchange no other words until they are "reunited" in the Bedouin camp where they are coincidentally both held captive. Even there, direct conversation takes place in a dark tent, where visibility is muted (250). Most of their communication transpires when Wardah is disguised or otherwise unrecognizable. Another example is their conversation when Suleiman is sick and imprisoned and Wardah disguises herself as a boy to see him (722).

Curiously, Arabic literature of the nineteenth century has been faulted for the lack of genuine dialogue, particularly by M. M. Badawi.[22] *Al-Huyam* shows

that the effect of this silence has a crucial function in forming the identification between the desiring male and his love object. Lacan might explain this by saying that since Wardah is an object of desire, she must be silent. This is because desire is defined in relation to "the lack of being properly speaking," a lack that "is only ever represented as a reflection of the veil."[23] We realize that, in *Al-Huyam*, the dearth of dialogue between the hero and heroine has a poignant effect. The absence of direct speech on the part of Wardah and the prominence of Suleiman's specular desire illustrate her passivity. This passivity defines her character, social, and libidinal role and enhances her desirability as a love object.

Throughout the novel, Wardah is a recipient of sexual, even predatory, advances. In the Damascene park, she and her friends are approached by a man on the prowl. Later, captured by Bedouins, the heroine is desired and threatened by the son of the tribal chieftain, Amir Sa'id. After she has failed to escape with Suleiman, Amir Sa'id, who is by this time betrothed to her, threatens to kill her, whereupon she humbly replies, "I am yours to do what you wish" (444). Clearly, her virtue and courage are defined by her passive response.

Like Voltaire's Cunégonde in *Candide*, Wardah is desired, coveted, and passed between men, which, in fact, motors the plot itself. However, Cunégonde's sexual activity and the ability to continually regenerate her virginity, if not her life, implies her active, albeit dubious, production of her selfhood and social role as a woman. Wardah's virtue, however, is never implicated, despite suggestions that the pirates who abducted her after her escape from the Bedouin camp may have molested her. Suleiman himself, after boarding the pirate ship, fears that he "would find and see her in a state in which he would otherwise prefer not to see her" (509). The mild statement is risqué considering the Victorian ideal that is under construction. Even more haunting is that, on the ship, Wardah's sole activities are crying and wishing for death until Suleiman saves her.

The passivity is an essential attribute of female sexuality and emerges quite explicitly in *Al-Huyam*'s narrative. Suleiman himself provides the reader with the very criteria for masculinity and femininity, which imply masculine activity and feminine passivity. "The nature of women," he states, "is to be kind, delicate, gentle, mild-mannered, and obedient. This is as opposed to men whose duties call for them to be rough, callous, and strong. Most importantly, these qualities are necessary for the defense of their women, their children, and their nation" (121). This statement categorically places the male subject as defender of the nation and the female subject as the embodiment of it. The manly efficacy of

Suleiman and the passivity of Wardah must be highlighted if she is to be the hero's desired love object.

Wardah's passivity, her underdeveloped character, and her relationship with Suleiman stand in contradistinction to the European Mme Bellerose. Distinguishing herself from her companions, Mme Bellerose speaks Arabic and is versed in Arabic poetry. She is described as having "a strong intelligence and firm rationality. She knew the righteousness of knowledge and the duties it entails" (121). Her conversations with Suleiman are intellectual dialogues, which may be heated but never antagonistic like the debates between him and the doctor. Suleiman is enthralled by Mme Bellerose because she displays all the virtues of civilization and progress along with an understanding of Arab ways and history. This is demonstrated when Monsieur Bellerose accuses the Arabs of being cowardly and slavish. Mme Bellerose preempts what the reader may expect to be Suleiman's defense of the Arab character. Contradicting her husband's belief, she says that the Arabs possessed a sense of "national and religious fervor," which motivated them to throw off Mamluk tyranny (254). Recognizing that Suleiman is conscious of European ideologically charged stereotypes, Mme Bellerose's invocation of history and defense of the Arab character is significant. Her intervention relieves an antagonism between the defensive East and the accusatory West. Her actions endow her with a unique position in between Arab and European subjects or, more specifically, the compatriots of Suleiman and Bellerose.

The relationship between Suleiman and Mme Bellerose develops in Wardah's absence. While all the main characters meet at the Bedouin camp, the direct relationship between Wardah and the hero transpires only after the relationship between him and Bellerose has been firmly established. Then, soon after Suleiman and Wardah reunite in the Bedouin encampment, the Europeans are released from captivity and not heard from again. At this point, the protagonists' relationship takes on the compelling and passionate force necessary to justify the hero's indefatigable efforts in finding Wardah, from whom he is soon separated again. These circumstances lead us to conclude that the relationship between the hero and heroine is a *transposition* of Suleiman's relationship with Mme Bellerose. The realization leads us to a disturbing but revealing discovery. Suleiman's desire for Wardah is a transference of his original desire for the Western Bellerose.

The process of transference binds the narrative of *Al-Huyam*. Throughout the romance, Suleiman is infatuated with almost every woman he sees. This is

even the case when he encounters Wardah disguised as a servant. Just as the hero observes Wardah in the garden, he spies on Mme Bellerose and Junly in a forest as they camp. Not recognizing them, he thinks that they are prostitutes (218). This act of spying recurs in alternative forms. Repeatedly, the hero offers internal monologues admiring the beauty of the women he sees. However, on each occasion, after admiring them, Suleiman associates these love objects with Wardah, waxing about how they remind him of her (e.g., 319).

This act of looking, the male, specular gaze possessing the female body, is a fundamental mechanism for reifying the active-passive relationship. If we agree with Lacan that "it is only with activity/passivity that the sexual relation really comes into play," then Wardah, not Mme Bellerose, offers the perfect libidinal object-choice for Suleiman's displaced desire.[24] The very qualities that make the European heroine desirable are undermined by her activity and her reciprocal relationship with the native hero. This insight becomes more apparent when we read that Suleiman himself recognizes the overlapping of his desire for these two women. He poses them as two competing love objects, who must be distinguished qualitatively by the type of the hero's love. Suleiman states:

> I said to myself that this lady Bellerose has shed my blood. Yet, with love and dignity, I forgive her for this grave sin. While my love for her is different from my love for Wardah, it is based on sincerity. As for my love for Wardah, my tongue is inadequate to describe it and my mind is too limited to fathom its depth. If I were to try to characterize the two loves, I would certainly fall short of the task, explaining, after much effort, water with water. (152)

This passage demonstrates that Suleiman's desire encounters a problem with representation, potentially blurring his two distinct types of love. Despite this problem, Suleiman's choice of Wardah as his primary love interest is as unambiguous as his attraction to Bellerose.

Substituting an accessible love object for an inaccessible one is a common trope in later Arabic literature, particularly al-madrasah al-hadithah (the modern school). One example is the lauded *Zaynab* by Muhammad Husayn Haykal (1888–1956). Hamid's desire for the peasant heroine Zaynab is increased only when his primary love, ʿAzizah, marries elsewhere.[25] Likewise, Ibrahim Mazini's *Ibrahim al-Katib* (Ibrahim the scribner) is another example of the transference of desire. The protagonist Ibrahim desires his cousin, Shushu, who is replaced by two accessible and willing substitutes. Both of the lovers, Laylah and the

Syrian-Christian nurse Marie, metonymically fulfill, at least temporarily, his primary desire for his cousin.[26]

The correlation between Romantic and post-Romantic novels of the early twentieth century and Salim's romance novels is not arbitrary, as we will see later. For now, however, we recognize that the transference of Suleiman's desire is more complicated than the substitution of one love object for another. As in Najib Mahfuz's *Bidayah wa nihayah* (The beginning and the end), written some seventy years later, the conflict between one hero's love objects (Bahiyah and Ahmad Bey's daughter) is informed by sexual, ideological, and class desires.[27] In *Al-Huyam*, Wardah's qualities of refinement and virtue facilitate the transposition of Suleiman's love. Complicated by issues endemic to the colonial period, his desire is fulfilled by its displacement and migration from Mme Bellerose to Wardah. Yet Wardah is more than a stand-in for Bellerose and the Western success that she represents, just as Ahmad Bey's daughter is class success for Husaynan in *Bidayah*. As a passive native love object, Wardah fulfills the desire of Suleiman without compromising his masculine efficacy, cultural autonomy, and national identity.

If the relational quality between characters (e.g., Suleiman and Boeuf) illustrates the hero's exemplary nature, it also endows Wardah with the characteristics for being an ideal native love object. Consequently, Suleiman's transposed desire for Wardah is not possible without the example of Mme Bellerose, just as his success is not possible without the pernicious native failure of the hotel servant or the cowardice of Dr. Boeuf. His pronouncement of love for Wardah serves as a commitment to the principles of both European-informed progress and the preservation of native authenticity. That is, while the representation that Wardah embodies is circumscribed by the example of Mme Bellerose, the latter's activity and foreignness prohibits the fulfillment of Suleiman's desire. On the other hand, Wardah, cultured and passive, is uniquely a "native daughter."

The Allegory of Love

We have seen that Wardah mirrors Mme Bellerose's refinement and enlightenment. However, they are differentiated as separate choices: native and foreign. This choice is a political necessity. Suleiman articulates this when, upon each encounter with an attractive woman, he reminds us that Wardah is his ideal love. For him, there can be no choice other than the native one.[28] In sum,

Wardah satisfies the protagonist's desire because she represents a nexus between the nation and a Western-inspired progress.

Likening the heroine to the nation and classifying this relationship as a national allegory is a popular intuitive device. The interpretive strategy occurs frequently in the study of modern Arabic literature, especially the study of Egyptian national literature (*al-adab al-qawmi*). For example, in Haykal's novel, Zaynab functions as a metonym for authentic rural Egypt. Young Muhsin's love for his neighbor, Saniyah, in Tawfiq Hakim's ʿAwdat al-ruh (Return of the spirit) is another ready example of this phenomenon during the Egyptian national liberation period.[29] Indeed, Northrop Frye tells us that the ornate portraiture of the romance genre fosters the reader's association with the protagonists, compelling us to read the individual's story allegorically.[30] Elsewhere, Frye meticulously combs out a basic "archetype" of the romance story, finding its roots in myth and fable.[31] However, while these maintain the same structure, he reveals that the "difference between [the two] is a difference in authority and social function."[32] The folktale "takes root in the culture" and develops into "secular" literature distinct from the divine myth.[33] While he does not explicitly state it, Frye would certainly agree that the romance genre itself is found throughout the world in the modern period because its form serves as an essential vehicle for engaging, inscribing, and molding national and class desires and identifications that accompany modernity. However, this study will show that the clean "vertical" structure of romance—the clear delineation between heroes and villains, for example—cannot "avoid the ambiguities of ordinary life."[34] So if the romance is a universal genre, so too in the modern age is its indeterminacy.

In Latin American literature, Doris Sommer adopts a method that reads melodramatic and romance novels as national allegories. These novels have important similarities to the Arabic romance, particularly regarding shared "social ideals and concomitant strategies."[35] Sommer notes that the main characters of nineteenth-century Latin American romance novels usually originate from clashing social groups, classes, and ethnicities. The lovers' struggle for unification allegorically illustrates the necessity and inevitability of the nation and national unity.[36] Latin American "novels are grounded ostensibly in the 'natural' romance that legitimates the nation-family relationship through love."[37] In Europe and Latin America, she states, "love and productivity were coming together in the bourgeois household where, for the first time in the history of the family, love and marriage were supposed to coincide."[38] Conse-

quently, "we may understand the concept love of country as a metonymy, and the goal of productivity as implying reproductivity.... Conjugal romance's national project... is to produce legitimate citizens, literally to engender civilization."[39]

Sommer's assertions are relevant to Arabic romances as far-ranging as those by Syrian Nuʿman al-Qasatli in the nineteenth century or Egyptian Shihatah al-ʿUbayd in the twentieth century.[40] Her insights reinforce the understanding that the transference of Suleiman's desire for Wardah is necessary to national reform and that the female protagonist is metonymically a national love object. In *Al-Huyam fi jinan al-Sham,* we find the popular leitmotif of "love of the nation" (*hubb al-watan*), so prevalent in the works of innumerable *ruwwad al-nahdah,* along with the conjugal metaphor at the romance's end. Discussing the progress of the nation towards social reform, the narrator states, "The day that unity (*ittihad*) weds concord is the day that prejudice (*aghrad*) dies and the welfare of the nation is consummated."[41] As Sommer and Frye suggest, the conjugal metaphor regarding national reform is particularly pertinent in a romance novel. The struggles of the protagonists are the struggles of the nation; they are not only mutually referential but inextricable. The union of two enlightened natives, Wardah and Suleiman, who allegorically wade their way through their country's decay and fanaticism, establishes a meaningful future for the nation, presenting the possibility for the reproduction of progress.

Al-Huyam classically expresses this process. Wardah is likened to the nation and even given the authority of the nation itself. For example, the narrator, Salim, writes a letter asking if Suleiman will surrender his search for Wardah. The hero responds, "How can I forget her? She is like my kidney.... She is my soul and the only thing I have in this world. She is my heaven." He continues, "You are asking if I am returning to my nation. What is my nation, you wonder? Is it the buildings of Beirut and its trees or its heat and dust? Don't you know that my nation is where Wardah lives? And if she settles down at the end of the world, there is my nation" (572). In this passage, the representation of Wardah transcends the nation that she otherwise embodies. She becomes an immutable sign of the nation and at the same time surpasses it as ideal and idyll. His testimony shows that Wardah's ontological status raises the nation to a new metaphysical level.

We have seen that for the hero the representation of the geographic nation becomes almost indistinguishable from Wardah. The plot of the story itself revolves around the protagonists' wandering from Syrian city to Syrian city and

beyond. In other words, Suleiman's journey, before and after Wardah, is a national tour. This tour brings the hero to the Cedars of Lebanon where he finds Wardah's name carved into a cedar tree. This sign is her message to him. The narrator, Salim, who has met his friend at the cedars, tells us that Suleiman says, "No doubt that Wardah, my love and the bloodline of my life, wrote her name here with her own hand because I told her that if I had escaped from the Bedouin's captivity, I would go, in search of her, to all the famous places in Syria. So she wrote what she wrote knowing that I would pass by here" (510). Wardah's name is carved into the sign of the nation, the cedar, which is explicitly stated to be one of the "famous places in Syria."[42] The national symbol and the female protagonist's name are conflated. The gesture reveals that Wardah brings to her relationship with reform-minded Suleiman a national authenticity that Bellerose could never provide.

Wardah-as-nation constitutes the very identity, even the very ontology, of Suleiman. Just as he welcomes death without her (722), his initial separation from her sends the hero into a state of anomie, leading him into profound, even profane, philosophical and existential questioning.

> I wonder, who am I? Where am I among God's creatures, and what are the requisites of existence? Am I awake or dreaming? Who are these people who pass around me, going from here to there? How do they begin and how do they end? What is the path of their existence and what is the meaning of their death? ... Are they born only to die and disappear and why? Does the sun set on humankind and never again rise? ... Why is this person great and this one lowly? Why is this one rich and that one poor; that one strong and this one weak? Why is one tall and another short, and one brown-skinned (*asmar*) and another white? Why is this one Muslim and that one Christian? What is one's kinship and what is one's origin? What is existence as compared to non-being? And non-being versus being? What is this great secret that hides from us the understanding of these mysteries? (126–27)

The loss of Wardah is the loss of the idealized and transcendental nation, the loss of identity and ontology. The absence of subjective and ontological certitude, the absence of knowing, constitutes a death of the nation. Since the libidinal object of desire acts as a metonym for the nation, Suleiman's unification with Wardah is allegorical of the success of native reform. Therefore, subjective and ontological presence—public and personal success—comes to fruition when the hero is joined with his desired object.

The uncritical adoption of European culture and scientific knowledge would certainly be an unhappy eschaton of reform and imply that civilization meant a surrender of the Arabs' national-cultural identity. The union between Suleiman and Mme Bellerose (if she were available) would produce such an effect and would represent rejection of the national choice. In fact, Salim illustrates the disastrous consequences of such a union in his subsequent novel, *Asma'*, where Nabihah, the culturally superficial counterpart to the heroine Asma, marries a less than desirable European. Nabihah construes her Western love to be the epitome of civilization by merit of his nationality, despite the poverty of his mind, spirit, and means. But in the case of *Al-Huyam*, as we have seen, the transference of Suleiman's desire for Bellerose to Wardah offers the satisfactory resolution to the desire for the West, substituting a domestic, indeed national, choice for his primary foreign one. A choice invested with political necessity and libidinal identification, the unity of our hero and heroine promises a productive future.

Recognizing the political importance of the protagonists' union, *Al-Huyam*'s conclusion takes on a particular irony. After their escape from the pirate steamship, the Arcadia, and Suleiman's release from prison in Crete, the lovers write to the narrator. He informs us that the two were married in Naples where they currently reside. As Sommer suggests, this marriage is the consummation of progress and the unity of the nation. However, the fact that the marriage is consummated in Europe has an ironic, discursive effect. While their union alleviates the tension caused by Suleiman's desire for an object that is primarily configured on a Western ideal (Bellerose), their marriage and residence in Europe return the allegory to the authority of the West ameliorated by Wardah's intervention. That is, *Al-Huyam*'s narrative relates the importance of cultural authenticity in national reform, but the protagonists' marriage in Naples reasserts the primacy of an ideal European space where the exemplary Arab subjects have found refuge, solace, and closure.

Genre and Limitations of an Epistemology

Happy closure is found in most of Salim's novels, confirming Sommer's conclusions that the romantic and historical fiction of the day was keen to represent the fruition of both personal and national unity. Concomitant to the protagonist's desire for the heroine was that, in attaining his love object, the hero would also manifest the possibilities for the community and nation that we found explicitly in the work of al-Muʿallim Butrus. Yet perhaps the severe po-

litical developments of the 1870s, particularly the Ottoman constitutional crisis, the ascension of the authoritarian Sultan ʿAbd al-Hamid, and the dissolution of the new Ottoman parliament as well as the indebtedness of the empire including Tunisia and Egypt under European financial commissions, took their toll on Salim's utopian vision. It is more likely, I believe, that after experimenting and stretching the epistemological boundaries of his father's reform discourse, Salim was increasingly confronted by its limits. Reflecting the shifts in his fiction and nonfiction, it seems that he found it more difficult to redress the many internal contradictions and solipsisms that we uncovered in the first chapters of this study. To this point, we have seen how Salim's novels struggle with the paradigm of reform that he and his peers had been formulating, but the variations within his oeuvre also indicate how he experimented with the limits of the epistemology reified in his father's work.

Whatever the reason may be, by the end of the decade, Salim would write his most somber novel, *Salmah*.[43] Named after its embattled female heroine, *Salmah* is a landmark novel among the works of Salim al-Bustani and, I would argue, in the development of modern Arabic literature in general. It exhibits pertinent differences from its predecessors, marking not only a shift in the narrative techniques and intellectual growth of its author but also a reconfiguration of his ideal native and, in fact, the very metaphysics of modern Arab identity.

Salmah is distinguished by many new literary and discursive elements. The first, but not necessarily foremost, of these is that the protagonists are not bourgeois native sons and daughters but peasants. Structurally, the character portraits of these heroes are based on typological dichotomies, as in *Al-Huyam* and Salim's other romance and historical novels. The hero, Raghib, and heroine, Salmah, personify a moral virtue that is the basis of a just society and just governance, which is the predominant theme of the story. The example of moral conviction rather than sociocultural ideals is not new to Salim's work, as seen in the portrait of, say, the heroine of *Fatinah*.[44] But in the case of *Salmah*, the protagonists' virtue cannot be separated from their social position as peasants, especially as peasants oppressed by a corrupt and arbitrary government.

Salmah's story is set in a generic village overseen by an abusive Ottoman-appointed ma'mur, or commissar. The ma'mur covets Salmah, who is renowned for her beauty. He pursues her and persecutes her parents in hopes of coercing her to "marry" him. He eventually forces her to agree to marry him through the aid of Salah, an intelligent and successful merchant whose desire

for Salmah is outweighed only by his desire for power. Before they can be married, Salmah is kidnapped by bandits and held prisoner in their village; here she befriends Fahimah. As in *Al-Huyam,* the protagonist Raghib manages to be captured by these same thieves. After he is reunited with Salmah, he escapes by playing on the superstition of his guard, pretending to have been possessed by magic. Fulfilling his promise to Salmah, he returns to save her and Fahimah, only to be immediately reimprisoned by the commissar, along with the women. Raghib dies of starvation and dropsy and Salmah dies immediately afterwards of a broken heart.

That peasants are the protagonists of *Salmah* is not coincidental but an effective strategy to illustrate a story about a native village and its inhabitants subjected to the unjust rule of local governmental officials. While the besieged Salmah and Raghib demonstrate many of the same virtues as Salim's other protagonists, they represent a new type of hero for him. Salmah is uneducated but virtuous and strong-willed. While never explicitly described as a peasant, Raghib clearly seems to be from the peasant community. The fact that, unlike Salmah, no reference is ever made to his house, work, or social network (i.e., to his immediate family) adds to a sense of his dispossession. Regardless of his class, Raghib eloquently invokes his civil rights as a citizen of the empire. Likewise, while imprisoned, he demands that human rights be afforded to all prisoners. This new type of hero signals a shift from the conceptualization of subjectivity along a rationalist, knowledge-centered paradigm to a new metaphysical paradigm, both humanist and, perhaps, romantic.

If the introduction of the heroic peasant signals a shift in epistemology from a rationalist to metaphysical basis of subjectivity, then it coincides with what might be seen as Salim's increasing sympathy for socialist principles. Indeed, throughout his life and fiction, he maintained a sustained attack on consumerism and ostentation. For example, in the short story "Zifaf Farid" (Farid's wedding), Farid is ruined by his and his fiancée's excessive spending in preparation for a lavish wedding.[45] Also, in *Asma',* the protagonist's female counterparts, Nabihah, Jamilah, and Badi'ah, are all bedazzled by the material trappings of modernity.

An examination of Salim's last novel, *Samiyah,* may disclose the depth of this epistemological shift.[46] On an immediate level, *Samiyah* continues along the path laid out by *Salmah;* yet it contains the more radical elements and possibilities of this new metaphysic through not only the tragic end of the protagonists but also the depiction of the ambiguous villain, Fa'iz. Fa'iz is a political revo-

lutionary who is both righteous and an opportunist. He competes with poor hero Fu'ad for the hand of Samiyah and instigates the murder of his rival. Fa'iz's understanding of nature resonates with romanticism's antagonism between physis and nomos. He sees nature as the original and pure state of humankind, the source of material and social equality and fundamentally opposed to human convention and culture. However, despite his noble beliefs, he is not only scheming and cowardly but also an atheist—indeed a shock to the contemporaneous reader. Therefore, what is particularly interesting about *Samiyah* in respect to *Salmah* is that its potentially burgeoning romantic discourse is partly discredited by Fa'iz's unseemly and reprehensible behavior. However, while his character is explicitly incongruent with the principles and virtues of Salim's peculiar combination of progress and morality, the hero Fu'ad is not. Impoverished and helpless but morally righteous, Fu'ad certainly recalls the character of Raghib. The difficulty in determining whether this romanticism is anything other than cosmetic is embodied by the very ambiguity of Fa'iz the villain vis-à-vis Raghib and Samiyah. Moreover, the continued visibility and predominance of the positivist semantic nomenclature of reform in Salim's fiction and nonfiction contradicts much of the subjective ideals that are presented in *Salmah*. What is certain, however, is that the appearance of the peasant as hero indicates a change in the ideal envisioned by Salim.

The emergence of the peasantry in popular fiction corresponds to a new understanding of popular identity in national ideology that was under way throughout the Arab world at the turn of the last century. The works of Nathan Brown, Zachary Lockman, Margot Badran, Beth Baron, and even Timothy Mitchell and Butrus Hallaq in different ways allude to a shift in the representation of the peasantry and urban poor in the formation of Arab national identities, particularly Egyptian identity.[47] Their works reveal how the representation of the peasantry changes from figures antithetical to progressive national identity to figures that in fact embody national identity, particularly in Egypt, during the struggle against British colonialism.

Nathan Brown draws attention to the fact that both colonialist and native reform views, at least pre-1906, concurred on the "ignorance" of the peasantry. Brown implies that the peasantry's intransigence towards reform was an act of resistance to reformist political and social goals, which they regarded with suspicion.[48] He also notes that the call of pro-independence Egyptian reformer for the enlightenment of the peasantry, ironically, legitimated the colonial mandate. His theory agrees with the proposition of this study as he reveals how

many Egyptian reformers surmised that the colonized nation was unable to govern itself without colonial education.

Zachary Lockman offers another illuminating inquiry into the configuration of the peasant and working poor in early Egyptian nationalist ideology.[49] In reading Muhammad 'Umar's *Hadir al-misriyin aw sirr ta'akhkhirihim* (The civilization of the Egyptians or the secret of their backwardness),[50] Lockman notes how 'Umar decries the excess of the rich and the indigence of the poor while praising the moderation and ingenuity of the Egyptian middle class. This class, in 'Umar's view, is the backbone of social order. Lockman concludes that while 'Umar is undoubtedly more callous than the average reformer, he "is operating more or less from the same discursive field as such contemporaries as Fathi Ahmad Zaghlul, Yusuf Nahhas, Qasim Amin, and Ahmad Lufti al-Sayyid."[51] Indeed, 'Umar's tenor is only the progeny of the fruits and paradoxes of social thinkers like al-Tahtawi and the senior al-Bustani.

Although the new bourgeoisie would remain narrative hero for some time, the valorization of the peasant as protagonist would grow over the next several decades. During the last decades of the nineteenth century, random short stories appeared in the literary-scientific journals where the urban poor or peasantry were cast irregularly as protagonists. Also, reviews of novels appeared, such as *Riwayat Fu'ad* (The story of Fuad) by the Lebanese Nuqula Bustris about "the love of a boy for a girl, poor of means but pure of morals and generous of character" and their difficulty in marrying because of the greed of the hero's uncle and aunt in Cairo.[52] By the first decade of the twentieth century, Egypt, in fact, presents us with the best example of the shift that took place in Salim's work some years earlier. As the independence movement gained momentum, Egyptian reformers found it increasingly untenable to maintain a view of their own citizenry that could justify colonial domination. Therefore, their discursive sameness had to give way to a romanticism and idealization of the peasantry, posing them as a privileged national symbol in nationalist enunciations.

Lockman locates this change in the conception of the peasantry in Muhammad Tahir Haqqi's *'Adhra' Dinshaway* (The virgin of Dinshaway).[53] The plot is based on the true events that occurred in the peasant village of Dinshaway, where British soldiers inadvertently shot and killed some villagers and set a farm ablaze, while poaching a peasant's pigeons. Running from the angry villagers, one officer dies from thirst and sunstroke. An inordinate number of villagers are tried in a military court and executed within a few days of the event,

including the father and the fiancé of the heroine, Sitt al-Dar or Lady of the House. While most of the characters are one-dimensional, the figure of the Egyptian prosecuting attorney is stylistically noteworthy. The narration shifts from an anonymous narrator to the attorney's first-person voice. In a chapter dedicated exclusively to his inner dialogue, he explains how he is torn between his professional ambition and his loyalty to the peasantry from which he originates. The tension in the prosecutor's monologue as well as his closing comments confirms that this text is a nationalist cry. Parallel to the characters of Fa'iz and Salah in al-Bustani's fiction, the prosecutor's personal testimony opens the personal dimension of "collusion with the enemy," disclosing the seduction of power and the colonial project. The peasants in *'Adhra' Dinshaway* remind us of the relationships between the protagonists and the commissar in *Salmah* because they are representative of the subjugated Egyptian nation, which is subject to the arbitrary justice of British rule.

The humanistic principles to which Haqqi's story appealed links Salim's proto-romantic heroes to the notion of civilization and progress. Salmah's protagonists offer a national subject that finds authority in the transcendence of material progress, economic production, urbanity, and even the cultural infrastructure that are the pillars of the Renaissance. But while the movement towards popular, particularly, peasant imagery highlights a shift in representing an idealized national subject, this idealized representation was still expressed in the standard language and nomenclature of reform. Like the figure of the hero Fu'ad in *Samiyah*, the characters and plots of Salmah and Dinshaway allude to enlightenment principles championed in innumerable writings of North African and Levantine intellectuals of the day. Raghib's invocation of his civil rights in prison simultaneously maintains a correlation with social and political objectives of reform. The romantic subject distinguishes himself from the previously seen reform subject by finding his ontology in a criterion exterior to civilization understood as urbanity. Consequently, the presence of Salim's proto-romantic national subject is rooted not in his knowledge of modernity but in the metaphysics of its essence.

The Romanticism of Death

Another radical departure separates *Salmah* and *Samiyah* from their predecessors and distinguishes them as forerunners of romanticism, and this is their use of death. The denouement of the conflict in *Salmah* is not a perfunctory and

happy reunion of hero and heroine but a melodramatic ending, culminating with their deaths at the hands of the unrelenting villain. In *Samiyah*, the peasant hero is murdered.

In his all too brief article, "Love and the Birth of Modern Arabic Literature," Butros Hallaq correctly states that the trope of love in the works of Jubran Khalil Jubran (Kahlil Gibran) and al-Manfaluti characterizes an epistemological shift towards romanticism. Relying on Lacoue-Labarthe's work, which explicitly ties aesthetics to the philosophy of the Self and being, Hallaq suggests that the trope of love assumes a new ontological significance in Jubran's short stories found in *Al-Arwah al-mutamarridah* (Rebellious spirits) as well in the seminal novel *Al-Ajnihah al-mutakassirah* (Broken wings).[54] Love, he says, stands in opposition to tradition, particularly institutionally sanctioned marriage, which Jubran's romanticism poses as emotionally suffocating and socially coercive, especially to women. Jubran's renowned anticlerical stance as seen, for example, in his elegant and allegorical short story "Yuhanna al-majnun" (Jonathan the crazy man) and also in *Al-Arwah* is an example of how romantic sentimentalized notions of love and freedom are opposed to institutionalized morality. Likewise, in *Al-Ajnihah al-mutakassirah*, the tragedy of unconsummated love, a result of the death of the heroine, is the effect of such sentimentality but also an effect that legitimizes the protagonist's commitment to her.[55]

Tradition, or what Hallaq calls a state of "non-love," stands in opposition to libidinal and sensual desires, which draw their legitimacy from nature, as seen in elegant pastorals of Jubran's work and Muhammad Husayn Haykal's *Zaynab*. Hallaq asserts that such an opposition is constituted ontologically by death. Certainly, Roland Barthes maintains that death is an integral and structural element of the novel itself, which might be one explanation of its appearance in Salim's better novels, *Salmah* and *Samiyah*.[56]

Furthermore, the element of allegory in such works is also stylistically and structurally relevant. Ironically, if Jubran is a writer of allegory, Hallaq remarks, following the work of poet-scholar Khalil Hawi, the "lexical, symbolic, and stylistic registers" that permeate his texts testify to their biblical origin.[57] More than discrediting or rejecting the material world, this biblical register legitimates not the church but the primacy of the metaphysical world in which true love, conjugal unity, and transcendence find their authority. Kant might say that the power of the romantic subject is in the ontological criteria and authority, which is not in the noumenal (knowledge, history, etc.) but in the phenomenal (love, morality, virtue, suffering). Therefore, death and the metaphysical world

are directly related to allegory and the aesthetics of romanticism, which, in its full form, displaces the paradigm of rationality as a constituting factor of subjectivity.

Hallaq also sees in the fiction of al-Manfaluti, inferior though it may be to the Arabic works of Jubran, a similar movement away from the rational reform to a romantic paradigm. I would add that the qualitative inferiority of al-Manfaluti's fiction arises from a reaction against the very positivist discourse of reform itself. His short stories discuss the superficialities of European-inspired progress and the immorality of women's emancipation, while also articulating notions of justice and equality.[58] I would contend that this contradiction is a consequence of reform discourse. That is, by al-Manfaluti's day, reform discourse still relied on a criterion for progress, which associated Europe with positivist and scientific knowledge and the Arabs with backwardness.

Since the reform-rationalist paradigms had failed to ameliorate the antagonism between what was construed as European material and political success and Arab disunity and failure, there was an ideological shift to a modernist romanticism. If tradition had signified backwardness and stagnation in discourse of reform, then romanticism recalibrated it into an ideal that drew its justification and strength from the pretences of a transcendental moral authority, spiritual purity, and cultural authenticity. This sense of tradition and authenticity is created by the political need for it. In his landmark *La crise des intellectuels arabes,* Laroui defined tradition as contingent to "traditionalism" and independent of modernity. As opposed to an a priori term of social analysis, tradition emerges only in moments of confrontation, or as the author states, "Tradition is born in opposition to something: to ideas accompanying foreign merchandise, or to universally proclaimed liberalism."[59] He rejects tradition's negative definition, positioned as the antithesis of progressive change. Rather, tradition is deployed ideologically by traditionalism to offset development threatening to native elites. This critique not only endows plasticity to tradition but reveals it as a social construct of power, power relations, and politics.

Al-Manfaluti, a progenitor of Arab romanticism, appeals to a plane of metaphysical sentimentality. As reformers anchored the power of their discourse in the very historical and empirical nature of their argument, al-Manfaluti and those who might be called Muslim romantics invoke immateriality of spirituality and emotionality in order to ground native subjectivity. Their visions were not antithetical to positivism, and in fact they shared a strong Victorian and moralistic dogma. With this in mind, we understand why the romantic strain

finds its lineage in the positivist tradition of "Islamic modernism," which will be discussed briefly in chapter 5. Consequently, in terms of a larger ideological heritage, we can understand how romantic discourse, with its claim both to social order and to native authenticity and morality, would maintain force over the following decades and convert even committed positivists like the Comtean Haykal.[60]

While death is explicitly mentioned in *Al-Huyam* as the only viable option in a life of slavishness and oppression, the performance of cultural success, which testifies to the power of modern knowledge, abates such a necessity. *Salmah*'s melodramatic and tragic conclusion, however, is necessary. Only in death do the persecuted heroes transcend the tyranny of the villain and thereby, as is the case in martyrology, establish through suffering and sacrifice—through performance itself—the legitimacy of the virtue for which the heroes died.

But this is not exclusively a personal commentary on virtue and tragedy. Death points to something even more profound; it is a subjective and national statement. The recognition of native failure and the need to adopt Western knowledge as the sole method for cultural and social rejuvenation place the native in a precarious position within the Hegelian Master-Slave struggle. We have seen that *Al-Huyam* as well as *Khutbah* and *Nafir* present the sustained struggle of the native to become effectual on this knowledge progress–oriented epistemological terrain. The introduction of death as a significant trope for closure indicates a breakdown or at least a crack in this paradigm, which remains fundamental even to contemporary secular Arab intellectual and political thought. It alludes to a new field of contestation, to the metaphysical plane of selfhood. In turn, the appearance of death in narrative is the beginning of the construction of a transcendental authenticity of Arab selfhood that finds its authority in the representational realms of spirituality, morality, and sentimentality. Romantic selfhood would locate its justification in its Otherness to the positivist reform discourses.

If we accept the definition that poses romanticism in opposition, at least discursively, to the reform project, it would be a mistake to classify *Salmah* as genuinely and generically romantic. A story of the innocent peasantry oppressed at the hands of tyrannical and arbitrary rulers, *Salmah* clearly articulates the values of the reform movement, especially as it changed during the reign of Sultan ʿAbd al-Hamid, who suspended the Ottoman parliament. While the extent to which ʿAbd al-Hamid was or was not a tyrant is debated, increased

centralization, censorship, secret police activity, and the concerted effort to recentralize power are indisputable. Therefore, *Salmah* can be seen not only as what Jameson has so infamously termed a national allegory but also as a political allegory. The emergence of romantic characteristics in *Salmah*, however, allows a stretching of the parameters and a widening of the possibilities for the reform discourse without discrediting, unlike true romanticism, the criteria that structured it.

In other words, Raghib, while poor and apparently uneducated, is articulate, weary of superstition, and aware of his rights. His character demonstrates a nexus of romantic imagery (the impoverished yet noble hero) and reform criteria for social success (knowledge of humanistic principles). Or as the texts describe it, Raghib's ambition is simple. He wants to achieve for himself and his love a state of comfort or *rahah*, which is constituted by freedom and maintained through the preservation of certain inalienable rights.[61] This goal, however, is attainable only through suffering.[62] Understanding this combination of both reform and romantic motifs, we perceive Raghib allegorically as a prefigurement of the Arab masses themselves. His struggle is the struggle of the nation, the struggle against oppression and self-interest, and a struggle to reach unity.

Just as this nexus between reform and romanticism is expressed through the allegorical figures of Raghib and Salmah, so it is expressed in the case of the villain whose allegorical function is made specific by Salim. Salah, like the ma'mur, desires Salmah. By actively aiding and counseling the ma'mur, he demonstrates his willingness to sacrifice his love to advance his position. His most distinguishing feature is that he is educated, intelligent, and shrewd. He is even attractive enough to tempt Salmah.[63] Despite his qualities, Salah specifically turns away from his duty to his country, rejects the innocence of his love, and pursues his greed and self-interest. That is, although he is educated and financially successful, he fails to use his education for collective interests, as al-Muʿallim Butrus adjured his compatriots in *Nafir*. On the romantic level, his wealth corrupts him, encouraging his love of power and blinding him to popular welfare. In other words, if Raghib and Suleiman enact national virtue, Salah, clearly cognizant of his evil, performs the consequences of the unwillingness to forego personal interests. This is the exact antithesis of the reform thesis found in both his father's writing and his own.[64] In this respect, *Salmah* is a political text not only because it inadvertently criticizes the abuses of the Ottoman government but also because its criticism is of the political praxis of the educated

and wealthy—the same class that al-Muʿallim Butrus rebukes for inaction, the class that stands in opposition to the innocent peasantry.

Conclusion

This study does not seek to determine whether or not *Salmah* is a romantic novel. Nor do I delve into how romanticism might or might not compete or intertwine with positivism per se. While a fascinating study for later research, this inquiry cannot pursue how literary, artistic, and philosophical romanticism generates several antipositivist and even antihumanist schools of nationalism and Islamism, both reactionary and progressive, throughout the Middle East by the 1920s.

Despite his innovations, I am not stating that Salim was the progenitor of the romanticism or even that his novels had a wide and profound effect on the literature that followed it. Certainly, much critical and comprehensive work remains to be undertaken regarding the fiction and nonfiction of the Bustani family in general. The aim of this chapter is to understand how the structure and structural idiosyncrasies of Salim's fiction are an effect of Arabo-Ottoman reform discourse. The early appearance of generic romantic motifs in his fiction tells us that the reform project was no longer in the process of being institutionalized but, in fact, was already the dominant epistemology in the Ottoman Arab provinces by the 1870s. Salim's early literary endeavors, like much of the ideological and cultural experimentation for the next fifty years, is the effect of this entrenched epistemology and an engagement with the discourses of identity that this epistemology organizes. I hope to make apparent the complexities of the interrelationship between selfhood, genre, epistemology, and the West in the colonial context as well as the intricate web of form, content, ideology, and power. The writing of new forms of literature, like the production of any new form of culture in the colonial period, is an interplay of desire, subjectivity, and ontology that forces us to think of cultural production not in terms of mimicking the West but as a part of larger theoretical processes.

If we are to agree with Georg Lukács in understanding the rise of humanist literature in Europe as a protest against imperial regimes, we may perceive Salim al-Bustani's *Al-Huyam fi jinan al-Sham* and *Salmah,* as well as most of his other romances and historical novels, as a protest not against a regime but against a condition. Certainly, the appearance of the Arabic romance and its generic cousin, the historical novel, corresponds to a changing consciousness and the

ascent of a new type of indigenous bourgeoisie. The rise of a new sort of intelligentsia—many of whom, as owners of presses and journals, were entrepreneurs—spoke specifically from this subject position. Their articles and books show us that the struggles of the new Arab bourgeoisie were more complicated than for their counterparts in Europe because they were compounded by imperialism. Critical of their own social and cultural states, organic Arab intellectuals strove to integrate nonindigenous (particularly Western), cultural, social, and political practices to redress what they diagnosed as the causes of Arab stagnation. Conscious of Europe's colonial and economic designs and the ideological apparatus used to justify these aspirations, Arab reformers, as nationalists and modernizers, recognized the politically loaded nature of their project. Therefore, we will further see that nineteenth-century Arab thinkers, regardless of confession or local origin, contemplated how to import "Western" knowledge in order to modernize but also reawaken or maintain an authentic native civilization (*tamaddun*).

This struggle is built into the innovative fiction and nonfiction of Salim. His opus encapsulates what he called the new "spirit of the age" (*ruh al-'asr*).[65] This was the spirit to strive for the unity of a popular society based on progressive, humanistic principles. Salim was, indeed, was one of the first Arab thinkers to talk of *al-sh'ab* (the people), and the enlightenment vocabulary of equality, justice, and reason (*musawat, 'adl, t'aqqul*) distinguishes his ideological convictions from those of his more conservative father.[66] The concepts underwrote his fiction where Salim strove for an original but resonate sense of Levantine identity that could circumvent the paradoxes of this new age and ameliorate the tensions within the practicalities and discourse of reform. That is, *Al-Huyam, Salmah,* or any of his romances should be seen not as qualitatively poor or exclusively didactic, but rather, as Lukács suggests, as a pivotal site of cultural and political contestation at a moment in Arab history where modernity was well on the way to being naturalized, where identity and nationalism were finding a language, and libido and economy were finding a secular representation.

As we have seen in *Al-Huyam,* Suleiman's plight is twofold and part of the modern colonial condition. The hero wrestles with Arab cultural "decay" and the preeminence of the West. His actions demonstrate the efficacy of the native subject, who enacts reform through his performance. This performance is multirelational to the conduct of his native and foreign counterparts, com-

plimenting the philanthropy of some and the misanthropy of others. Yet Suleiman is torn between the love of his nation (*watan*), Syria, and his desire for the Western ideals of progress and modernity, represented by Mme Bellerose. The second half of the narrative resolves this tension. With Wardah's intervention, Suleiman is able to cathect a national love object who personifies the Western-inspired reform principles that he cherishes but who also embodies native cultural authenticity. Undoubtedly, this cultural-political-libidinal dilemma is found in later Arabic novels from Yahya Haqqi's *Qindil Umm Hashim*, to Mahmud Taymur's *Al-Nida' al-majhul*, to Tayyib Salih's most brilliant *Mawsim al-hijrah ila al-shamal*.[67] Likewise, we have seen how *Salmah* works toward a new form of, and new equation for, authenticity and reform virtues. By illustrating a popular hero and heroine as subjects of abject and arbitrary power, the author offers an alternative narrative to the positivist paradigm by sidelining several narrative techniques such as writing in stock European characters; centering the story on an exemplary bourgeoisie hero; and not relying on a closed happy ending.

Al-Huyam warrants investigation not because it was the first Arabic romance or because it has been forgotten in the study of Arabic literature. Rather, like *Salmah* and his other novels, it shows how Arabic literature was a fundamental space in which to contest imperialist intrusions. In doing so, it configured new possibilities for an Arab subjective ideal that could be both progressive and authentic. It was a guidebook but also an example of reform praxis. Yet the struggle and resolution within *Al-Huyam* reaches beyond formulating a satisfactory national choice in lieu of desire for the European Self-same. A close reading of *Al-Huyam* divulges that the narrative is enframed, as Derrida might say, by the binary metaphysics of ontological presence and absence. On the other hand, *Salmah* and *Samiyah* try to escape such metaphysics. While the union of Wardah and Suleiman presents the promise of native progress, Wardah functions as a supplement for Suleiman's primary desire for the West and a supplement for what the natives lack. The ironic ending revisits Western success despite Suleiman's exemplary performance and the consummation with Wardah. Not surprisingly, despite the absence of Westerners from his last two novels, Salim recognized that this struggle with European presence and native failure would continue for some time. In one of his final editorials before his premature death, Salim criticized his urban compatriots for confusing materialism with true progress:

> Nothing is uglier than the establishment of progress without any real basis. We are not surprised that the introduction of superficial foreign civilization (*al-tamaddun al-khariji*) spreads throughout the East before true civilization (*al-hadarah*) overtakes the mountains, plains, and the interior. This is because the superficial spreads very quickly, as if it is riding on the waves of the sea or wings of lighting. It plants itself firmly in foolish and weak-minded people, who have no patience to understand serious matters or facilitate true progress. Easterners have overemphasized this superficial sort of "progress," which has allowed the people of the West to belittle us. Westerners treat unjustly even those who have earned the right to be revered and honored. The masses (*al-'ammah*) quickly turn to harmful foreign ways. The blood of this kind of civilization is corrupt in us, and it is most difficult to reform it if the contamination matures.[68]

Within this passage, we encounter the spirit of the writing of Salim's father. Yet the son is different from the father. He championed liberal concepts that were controversial in the Hamidian era. Moreover, he understood consciousness as metaphysics that must stretch beyond a positivist principle if the Arabs are to confront Western hegemony. But how, the question remains, to achieve "true civilization" that marks the Arabs' place in universal history but also maintains their sense of identity and difference from the West?

4

The Hybridity of Reform

Arab literature underwent a radical change in the nineteenth century. In a movement away from the traditional understanding of literature as synonymous with the belles lettres, a burgeoning native intelligentsia, who created as much as targeted a new and diverse Arab readership, popularized *adab* as a social practice. The fiction of Salim al-Bustani, a leader of this bourgeoisie, reflects this shift. On a material level, this critical change in writing practices coincided with radical transformations in the economy of Arab lands. The innovations within Salim's own oeuvre reflect the relationship between subjective consciousness and political and social realities. The Ottoman Tanzimat loomed large in the fiction and nonfiction of Salim and his peers. Likewise, Sultan ʿAbd al-Hamid's political strategies, his annulment of the first Ottoman constitution and the parliament, and the repression of newly gained civil liberties emerged in virtually every form of fiction and nonfiction of the day. A crippling debt, Balkan independence struggles, European incursions into North Africa, and the West's increasing political and economic presence in Egypt and the Levant had chipped away at the unity and continuity of the Ottoman Empire and dominated public writing in Arabic as in Turkish and Armenian. The examples of the Bustanis relay to us that the shift in writing practices at the beginning of the modern era corresponds to radically different ways in which Arabs, both popular and elite, viewed themselves vis-à-vis their own history, culture, and the West.[1] The significance of this social and political transformation, however, reaches beyond the composition and dynamics of civil society to a metaphysical level, a level of subjectivity. That literature illustrates this is not coincidental.

A new aesthetic was being created along with a new consciousness and a new ontology of national and personal identity. This aesthetic expressed itself

readily in fiction. The novels of Salim demonstrate how a new genre of fiction both embodies the modern reform project for native intellectuals and acts as a critical space in which to confront the ironies, tensions, and challenges that this very project presents. Moreover, the rise of the didactic romance, not unlike the appearance of the historical novel, as we will see in a later chapter, is indicative of the developing nexus and differentiation between the public and the private and between the political, the social, and the cultural.

As the genre of currency of the time, the stock assessment of the romance is that Arabic writers had not developed a sophisticated aesthetic compatible with the novel. In this view, romance is perceived as a degenerate and vulgar form. The argument is that native literati could not distinguish between pedagogy and narrative art.[2] This chapter demonstrates that this view is incorrect. The cultural productions of the age, from fiction to poetry to painting to photography, cannot be separated from the issues that were framed one way or another by Salim and his father's generations. Desires for progress, contentious identifications with the West, the Hegelian and Comtean criteria for historical and subjective universality, and the problematics of knowledge and rationality—all are repeated in modern Arab cultural production, particularly modern prose.

A handful of researchers have demonstrated the centrality of Arabic fiction in the nineteenth century as a critical space for aesthetic and linguistic experimentation. Sasson Somekh's *Genre and Language in Modern Arabic Literature* reveals how Arabic was transformed, both stylistically and syntactically. He discusses the development of new forms of standard Arabic, which rejected or assimilated the particularities of colloquial dialects, depending on author, period, and region. Moreover, he shows how this experimentation produced new local and national literary genres such as the novel and drama.[3] Jaroslav Stetkevych also offers a study of the lexicographical and stylistic shifts that transpired in the nineteenth century, especially in relation to the classical canon.[4] These studies confirm that Muhammad Husayn Haykal's project of codifying a transparent language (*lughah shaffafah*) for literature and nonfiction actually is a continuation of precedents forged in the nineteenth century.[5] Such a realization is hardly revolutionary and was continually recognized by literati and activists of the twentieth century. Salamah Musa, for example, tells us of the "telegraphic style (*al-uslub al-tilighrafi*) of Yaʿqub Sarruf who did not like embellishment (*tazwiq*) and ... had general distaste for prolix, highfalutin words, and glittery expressions."[6] Writing should be free of verbosity and verbiage, Musa and his peers asserted, so that reality is communicated. The linguis-

tic changes under way during the nineteenth century were so conspicuous that Ibrahim al-Yaziji, son of the famed Sheikh Nasif al-Yaziji, wrote a series of articles in various journals, including his own journals *al-Bayan* and *al-Diya'*, discussing the creation of this new language, which he called "the language of the newspaper" (*lughat al-jaridah*).⁷ The creation of a language unencumbered by classical Ciceronisms and baroque embellishment is critical to the reform movement's desire for efficiency. It also accurately represents the epistemological foundation of the movement. That is, Arab reformers and modern literati needed a language that seemed to present objective, scientific knowledge in a way that was not self-conscious or opaque. Despite their reverence for the ancients, these reformers and literati were committed to creating a language that would not call attention to itself or demand the erudition of its reader, thereby interfering with the naturalness of the knowledge that it presents. Despite the positivist inspiration of this narrative language, I would argue that it finds its most original form in the romance novel and later in romanticism itself.

On a more theoretical level, we have seen how Butrus Hallaq discusses the relationship between the conceptualization of self, language, and love in early modern Arabic literature, which comes to fruition particularly in romanticism.⁸ A handful of more recent articles have breached the relationship between poetic genres and Egyptian national identity at the turn of the century, touching on issues of language.⁹ Overall, despite their varying quality and rigor, these researches have ventured to study the kinship between developments in literary styles, genres, narrative, and language during the modern era. Despite the predominance of this sort of research in the study of modern Western literature, largely initiated by Stephen Greenblatt, the trend is generally absent in Arab studies.¹⁰ This is unfortunate because scrutinizing the narratives of even forgotten texts reveals the degree to which the discourses of self have already been inscribed within the popular consciousness of the day. The fiction of Nuʿman al-Qasatli offers a fine example of this.

The Forgotten Fiction of al-Qasatli

Little is known of al-Qasatli. However, in addition to a history of his native Damascus, we find three of his novellas in *al-Jinan*.¹¹ *Al-Fatat al-Aminah wa ummuha* and *Riwayat Anis* are structurally and narratively based on the model set by Salim's early romances.¹² Both present the story of a bourgeois hero and heroine, struggling to unite against social and familial prohibitions and jealous

rivals. They end happily with the vanquishing of the villains, the redemption of the parents, and the happy union of female and male protagonists. The romance novella *Murshid wa Fitnah* uses the same structure of conflict of planned marriages.[13] What marks it, however, is that it relates the struggle not of a couple from the native bourgeoisie but of two Bedouin lovers from separate tribes. More interesting, the narrative relies on imagery and a discourse more in line with romanticism than with the didactic romance. In the novel, Fitnah is a beautiful and Amazonian shepherdess whose culture and actions are continually differentiated from those of "city people" (*ahali al-mudun*). She is respectful of her own social conventions while defying gender roles. In the first pages of the story, she beats up and imprisons thieves and fights off and kills wolves who are poaching her sheep. She is bitten by a wolf, but dances the same night for her tribe and her father, who is the tribal chief, and even recites poetry to them. Fitnah is an astonishingly well developed character. The reader is privy to her internal conflict. She contemplates whether she should transgress her beloved father's authority and marry her love, Murshid, or marry the less-than-noble son of a tribal leader as the chief wishes. The pressures upon her are so great that she attempts suicide.

The portrait of Fitnah, at first, stands in stark contradistinction to Wardah in *Al-Huyam*. She is active, strong, articulate, and energetic to a degree that the narrator calls "miraculous."[14] Her virtue is obviously intact, due not to the watchful eye of her father, love, or society, but rather to the force of her personality and physical strength. She is envied by women and desired by men, including Murshid, who falls in love with her at first sight. Murshid himself, the son of a rival chief, is a far less developed and imposing character. In fact, he seems ineffectual in comparison to Fitnah for much of the novel. Despite her activity, Fitnah is humble and deferential to her father. It is this deference which operates as the crux of the story's conflict. The struggle is not against a conniving villain as much as it is against the law of the father, particularly the sheikh's interdiction of her marriage to Murshid. While this text is indeed a conscious political call for a woman's right to choose a partner, it would be misguided to call it a feminist text. The independent Fitnah asserts her right to choose her own love object. However, a fundamental irony exists. In the end, the active female protagonist fights to be united with the passive Murshid. In doing so, she submits to his authority and relinquishes her life as a shepherdess, something her father had beseeched her to do early in the story.[15] She is successfully domesticated.

This said, *Murshid wa Fitnah,* although now forgotten in the historiography

of modern Arabic literature, is important because it demonstrates that the experimentation in Salim's oeuvre was not unique and that *al-Jinan* set the standard for being a vibrant venue for the creation of a new kind of popular fiction. Moreover, al-Qasatli's text resonates with Salim's later work. However, offering innumerable pastoral landscapes, the narrative clearly invokes the romantic tradition in a way much less ambiguous than *Salma* and *Samiyah*. Indeed, the story has much potential as seminal text despite the overbearing, almost debilitating, ethnographic information given concerning the Bedouin.

Al-Qasatli, in writing his history of Syria, spent some time with Bedouin Arabs and could be seen as the first Arab anthropologist. In detail and in a nonjudgmental tenor, he relates in *Murshid* Bedouin social practice from honor codes to gender roles to superstitions.[16] The existence of the text's anthropological fixation is not a reflection of the author's inability to understand the romance or the novel generically. It illustrates how the new *nahdah* discourse of self and society had become entrenched to the point that it was almost invisible. Furthermore, this discourse was informed by the cultural dominance of an urban bourgeoisie metropolitanism. That is, *Murshid wa Fitnah* is explicitly written for this bourgeoisie on which al-Qasalti styles his remaining two novellas. While its narrative, imagery, and character portraiture are romantic, even explicitly critiquing the superficialities of urban and modern life, the story illustrates narrative's new role in presenting an objective account of the manners of the Bedouin. In addition to the objectification of the Bedouin, we see that by this early period, the urban readership was already in place to imagine its nomad Other.

Arabic literature and *udaba'* have long been concerned with ethnography. However, Ibn Battutah, al-Mas'udi, and Ibn al-Jubayr offer accounts more in the tradition of Herodotus than of modern anthropology. *Murshid wa Fitnah*, on the other hand, seems to anticipate modern anthropological practice by demarcating Bedouin society and culture as an object of study. Like the seeming transparency of new literary Arabic, the narrator's tenor is objective and his voice functions as an unmediated lens through which to view Bedouin culture. Dealing with culture as an artifact, al-Qasatli presents the practices of Bedouin to their urban counterparts, unmistakably representing the latter as modern and the former as traditional or archaic. The young al-Qasatli's portrait of the Bedouin is far more flattering than Salim's in *Al-Huyam* or even in his short story "Hadhir wa Laylah."[17] Yet it betrays the epistemology that had been laid down in the previous decades, naturalizing the temporality of the paradigm of

civilization and progress by positing Bedouin culture as primitive, albeit noble, in contrast to the progress of urban culture.

Al-Qasatli would write one last romance, more in line with his first novella than *Murshid*, before fading into anonymity. The lack of critical scholarship on works such as his betrays the failure of the historiography of Arabic literature for neglecting serialized long fiction in general. His novellas, particularly *Murshid*, call attention to the importance of the journal *al-Jinan* as a critical and dynamic forum for the dissemination of new fictional narratives. *Al-Jinan* set the prototype for the formative literary-scientific journal, whose numbers would explode by the turn of the century. It published fiction and a regular supply of humor. It also published original short stories of varying quality and odd fiction like "Riwayat rajul dhi amra'atayn" by Jirji Jibra'il Balit al-Halabi, the story of a Frenchman who finds out on his wedding night that he is married to two women.[18]

Experimentation

Upon their establishment, literary-scientific journals such as *al-Jinan*, *al-Hilal*, and *Misbah al-sharq* quickly became the medium for disseminating humanist and scientific knowledge and its concomitant discourse as well as new genres of literature. Some like Muhammad Kurd ʿAli's *al-Muqtabas* and the Egyptian *al-Liwa'* became mouthpieces for indigenous independence and political movements but also published the occasional poem and short story. The fiction, literary history, criticism, book reviews, and even plays that appeared in journals such as Ibrahim al-Yaziji's *al-Diya'*, Farah Antun's *al-Jamiʿah*, and Yaʿqub Sarruf's *al-Muqtataf* remain a neglected and rich source of study. Such fiction, while not always qualitatively superior, often broke ground regarding issues of gender, genre, and subject matter. For example, the short stories of Labibah Hashim appeared in *al-Diya'*. One of the earliest women writers of the modern Arabic short story, she remains virtually unstudied and unread in Arab studies. Her short story "Hasanat al-hubb" is noteworthy because of its quality.[19]

The Arabic short story by Hashim's day had become prevalent, finding its way into every sort of literary-scientific journal. Salim al-Bustani published four of his short stories in 1870, but the Egyptian activist ʿAbd Allah al-Nadim is considered by some to be the genre's progenitor.[20] Sabry Hafez ambitiously asserts that the origin of modern narrative art lies in al-Nadim's fiction. Whether one agrees or not, it is clear that al-Nadim's short stories maintain an

unprecedented generic coherence.[21] He is also interesting because his writings are exclusively concerned with nationalist and social reform issues. In fact, he was forced to go underground for some time due to his support of the failed ʿUrabi revolt. His fiction and social commentaries were published in his journal *al-Tankit wal-tabkit* and exemplify nationalist resistance to the increasingly intrusive presence of the British into Egyptian political and cultural spheres.[22] Despite the markedly political character of his writings, we find the same concerns that exist in the works of Salim and his father. That is, his fiction and editorials are rife with discussions of British political intervention, Khedival politics, native education, women's and minority rights, and "love of the nation."[23] For example, "'Arabi tafarranaj" (Frankified Arab) is a humorous skit about an Egyptian student who forgets how to speak Arabic after returning from his studies in Europe. His haughty Westernized ways prevent him from recognizing an array of Egyptian cultural practices and alienate him from his parents. Deploying Egyptian colloquial, the story is farcical, but it addresses reform standards of modern knowledge, modernity, national popular culture, and language.[24] This emphasis on language occurs throughout al-Nadim's writing, both fiction and nonfiction. At one point, he goes so far as to say, "If an Arab loses his language, he loses his nation and his religion."[25]

The health and future national identity in the wake of Western dominance pervades al-Nadim's work whether it is satire or drama. "Majlis tubbi ʿala al-musab al-afranji" (Medical meeting about the European disease), for example, is an allegory concerning a successful, healthy, and handsome Egyptian son who, after befriending a European ne'er-do-well, cavorts with unsavory men. In carousing with fallen women, he contracts syphilis, the European disease. Like socioeconomic developments under way at the time of his life, the protagonist's illness and new harmful habits are causing him to become ugly, detested, and impoverished.[26] While these stories are modern parables, the author deals with concrete social issues anecdotally as well. His short story "al-Nabih wal-fallah" (The noble and the peasant) is a criticism of the increased practice of borrowing money with interest from banks. Moreover, his characters become indebted to cover expenses of running a business or farm but also to pay off existing debts.[27] Al-Nadim attempts to make every page of his publication relevant, critically addressing the gambit of social, economic, and political problems in Egypt.

While al-Nadim offered an unequivocal, often mocking, criticism of blind imitation and European political intervention and economic dominance, he never exonerated his countrymen for their own culpability in the negative va-

garies of modernity. Like his friends ʿAbduh and ʿUrabi, he was a typical reformer and proponent of the very paradigm of "progress and civilization" that we find throughout the writings of nineteenth-century Arab intellectuals. Like the works of Salim and many other intellectuals, al-Nadim's writing is an internal dialogue fixated on the *presence* of the West, and therefore it often expresses ironic or indeterminate effects. "La yusaddiq wa law khalaftu laka" (Don't believe unless I've sworn to you) reminds us of Butrus al-Bustani's debate with anonymous European figures. That is, the story recounts the life of a European scholar who dedicates his studies to educating the West regarding the "courtesy, honesty, hospitality, history and aspiration, and refinement of the Arabs."[28] What is fascinating about this short piece is that, just as Salim and Butrus al-Bustani use foreign figures either to praise Arab culture or to demonstrate European prejudice against it, al-Nadim also ventriloquizes. Quoting from the conclusion of the fictitious scholar's latest study, the author affirms the value of Arab culture, history, and language. Yet, in every vindication, in every defense, the Western specter lingers. That is, if the make-believe European scholar stands witness to the value of Eastern history, then al-Nadim, like Butrus and Salim, appeals to the West for the validation of authentic native culture and history.

Over time, the quality of the short story improved and the subject matter broadened. Indeed, the stylistic, content, and compositional differences are vast between al-Nadim's short stories of the early 1880s and Hashim's short fiction of the late 1890s. Al-Nadim uses Egyptian colloquial in dialogue alongside a steady invocation of the reformist semantic nomenclature. Much of his oeuvre is satirical, and all of his stories are social, political, and cultural commentaries. They laud Arab culture and language, insist on the need to maintain it through the infusion of modern knowledge, and reject Western cultural, economic, and political imperialism. Hashim's fiction, on the other hand, bypasses any explicit discussion of the reform master narrative. Her short stories are artistically successful portraits of the domestic life of bourgeois native women. Gender plays a role in this choice, but not because women of the period were assumed to be apolitical. On the contrary, as al-Nadim and his peers comment on the changes in public space, Hashim's narrative illustrates a new sort of private space for both men and women and a new understanding of exemplary selfhood. This division between public and private will be discussed at length in chapter 6. For now, we understand that experimenting with genre, narrative, and content fundamentally reflects the reform paradigm as laid down by the pioneers of the Arab renaissance. M. M. Badawi concludes in his study of the literature of the

period that the experiments of the nahdah were a "dead end," failing as an artistic project because the Arabs lacked an aesthetic that could understand the novel as an exclusively modern genre.[29] Such a simplistic comment overlooks the political nature of all art. Certainly, the failures of the Arab renaissance, as much as the successes, have taught us this. Francis Marrash's *Ghabat al-haqq* anthropomorphizes French Enlightenment virtues and principles in a struggle between the kingdoms of civilization and liberty and oppression (*al-istibdad*).[30] That Marrash's allegory is unbearably symbolic discloses the rudimentary relationship between modern narrative prose and the politics and society that these intellectuals saw. However, Marrash does nothing less than what he intended; he reproduces the aesthetic representation of the French Enlightenment, wrenched from its revolutionary context and translated generically into Arabic. What we have thus far witnessed, therefore, is that the "failures" are not failures, nor do the cultural producers of the day ignore or miscomprehend the aesthetics of the novel as a modern literary phenomenon.

This study reveals that the genesis of new forms of Arabic prose narrative marks the nineteenth century as foundational in the development of modern Arabic literature as a whole artistically, politically, and intellectually. As we have seen, Arab authors were dealing with questions of literary representation and narrative, with the tension between the mimetic and the metaphoric, and the artistic and the discursive. We have begun to see how these *udaba'* privileged new sorts of fiction to work out and, in fact, reinscribe notions of self, society, subjective failure, and aesthetics. That these intellectuals and literati chose fiction to do this, not the classical genres of *khitab*, rhetoric, or even poetry, shows us that they were aware that the novel is the appropriate medium in which to narrate what they understood as the essential march of modernity.

The Strategy of a Classical Genre

A disciplined glance at the literature forces us to acknowledge that, among the plethora and diversity of narrative experimentation, many Arab writers remained loyal to classical genres of poetry and prose in the hope of reawakening high Arabic literature. Sami Basha Barudi, Hafiz Ibrahim, Ahmad Shawqi, and Khalil Mutran were nahdah poets experimenting with new topics in classical forms.[31] These poets deserve closer critical attention than this study can afford. For now, it is noteworthy that their respective oeuvres are more eclectic, diverse, and experimental than their classical shell might immediately indicate. The

new content within classical content is what interests us here. The reappearance of the maqamah offers such an example. Its plastic form often obfuscates how the genres shift in relation to changes in society and economy.

Peter Gran has shown in *Islamic Roots of Capitalism* that eighteenth-century Cairo experienced a similar boom in cultural production, particularly the prominence of the maqamah, as a result of Egypt's economic prosperity. The maqamah (pl. maqamat) originated in the tenth century in the work of Ahmad ibn al-Husayn Abu al-Fadl al-Hamadhani (967–1008), otherwise known as Badi' al-zaman (wonder of the age). He is said to have completed his masterpiece by the age of twenty-four.[32] Orientalist A. F. L. Beeston, in his unflattering study of al-Hamadhani, asserts that the maqamah is adapted from al-Tanukhi's *al-Faraj ba'd al-shiddah*, which Badi' al-zaman allegedly mimics in his maqamah "al-Maja'iyah."[33] However, the continual poetic, intellectual, and literary intertextual references in the maqamat suggest that this erudite bricolage and self-conscious borrowing are conscious, ironic, and parodic, as much artistry as plagiarism.[34]

In the fifty-two maqamat, the traveling merchant 'Isa ibn Hisham narrates his travels throughout the Islamic world and his encounters with the antihero, the vagabond Abu al-Fath al-Iskandari. The text is written in rhyming prose (*saj'*), filled with wordplay and archaic vocabulary, and interspersed with original and classical verse. It is through these linguistic acrobatics that Abu al-Fath (usually) manages to extort money from his gullible audience. Traditionally, the genre has been understood not aesthetically or politically but strictly as a linguistic and stylistic exercise, as an attempt to prove the author's mastery of the language. James Monroe is one of the first to clearly disprove this, arguing that al-Hamadhani's text is a specific and powerful social commentary.[35]

Monroe has argued that al-Hamadhani's maqamat form a moralistic commentary in which the actions of the opportunistic Abu al-Fath serve as negative lessons regarding materialism following the golden age. He states that al-Hamadhani's maqamat offer a satirical parody or perversion of the Hadith genre (the sayings of the Prophet). However, in place of moralistic and religious dictates and anecdotes, they contain irreverent and amoral lessons.[36] I would add that the text examines the loss of an age, but it is also a specific commentary on identity and social practice. That is, it is well known that the sciences and belles lettres flourished during the 'Abbasid era. This patronage of the arts and sciences was a direct redress to the civil and religious disunity that had plagued the Muslim community since the death of the Prophet. In the wake of the revolution, the high 'Abbasid caliphate attempted to forge a new imperial secu-

lar culture that would be suprareligious but also would validate its religious legitimacy. The maqamat of al-Hamadhani are specifically preoccupied with this aesthetic. For example, many of them deploy extended references to poets such as Dhu al-Rhummah, Imru al-Qays, Abu Nuwas, Jahiz, Abu Tammam, and al-Mutanabbi and the debates of the rationalist *mu'tazilah* and the *shu'ubiyah*. Therefore, Monroe claims that Abu al-Fath's artful deception marks the passing of the golden age, championing and self-consciously ironizing the virtues lauded by high 'Abbasid culture.[37]

Yet al-Hamadhani's maqamat offer more than a nostalgic commentary on loss or an orthodox religious statement; they are a play on aesthetics, seeing, and subjective certitude itself. Abdelfattah Kilito, borrowing from Vladimir Propp, offers an eight-tiered structure common to the classical maqamah in general.[38] Monroe adds a heuristic function to this structure that understands the maqamah as a movement from the visually immediate, which is a deceptive illusion, to the unlikely real. While he does not develop this insight, his analysis fundamentally corresponds to the understanding of knowledge and knowability in classical Arabic belles lettres. That is, the world is divided between the apparent exoteric (*zhahir*) and the hidden esoteric (*batin*); the former can only be a shadow of the latter. This is the Neoplatonic epistemology of classical Islamic thought. As classical Arabic literary narrative was driven less by narration than by poetic representation, we see that Monroe's interpretation of Kilito's tiers yields fruit. In the maqamat of al-Hamadhani and al-Hariri, for example, preference is given to the seeding and transformation of imagery and leitmotifs over strict narrative development. Here we see influence of the preeminence of, say, the *qasidah* form on prose like *Qays wa Laylah* or the earliest maqamah, "al-Qardiyah." That is, the classical maqamah uses language to play on vision, knowability, and representation of the exoteric. This assertion is not completely original, as Kilito suggests that the maqamat rotate around the antihero Abu al-Fath's concealment and disclosure of his true identity.

Equally enigmatic are the identity, origins, direction, and journey of the hero, 'Isa himself. Just as Abu al-Fath's true identity is never revealed, 'Isa's past is never disclosed. In each maqamah, we are presented with a different portrait of both the narrator and the antihero. 'Isa-the-narrator is at times old, at other times young, establishing a life in exile, wandering as a homeless merchant, or traveling as a pilgrim on the way to or from Mecca. That 'Isa is displaced and never static is one of the text's few common denominators. Al-Hamadhani continually highlights the ambiguity of what appears real and what is false, the ephemeral and the permanent, and *zhahir* and *batin*. He states, for example:

> Alas, this age is a counterfeit one.
> Do not be enraptured by it or by its deception.
> Never commit yourself to one state of being.
> But just as the evening comes and goes,
> Keep moving and changing. (9)

In the following maqamah, "al-Balakhiyah," he states:

> We are all God's servants;
> Those who take various lives.
> They become Arabs in the evening
> And then become Nabateans in the morning. (17)

Among all of the trompe l'oeil and misrepresentation, the ambiguity of 'Isa the narrator-hero mirrors the enigma of the vagabond Abu al-Fath. My argument then is that these two figures can be considered as each other's negative double, or doppelgänger. 'Isa is respectable in appearance, maintaining fundamentally one stable identity, that of a merchant of good social standing. Abu al-Fath, on the other hand, is a trickster who continually appears in different forms. While the disguises of Abu al-Fath are compelling, 'Isa is little deceived by his counterpart. This unspoken knowing of the concealed suggests that, more than being doubles, the narrator and antihero are in fact one and the same character.

Several passages imply this. For example, the ages of 'Isa and Abu al-Fath are constantly exchanged: When one is graying, the other is a reckless youth, and vice versa. In no maqamah does Abu al-Fath con 'Isa. Rather, the narrator is accompanied by someone who is usually fooled by Abu al-Fath's guile. Disclosure of the antihero's true identity, however, occurs only when he and the hero are alone together.

Furthermore, 'Isa is attracted to Abu al-Fath and seeks him out, even forcefully pushing through crowds, searching the bazaars, and exploring dark alleys. For example, when 'Isa is in a market, he hears the voice of an orator:

> I was compelled to meet him.
> He was a man on a horse
> Who lost his breath.
> He turned his back to me and said,
> "He who knows me, knows me well!
> But he who doesn't, I shall make know me!
> I am the harvest of Yemen
> Lauded through the ages,

A mystery among men and an
Enigma among cloistered women." (19–20)

In the following maqamah, 'Isa is a traveler who enters Basra "adorned in Yemeni garb, dyed and embroidered" (63). Later, in "al-Shirazyah," 'Isa is returning from Yemen (167).

More forceful evidence that Abu al-Fath might be a narrative projection or alter ego of 'Isa is found in "al-Qardiyah," when 'Isa and his entourage interrogate Abu al-Fath about his opinion of classical and preclassical poets. As they disperse and Abu al-Fath leaves, the narrator is drawn to the speaker and follows him, saying:

"I rejected him but recognized him;
I spurned him but I knew him.
I was compelled but then,
The sparkle of his two front teeth (*thanayahu*) told me who he was." (9)

If we recognize that 'Isa and Abu al-Fath are, in fact, the same character, the maqamat can be understood as an attempt to narrate contradictory and ironic currents within classical Arabo-Islamic identity. That is, the splitting of the narrator into 'Isa (condoned) and Abu al-Fath (taboo) characters reflects a classical identity in crisis if not also the very episteme of the *batin/zhahir* binary. Al-Hamadhani was confronted by an identity that lauded orthodox religiosity but championed high 'Abbasid libertine culture. It was an identity that was built on the centrality of the religious community (*ummah*) but was fragmented into secular, competing principalities. Finally, late 'Abbasid culture was defined by an identity that found its raison d'être in its spiritual and religious past but judged success and priorities on mercantilism and materialistic gain. Recognizing that the maqamah provided a comment on the crisis of subjectivity as well as an aesthetic statement allows us to understand why it maintained such force, even in the nineteenth century.

Majmaʿ al-bahrayn and al-Yaziji's Classical Consciousness

Still an elite phenomenon by the midcentury, the most notable nineteenth-century example of the maqamah genre is al-Sheikh Nasif al-Yaziji's (1800–1871) *Majmaʿ al-bahrayn* (The confluence of two seas).[39] Its importance lay in the fact that it uncannily reproduced the style and lexicon of al-Hariri's master-

piece.⁴⁰ Published in 1856, *Majma'* includes sixty maqamat, in which Suhayl bin 'Abbad, the narrator, recounts the exploits of the antihero, Maymun bin Khizam. Clearly, al-Yaziji adopts the maqamah because it displays the author's lexicographical, grammatical, and syntactic virtuosity. He writes in his self-deprecating saj' introduction:

> I have trespassed into the territory of cultivated Arabs by concocting tales [*ahadith*] that are content at least to resemble maqamat, even nominally. ... I have attempted in these maqamat to collect—to the best of my ability—morals, laws, and grammar, linguistic oddities and anomalies, idioms, wisdom, and stories. My pen pours forth in striving for the ideal set by days long gone. Other than this, I hoped to gather rare plays on syntax, elegant styles, and names that one does not come across except through diligent investigation and research.⁴¹

In this introduction, al-Yaziji makes clear that his aesthetic is one rooted in the classic Arab belles lettres or adab.⁴² The maqamah's linguistic registry, style, and subject matter are all typically classical Arabic. A panegyric penned by 'Abd al-Baqi Effendi al-'Umari from Baghdad asserts how al-Yajizi's maqamah does justice to the model of al-Hariri and al-Hamadhani.⁴³ Indeed, the text designs a baroque Haririan hero, antihero, and narrative structure. In the sixth maqamah, Suhayl ibn 'Abbad finds Maymun ibn Khizam with an Arab tribe. The antihero's knowledge is challenged and, in reply, he provides obscure synonyms for banqueting, the pre-Islamic terms for fire, the names of the hours of the night and the day, and the various appellations for racehorses—all in verse (*Majma' al-bahrayn*, 36–39). Al-Khizam waxes lyrically about legendary Arab heroes of the pre-Islamic tradition in "al-Khutbiyah" and throughout the text engages in various genres of poetry including *hija'* (satire) and *madah* (elegy) (115–17). Moreover, in the most technically complex maqamah, "al-Ramliyah," the antihero bedazzles his listeners by reciting verse that contains words made of letters without diacritic marks (*'awatil*), then verse exclusively made of words with diacritics (*mu'jam*), followed by a poem where every letter of every word alternates between being with and without diacritics (87–97). The maqamah continues with this sort of pyrotechnics until al-Khizam ends with a short, triumphant poem. All of the maqamat display the erudition of al-Yaziji, clearly placing *Majma' al-bahrayn* within a classical aesthetic and literary context. Even the discussion of knowledge (*'ilm*) and money in "al-Jadaliyah" resembles Jahiz or al-Hamadhani more than writers of the nahdah on these subjects (231–34).

Majma' seems to have enjoyed a large circulation and degree of popularity in traditional literary circles. *Fakihat al-nudama'* (The anecdotes of friends) is a compilation of epistolary and poetic correspondence between al-Yaziji and various sheikhs and poets in places throughout the Arab world, including Alexandria, Saida, Tripoli (Lebanon), Mosul, and Baghdad. Within this compilation, all the praise, comments, and criticisms, mostly in regard to *Majma' al-bahrayn*, are presented in typical classical poetic and rhetorical forms and further reinforce the place of al-Yaziji's work in the classical tradition. This includes its epilogue, which makes reference to the classical Islamic episteme, differentiating between the exoteric and the esoteric (111). *Majma' al-bahrayn* certainly mimics al-Hariri's model in complexity of form and register and al-Hamadhani in individual narratives. However, al-Yaziji varies the introductory phraseology of each maqamah, switching between *hadatha, khabara, qala, haka*, and *rawa* Suhayl ibn 'Abbad (all meaning Suhayl ibn 'Abbad told or related). Indeed, al-Yaziji writes in his introduction that the poet is not aiming to reproduce classical prosody but that he "aspires to a new sort of elegance" (10). This newness is reminiscent of *al-'Asr al-jadid* by al-Yaziji's younger colleague, Khalil al-Khuri. The freshness of al-Yaziji's prosody can also be seen in the introduction to each maqamah. Here, he maintains a strong narrative, rather than poetic, quality that effectively pulls the reader into the otherwise complex language of the story.

More than in phraseology or mannerisms, the newness of al-Yaziji's *Majma' al-bahrayn* is found in the text's social and cultural implications, which have a larger discursive effect. Al-Yaziji explicitly writes his maqamat as a classical poet in the dawn of a new era. He was the last court poet of the last great prince of Lebanon, Amir Bashir al-Shihab, before he was sent into exile after supporting Ibrahim Pasha's occupation of the Levant. Al-Yaziji also writes his classical text explicitly as a Christian Arab and locates himself specifically as "one from the Christian community (*al-ummah al-'isawiyah*) of Mount Lebanon" (9). This fact is not lost on many of his admirers and critics, some of whom comment on the author's minority status in *Fakihat al-nudama'*.[44] However, it should not be understood that maqamat were a tradition alien to Christian and Jewish Arabs. Quite the contrary is true. Christian and Jewish Arabs wrote maqamat in Arabic, Hebrew, Syriac, and Karshuni.[45] However, while Christian and Jews would often write them in Arabic, the perfection of al-Yaziji's stylized Arabic, his erudition in various classical Islamic disciplines, and his mastery of the language and verse were all found unique by the author's Muslim peers. Al-Yaziji locates himself in but also rips himself away from his critical minor position, as

Deleuze and Guattari call it.[46] That is, he identifies himself as a Christian Arab by using a phrase composed of two undisputedly Islamic terms, *al-ummah* (traditionally used of the Muslim community) and the adjective *al-'isawiyah* (from the Quranic name for Jesus). Adding to this self-conscious invocation of the classical tradition, Islam, and his own minority status, al-Yaziji lifts the very title of his maqamat directly from the Quran, citing the passage 18:61, "Hence, Moses said to his attendant, I will spend much time and not relent until I meet the confluence of the two seas [majma' al-bahrayn]."

The tenor of al-Yaziji's work has a subtle but profound effect. His classical language combined with his confessed religious affiliation secularizes an otherwise expressly Islamic register. In doing this, the poet expands the cultural and social parameters of classical Arabic and the classical genre of the maqamah, not by forging a new secular language as was done later. Rather, al-Yaziji employs an explicitly Islamic nomenclature and places it in a non-Islamic context. The text is by a Christian Arab author who happens also to be a *hafizh* of the Quran. Al-Yaziji's secularizing move is emphasized by his choice to include only Arab cities as locations for his maqamah, unlike the maqamat of al-Hamadhani and al-Hariri, which extensively use cities in the Arab and non-Arab Islamic worlds. Also, many of the maqamat in *Majma'* bear local references to towns and regions within Lebanon, Syria, and Palestine.

Majma' al-bahrayn makes an explicit social statement regarding the relationship between Arab cultural tradition, Islam, and its minorities. More than this, the cultural consciousness that it subtly articulates sets the discursive stage for later Christian and Jewish Arab intellectuals who would contribute to the formation of Arab subjectivity as a secular nationalist phenomenon. Therefore, we should understand al-Yaziji's adoption of the maqamah and its highly stylistic prose neither as the inability of nineteenth-century Arab literati to be innovative in the field of Arabic literature nor as the rejection of modern stylistics and narrative. *Majma' al-bahrayn* recoded classical genres (form) with a new, expanded sense of secular Arab culture (content) that would be most appropriate for the new subjectivity that would emerge.

Al-Fariyaq and the Authorial Interlocutor

Al-Yaziji's oeuvre is not alone in secularizing Islamic aspects of Arab culture and literature. A year before *Majma' al-bahrayn* was published in Beirut, Ahmad Faris al-Shidyaq's seminal *Al-Saq 'ala al-saq fi ma huwa al-Fariyaq*

(Fariyaq's thigh over thigh) was published in Paris. Al-Shidyaq (1804–87) was a Maronite Christian who studied at the same school as Butrus al-Bustani. He, too, converted first to Protestantism and then to Islam, at least nominally, allegedly back to Catholicism on his deathbed. These conversions add to the enigma of al-Shidyaq but also reflect his nomadic life and identity.[47] The text is an extension of this. Divided into four books, the story narrates the adventures of al-Fariyaq in Lebanon, Egypt, Malta, Tunisia, France, and England. Categorization of *Al-Saq*'s genre is antithetical to its very composition.[48] In addition to four separate maqamat appearing at the thirteenth chapter of every book, the work contains narrative saj' and non-saj' prose and poetry in a variety of meters, genres, and styles, as well as digressions on hundreds of lexicographical items.[49] For example, the author provides pages of names, well known and obscure, of luxury items such as gemstones, jewelry, and clothes (325–50). In the concluding chapter, al-Shidyaq even mixes colloquial into his classical language (709).

Regarding narrative content, the reader is furnished with ethnographic details of French and British cultural idiosyncrasies, geographic descriptions, and comparisons between various Eastern and Western customs. Ethnographically, then, *Al-Saq* offers an incisive social criticism and cultural defense of certain European and Arab cultural practices.[50] The manuscript's force lies in its production as adab. The text-as-story provides innumerable tales, mostly humorous and ironic, of al-Fariyaq's interactions with Arab 'ulama', clergymen, intellectuals, and professionals and British and American missionaries, Orientalists, and common folk, as well as his bickering wife, al-Fariyaqah. Al-Fariyaq's erudition and wanderings invoke the image of a nomadic maqamah antihero, but his story maintains a sustained, cohesive narrative that is otherwise absent from the surface of the maqamah.

While continually changing speed, style, and genre internally, the masterpiece is bound by two constants: the continuous presence of the protagonist, al-Fariyaq, and the voice of the narrator-author, al-Shidyaq. Clearly *Al-Saq* must be seen as more than an autobiography. Al-Shidyaq, speaking in the first person, intervenes directly in the narrative. These interventions are not constative or informative in nature or used to illuminate the text's narrative. Rather, al-Shidyaq's authorial intrusions act as an interlocution between al-Fariyaq, the reader, and the narrator himself. For example, chapter 7 of book 2, entitled "About Nothing," consists exclusively of the author's direct address to the reader. Al-Shidyaq narrates, "I thought that I should leave al-Fariyaq for the

time being and offer a description of Egypt . . . but, in the darkness of this chapter, I really must go to sleep now" (246). A similar example occurs when he introduces his second maqamah: "I will not sleep comfortably if I do not compose a maqamah today, so let me return my pen to its camaraderie with *saj'*" (272).

More stunning than this is his dialogue with al-Fariyaq himself. For example, the author opens chapter 17 of book 2 as follows: "Hello! Hello! My dear al-Fariyaq! Where have you been? Where have you been for such a long time?! Have you been in a secret hiding place? Well, this much I know. So I won't ask you anything except: What's going on?"[51] The use of authorial intrusion creates an original fictional protagonist. Mirroring him, the presence of al-Shidyaq gives further dimension to the protagonist's character and epic. The relevance of this dimension is not exclusively aesthetic. While he is not talking to himself, the author is talking to al-Fariyaq as a manifestation of Self. More likely is that the breach of al-Shidyaq's narrative voice functions as the political, personal, and cultural unconscious of al-Fariyaq himself. The strategy is a subjective necessity because the story is of an Arab navigating and maintaining his cultural identity while living in Europe during the age of colonialism.[52] *Al-Saq*, therefore, is an attempt at a new genre of fiction not because of its narrative continuity, stylistic diversity, humor, and linguistic force but because it forges and animates a new type of hero. The hero reflects the nomadic life and identity of the author himself and embodies the alienation, displacement, promise, and potential of the Arabs. From a scholarly family, a son of Lebanon, al-Fariyaq is estranged from his homeland, exiled because of persecution by the Maronite Church.[53] He has mastered the traditional disciplines from languages, astronomy, and medicine and become fluent in European and ancient languages. He interacts with European and Arab scholars, clerics of all denominations, and reform-minded Ottoman officials. He engages Arab and European societies and cultures, sometimes sincerely and otherwise humorously and pedantically. All the while, al-Fariyaq is sophisticated and mature enough to appreciate certain aspects of the unique character of both cultures. Consequently, *Al-Saq* is the first Arabic fiction of the modern era that presents a hero struggling with the cultural, social, and political presence of the West.

In contrast to *Majma' al-bahrayn*'s Maymun ibn Khizam, the figure of al-Fariyaq marks the dawning of a new native subject, a new narrative subject, and the birth of modern Arabic literature itself. The intersection between narration, portraiture of the protagonist, authorial voice, and stylistic and generic modu-

lations yields a new hybrid genre that is innovative yet laden with classical resonance. This cultural hybrid communicates a new social circumstance of the nineteenth-century Arab world. Specifically, the dual nature of the text—innovative and classical—reflects a perceived need by the *ruwwad al-nahdah* to rejuvenate and reform indigenous cultural and social practices, including literary narratives. *Al-Saq*, then, is an attempt to affirm Arab cultural presence in response to increased and conspicuous Western and colonialist assertions of Arab cultural decadence. The diversity of styles and genres within *Al-Saq* parallels the versatility of al-Fariyaq in countering European accusations of native failure. The text's multiplicity parallels the disparate situations in which the protagonist finds himself and his adroitness in translating cross-cultural experiences—all while jealously guarding his Levantine Arab identity. Consequently, al-Shidyaq-the-author (the voice of the unconscious) intervenes or rather surfaces to mediate this diversity. He stands as a narrative bridge between the protagonist al-Fariyaq, the narrator al-Shidyaq, and the reader. Hence, his authorial intrusions bring continuity to disparate scenes, genres, styles, and linguistic registers, as well as to the consciousness of a native son outside his homeland.

Journey of Self and National Consciousness

The romance and the historical novel offered Arab authors a radically new literary form in which to narrate an authentic yet progressive native ideal conducive to the modern era. The continual experimentation with generic forms testifies to an expanding subjective and political consciousness and struggle with paradigms for Arab success. With this sense of experimentation in mind, two further prose works stand out in terms of communicating the connection between literary form and Arab subjectivity. ʿAli Mubarak's *ʿAlam al-din* and Muhammad al-Muwaylihi's *Hadith ʿIsa ibn Hisham* both synthesized their maqamah pedigree into a new form of modern fiction.

ʿAli Mubarak (1823–93) was the consummate reformer. As minister of education under the Khedives ʿAbbas and Ismaʿil, he worked to establish a standard curriculum for national schools and founded the Egyptian national library, Dar al-Kutub. He published *ʿAlam al-din* in 1882, the same year as British military intervention in Egypt. While managing to exceed fifteen hundred pages, the four-volume story has no real denouement. The story relates the travels of an Azhari sheikh, ʿAlam al-din, his son, Burhan al-din, and an English Orientalist.

The Englishman, as he is named, recruits ʿAlam al-din to compile in Europe an authoritative Arabic lexicon. Every chapter, or *musamarah*, recounts a new leg of the journey and/or a discussion between the three protagonists regarding Arab and Western culture and social practices, scientific and Islamic knowledge, and modern technological innovations and inventions.

As a scholar, ʿAlam al-din excels in the classical Arabic linguistic, scientific, and religious disciplines. Unlike his peers, he is anxious to assist the Englishman in his studies (24). Among his countrymen, he is respected because of his character and also because his knowledge surpasses even the learning of his Azhari father (23). The sheikh is also humble, self-critical, and proud of his own cultural and religious tradition. Pursued by the English Orientalist, his mastery of Arab-Islamic knowledge confirms the value of the tradition in the face of the ascendancy of modern knowledge (25). However, the story is about this modern knowledge as much as ʿAlam al-din himself, who confesses and demonstrates his lack of it and foreign cultures. Rather than being a negative commentary on the protagonist or Egyptian culture, this shortcoming and his conviction to study ironically confirm ʿAlam al-din's religiosity, intellectual humility, and strength. The anonymous narrator tells us of the sheikh's excitement:

> Upon the eve of his travels, ʿAlam al-din cried about leaving his family and his country from which he had never been separated. On the other hand, he was overjoyed. His heart was attracted to knowledge [ʿilm] and desirous of obtaining it, just as the Quran adjures. He saw for himself the opportunity to expand the scope of his learning [*daʾirat maʿarifihi*]. (22)

Without rejecting his own intellectual tradition, ʿAlam al-din recognizes the importance of new knowledge in the modern age and is therefore an exemplary native hero. This critical recognition allows him to become a student of modern learning as much as he is an instructor to the Englishman of his own cultural tradition.

The figure of the hero stands in contrast to his son and father. The son, Burhan al-din, displays adeptness in understanding modern knowledge, Egypt's pre-Islamic history, and Western social practice. He is adroit in conversing with the Englishman, showing none of the awkwardness of his father in encountering Western culture. On the other hand, ʿAlam al-din's father, remaining in Cairo, entrusts his son with ten key principles by which to guide his life. He advises his son to maintain his faith and morals (*akhlaq*), reject materialism, and search for knowledge. The elderly sheikh assures ʿAlam al-din that

there is no hierarchy of knowledge, all disciplines deserving thorough research. A means for self and spiritual elevation, learning should not be used for self-aggrandizement but should be understood as a religious dictate (12–19).

This code represents the classical, rationalist Islamic paradigm of knowledge, similar to what we find in the introduction to al-Yaziji's *Majma' al-bahrayn*. That is, attainment of self-enlightenment and knowledge of the material world is a means to become closer to God. The father's code, however, provides something more, both literal and metaphorical. His sheikhly speech is nostalgic and outdated apropos the cultural discourse of the Arab renaissance. Simultaneously, however, it represents the historical foundation and intellectual justification for 'Alam al-din's adventure and the education project of Mubarak the *wazir*. Consequently, within the discourse of the obsolete father we find the seeds for the new age of progress (*taqaddum*), which maintained such prominence in the discussions of the story's heroes. Unfinished and wandering, their story can be seen as an open-ended, incomplete journey. This journey is open to literal, metaphorical, and allegorical interpretation. While it is literally a physical tour of Egypt and France, the tale is also a metaphorical journey into all things new that the modern age holds for the protagonist and his culture. Therefore, 'Alam al-din's travel and education offer an allegorical journey down the road to progress and modernity for his kind, the native intellectual elite. The fact that he sees this journey as an imperative emphasizes a shift in the consciousness of his secular and religious colleagues. However, 'Alam al-din communicates more than a singular sense of class consciousness, interacting with a variety of Egyptian classes, from peasantry to rural aristocracy. Through the discussion of Arab, Egyptian, Islamic, and Pharaonic history, a national consciousness is created.[54] In addition, then, to the generational and paradigmatic differences between the protagonist, his father, and his son, Arab Egyptian Muslim identity is a common denominator that binds diverse class levels, creating a new national Egyptian consciousness. The utopian vision of Mubarak's text, however, glosses over the political conflicts that embroiled his life, establishing almost a false consciousness of reform and national identity.

Competing Visions of Consciousness

The national consciousness and subjectivity that appear in *'Alam al-din* were bound to come to loggerheads with later texts, some of which fit more definitively into the maqamah literary form. *Hadith 'Isa ibn Hisham aw fatrah min al-*

zaman (The story of Isa ibn Hisham, or a period from time) was written by Muhammad al-Muwaylihi and serialized in his father's journal, *Misbah al-Sharq* (Lantern of the East) in 1898–99.[55] The title and protagonist's name are lifted directly from al-Hamadhani, announcing that al-Muwaylihi's text falls squarely in the tradition of the maqamah. The first sentence of the book introduces the epic in the stock phrase, "hadathana 'Isa ibn Hisham" or "Isa ibn Hisham told us." The following sentence, however, reveals that this is no ordinary maqamah. 'Isa continues, "I imagined myself in a dream as if I were in the Imam graveyard" (4). As 'Isa ibn Hisham walks in the cemetery, a resurrected corpse disturbs his meditation. This zombie is none other than the Pasha, a military officer of the highest rank who served the celebrated Muhammad 'Ali and who will be guided now by 'Isa ibn Hisham. Snapping off commands to 'Isa, the Pasha quickly demonstrates that he is out of place and time in a new era. Unlike the maqamat, the chapters form a continuous, linear narrative where the heroes find themselves in different situations. For example, the Pasha is tried for assault in an Egyptian criminal court, takes a stroll in a public park, and sits in a restaurant bar, all the while encountering and engaging with a diverse group of Egyptians, including a donkey driver, a doctor, some aristocrats, and 'ulama'.

Hadith 'Isa ibn Hisham employs classically stylized literary Arabic that is more similar to the language of al-Yaziji and al-Shidyaq than that of Mubarak, whose language and register were clear and almost secular. This is not inconsequential, as the text in style, form, and content, like *Al-Saq*, is a hybrid, combining classical and modern elements strategically. Unlike al-Yaziji, al-Muwaylihi transformed the classical maqamah into an extended and coherent prose narrative resonant of the novel. Furthermore, within the text's classical form, language, and nomenclature, the author successfully develops the Pasha's character. For example, upon meeting 'Isa, the Pasha is arrogant and aristocratic. By the story's end, he is curious, humble, and thirsting for modern knowledge, and he even conveys a sense of empathy and ambiguity more characteristic of modern than classical Arabic prose. Therefore, in terms of genre and story, the force of the text comes from this mixture of new and old, innovation and tradition.

Although he crossbred language, style, and form, al-Muwaylihi did not produce a text that would alleviate the antagonism between the East and the West. Nor do these techniques establish a utopian vision that ameliorates the tension caused by importing into Arab society Western ways and "new knowledge," as is the case in *'Alam al-din* and the fiction of Salim al-Bustani and Jurji Zaydan.

We recall that Salim's *Huyam fi jinan al-sham* shows us that the hero's anxious relationship with his European friends is diffused by his attraction to Mme Bellerose, who is sympathetic to and knowledgeable about Arab culture and history. Likewise, no tension exists in *'Alam al-din* between the Egyptian protagonists and their foreign friends. 'Alam al-din, while displaying proficiency in Islamic knowledge and disciplines, acknowledges uncritically the importance in learning and internalizing European knowledge but not necessarily European ways.

Al-Muwaylihi does not open such an outlet. His text allows contradictions and tensions to stand. In fact, the Pasha's tour of Cairo with his guide 'Isa ibn Hisham is a sustained witnessing of the debate regarding the importance of native political and social reform, the relevance of importing Western ways, and the worth of Egyptian, Arab, and Muslim cultural, religious, and intellectual practices in modern Egypt. Nowhere in the story does al-Muwaylihi make an unequivocal judgment on these debates. As the Pasha is introduced to each new phenomenon, 'Isa explains the scene to him. Gradually, the Pasha becomes adept in conversing and understanding the new milieu in which he finds himself. While both 'Isa and the Pasha reveal their distaste or admiration for a certain character or development, these comments cannot be neatly categorized as completely for or against the West, or reform, or tradition.

One fine moment that presents the multiplicity of ideological views regarding the modern era is when the Pasha and 'Isa happen upon a native wedding. The maqamah has several diverse movements. Befriended by a wedding guest, the protagonists sit down with a cleric and, during the festivities and singing, ask him about Islam's pronouncements concerning music. What is noteworthy is not that the sheikh asserts that music is natural to man and that Islam has no interdictions regarding it. Rather, the sheikh cites both Islamic and Western figures to substantiate his opinion, among them Galen, Plutarch, Pythagoras, al-Farabi, and the Caliph 'Umar, and he provides numerous examples from *Al-Sahih* and *Kitab al-aghani* (200–207). The Pasha is floored by the breadth of the sheikh's learning:

> What is this that I see! This ocean of knowledge with such depth of thought! . . . Never before have I witnessed among the 'ulama' a sheikh with such precision in observation, clarity of analysis, and comprehensive knowledge regarding the history of so many peoples with diverse languages and nationalities. . . . He has given us examples from Greek,

Roman, European, and Islamic history. Amazingly, he combines the Arab and the foreign [ʿajami], the Eastern and the Western! Oh, how you differ from your sheikhly brothers! You have not adopted their manners or ways! Instead, on the verge of discussing jurisprudence and the prescripts of Islamic law, you stop and turn away and expound on rational research and the secular sciences [al-ʿulum al-duniyawiyah]. (208)

Clearly, the reader is expected to glean from the Pasha's accolades of the sheikh an overt criticism of the clerical class. Simultaneously, the figure of the sheikh provides a careful representation of native humanistic and rational paradigms synthesized with Islamic learning. Similar to the hero ʿAlam al-din, this sheikh stands in contradistinction to his peers who appear elsewhere in ʿIsa. For example, in one maqamah, several clerics bewail the rise of secular intellectuals and their reformist ideas. They belittle the importance of modern knowledge (al-ʿulum al-muhaddathah) and "the new sciences" (al-ʿulum al-jadidah), criticizing them for leading Muslims into spiritually and intellectually dangerous territory (156). The clerics decry every aspect of reformist culture, including the preponderance of newspapers, the accessibility of secular learning, and the adoption of "European innovation," all of which are leading the nation astray (158–59). What is interesting is that, while the Pasha and ʿIsa clearly display contempt for these self-aggrandizing clerics, al-Muwaylihi states the conservative Azhari opinion on contemporaneous social and cultural transformations honestly and without parody. The narrative illustrates conflicting visions of the nation and its past, present, and future.

This conflict, seen in the story's numerous dueling portraits and various running debates, is clearly ironic. After the appearance of the ideal sheikh, the wedding guests observe the intrusion of European tourists who have come to witness an authentic Egyptian wedding. Their presence is important for many reasons. First, it facilitates a discussion regarding the very authenticity of the allegedly traditional Egyptian wedding. When the Pasha asks whether the tourists were invited, his friend replies that tickets are left at the hotel for tourists, encouraging them to attend the wedding as it is a mark of distinction for the urbanites to have them there. The friend explains that these Europeans tourists, fully armed with cameras, "have come to Eastern countries to see with their own eyes everything from Egyptian ruins to Egyptian parties and bazaars" (212). Further reinforcing the fetishization of Egyptian culture, ʿIsa relates that "the groom then guided the women tourists up the staircase to the harem as if they were climbing on the Pyramids" (213).

What makes this scene more ironic is the vociferous debate that follows. Two Egyptian men, one young and one old (*shabb wa kahl*), argue about the value of popular and venerated Egyptian cultural practices. Apparently, the groom was of southern peasant origins, but after some financial success in Cairo he had adopted the fashion and mentality of the urban bourgeoisie. The aged man asks:

> How could he have rejected the traditions [*sunnah*] of his fathers and forefathers and abandoned the beloved customs of his people and home? How could he have jumped in one big leap to using Western customs and copying European innovations? (215)

His young counterpart rejects his senior's argument:

> The way I see it, the groom is correct in what he's doing.... It's about time country folk start catching up with city folk with respect to Western manners.... They should strip the yoke of ancient customs from their necks and free themselves from the shackles of outmoded thinking. Only then will the nation [*al-ummah*] be elevated and the country benefit! (215)

The heated debate continues and two visions of Egyptian and Western culture are presented. The old man laments the disappearing of rustic and simpler ways, such as weddings without pretence, imported foods, or foreign adornments. The young man finds little of worth in the traditional, seeing these new cultural practices as a sign of progress.

The scene and the debate are enframed by a further irony. On the one hand, Europeans participate in the surveillance of what they have fetishized as the authentic culture of the Eastern Other. An Egyptian wedding and the harem have been made exotic to the extent that they resemble the Pyramids themselves. On the other hand, clearly the very authenticity of native culture is under debate between the two men. The wedding in question is all but authentic, infected by new kinds of food, music, dress, and behavior. For the old man, the ritual at hand symbolizes the loss rather than the presence of tradition and the passing of simpler and more sincere ways of behavior. The younger man, however, sees the groom's innovations as an indication of the advancement not only of the peasantry but of the nation itself.

Al-Muwaylihi does not simply present the reader with an idealistic synthesis between old and new, foreign and indigenous. Unlike 'Ali Mubarak, he does not

present native characters who acknowledge the superiority or inferiority of either Arab or European culture. Nor does he offer an epic hero who navigates a simultaneously modern and classical identity amidst the dominance of Western culture and corrupt and progressive compatriots, such as al-Fariyaq or the protagonists of Salim. Instead of a singular synthesis that may form an ideal native Egyptian Arab Muslim subject, the author depicts multiple facets of native subjectivity, informed by differences in class, generation, education, and ideology. As well as the benefits, the author illustrates the violent processes, social tension, and cultural dangers in implementing reform. The magic realism hides a most striking fact in the text: There is no common denominator of Egyptian Arab subjectivity, as in ʿAlam al-din, not even among the Muslim majority. Nor is there a sense of an unquestionable secular Arab culture that binds all Arab subjects regardless of religion, as in Majmaʿ al-bahrayn. Rather, al-Muwaylihi unveils the conflicts within Egyptian and Arab society that result from forging a national subjectivity, conflicts that arise with the genesis of a new sort of self-consciousness. He reveals an epistemological and ideological violence found in synthesizing competing world visions. This violence is productive because the synthesis of the results tries to create an indigenous culture that is modern without losing its cultural authenticity or religiosity, all the while not alleviating the tensions inherent to such a process.

What I have tried to do in this chapter is survey certain shifts in prose writing. Regretfully, I have ignored the developments in short fiction, poetry, and gendered writings. Despite this shortcoming, I still hope to demonstrate the vitality and dynamism of Arabic literature during this period. Also, I hope to evince that experimentation by Arab intellectuals and literati with genres of long prose reflects their struggle in fashioning paradigms for native reform, cultural authenticity, and subjective efficacy, especially in the midst of massive social transformations and the intrusion of Western imperialism. Most of the *littérateurs* discussed in this chapter subscribed to paradigms of reform laid down by those such as Butrus al-Bustani and al-Tahtawi. These paradigms posited the import of secular knowledge and the establishment of cultural infrastructure that would lead not only to communal unity but also to national progress and civilization. Shifts between classical genres, the maqamah, the romance, and the historical novel, quasi-romanticism, and other hybrid genres show that these paradigms were always under reformulation, especially since they always included the troublesome component of import of Western knowledge, technology, and customs.

It is held that the nineteenth century was a time for the revival of the classical genres such as the maqamah. I would disagree. By the turn of the century, there had been an explosion of innovative Arabic long and short prose, poetry, and theater. While the maqamah was popular throughout the Mamluk period, the nineteenth century saw its death throes, not its revival. Within a few years of the serialization of *Hadith 'Isa ibn Hisham,* Ibrahim al-Muwaylihi and others published similar maqamat.[56] Esteemed neoclassical poets Hafiz Ibrahim and Ahmad Shawqi also wrote eclectic long prose. Ibrahim's *Layali Satih* is strongly reminiscent of the maqamah, particularly al-Muwaylihi's model, and even starts in a dream.[57] Shawqi, however, also writes a story with a Hellenic and Pharaonic setting, employing mythical characters and imagery.[58] This historical writing was neither new nor unique, and we will see that historical fiction enjoyed popularity in the first decade of the twentieth century, achieving its apex with the work of Jurji Zaydan. Even reformers like Lebanese expatriates Farah Antun and Ya'qub Sarruf wrote historical fiction, published in their respective journals, *al-Jami'ah* and *al-Muqtataf,* as well as, in the case of Antun, numerous other romance and didactic novels, including *Wahsh Wahsh Wahsh* (Savage, savage, savage) and *Hubb hatta al-mawt* (Love unto death).[59] Likewise, Jamil Nakhlah al-Mudawwar wrote a fictional travelogue set in the 'Abbasid age, *Hadarat al-Islam fi dar al-salam* (The civilization of Islam in Baghdad).[60] More significantly, the paradigms of the reform era had themselves begun to be transmuted if not radically challenged in new types of prose genre. In 1906, Muhammad Lutfi Jum'ah wrote *Wadi al-humum* (Valley of sadness), along with an extended preface introducing the genre of realism. Likewise, socialist Niqula al-Haddad, a brother-in-law of Farah Antun, wrote several books, now forgotten, in the vein of social realism, including *Al-'Ayn bil-'ayn* (Eye to eye) about the pitfalls of usury.[61] The existence of these texts along with others, such as Tahir al-Haqqi's *'Adhra' Dinshaway,* testifies to the fact that the literary and epistemological possibilities of realism as a genre existed in the Arabic cultural milieu as early as the beginning of the twentieth century.[62]

However, it was not realism but romanticism, that was to seize the reins of modern Arabic literature. In 1912, Jubran Khalil Jubran published his groundbreaking novel *Al-Ajnihah al-mutakassirah* (Broken wings). Irrespective of whether this was or was not the first novel written in Arabic, the language and structure of the story hailed a complete reconceptualization of native consciousness and Arab subjectivity. Romantic tropes that appeared sporadically in the fiction of Salim al-Bustani and al-Qasatli now unambiguously replaced

the paradigms of social and cultural reform, which by that time had become almost institutionalized. In Jubran's first novel, for example, not only does the heroine tragically die in the end and the hero mourn at her grave, as in Poe's "Annabel Lee," but also bucolic scenes of gardens and parks are presented in place of an urban landscape, even though the story takes place in Beirut. In 1913, Muhammad Husayn Haykal published the monumental *Zaynab*. The melancholic and alienated narrative and pastoral imagery confirmed that romanticism was to become the dominant genre in Arabic prose and that subjective consciousness had taken on new ontological profundity. Romanticism and the rise of the Arabic novel as we know it marked, therefore, the end of the Arab renaissance and the reconfiguration of the criteria used to define cultural success and an ideal Arab subjectivity. However, before Arab readership and penmanship would arrive at this romanticism, its diachronic paradigm of progress and civilization would find its voice most popularly in the historical novels of Jurji Zaydan, whose success and impact no one can deny. In addition, we will see that in both fiction and nonfiction, the presence of Western success will remain to haunt Arab consciousness and subjectivity and continue to be a source of contention as well as the catalyst by which the Arabs both reject Western imperialism and internalize its discourse of success and modernity.

5

The Great Debate

No...no...How could he surrender himself to this sort of logic? To
do that would be to reject his reason and his science. Who is able to refute
the civilization and progress of Europe? Who can deny the degradation of
the East, its ignorance and its sickness? Hasn't history passed its irrefutable
judgment? There is no way that we can disavow that we were a luxurious
tree, which for a time flowered and bore fruit. Then, unfortunately, the
tree gradually slowed down to produce nothing new.

Yahya Haqqi, *Qindil Umm Hashim*

We shall show that there is not speech without reply.

Jacques Lacan, "Fonction et champ de la parole et du langue"

The previous chapters theorize the ways in which intellectuals and literati located and defined their identity within humanist, positivist, and universal criteria of "mankind" in order to rectify derailed Arab culture to the tracks of progress. It was no coincidence that Arab reformers took particular interest in the European Renaissance, the Scientific Revolution, and the Enlightenment. By opening the question of "Enlightenment," the reformers identified with the grandeur, success, struggles, and history of Europe. This identification implicitly drew them into a Hegelian dialogue with the West in which they were bound to find their own culture lacking in the universal spectrum of historical, social, and culture progress.

This study consciously has concentrated on the indigenous forensics of culture and society. Concerned with the internal voices that instituted modernity, I have avoided an entanglement with the annals of justifications for imperialism and colonialism and left the plethora of literary, missionary, bureaucratic, scientific, artistic, and Orientalist texts to other scholars of postcolonial

studies. The impugning articulations found in that archive haunt nineteenth-century Arabic writing and thought. If the mantra of progress and civilization, then, is a symptom of the repression of the threat felt by these intellectuals and their implicit fear of European supremacy, this chapter offers a diagram of this Hegelian conflagration as it unfolded in a cordial confrontation between intellectuals. Specifically, we will focus on the renowned debate between Shaykh Jamal al-din al-Afghani (1838–97) and the Orientalist Ernest Renan (1823–92). While this book is concerned with the homegrown generation of modern Arab identity, we recognize that al-Afghani was not an Arab. He was, as Nikki Keddie supposes, Persian.[1] However, he worked for some years in an Arabic milieu and lived in Egypt, and the force of his thought and activism left an indelible mark on his Arab contemporaries as well as generations to come. His circle of acquaintances included Muslim, Jewish, and Christian intellectuals such as ʿAbd Allah al-Nadim, Yaʿqub Sannuʿ, and Adib Ishaq, and he contributed to al-Bustani's *Daʾirat al-maʿarif* and Arabic journals such as *Abu al-nazharah, al-Basir, Misr, al-Manajir,* and *al-Tijarah.* Most notably, he wrote commentaries in *al-ʿUrwah al-wuthqa,* the Arabic language broadsheet published in Paris with Muhammad ʿAbduh, who is said to have been his editor.[2] He resided in Persia, India, Istanbul, and Egypt as well as in Paris, and his writings and theories reflect the predicament of Islam during the colonial era, addressing issues of communal and intellectual rejuvenation, historical successes and failures, and religious reasoning apart from and regarding the confrontation with British designs on the East. Considering his impact on the Arab world, the discursive articulations enunciated in his debate with Renan are representative of an epistemological and political struggle endemic to the paradigms of the sociocultural reform with the Arab provinces of the Ottoman Empire.

Long before the al-Afghani–Renan debate, intellectuals tussled with methods and criteria for sociocultural reform, internally debating ways to regain lost cultural dynamism and communal unity. Muslim scholars in eighteenth- and nineteenth-century Damascus, Cairo, and Baghdad were reformulating classical, rationalist, and Sufi schools of thought to redefine their communal and confessional identity. In the formation of modern Arab identity, we have seen that Western presence is acknowledged as a necessary mediator for social, cultural, and political success and reform. Only Western intervention, specifically the physical *and* ontological presence of the West, bridges the gap between subjective incompetence and national unity, a gap that the Arab subject alone is allegedly unable to traverse. In the preceding chapters, the narrative and logical sequences and consequences of the work of the Bustanis, al-Shidyaq, al-

Qasatli, al-Nadim, Mubarak, and al-Muwayihi highlight this tension. In their confrontation with the West's imperialist hopes to control the region directly or indirectly, and against the seemingly overwhelming political, economic, and military might of the colonial empires, intellectuals reinscribed the very presence of the powers against which they were struggling. The efforts and production of these cultural producers, social critics, or political activists resulted in the entrenching of a master narrative of historical success, cultural failure, and contemporary lack into the analytical apparatuses that generations would use. The West is *recognized* not only as masterful (in this case, mastering knowledge, social progress, and civilization) but also as the eventual mediator of Arab access to, even desire for, these key objects of "concord and unity."

We have understood this process in psychological and Hegelian terms. However, Lacan's reading of Freud is marked by a particular Marxian accent that finds its origin in the theory of Alexandre Kojève. Kojève's stamp can be seen on Lacan when he asserts in "Fonction et champ de la parole" that a full ontological subject is one that possesses the privileged signifier and, consequently, mediates the desire of the lacking Other. In the case of the Arab renaissance, the West is viewed as representative of a successful ideal who masters science and thereby mediates the very ontological becoming of the Arab subject or, perhaps more accurately, mediates the non-becoming of his ontology. Kojève integrates the Marxist notion of work and *value* into this process of self-formation. That is, Kojève states that only through partaking of the "work" of the Master does the Slave "finally become aware of the significance, value, and the necessity of his experience of absolute fear."[3] Or, more suitably for our discussion, only through striving for progress and civilization does the native develop reverence for the Master. Yet Kojève, like Hegel, does not make this process unproblematic, symmetrical, or even reciprocal. It is the Slave who works and whose consciousness therefore expands.

> Man who works *thinks* and *talks* about what he is working on.... Thus, the working Slave is conscious of what he is doing and of what he has done: he *understands* the World which he has transformed, and he *becomes aware* of the necessity of changing himself in order to adapt to it; hence he wants to "keep up with progress," the progress which he himself realizes and which he reveals through his discourse.[4]

Kojève's language is not accidental, and it illuminates the struggle that binds the colonial subject. This subaltern subject is exposed to the power of the self-same and reacts against its apparent hegemony. Still he struggles, and through that

self-consciousness he is affected by and comes to own the episteme, which relegates him, at least temporarily, to a subordinate position. The dialogia and performance in *Nafir, al-Huyam, 'Alam al-din,* and *Hadith 'Isa,* among others, do just this. They attempt to work, speak, and create national, subjective, and libidinal consciousness, new organizations for the public and private selves. These texts strive to work out the intricacies of discourses of social and cultural reform that have their epistemological origins elsewhere. Accepting a paradigm that unquestionably positions modernity as the diachronic endpoint of sociocultural evolution, these texts invoke readily accessible and seemingly pertinent idioms (e.g., "love of the nation is a tenet of faith"), naturalizing them within a discourse of both authenticity and self-criticism. The genesis of new prose narratives was a critical political, cultural, and discursive technique by which cultural producers and reformers struggled to emulate the master by forging their own aesthetic venture. This aesthetic was, if I may invert Memmi and Fanon, the mold for the mask of authenticity that veils the master narrative of modernity. However, simultaneously, the literary efforts of these *udaba'*—particularly in regard to prose—endeavored to reimbue their culture with value, without reasserting the West (the Master) as the very standard of that value. What is important for this chapter is that the dialogue initiated by al-Bustani and his peers and its ironic conundrum is the epistemological circumstance for the reform discourse of the nineteenth and early twentieth centuries.

Renan and al-Afghani: Teleology of the Idea and Arab-Muslim Irrationality

So far, I have focused on the simulated and performed Hegelian dialogic in early modern Arab fiction or nonfiction and the ways in which they struggled with European presence and native failure. In this chapter, I examine a conspicuous instance where the dialogue between East and West migrates from its literary and social existence to the lectern. That this dialogue has become so public indicates to us the early date at which the colonial subject is drawn into a new discursive realm of value. The most prominent example of such a dialogue is the now renowned debate between Ernest Renan and Shaykh Jamal al-din al-Afghani, which appeared in the *Journal des débats*.[5]

Public debates and rivalries have a long history in the Arab intellectual tradition. In pre-Islamic days, poets developed rivalries of epic and infamous proportions that mirrored tribal rivalries, perhaps the most famous of which was the feud between al-Jarir and al-Farazdaq. Al-Hamadhani, to much fanfare, vanquished his rival, al-Khawarazmi, the most renowned poet of his day. The

debates were not limited to literary bravado but were traditional in other disciplines, including philosophy, as the debate between Ibn Sina and al-Ghazzali demonstrates. Philosophical debates undoubtedly took on a markedly political dimension, as was the case with the *shuʿubiyah* controversy and the rationalist *muʿtaziliyah* movement, which claimed all things, including the Quran, deserved rational and object inquiry. More contemporaneously, high-profile debates and rivalries reappeared within the reform community. The most notable if not rancorous was the debate between al-Shidyaq and Ibrahim al-Yaziji, with Butrus al-Bustani in the wings, in the pages of *al-Jinan* and *al-Jawaʾib*.[6]

In 1883, Renan presented a lecture, "L'islamisme et la science," at La Sorbonne, critically discussing the Arabs' claim to and inclination for the sciences and rational thought. It was not meant to be a debate; it was intended as a normal and "objective" exposition of Islam's relations to the sciences. As in *Averroès et l'Averroïsme*, the speaker claimed that "any person who studies only a little about the things of our time clearly sees the actual inferiority of Muslim countries, the decadence of the governance of their states by Islam, the intellectual nullity of the races that hold exclusively to this religion, their culture, and their education."[7] While the accusation was visceral and vituperative, the implication was more pernicious and far-reaching than accusing contemporary Muslim peoples of backwardness. Rather, Renan states that Arabs are, *by the nature of their race*, hostile to rational thinking. Their hold on early Islam was inimical to the very spirit of objective scientific thought. He adds, "As long as Islam was in the hands of the Arab race, that is to say, under the four first Caliphs and under the Umayyads, they did not produce any intellectual movement of a profane character.... The principle which triumphed in the world was in reality the destruction of scholarly inquiry" (1:948). The trope of the Umayyads as destroyers appears in al-Bustani's *Khutbah* but has a clear Orientalist pedigree, which the student of De Sacy reproduced and disseminated to an unparalleled degree.

The celebrated intellectual and scientific developments of the Muslim past, Renan concludes, were accomplished not by Arabs but despite them. The explicit subtext of Renan's assertions is that the Aryan peoples of Islam, particularly those of Persian and Greek origin, are responsible for the scientific and philosophic spirit of Islam's golden age. These pseudo-Muslim Aryans, "who only converted to Islam at a late date and without conviction," maintained their ethnic esprit (1:949). When the allegedly Persian-influenced Abbasids ascended to the Caliphate, he states, "everything changed" (1:948). In fact, "all these brilliant Caliphs... were hardly Muslims. They practiced the religion on the outside

only because they were the leaders, the popes. . . . They were curious about everything, especially about things exotic and pagan. They inquired into India, ancient Persia, and above all Greece" (1:949).

Apart from Greek, Persian, and Hindu learning, Renan is also eager to commend Syrian Christians and the Christian community in Harran for their contribution to the intellectual atmosphere and developments of the Abbasid age, but circumspectly he avoids calling them Arab Christians (e.g., 1:948, 952). He briefly mentions Andalusian Jews in the same fashion while he dubiously distinguishes the Turks for taking Islam and the East to even greater depths of cultural decadence than the Arabs (1:951). Renan does not deny that great philosophical and scientific gains were accomplished under Muslim auspices: "One might say that during this time, the Muslim world was intellectually superior to the Christian world" (1:947). Clearly, the Orientalist's attacks on the Arabs and the Turks rest specifically on a race, even blood-based theory. He disputes that these advances should be called Arab contributions. The Turks, however, are barely worth Renan's time. His target is the Arabs, to debunk the myth of their alleged contributions to science, art, and culture. In doing so, he repeatedly uses the metaphor of Greco-Persian rationalism in Arab clothes, asserting, "Such is the great philosophical ensemble, wearing so-called Arab garb because it was written in Arabic but which, *in reality*, is Greco-Persian."[8] Following that line of reasoning, he regards the eager reception of the Andalusian philosopher Averroes (Ibn Rushd) in medieval Europe as symptomatic of their desire for knowledge while at the same time the Arabs were spurning the thinker in the Muslim world. In full rhetorical stride, Renan responds to his own pedantic question, "This so-called Arab science, was it Arab in reality? In language but nothing but language!" (1:954). Unequivocally, he insists that "this science is not Arab!" The Orientalist continues, "Is it at least Muslim? Did Islam offer to rational research any aid? No, not in any way!" (1:955). The exclamatory nature of his statement reveals not only his anxiety but also the depths to which Renan feels compelled to rectify the historical record.

At a time when bohemians were romanticizing the learned history of the East, Renan states that Islam reflects the temperament of its Bedouin creators. The religion is fatalistic, narrow-minded, and antipathetic to rationalism and scientific thought (1:958). The Frenchman was an atheist, and it could be argued that he was not against Islam—only against all religions, including Christianity. This is a flimsy argument, however. He maintained an infatuation with the figure of Jesus and was invested heavily in Christian morality, despite his rebukes of the Catholic Church. Moreover, his attacks on Islam were unparalleled

in intensity and vociferousness. Emotionalism aside, his analysis was rooted in a racist paradigm. Similar paradigms, adopting a pseudo-scientific posture, proliferated in France during this time, as the work of Le Bon and Gobineau demonstrate.

While under Arab control, Renan proclaims, Islam was pedantic, dogmatic, and fanatical, "without any possible separation of the spiritual from the temporal" (1:955). Since then, the religion has dealt the most profound wounds to the liberty of humanity witnessed outside the Spanish Inquisition. His attack is relentless. "Philosophy was always persecuted in the hands of Islam," he states. "Philosophy was abolished in Muslim countries. Historians and writers were not spoken of except as a memory, a bad memory. Philosophical manuscripts were destroyed and became rare. Astronomy was tolerated only for the purpose of determining in which direction to pray" (1:953).

These allegations are not his own but are expressed by Muslim thinkers themselves, he insists. For example, Renan quotes the philosopher Abu al-Faraj to confirm that the Arabs were preoccupied with valorizing their language and contributed nothing to philosophy. This technique comes to a crescendo when he cites at length the reply of an anonymous *qadi* of Mosul to English archaeologist Sir Henry Layard in their epistolary dialogue. In researching the "manners and ways" of Mosul, Layard inquired into its pre-Islamic history. The Arab judge confirms Renan's contentions. The qadi says, "For the ancient history of this city, only God knows and is able to say how many faults its inhabitants committed before the Muslim conquest. It would be dangerous for us even to want to know. Oh, my friend, my dear, do not search to know things that don't concern you" (958–59). To corroborate his allegations, Renan's prosecutorial procedure blurs testimonial with ventriloquism. Asserted in the voice of an authoritative native, the testimonial provides the evidence of Arab fatalism and the lack of intellectual spirit. The creation of this metanarrative is uncannily similar to al-Bustani's metadialogue in *Nafir*. If the intent is different, the effect is similar. The technique of dialogue enacts the failure of Islam through the speaking voice of the unconcerned *qadi*. His testimony is performance, performance that provides evidence of Arabo-Islam's dereliction of secular history and knowledge. This neglect inevitably is contrasted with the Ur-spirit of the European intellect. The metanarrative indicates that the deck is loaded in the Hegelian confrontation between the Western and Arab worlds. The prism of seeming objectivity mystifies and reifies the very nomenclature of the debate (civilization, progress, rationality, and cultural decay).

The Value of Self

I purposely invoke the Marxian concept of value, which Kojève brought into our discussion of subject formation earlier. Within this concept, the relationship between work, commodity, and capital undergoes a radical transformation between use and exchange economies and between premodern and modern economies of Self. In Hegel's dialectic, the work of the Slave belongs to the Master who claims rights to the Slave's labor because he confronts death. But through this work, the Slave reaches the truest sense of consciousness. In capitalism, the bourgeoisie does not have a Master to define the standard of value. Value, subjective or otherwise, is attained through work or labor. Recognizing Marx's impact on his reading of Hegel, we acknowledge that Kojève maps the circuit that intertwines subjective value with ontology and social praxis in the modern era. The process of recognition between the Slave and the Master becomes more complex when, as a working and therefore active agent, the Slave is transformed into the creator of History. Or Kojève states, while the Master "undergoes History... [and does] not create it," the Master possesses a self-worth because he is the possessor and consumer of the Slave's labor.[9]

In Kojève's terms, work becomes something new in capitalism. It becomes autonomous as human action in relation to an idea beyond the community, which previously imbued the Master with self-worth.[10] We see the writer's elegant exposition of Hegel's influence on Marx. He states that the Masterless bourgeois, working only "for himself," is isolated by private property, a concept antithetical to community. Working for money, the value of the bourgeoisie's "work" comes from property itself, from the very idea of capital.[11] Marx shows us this system of instilling value in work, the commodity, labor, and the laborer him/herself. Through creating surplus value and capital, the process mystifies itself, erasing its own traces, only to appear as natural, even primordial.[12]

I suggest that this process of mystification and reification transpired during the colonial encounter. It necessarily transpired during a time that preceded direct colonial intervention in Southwest Asia. The process of mystification of not only capital but subjective value was facilitated by the illusory equity that seems inherent in the "dialogue" between the East and West, the apparent sincerity, good faith, or happiness, as J. L. S. Austin says, of both sides in engaging one another. That two intellectual and cultural traditions—not governments, factory owners, or armies—were speaking to one another served to reinforce that seeming symmetry between the two sides. The point is pertinent when

we understand that Europe's intervention in the region was almost in full throttle but also relied on the justification of its civilizing mission. That is, by the 1880s, Algeria, Tunisia, and Egypt had been subjected to direct or virtual colonial rule, while the Great Powers took active interest in Lebanon, Palestine, and the Maghreb. The fiction of Salim al-Bustani, al-Nadim, Mubarak, and al-Muwaylihi, for example, shows us that the economic, political, and cultural presence of France and Great Britain had become conspicuous to the degree that it could not be ignored. In fact, it had become intrusive upon the lives of even the rural populace. Accusations of backwardness abounded not only from Europe but also from "progressive" secular and nonsecular circles throughout the Arab lands. Despite this, reformers believed that through writing, traveling, studying, and even interaction, they could engage the West on an equal intellectual, academic, and cultural footing. The dialogue then, whether figurative or literal, offered such a platform.

As we have seen, responding to allegations of irrationality, ignorance, and backwardness, the Arabs implicitly accepted a standard for subjective fullness, mastery, and competence invested in a new epistemic terrain; that is, a new idea. For the nineteenth-century reformer, the idea is not capital per se. It is that which makes capital possible, specifically modernity or "civilization and progress" in the ideological nomenclature of the time. These concepts differed from the "traditional," cyclical conceptualization of social, cultural, and political development based on the accumulation and degeneration of wealth, power, and social networking as pondered, as we have seen, by Ibn Khaldun or Ibn al-Athir (1163–1233). Rather, for reformers, thinkers, and even progressive Ottoman bureaucrats, "civilization and progress" became transcendental in the Kantian sense—existing outside time, existing as universals. They became transhistorical and transcultural endpoints for universal advancement. For al-Bustani, ʿAbd Allah al-Nadim, Adib Ishaq, Muhammad ʿAbduh, or Jurji Zaydan, the idea of Enlightenment and modernity was measured through the degree of cultural, social, and philosophic *production*. "Civilization and progress," modernity and all of its humanistic regalia were not exclusive to discourses of reform but were rooted in the Ottoman Tanzimat.

They Are Arabs

The anonymous *qadi* of Mosul ironically would have been the target of the Tanzimat reformers. But al-Afghani was challenged in replying to Renan. The sheikh was an advocate of the new idea. Having attended Renan's presentation,

he responded in Renan's own *Journal des débats*. Al-Afghani's "Réponse" attempts to separate Renan's two indictments—that Islam is intolerant of science and that the Arabs were inherently hostile to rational thought. He acknowledges the primitive state of the Arabs during the advent of Islam, but states that "this Muslim and Arab child" came to distinguish himself "by the brilliant and fecund works which proved his taste for science, for all the sciences, including philosophy. No one can ignore that the Arab people, while they were in a state of barbarism, threw themselves into the channel of intellectual and scientific progress with a rapidity which was unequalled even by the rapidity of their conquests because, in the space of one century, they assimilated nearly all of the Greek and Persian sciences."[13]

Al-Afghani is clearly referring to mastery. Reminiscent of al-Bustani's writing, he argues for the Arabs' ability not only to be a custodian of knowledge but also to possess it. His argument reveals how Islam and Arab culture is sucked into a Hegelian dialogue with the West, a dialogue that can be reduced to a struggle for the recognition of cultural *and* subjective competency, mastery, and presence.

The very image of scientific mastery that al-Afghani recalls resonates with Renan's own description of how the Europeans received and gave sanctuary to Arabo-Islamic Aristotelianism. His admission of Arab "ignorance and barbarism" marks the starting point for the cultural movement of the Arabs (180). They prove, argues the sheikh, their ability to transform themselves from intellectual barbarians to cultural and intellectual innovators, thereby disputing Renan's deterministic race theory. The echoes of Renan's own stratagem become clearer when al-Afghani directly asserts that Europeans displayed little interest in such matters until "Arab civilization reached the summit of the Pyrenees and shined its light and richness on the Occident. The Europeans welcomed Aristotle as an immigrant who now had become an Arab, but when he was a Greek and their neighbor, they did not even think of him" (180–81). This passage nicely demonstrates al-Afghani's discernment. Arab command of science and philosophy takes on the same generative power as Western science does in the reform formulas. Moreover, al-Afghani implicitly addresses Renan's own metaphor of Greco-Persian knowledge in Arab garb by unequivocally stating that Aristotle *became* Arabized.

The force of al-Afghani's defense of the Arabs extends beyond their relationship to Europe. In this way, he depicts the historical Arab as autonomous, more Master than Slave. For example, the Arabs, he professes, transformed them-

selves as rulers and heirs of the great Hellenic, Roman, and Byzantine Empires. As conquerors, they provided the intellectual environment where the conquered could flourish culturally—a concept that corresponds with Hegel's theory of cultural production in the *Introductory Lectures on Aesthetics*. Like Latin and Greek, the Arabic language—denigrated by Renan—became the honored medium for intellectual inquiry regardless of the specific thinker's ethnic ancestry. Moreover, the Arabs should take some degree of credit for the glories that were written in their language (183). Al-Afghani's rebuttal is as intricate as it is problematical. Its language, logic, and criteria are indistinguishable from Ottoman thinkers and European Orientalists. Renan's race-based theory of cultural competence is directly attacked by the very positivist paradigm it purports to uphold. Mirroring the method of the Orientalist, al-Afghani continues to address Renan's claims point by point. Regarding the advances made by the philosophers of Harran, Syria, and Andalusia, al-Afghani politely calls attention to Renan's having failed to note that

> [t]he people of Harran were Arabs and the Arabs who occupied Spain and Andalusia did not lose their nationality. They remained Arabs. Several centuries before Islam, Arabic was the language of the Harranians. The fact that they converted from their ancient religion, Sabaism, cannot make them strangers to their Arab nationality. The early Syrians were also for the most part Arab Ghassanids, who converted to Christianity. When Ibn Bajah, Ibn Rushd, and Ibn Tufayl were unable to say that they were Arabs in the same veins as al-Kindi, it is because they were not born in Arabia. Above all, one wants to consider that the human races are distinguished by their languages. (181–82)

Al-Afghani wrenches the cultural propensity for secularism and rationality away from any racial determinants. In the vein of his senior Nasif al-Yaziji's *maqamah*, he disassociates Islam from Arab culture. He also reattaches the most renowned Muslim Neoplatonic and Aristotelian philosophers to their racial, *cultural* Arab origins. That is, just as Arab Christians were reconceptualizing their own historical-cultural position vis-à-vis a larger Arab identity, al-Afghani separated essential Arabness from race and Islam, not only making religion a cultural production but also removing it as a prerequisite for Arab cultural and racial identity.

In addressing the indictment against the "Arab race," al-Afghani ties together all of Renan's criteria for defining a civilized society: the recognition, compe-

tence, and mastery of science and philosophy, rationalism, subjective autonomy, and the capacity for cultural transformation. His argument exposes how the paradigms of identity and social progress were purely Hegelian. He does not argue against the racist nature of the criteria that supposedly define civilization or that allow one to be a creator of history. Rather, al-Afghani is arguing that the Arabs have successfully worked as Kojèvian Slaves and have been creators of history.

Al-Afghani's mind was as dynamic as his personality, and he was clearly arguing against Renan's most blatantly racist and stereotypical misrepresentations of Arabo-Islamic history. He was fully aware of the consequences of his argument and the repercussions of Renan's accusations. What I want to demonstrate is the complexity and self-awareness of the colonial confrontation with Western claims to rationalism and civilization. The debate in the minds of the colonized, the pages of their journals, and the salons of their diwans confirmed that the surplus value of cultural production remained in the proprietorship of the European Master.

The conclusion is inevitable, if not repressed, even for al-Afghani. If the Arabs are not inherently hostile to science and philosophy, he reasons, "one is permitted to ask how Arab civilization, after they had ascended so quickly to an apex above the world, was extinguished all of a sudden? Why was the flame not rekindled when the Arab world became enshrouded by profound darkness?" (183–84). This is the point at which al-Afghani, the Arabs, and the Muslims get dragged back into a mode of reasoning and analysis that was predicated on Renan's own discourse. The evidence of this is not difficult to collect. Al-Afghani provided a surprising answer to the question that he posed. Islam, he confessed, had suffocated rational inquiry. That is, after defending the Arabs, racially, culturally, and historically, al-Afghani placed the blame for their contemporary decadence on Islam. In no uncertain terms, he claims, "Above all, it is clear that this religion, where it was established, searched to suffocate the sciences, and it served wonderfully in the designs of despotism" (184). What is especially interesting is that this answer is the point of departure for al-Afghani's defense of Islam. The admission of guilt—that Islam is implicitly antithetical to rationalism—frames al-Afghani's redress of Renan's accusations on behalf of Islam. He confesses, "In truth, the Muslim religion has sought to suffocate science and halt progress. It has also succeeded in erasing the intellectual or philosophical movement and obstructing the spirit of the search for scientific truth" (177).

In the face of such a deduction, al-Afghani can do little to destabilize the naturalness of the endpoint of Renan's assertions. Therefore, like the elder al-Bustani's initial response to his own *fictional* Western interlocutor ("all people are liars"), he attempts to salvage his reply within similar universalist parameters.

> If it is true that the Muslim religion was an obstacle to the development of the sciences, is one able to affirm that this obstacle will disappear one day? How does the Muslim religion differ in this point from other religions? All religions are intolerant, each in its own way (177).

Al-Afghani invokes a familiar social evolutionism that is bound by the universalism of Man and that orbits around the likeness between the East and West. The tact is not only ideological but also strategic, considering Renan's contradictory proclivity for Catholicism and secularism. That is, Al-Afghani tries to expose the similarity between Islam and the Orientalist's own cultural tradition. His comments are not limited to the Church's past; in fact, Catholic authorities "continue energetically to struggle against what they call the spirit of dizziness and error" (178). The statement is not necessarily judgmental or accusatory. It acts as a gesture that mimics Renan's own argumentation. Al-Afghani's faithful reproduction of this positivist paradigm inevitably leads him to find that Islam is like "all religions" (177).

The irony is that his social evolutionism and defense based on universalism mystifies and naturalizes the etiology of progress and civilization. Within such an etiology, Europe is the teleological endpoint. The debate reproduced the psychology of the literature of the period and ironies of reform, as we recall that al-Afghani was himself an Abu al-Fath figure who found temporary refuge in France. This point, that Europe has arrived, becomes clearer when he states, "I hope that Muhammadan society will succeed one day in shattering its shackles and marching resolutely on the path to civilization, imitating Occidental society, to which the Christian insanity, despite of its harshness and intolerance, was not an invincible obstacle" (177–78). Therefore, the very social evolutionism that al-Afghani used to defend Islam unambiguously places Europe at the end of "the path to civilization." The effect was that his defense of Islam and his more forceful rebuttal on behalf of the Arabs are devalued by the very idea of a universal, historical progression.

Caught in this paradox—that Islam should be acquitted because of the universal nature of its guilt—al-Afghani offered a no less ironic and complex

conclusion that agrees with the ideological precursors to Romanticism.

> As long as humans exist, the struggle will not cease between dogma and free thought, between religion and philosophy, a fierce struggle in which, I believe, the triumph will not be for free thinking because reason is more unpleasant than foolishness. Its lessons are understood by only a few intellectual elite and because science, as beautiful as it is, does not completely satisfy humanity's thirst for an ideal . . . that philosophers and savants are not able to perceive or explore (185).

By arriving at this conclusion, al-Afghani moved to open up the field of knowledge where ontological fullness is found. Like Salim al-Bustani and others, he gestured to the transcendental. Instead of naturalism or emotionalism, he appealed to the sublime essence of faith, the "oceanic feeling," which, as Freud said, satisfied only an alternative ideal.[14] However, in this Hegelian dialogue with the West, the idea framing the debate was not a philosophical one of knowability. It was not concerned with the Neoplatonism of classical Islam which suggested that the sublime is beyond the visible. The idea was about the transparency of representation, as we have discussed earlier, about representing "truth" and reality objectively and unproblematically through the prism of progress and civilization. That is, al-Afghani attempted to shift the terrain upon which subjective and social value is instilled. He was unable to do so because his argument corroborated the notion that subjective value and cultural success are measured by the ability to participate in the *work* of modernity. More specifically, al-Afghani never questions the assumption that the Muslim societies must possess the ability to produce a secular civil society if they are to march on "the path to civilization."

In his final response, Renan invoked this universal path of civilization, which Europe has blazed in the modern period. As an example of the likeness that al-Afghani himself raised, Renan states that the hostility Averroes (Ibn Rushd) met in Islam was similar to the hostility Galileo encountered from the Catholic Church.[15] Therefore, he concluded that "the regeneration of Muslim countries will not be made by Islam. It will be to the detriment of Islam, like the rest. The great impetus for Christian countries started with the destruction of the tyranny of the Church during the Middle Ages."[16] The subtext of the argument is clear. If Muslims are to become civilized, to progress and develop, to break their traditional "superstitions and fanaticism," they must jettison Islam. The process by which one progresses is universal, but it is a process by which one becomes *like (comme)* modern European culture.

It is from this shared *likeness* that Renan salutes al-Afghani in the opening of his reply, welcoming him into the company of "other great infidels" such as Averroes, Avicenna, and, by association, himself. As a companion in rationalism, then, he celebrated his counterpart, exclaiming:

> Sheikh Jamal al-din is an Afghan, entirely free from the prejudices of Islam. He belongs to that energetic race from high Iran, the neighbor of India, where the Aryan spirit lives under the superficial cover of official Islam. He is the best proof for this great axiom that we often proclaim, that religions are only worth as much as those who profess them.[17]

The very effectiveness of al-Afghani's refutation is reversed. Instead of addressing the argument's particularities, Renan praised al-Afghani's ability to argue rationally, thereby overcoming the prejudices of his religion, like Avicenna, Averroes, and the Europeans. Yet, while Renan commended the level of the Afghani's intellect, the latter's capacity for rational, scientific inquiry was attributed to his Persian racial origins. The force of al-Afghani's argument, Renan claims, is a testament to the indomitable Aryan spirit and its natural "philosophical and scientific curiosity."

The irony of al-Afghani's apologia is more than an admission of guilt. Rather, the success of his intellect and argument springs from his ability to partake of the idea, the *episteme*, of progress. Consequently, his effectiveness becomes for Renan the very evidence of the failure of Islam and the Arabs and of Western mastery. Al-Muʿallim Butrus al-Bustani's dialogue, some twenty years earlier, was strictly narrative. In it, he struggled with his own inevitable conclusion that only through Western presence (ontological and cultural) can the Arabs reembark on the path to progress and national unity. In the debate between al-Afghani and Renan, the nature of the dialogue, its criteria, and its parameters are no longer rhetorical but empirical and epistemological givens. Al-Bustani's performative dialogue has become constative, taking on an objective quality and further naturalizing the idea of "the path of civilization." The difference between the two debates marks a shift from talking to the Other inside oneself and talking to the self as Other.

Antun versus ʿAbduh

Twenty years later, the debate found in the Renan–Afghani dialogue and in the literature we have examined takes on a new dimension. Intellectuals themselves begin to address the question of whether rationalism and intellectual-scientific

competence are inherent to Arab culture. In some of the fiction we have seen, native archetypes have championed and ventriloquized Western accusations of ignorance through fictive or anonymous voices. Some books would be written or translated that explicitly stated that Arabs were inferior, racially and culturally. The most prominent example is Fathi Zaghlul's translation of Gustav Le Bon's *Psychologie des foules*.[18] This study, however, has shown that it is not a question of internalizing the articulations of positivist or racist Western thinkers, whose authority is inscribed blindly through translation. Contrarily, we have seen that, while the premise of Arab cultural inferiority is argued to varying degrees, the accusation is rebuked, redressed, or deferred one way or another in virtually every piece of native writing. However, the Renan-Afghani debate is reconfigured, not necessarily as enlightened Arab versus ignorant or corrupt Arab as is the case elsewhere. Nor is it posed in such terms as reformer versus traditionalist, as in *Hadith 'Isa ibn Hisham*. Rather, the debate that would develop in regard to Islam's alleged ability to accommodate scientific and secular thought would inscribe a critical fissure in the discourse of secular subjectivity because it would take on a distinct confessional tenor.

Farah Antun (1874–1922), author and early socialist thinker, wrote in his journal, *al-Jami'ah*, several articles on the life, works, and impact of the great Andalusian philosopher and Renan's pet, Ibn Rushd, among other Arab and European intellectual figures. Not by coincidence, Antun also translated Renan's *Vie de Jésus* and was a fan of the French intellectual's radical secularism.[19] As an early socialist and relatively radical intellectual and tireless cultural producer, Antun's life was interesting. As we have seen, he was the author of several interesting although pedantic literary attempts that ranged from novel to melodrama to plays as well as innumerable translations particularly from French. Unlike many of his compatriots, he did not come from or near Beirut but from northern Lebanon near Tripoli, where he taught literature and the sciences after his secondary education. In 1896, he established his journal in Beirut, then moved it to Alexandria, presumably because of increasingly intrusive Ottoman press restrictions. After a degree of success in Egypt, he traveled to Paris and New York in 1905, taking his journal with him. His journal, marketed to both expatriates and the Arab world, faltered in the New World, however, and francophone Antun never seemed to be at home in New York. Returning to Egypt, Antun eked out a living until his premature death, leaving us an oeuvre that has yet to be critically examined.

In the meantime, the Mufti of Egypt and student of al-Afghani, Sheikh Mu-

hammad ʿAbduh (1849–1905), had risen to prominence as the most respected reform-minded Muslim cleric in the Arab world. He had been exiled twice to Beirut and Europe for his opposition to the Khedive's policy on Egypt's position regarding Britain and British policy in Egypt. As a graduate of al-Azhar, the foremost student and colleague of al-Afghani, and an erudite thinker, ʿAbduh was in a particularly good position to offer a critical appraisal of the state of Arab Islam. His commentary in *al-ʿUrwah al-wuthqa* and his well publicized sociopolitical editorials in the newspaper *al-Ahram* in 1876, in addition to his commentary to al-Hamadhani's *Maqamat*, demonstrate the wide range of social and political topics and academic disciplines that he could masterfully discuss.

Much of his work comes to us through his own disciple, the Lebanese cleric Rashid Rida (1865–1935), who had once been Antun's friend.[20] However, ʿAbduh's most profound work is perhaps *Risalat al-tawhid*, a series of lectures presented at al-Madrasah al-sultaniyah during his exile in Beirut. In this text, ʿAbduh expresses the complete reform paradigm regarding Islam, Arabo-Muslim society, history, and polity. He argues against *taqlid*, the blind acceptance of religious tradition and interpretation. On the other hand, he was a proponent of *ijtihad*, which is a personal engagement of the sources of Islam based on knowledge, education, and reason. ʿAbduh believed that this classical method was the only way Muslim Arabs could create an interpretation of Islam and the world appropriate for the modern age while simultaneously returning to the true spirit and dictates of the religion.

Delving into issues such as divine and free human will, the reliability of *al-Hadith*, and reasons for faith in the revelation of the Prophet and *ʿijaz*, ʿAbduh mimics the classical masters in *Risalat al-tawhid* by positing with erudition and logic the most important traditional and contemporaneous socioreligious issues. Moreover, like the Renan debate, the main thrust of the lectures was to communicate the fundamental rationality of Islam as a religion but also to show that this rationality was endemic to the Muslim intellectual tradition. Such a concern discloses the priorities of "Islamic modernism," the sociopolitical school of thought of which al-Afghani and ʿAbduh are seen to be the founders.

While a confessional text, ʿAbduh's manifesto resonates with reform discourse in general. Chapter 2 of *Risalat al-tawhid* demonstrates that ʿAbduh's discourse is rife with the nomenclature of knowledge. Knowledge, ʿAbduh concludes, is essential to social and communal renaissance and key to the redress

of Islam's current state of "decay." For him and his "modernist" successors, Islam requires its adherents to come upon the truth of the religion through rational and methodical reasoning. In doing so, rationality and reason allow the believer to understand not only God and nature but society and culture in objective and scientific as well as sublime terms. Religious, social, and cultural reform, to these activists, clerics, and intellectuals, would only be achieved by returning to this inherent rational impulse of Islam as represented most importantly by *ijtihad*.

As Grand Mufti of Egypt under the reviled Lord Cromer, 'Abduh took issue with Antun's commentary on Ibn Rushd, writing several articles and replies to him in his own groundbreaking scientific-social journal, *al-Manar*. Never missing a chance for publicity and a public intervention, Antun reproduced the debate in his book, *Ibn Rushd wa falsafatuhu*, and Rida followed suit by reproducing much of the exchange in his biography of 'Abduh.[21]

The debate between 'Abduh and Antun seemed to emerge quickly, burning brightly before burning out, but it informs us about social tensions between Arabs as much as their anxiety about the West. Antun launched his discussion of Ibn Rushd out of a sincere intellectual commitment to excavate the precedents for scientificism, humanism, and rationalism within his culture. However, 'Abduh viewed his articles as "belittling" Islam by representing it "between truth and falsehood."[22] His accusation is interesting because Antun focuses on how the philosophy of Ibn Rushd encountered much resistance during and after his lifetime. It is also interesting because 'Abduh's comments are specifically sectarian in tone and content, thereby putting into question the very secular-cultural project seen in al-Yaziji's invocation of the Quran and a Quranic language in the context of secular culture.

We have acknowledged previously that intellectuals of all religions maintained paradigms of reform that greatly resembled one another. Hence, it is the proposition of this research that while the lion's share of cultural producers under examination here may be Christian, indeed Arab Christians of Lebanese origin, the epistemology of their discourse differs little from their nonsecular reformist counterparts throughout the empire. This is not to say that confession should be overlooked, particularly because issues of political power, economic status, and social equality became increasingly divided along sectarian lines. This must be understood not as indicative of an a priori difference in Christian versus Muslim mentality but as a historical process from which capital, power, class formation, and colonialism cannot be separated.

What is important for us at this point of the study is that minority intellectuals were actively attempting to share in Muslim Arab culture and Islamic history despite their *dhimmi* status just as Muslim Arab intellectuals, such as al-Nadim, often bent over backwards to be inclusive in their formulations of reform. As we have seen, with al-Yaziji and al-Shidyaq, the method by which Christian Arabs could claim membership in their communal history was to recognize Islam as a cultural phenomenon, one in which they shared and to which they had contributed. Their discourse on identity was a secularizing gesture not because it called for only the separation of the Mosque and State, religion and civil society. This was after all a fundamental social assertion underlying al-Bustani's ideological, patriotic enunciations in *Nafir*. While it is a cornerstone of a modern civil society, this secularizing gesture is not without its own epistemological and discursive violence as it displaces the sacred in Islam by transforming it into the privatized profane in contrast to its previous omnipresent public status. This is, in fact, 'Abduh's point. Simultaneously, this displacement of the sacred to private space permitted minorities to match their economic gains with political ones in countries such as Palestine, Iraq, Lebanon, Syria, Egypt, and to a lesser extent the urban centers of North Africa. Therefore, the process by which Arab minorities could lay claim to the tradition of the majority was as delicate and complicated as it was necessary.

Antun's literary oeuvre represents the ambiguity, complexity, and contradictions of his minority status. However, this status should not overshadow his work or the work of most of his fellow secular Christian intellectuals. In fact, intellectuals like Antun, Salamah Musa, and Shibli Shummayil were in a double minority situation because they were visible, self-confessed atheists. Despite their radical differences from other intellectuals, these early socialist intellectuals held beliefs that could fall comfortably into the ideological platforms of even their rivals or Muslim counterparts. The discursive common ground between the various schools of thought reveals more than an "interfaith dialogue" or shared intellectual genealogy inherent to various "competing" ideologies and cultural production, such as secularism, positivism, Islamic modernism, or romanticism. It demonstrates a shared epistemology that informs these reformers' vision of modernity.

Returning to the issue of the debate, 'Abduh and Antun invoke the very same universalist discourse that al-Afghani and Renan used—a discourse reminiscent of Kant's notion of an undifferentiated mankind with the European man as model. Naturalized, the universality and transcendental truth of rationalism

are never called into question. Rather, the two argue over the propensity of Islam and the Arabs to master science, the place of religion in society, and its role in reaching civilization, both agreeing on the basic criteria of knowledge and reason to achieve this end result.

The bitterness of the debate between Antun and ʿAbduh was sparked by ʿAbduh and Rida's antagonism toward Antun as an interloper. Despite this, Antun tried with most conspicuous effort to appease ʿAbduh in his book *Ibn Rushd*. Writing in an exceedingly civil and reconciliatory tone, Antun explains the origins of his research on Ibn Rushd and the debate that ensued with ʿAbduh. He states that while ʿAbduh misunderstood and misrepresented some of his assertions, there remained irreconcilable differences of opinion on key historical and social issues. Despite this, the author insists, in an uncharacteristically wishy-washy tone, "that every human has the right to believe in his own opinion."[23] This statement is symptomatic of Antun's interest in Ibn Rushd in general. He had little interest in Ibn Rushd's true place in the Arabo-Islamic religious tradition or the actual profundity of his thought, although he dedicates some time to discussing his contribution. For Antun, Ibn Rushd was the pretext for an intervention on behalf of the freedoms of speech, scholarship, and thought and consequently the importance of the nondenominational, nonethnic, and potentially socialistic Young Ottoman movement.[24] ʿAbduh saw and resented this. Considering the intensity of the debate, it is surprising that Antun does not touch upon substantive issues in the opening pages of his book. He explains only that ʿAbduh accused him incorrectly of "defaming Islamic doctrines and tenets of Muslims" and alleged that his assertions were "between truth and falsehood" (2–3). The reader must wait to read the debate as the first half of the book is an expansion of research that Antun had previously published in *al-Jamiʿah*, the very articles that sparked the controversy.

The principal issue under debate is the degree to which Christianity and Islam infringe upon the progress and governance of secular society. More provocatively, the debate discusses not only whether the religions accommodate rational thought and knowledge but also to what degree they inherently and historically have oppressed its development. Much to ʿAbduh's chagrin, Antun distinguished between the secular and the religious, quoting the biblical idiom, "Render therefore unto Caesar the things that are Caesar's; and unto God the things that are God's." On the other hand, he says that in the case of Islam, the Caliph was invested with both secular and religious power, making it more

difficult to separate them (125). As ʿAbduh accused him of following the research of non-native, non-Muslim Orientalists, Antun did his best to cite Muslim Arab sources, even quoting a very lengthy passage from the writing of Qasim Amin, the famous advocate of women's rights. Amin also refused to entertain the question of which religion is more valid, insisting only that religion in general should remain separate from the civil-political sphere. Like Antun, he insisted that there is a natural "conflict" between the secular and religious that is not more acute in Islam or specific to it (211).

While the method of "compare and contrast" between Christianity and Islam runs throughout their debate, Antun does try to change the paradigm and terrain of what ʿAbduh successfully circumscribes. In a section entitled "Eastern Christians," he tries to discredit ʿAbduh's conflation of Eastern and Western Christians, insisting that "Eastern Christians do not have a relationship with Western Christians as they do with their fraternal Muslims." In evincing the cultural sameness of Christian and Muslim Arabs, he goes on to say that "when the Christians of the West came to the East during the Crusades, the Christians of the East did not join them as the famous Turkish writer Ahmad Jawdat Effendi wrote" (205). Furthermore, Antun dissociates the Eastern churches from their Western counterparts on the grounds of authenticity. That is, the Eastern Christians, inhabitants of the birthplace of Christianity, inherited and maintained true Christianity and "have not dirtied their religion by mixing it with politics as they have in the West" (206).

Despite the fact that he was an avowed atheist—a brave stance for an intellectual of his day—and a committed if not naïve socialist, it can be said that Antun's oeuvre is one of radical secularism from a Christian Arab perspective. In many ways, his work is more "Christian Arab" than that of his counterparts like Zaydan and Salim al-Bustani. Antun's most cited work of fiction, *Urushalim al-jadidah* (New Jerusalem), is set in Jerusalem during the Arab conquest. The city's Christian and Jewish inhabitants laud the entry of the Muslim army, who are seen to be ushering in a new period of tolerance and equality after Byzantine mismanagement and tyranny. Later, Antun wrote a moralistic story, virtually forgotten in the historiography of Arabic literature, entitled *Maryam qabl al-tawbah*, which is set in Palestine and is an allegorical story based on the figure of Mary Magdalene. As in the case of his other works of fiction, such as *Hubb hatta al-mawt* and *Wahsh Wahsh Wahsh*, most of the main characters are explicitly Jews and Christians. The issue of minority status is acutely apparent in Antun's work as is illustrated by his discussion of Palestinian Jews under

"Roman oppression" during the life of Jesus, comparing it to the English occupation of Ireland of his own time (194).

In the debate with ʿAbduh, as in *Urushalim al-jadidah*, Antun is explicit about the Eastern Christian contribution to Islamic Arab culture and society and takes pains to show that minorities cannot be separated from their greater cultural, social, and historical context. ʿAbduh, on the contrary, blurs the line between the Eastern and Western churches. By associating them with one another and effectively fusing Eastern Arab Christians with their European counterparts, the renowned Muslim reformer deprives Arab Christians of any claim to proprietorship of their culture. Antun refused, however, to allow him to make such an overarching gesture. He mentions the participation of Christians in the Islamic empires, which by that time would have been standard. For example, he talks about the advances of Arab Christians under the high Abbasids, devoting some time to Jurjius Ibn Bakhtishuʿ al-Nishapuri, al-Mansur's doctor, whom al-Bustani mentions in *Khutbah* (130–31). The text has an apologetic quality to it that cannot be ignored. Antun states that "contemporary European civilization and tolerance [*tasahul*] are not the fruit of the Christian Church." It is undoubtedly guilty of intolerance, fanaticism, and irrationality (207–8).

The point of Antun's research on Ibn Rushd and the subsequent debate, however, is not necessarily to claim proprietorship over Islamic Arab culture. It is, rather, to erase the very distinction of religion in Arab culture; in other words, to radically secularize Arab culture and society. Indeed, this is what ʿAbduh was reacting implicitly against. Throughout his polemic and reply, he concurs with ʿAbduh's accusation of Christian "fanaticism," "intolerance," and the Church's historic aggression against science. He argues for a universalist understanding of religion and the same universalist understanding of the primacy of secular, rationalist knowledge that underscores the renaissance project in general (87). In fact, he specifically argues for a positivist, materialist, and causal understanding of the world in which he lived (91).

Despite Antun's attempt at being nonjudgmental and nonprejudicial, his conclusions find their logic in the very epistemology of the *nahdah*, uncannily resembling the writings of his numerous intellectual counterparts. That is, Antun could not help but claim that the difference between Christianity and Islam is, in the end, a question of progress and civilization. He states that "science and philosophy have enabled us now to be victorious over Christian oppression, and with this, their plant has grown in the soil of Europe, ripened and become the fruits of modern civilization. But the two have not yet enabled us

to be victorious over the oppression of Islam" (125). While Antun never argued according to a race-based theory, clearly he and 'Abduh were debating whether or not the idea of progress and civilization—the cornerstones of modernity—is inherent to Arabo-Islamic culture. Despite their differences, 'Abduh, al-Afghani, Antun, and Renan based their arguments on the same mutually accepted epistemology and failed to question the hegemony of the new logos of "knowledge."

We recognize that they argued from a single epistemological platform. This recognition reveals the discursive sameness that underlies their enunciations. Therefore, while it is fascinating, we are not surprised to read that Antun insisted on the necessity of becoming *like* the West. This likeness does not mean imitation, however. While praising European culture and history, Antun also warned against European designs on the East, decried blind imitation, and impugned Western moral fiber (176–77). Rather, the likeness is that of the "comme" in the debate between al-Afghani and Renan. It is the sameness of the idea. This is understood from the very first pages when Antun dedicates his book to the birth of a new generation of Muslim and Christian Arab secular intellectuals.

> These intellectuals, these "new buds" in the East, have become numerous in every community and every religion in the East. They know the detriment of mixing worldly affairs with religious matters in an age such as our own. They have come to seek a sacred and respected place for their religions on the side, so that they can master unity—real unity—and keep up with the current of European civilization and be able to compete with its people. If they cannot put religion aside and master unity, this current will pull them down altogether and make them all subjects of others. ("Dedication")

The tenor of the 'Abduh–Antun debate took on a new urgency for Arab reformers during direct colonial intervention; cultural and social reform became an important issue in discussions of self-governance and of the struggle for national independence. The Hegelian dialectical nature of the dialogue strongly surfaces as Antun voices his concern regarding the danger of enslavement. Al-Afghani, 'Abduh, and Antun, like their intellectual peers, were keenly aware of this threat and tried to address it through a dialogue; they attempted to allay it through participation in the idea. Ironically, blinded by the vision of Enlightenment, the vision of progress and civilization, this very method,

the debate, proved to be one of several processes by which the idea becomes reified. Nietzsche's critique of Hegel's views on "monumental" history and the valorization of the idea is relevant: "[Hegel] has implanted in a generation ... the worship of the 'power of history' that turns practically every moment into a sheer gaping at success. . . . If each success has come by a "rational necessity," and every event shows the victory of logic or "the Idea," then—down on your knees quickly, and let every step in the ladder of success have its reverence."[25]

6

Doubleness and Duality

Allegories of Becoming

Hilary Kilpatrick offers a valiant but insufficient solution to the competing theories of the development of narrative prose. She asserts that the novel is not a singular phenomenon but has separate pedigrees and strains of development according to region. This explanation simply confronts the myth that the Arab world is a homogenized cultural, historical, and linguistic space with one linear and unified literary tradition. However, apart from ignoring the politics of the historiography of the Arabic novel, her argument incorrectly assumes that, conversely, the diverse regions such as the Levant, Egypt, the Maghreb, and Iraq had little significant cultural and political interaction.[1]

Like the correspondence republished in al-Yaziji's *Fakihat al-nudama'*, the works of Jurji Zaydan stand in testimony to how quickly new Arabic publications had reached all parts of the Arab world. Zaydan's seminal literary-scientific journal, *al-Hilal* (The Crescent), had an impressive readership that extended from Iraq to Morocco and gained a substantial readership in the Americas.[2] Although they are virtually unread today, the historical novels of Zaydan maintained unparalleled popularity for decades and, consequently, have been noted as formative in the growth of renowned literary figures of the Arab world. The Egyptian scholar and activist Taha Husayn read Zaydan's histories and novels as a youth. Najib Mahfuz, himself a historical novelist, specifically names Zaydan's novels as an early influence on his literary tastes.[3] In addition, during Zaydan's lifetime, several articles appeared discussing the merit and problems of his fiction, often in his own *al-Hilal*.[4] Zaydan's Arab, Islamic, and literary histories, which have overshadowed his fiction, elicited discussion among some of the most prominent intellectuals of the early twentieth century, including

Rashid Rida', Muhammad Kurd 'Ali (1876–1953), Père Louis Cheykho (1859–1927), and Muhammad Husayn Haykal.

Zaydan's subject position was a complex one. He was a Lebanese Christian expatriate who lived virtually all of his productive life in Egypt. While he found a substantial community of like-minded Syrian immigrants in Cairo, he wrote to a larger audience. By no means an "Arab nationalist" politically, he occupies a precarious position in the intellectual tradition of Arab identity. Zaydan was less the revolutionary than his fellow Ottomanist Antun, but, despite their public differences, he often found himself in the same position as Antun. The founder of *al-Hilal* was committedly secular. He was concerned with the Arabs' contribution to world history where Islam was only one, albeit the major, aspect. This stance attracted antagonistic responses not only from traditional Azhari sheikhs but also from Muslim reformers. For example, only a few years after the Antun-'Abduh debate, Rashid Rida is suspected of orchestrating the protest against Zaydan's appointment as the first professor of Islamic studies at the new Egyptian University. This mass action eventually resulted in the university retracting the offer.[5]

Shortly preceding this scandal, Rida attacked Zaydan's histories in *Intiqad kitab tarikh al-tamaddun al-islami* (Criticism of the book: History of Islamic civilization), stating that he lacked the proper training in *'ilm islami* to comment on Islamic history.[6] Like 'Abduh's attack on Antun, Rida accused Zaydan of relying on Western Orientalist scholarship and neglecting Arab-Islamic sources. While Zaydan avoids the subject of religious affiliation, Rida's comments are interesting because they are often explicitly confessional in content. He refers to Zaydan as representing the resurgence of "*shu'ubi* beliefs among the Christian intelligentsia." This was tantamount to accusing Zaydan of cultural treason, considering the *shu'ubi* adherents were seen as coming from Persian or foreigner origins (*'ajam*) who attacked Arab cultural hegemony and the legitimacy to the Caliphate.[7]

Despite the controversy, Zaydan was the most prolific fiction writer and intellectual of his day, and his impact is still felt on Arab historiography. The repressed confessional tension threading itself through his work deserves close and critical attention, which this study cannot afford. For now, we acknowledge that Zaydan was an ardent supporter of decentralization and constitutionalism and a defender of Istanbul even during the CUP's Turkification program. He believed that Ottomanism was the best way to preserve the rights of Arab Christians, maintain cultural authenticity in the face of the onslaught of Western

cultural imports, and achieve social progress for the Arabs in general. In spite of these principles, I want to focus on how Zaydan's writing strategies present a "procedure of intervention" during a crucial time in modern Arab history. Foucault explains that such procedures serve as "the methods of systematizing propositions that already exist, because they have been previously formulated, but in a separated state; or again the methods of redistributing statements that are already linked together, but which one rearranges in a new systemic whole."[8] Building on the works of his mentors and predecessors, Zaydan literary, social, and academic work embodies a matured set of representation of Arab selfhood and history that, despite the objections of many, took hold in the minds of innumerable nationalist activists preceding World War I.

Life and Works of Jurji Zaydan

The oeuvres and contributions of Jurji Zaydan (1861–1914) have been commented on considerably more often than those of Butrus and Salim al-Bustani.[9] Unlike them, and other intellectuals examined here, Zaydan wrote an autobiographical memoir that was in actuality an unfinished letter to his son, Emile. Published piecemeal in *al-Hilal* in the 1920s, it sheds light on his life before he arrived in Egypt. It was only published in full in 1968, under the title *Mudhakkirat Jirji Zaydan*.[10]

Zaydan was born in Beirut in 1861. His father owned a small restaurant where Jurji worked as a youth. He entered the Syrian Protestant College in 1881, distinguishing himself despite his humble origins and the paucity of formal education. The following year, the infamous Darwinian Crisis occurred at the college in which a young professor of biology gave a graduation speech that vaguely endorsed Darwin's theory of natural selection. Upon the professor's immediate dismissal, Zaydan joined SYC students in staging the first Arab student strike in the modern era. Student activists were expelled, several of whom would become leaders of the Arab renaissance. After his expulsion, Zaydan emigrated to Egypt, where there was a large community of Levantine expatriates including several alumni or ex-affiliates of the Syrian Protestant College. Arriving in Alexandria, which had been recently demolished by the British suppression of the 'Urabi revolt, Zaydan found work with various literary-scientific journals, among them *al-Zaman*, edited by Alkasan Sarafian, noted for its anticolonial views.

In 1885, he joined Gordon's British expedition to save the beleaguered Kitchener in the Sudan and to crush the Mahdi revolt. Zaydan opened his

monumental journal, *al-Hilal*, in 1891, the same year he wrote his first historical novel, *Al-Mamluk al-sharid* (The fugitive Mamluk prince). His historical novels cover virtually the complete history of Islam up to the Committee of Union and Progress (CUP) and the Young Ottoman revolution in 1906. *Al-Hilal* contained a plethora of information on scientific phenomena, world history, political developments, ethnographies, and numerous serialized biographies of both Western and Arab historical and contemporary figures. It was founded on the model of *al-Jinan*, but it surpassed it in organization, breadth, and regularity. He traveled to London, returning to Egypt in 1912 and writing an account of his travels, which he serialized in *al-Hilal* in 1913. He maintained many ties with his birthplace, educating his son Emile at the Syrian Protestant College and often summering in Lebanon.

Zaydan is well known for his monumental histories of Islam, the Arabic language and its literature, and biographical encyclopedias. A few titles are *Tarikh al-'amm* (Universal history), *Tarikh al-tammudun al-islami* (History of Islamic civilization), *Tarajim mashahir al-sharq fil-qarn al-tasi' 'ashar* (Study of famous people of the East in the nineteenth century), and *Tarikh adab al-lughah al-'arabiyah* (History of the literature of the Arabic language). Although Zaydan was not actively involved in politics, he supported the secularist CUP, and following the coup of 1906 he produced a historical novel, *Al-Inqilab al-'uthmani* (The Ottoman revolt), about the tyranny of Sultan 'Abd al-Hamid. He was also vocal on many social issues, such as education, freedom of speech, women's rights, and even prostitution.

Reproducing the Victorian morality of his former teachers, these articles reflect the author's degree of sincerity, thought, and involvement in the social affairs of Egypt and the Empire. Like al-Mu'allim Butrus, Zaydan married Maryam Matar, a graduate of the missionary American School for Girls, with whom he had four children. Emile took over his father's position as editor-in-chief of *al-Hilal* after Jurji's death in 1914.

National Allegory and the Historical Romance

The historical novel enjoyed success well into the twentieth century due to the efforts of Salim al-Bustani and Jurji Zaydan. That Zaydan chose to write historical novels is no coincidence. If modern knowledge was the panacea for the ills of the region, what better mode of its public and mass dissemination than the historical novel? But literary form should not be wrenched from its content. In

other words, the aesthetic choice of the historical novel is significant for the most profound political and social reasons. According to Georg Lukács, its success reflects a pivotal change in consciousness that emerges out of the genesis of a new, dynamic bourgeoisie. This is certainly the case in the Arab world. Not only did the new prose of writers like Salim, ʿAbd Allah al-Nadim, Antun, and al-Muwaylihi mold a model of bourgeois character and ethics, but their narratives were underwritten by the same Spencerian ideology as found in the nonfiction of Yaʿqub Sarruf and even socialist Shibli Shummayil. These intellectuals clearly articulated the ethos and ideals of the new albeit amorphous bourgeoisie, who were concerned with making the most of accumulating the growing native capital surplus while intellectually, economically, politically, and culturally engaging the West. Considering the increased control of the Great Powers in the daily economic, political, and social affairs of the Arab Middle East and North Africa, Lukács's comments concerning Napoleon's effects on the national consciousness in Europe seem pertinent. He explains that the appearance of the historical novel in the West is the consequence of "the appeal of national independence and national character [which] is necessarily connected with a reawakening of national history, with memories of the past, of past greatness, of moments of national dishonor, whether this results in a progressive or reactionary ideology."[11] Therefore, despite its pulp exterior, the genre of the historical novel itself was a crucial political statement that invites deeper reading.

I understand how this materialist contention may deflect from the methodology of this study, which understands epistemological and discursive formations as constitutive of the economies of identity, society, power, and capital. I also realize how Lukács's materialism forces us to an inevitable analysis of reading Zaydan's historical novels as allegory, particularly as what has become known as "national allegory." The concept of national allegory presents many dangers, many of which have been debated as a result of Fredric Jameson's controversial article.[12] However, if carefully done, it allows us to examine the representation of the subjective ideal put forth by the texts' explicit didactic aims.

Because of its challenges, Jameson's article was a catalyst in refining our thinking of national allegory. In it, the author slides comfortably into a universalizing myth of literature and aesthetics as well as slavishly adhering to West/East and Self/Other binaries, which he usually attacks. It is uncanny, in fact, how his theory resonates with the problematic articulations of our Arab intellectuals found in this present study. As Aijaz Ahmad states, Jameson's deployment of the

notion of "Third World" as an analytical tool "reinvokes Hegel's famous description of the master-slave relation." The effect is that he "divides the world between those who make history and those who are mere objects of it."[13] Although incomplete, Ahmad's critique is a noteworthy starting point as it indicates the pervasiveness of the Hegel's conceptualization of subject and history but also because it highlights the erasure of local specificities that inform cultural production.

Indeed, Jameson's article is largely consistent theoretically with his most complex work, *The Political Unconscious*. In this monumental 1981 study, he states that "history is inaccessible to us except in textual form" (34), which assists us in isolating and privileging "elements *within* [historical] totality" (27). Hence, his Marxist hermeneutic interpretive method intends to "recover the original urgency [of the historical moments] for us only if they are retold within the unity of a single great collective story" (19). He states that the "expressive causality" of an indeterminate text represents a dialectical relationship between master narratives and the specificities of the text, consequently "[reflecting] a fundamental dimension of our collective thinking and our collective fantasies about history and reality" (34). As the universalizing notions of totality spill into his "Third World allegory" article, Jameson collapses time, space, and literature into one category of "Third World literature." The universal master narrative structuring the critic's analysis undermines his famous call to historicize and contextualize cultural production. While raising issues of economy and libido, he denies the complicated network of desire at the heart of national literatures by failing to take into consideration the contentions of language and self that communicate libidinal conflicts endemic to nationalist ideology. Nor does Jameson critically reevaluate the concept of allegory itself as Craig Owens does in "The Allegorical Impulse."[14]

Ironically, the article's shortcomings have provided us with a productive event to begin to engage popular texts previously dismissed as inferior, pulp, or crude because of their ideological intent. In this study, I salvage the notion of national allegory if only by using it tactically and rooted in close readings in the original language, unlike Jameson. This methodology recenters Zaydan's otherwise dismissed popular novels as foundational to modern Arab subjectivity, while avoiding Jameson's epistemologically and aesthetically loaded critique, which is so invested in a universal master narrative. Confronting Jameson more directly, I also find that libidinal and "private" enunciations of self and desire are part and parcel of national allegory. The formal, although not univocal, reading

of allegory that follows defines a narrative structure. As Paul De Man says, it delineates a "genetic pattern" of the representation of the Arab subject as expressed in Zaydan's fiction. According to De Man:

> In literary studies, structures of meaning are frequently described in historical rather than in semiological or rhetorical terms. This is, in itself, a somewhat surprising occurrence, since the historical nature of literary discourse is by no means an a priori established fact, whereas all literature necessarily consists of linguistic and semantic elements.[15]

This comment seems particularly pertinent to the contemporary state of modern Arabic literary studies, and it calls attention to the need for methodologies such as those offered by the present research. More to the point, De Man's notion of genetic patterns is useful in opening a discussion of an allegorical reading of Zaydan's fiction because it reminds us to search for the discursive referent to the allegories of historical novels, not to their historical veracity or periodization.

When looked at formalistically and structurally, genetic patterns easily surface. In Zaydan's novels, three plot patterns can be discerned. The first is that the story rotates around the separation and unification of the protagonist's family, as in *Al-Mamluk al-sharid* and *Istibdad al-Mamalik*. The second involves the separation and unification of two lovers and ends happily.[16] The third narrates tragic stories, entailing the death of the heroine and/or hero, death of the (usually female) protagonist's parents, or unrequited love.[17] These three standard plot scenarios serve various pedagogical and indeed ideological goals of the reformer but also reflect the complexity of the subjective ideals that the author's fiction puts forth.

Despite this complexity, what interests me is how the fiction's genetics, regardless of plot structure, are similar in terms of subjective representation and its discursive effects. On the surface, we understand each novel as an attempt to educate a popular Arab readership in the history of its own identity, political events, and cultural achievements. Perhaps, more accurately, each work is an attempt to form an identification with a specific subjective ideal, an ideal with claims to historical truth. They articulate a rhetorical national sentiment that extends itself simultaneously to both public and private levels of subjectivity, such as social conduct, political propriety, interconfessional relations, gender roles, and moralistic virtues. The novels' didactic purposes, then, have the effect of forming public and private identities and even tying them together. In terms

of what De Man calls the texts' "semiological and rhetorical" patterns of representation, Zaydan's historical romances present two literary topoi: the fictional romance protagonists and the supporting historical figures. These two topoi do not demonstrate a conflation of public and private realms as Jameson has suggested, nor do they correspond in a one-to-one metaphorical or allegorical relationships. Rather, they delimit two separate but related social and political spaces, in conflict as much as they are codependent. In terms of the public, Zaydan's novels narrate the triumph or ascension of historical Arab leaders and their struggles with and victories over decadence, treachery, political intrigue, and immorality. Or conversely, his fiction narrates the downfall of historic figures who perpetuated these vices. Simultaneously, the plights of Zaydan's fictional protagonists—whether they are a family or lovers—emerge from the trials and turmoil of the historical moment thanks to the quality of their virtue, the sincerity of their affection, the solidity of their reason, and the stalwartness of their perseverance. As the stories of the fictional and historical characters intertwine, the representation put forth by the narrative illustrates an ideal personal and social subject (the fictional protagonists) and an ideal public and political subject (the historical figure), who is represented negatively as often as it is seen positively.

This very sketchy genetic pattern commits an injustice to the complexities, nuances, and pertinent deviations within Zaydan's literary oeuvre. Not only do his novels span Mediterranean and South West Asian history starting from the eve of Islam, but they involve fictional and historical characters who are often neither Arab nor Muslim, as is the case in *Al-Inqilab al-ʿuthmani, Armanusah al-misriyah, Fatat Ghassan, Ahmad ibn Tulun,* and *Fath al-Andalus.* However, my brief description of a genetic pattern common to all of Zaydan's novels serves to introduce the issue of representation of an ideal subject. Particularly, my observations hope to delimit the basic representational structure of Zaydan's novels whereby identity takes full form through the rapport between its historical, empirical, public face and its moralistic, human, private face. Therefore, to evade any further injustice to Zaydan's literary portfolio, I have chosen to focus on a single text, Zaydan's first novel, *Al-Mamluk al-sharid.* Examining the differences between the historical and fictional characters allows me to map out coterminous but interrelated allegories that emerge in one text, representing a subject who is both public and private.

Before I begin to discuss *Al-Mamluk al-sharid,* I would first like to engage further the notion of allegory, particularly its relevance to national romances.

Doris Sommer's *Foundational Fictions* treats the subject with impressive insight and rigor. It reveals the scholarly and literary value of the nineteenth-century romance novel, which has been traditionally dismissed as a valid field of study. Fundamental to her argument is the understanding that the popularity of romance novels during the nineteenth century is not due to the unrefined tastes of burgeoning national communities, in this case of Latin America. Rather, the genre served unique and precise goals in forming national identities by ameliorating class, intercommunal, and interracial antagonisms. Through an allegorical prism, Sommer discovers that the Latin American romance served to signify an ideal sense of national identity and that these national enunciations were informed by constructs of sexuality and sexual identity. Or as Sommer puts it, allegory allows her to understand sexuality and nationalism as two interlocking, not parallel, lines that trace one another and where "each helps to write the other" (42–43). Therefore, she is able to read national-patriotic and romantic-sexual desires as dialectical, mutually referential, and reciprocally legitimizing. Consequently, these coterminous desires, erotic and political, "weave between the individual and the public family," binding them together into the articulation of a national ideal that encompasses both private and personal realms of identity (48).

Sommer closely reads several Latin American romances, varying in national origin, political aims, and discursive effects. These close readings are, undoubtedly, not only fascinating and fruitful but thorough and methodologically sound, setting an example for postcolonial and literary studies. Her study demonstrates several important similarities between Latin American historical romances and their contemporaneous Arabic counterparts. For example, the separation of the male and female protagonists and their struggle and the obstacles to their reunion are never caused by interpersonal animosities. That is, the lovers' crisis is never a result of contrary desires or clashing character traits; it invariably springs from exterior forces. The social or political obstacles that lie outside their otherwise flawless characters hamper their love and, more accurately, their union. These external forces, the political and social, establish a clear bridge between the social and personal; they present the lovers' relationship to one another as a metonymy for the native subject's relationship to the nation (48–49). Another fundamental similarity, which this present study regrettably neglects, is the gender relations between protagonists. The foremost structural trait in regard to gender is that the hero in both early Latin American and Arab romances is the active, effectual character of the story. He overcomes

adversity, particularly by struggling against foreign invaders, internal rebels, or decrepit, corrupt, repressive leaders. Conversely, the heroine and most of the female protagonists are passive, coveted, dispossessed, fleeing, or oppressed. Confirmed by *Al-Huyam*'s plot, they are more often than not static. Just as Arab romance feminizes the land, Sommer reveals how the female figure is interchangeable with it. The two are fertile yet stagnant, relying on the male characters for its productivity or cultivation. The male figure is not only a catalyst but the metonym for the nation itself, the *patria* (257–58).

Despite these similarities, fundamental differences exist between Latin American and Arab historical romances, some of which have been alluded to here regarding the fiction of Salim al-Bustani. The most pertinent of these differences is the role of history and historical knowledge. Sommer states that the Latin American novel depends on the nonscientificity of its historical novels to establish the myth of a unified community (7–8). The Latin American historical romance was meant to construct an imagined and supplemental history in the place of what was seen as the lack of grandiose history as Europeans understood it. That is, the historical romance of Latin America constructed a monumental history, as Nietzsche says, a creation of "great moments in the individual battle [that] form a chain, a highroad for humanity through the ages."[18] Authors, says Sommer, would draw their inspirations "from private passions" in an attempt to articulate an idealized national community (9). Sommer's view is informed by her distinction between New and Old Worlds and a sense of monumental history found in the latter. The differentiation between New and Old Worlds stands in opposition to an understanding of the modern world as divided between the West and the East. Sommer's invocation of New/Old World dichotomy stresses Latin American writers' need to create specific histories regarding the origins of burgeoning Latin American nations but histories that were not necessarily beholden to historical empiricism (42). However, Nietzsche also notes that the process of creating history, even if empirically grounded as is the case in the Arab world and the project of Zaydan, differs little from "mythical romance" itself.[19]

As opposed to this, Zaydan, the historian, editor, and author, writes from a knowledge progress–centered epistemology. He was interested in the scientific method of cause and effect, which was valid over spiritual (*batin* vs. *zhahir*) paradigms of knowledge.[20] His novels find their authority in the scientificity, empiricism, and objectivity of history. The authenticity of history legitimizes the representation of these fictional narratives by intertwining them with em-

pirical, positivist historical knowledge. In other words, the ego-ideal that is represented in these texts is naturalized as an a priori historical subject. This sense of historicity is key because, for Zaydan, positivist knowledge, including historical knowledge that pertains to both the region and the world, is an essential cornerstone of societal progress and cultural renewal.

Just as the empiricism of historicity empowers the representation of the ideal as put forth in his oeuvre, Zaydan's mission is to foster a cathexis between the subject and knowledge. This point cannot be overstressed. He explicitly states that the genre of the historical novel permits him to create a desire for historical knowledge. In his introduction to the historical novel *Hujjaj ibn Yusuf* as well as in an article in *al-Hilal*, he explicitly states the relationship between desire, knowledge, and reform, which we have been examining in this study:

> We have seen from experience that the dissemination of history via the novel is the best means for arousing the desire for history; a desire that will make them ask for more. We intend that history dominate the story [*riwayah*], not the other way around as is the case in some European books.... This, the story, guides the reader and facilitates in the narration [*sard*] of historical event.[21]

Consequently, Zaydan's historical romances appropriate the power of love to instill historical knowledge. As we will see in the following allegorical reading of *Al-Mamluk*, love's power is threefold. It brings the protagonists together, whether they be family members or lovers. It binds communities and individuals to their homeland. And its motivations serve as an opportunity to represent the cultural and historical criteria of national selfhood.

Al-Mamluk al-sharid

Zaydan's novels easily lend themselves to Sommer's allegorical readings. The struggle of his male protagonists, their desire for their loved ones, their wandering or searching in foreign lands—all demonstrate a similar metonymic relationship between the hero and his beleaguered homeland. My readings of Salim al-Bustani's *Al-Huyam fi jinan al-Sham* and *Salmah* in chapters 3 and 4 address this metonymy. We remember that al-Bustani's female protagonists are cathected as an ideal national object of desire while the male protagonist's desire for her arises from her progressive characteristics, most notably Wardah's

cultured and Salmah's virtuous personae. The unification of lovers or, in the case of *Salmah,* their ironic tragic end refers to the promises of national unity and progress. Indeed, this allegory is predicated on a problematic formula that reveals the epistemological pitfalls of the reform project. The object of national (Suleiman's) desire in *Al-Huyam* is not constituted as an authentic and autogenetic hometown heroine. Rather, Wardah is a substitution for the European Mme Bellerose. While the native love object displaces the European object of desire, it is the latter which sets the criteria for success.

The historical novel disseminated this cathexis throughout the Arabic-speaking world. Many works discussed in the previous chapters were of a historical nature.

Salim's first historical novel was *Zenobia,* in 1871. An enigmatic Lebanese immigrant to Egypt, Jamil Nakhlah al-Mudawwar, wrote *Hadarat al-Islam fi Dar al-Salam,* which is a faux-travelogue set during the high Abbasid Caliphate.[22] A renowned neoclassical poet, Ahmad Shawqi, wrote several historical novels, including *Riwayat Ladyas* and *'Adhra' al-Hind.* Among his other experimental social realist and romance novels, we have mentioned that Farah Antun produced the historical utopian novels about the Arab conquests (*Urushalim al-jadidah*) and biblical days (*Maryam qabla al-tawbah*) as well as historical dramas including *Al-Sultan Salah al-din.*[23] Zaydan, however, perfected the popular historical genre and offered a power yet unseen in Arabic literature. That is, his historical fiction refers us beyond a singular, one-dimensional representation of national success to new depths and facets of the national subject, to newly bifurcated public and private space.

Zaydan's novels, while containing their own political and ontological ambivalences, generally have characters that are arranged within clear dichotomous relationships, particularly along a good-bad, virtuous-ignoble, and reformed-decadent axis. For example, *Istibdad al-Mamalik* (The Mamluk oppression), written two years after *Al-Mamluk al-sharid,* is what I would call its sister story because it is the only other novel dealing with the fragmentation and reunion of a family, as opposed to lovers.[24] Also, *Istibdad* is the second of three novels related to the Mamluk dynasty, the third being Zaydan's last novel, *Shajarat al-durr.* Unlike *Al-Mamluk, Istibdad*'s tragedy originates from the tyrannical rule of 'Ali Bayk the Great, Mamluk ruler of Egypt. His ambition, greed, and uncontrollable wrath fragment and scatter the family of 'Abd al-Rahman, pious merchant, his devoted wife, Salmah, and his learned son, Hassan. The examples, actions, and tone of speech of 'Ali Bayk and Muhammad

Bayk Abu al-Dhahhab, the leader of 'Ali Bayk's destructive campaign in the Levant, stand in clear contradistinction to the rationality, selflessness, and virtuousness of 'Abd al-Rahman and Hassan.

Doubleness and Signification

While the fictional protagonists in *Al-Mamluk al-sharid* are no less noble or virtuous than *Istibdad*'s 'Abd al-Rahman or Hassan, their identities are far less firm and undergo a marked crucial subjective movement. The movement is, most simply, the return from a state of fragmentation and displacement to stability and fullness. More specifically, every fictional protagonist in *Al-Mamluk* is at one time or another disguised by a double identity. This *doubleness* sets up a movement between false and true identities, which is the narrative of the story itself. The movement from secondary to primary or false to true identities is what Deleuze and Guattari might call a process of *becoming*. This process transpires on a series structured by an inauthentic/authentic binary similar to the absence/presence binary that enframes the very ontology of Arab subjectivity. In discussing the necessity of becoming "minoritarian," Deleuze and Guattari use not ontological examples but examples of subjectivity, such as female, Jewish, and black identity. The discursive, social, and ontological processes by which Arabs assumed their new sense of identity correspond to the process of becoming "minor," as we recall the early discussion on al-Yaziji's *maqamah*.[25] This is because the epistemological boundaries of reform discourse remained delimited by the principles of universality that they consciously and unconsciously purported. That is, intellectuals worked within and indeed enacted a condition of modernity that would locate them on the evolutionary yardstick of "progress and civilization." As is the case in the fiction of al-Bustani, al-Qasatli, Mubarak, and al-Nadim, the protagonist in Zaydan's novel becomes fully recognizable vis-à-vis the universal criteria determined by the Self-Same or Major. In other words, he becomes a masterful subject when he can demonstrate that he is a true historical actor, an innovator, a unifier, and a producer.

A crude reading of Zaydan's historical novels might divine that they are an attempt to regain "past glory." Or his novels recover a preexisting and rightful identity undeservedly stripped from the hero, as in the case of Dumas's *Count of Monte Cristo*. Rather, the becoming found in his novels is more than a reclamation of an authentic identity but a course to what the subject should and can

become. The protagonists present the possibility of becoming Major when one finds himself in a condition of liminality.

In *Al-Mamluk*, the subjective movement of the fictional characters begins not with their original identity but with an assumed identity. The characters may or may not know that this secondary identity is not their true identity. This instability, therefore, signifies that the subject is in a state of subjective anomie, ineffectual and inauthentic. This double identity is different from a dual identity or an alter ego because it is a second, coterminous identity which, while obfuscating it, coexists with the protagonist's primary or original identity. In the case of the father, Amin Bayk (a.k.a. Suleiman), mother, Salmah (Jamilah), and first son, Salim (Salam Agha), this doubleness entails the adoption of an alias, a new social role, new dress, and even a new family. Suleiman, Jamilah, and Salam Agha develop new lives to accompany these new names. Moreover, almost every character's second life is initially independent of the lives of other family members to the degree that they even fail to recognize one another when they meet.

Family Affair(s)

The movement of Amin Bayk (father and husband) from false to true identity can be seen as exemplary of the process by which the fictional protagonist *becomes* an efficacious, native subject in the private sphere. As the fugitive Mamluk, he journeys from a state of liminality to a state of copious completeness. The reader first encounters Amin Bayk as the virtually anonymous Suleiman, a Bedouin warrior in the Egyptian desert, who saves Prince Ghurayb, the supposed son of the historical Lebanese prince, al-Amir Bashir, from a group of bandits. The protagonists are unaware that Ghurayb is, in fact, Amin Bayk's second son, born in exile after his parents' separation. Despite this anonymity, Amin and Ghurayb's first meeting serves as a catalyst for the father's reassuming his previous identity.

At Amir Bashir's request, Muhammad 'Ali, who had murdered all the Mamluks at the turn of the nineteenth century, pardons Amin, allowing him to come out from hiding. Upon the assumption that his wife and son, Salim, have since died, he joins the Egyptian forces that are repressing a rebellion in Sudan. Ghurayb soon returns to Lebanon and tells his mother of his adventures in Egypt. She recognizes the scarf that Amin (Suleiman) had used to tend her son's wound, and she sends their slave Sa'id to confirm whether the mysterious

warrior is her lost husband. Unfortunately, Saʿid is mistaken for a Sudanese enemy and is seemingly mortally wounded by Amin as he attempts to tell his master that Salmah is still alive. Distraught that he has killed his faithful servant, Amin runs into the desert, later to emerge in Lebanon as a vagabond who happens upon Ghurayb. Although he does not recognize him at first, the boy is elated to see his friend and invites him to visit Amir Bashir, whom he still believes to be his father, and his mother, Salmah. In the palace at Bayt al-din, the couple is reunited after twenty years, and Ghurayb learns that Amin Bayk, not Amir Bashir, is his true father.

In the meantime, Salim, the first-born who is thought to have drowned in Palestine during Salmah's flight from Egypt, has saved Ghurayb from the jail of the besieged governor of ʿAkka. Escaping together, Salam Agha (Salim), an officer by profession, joins the conquering army of Ibrahim Basha. Reminiscent of the reunion and recognition sequence of his father, Salam comes across his loyal friend Ghurayb in Lebanon and is invited to the Amir's palace and Ghurayb's residence at Bayt al-din to meet Salmah, their mother. Introduced to Salmah and Amin, Salam Agha recounts how he was kidnapped by Albanian pirates as a child while in Palestine and sold to Greeks. He fought in the Greek war of independence, defected to the Ottoman camp, and returned to ʿAkka where as captain of the prison guard he met Ghurayb. Upon hearing this story, Salmah realizes that Salam is her long lost son, Salim.

One would think that Salim's reunification would constitute narrative and subjective closure, especially if *Al-Mamluk* is to be read allegorically as simultaneously equating familial and national unity. However, the *fabula* is extended beyond the original family portrait. After the original family is reunited and all true identities are reestablished, both Salim and Ghurayb marry Lebanese women of social standing, albeit not uneventfully. Furthermore, during Ghurayb's weeklong wedding celebration, the faithful slave Saʿid , thought to have been killed by Amin Bayk, reappears, recounting how he was saved by Egyptian reinforcements while on the brink of death in the desert.

I have provided this complex plot summary to demonstrate the distance between the false and true identities of Amin, let alone Salmah and Salim. The elaborate plot communicates the complexity of the movement from a precarious to a stable selfhood, which I am equating with the movement from what I have called subjective failure to success. The binary poles of enigma and verity structure the sequence along which the movement from false to true identities takes place. This is particularly true for Salmah, who is originally from the royal

Lebanese family, the Shihabis, and Salim, who was a child at the time of his separation from his father and mother.

Amin's *becoming* a hero most clearly corresponds to the movement from subjective, social, and ontological failure to success. The sequence of his becoming begins with his association with the Mamluks, who were traditionally considered representative of, if not responsible for, the state of cultural and political decrepitude in Egypt. In other words, the variety of identities that Amin assumes (noble Bedouin, distraught soldier, searching vagabond, and reunited father) is preceded by his original Mamluk identity. While demonstrating exemplary virtue throughout the novel regardless of guise, Amin Bayk's origins are directly rooted in the Mamluk reign, the very era of stagnation that the *nahdah* constitutes itself as rising out of. Consequently, the story does not end with a return to the protagonist's preexisting state of unity and prosperity. Rather, the protagonist's subjective state surpasses his prenarrative beginnings and dubious origins. By the story's end, Amin's family is larger, with the birth of the precocious Ghurayb, the addition of his sons' new wives, and the restoration to life of Saʿid, who is now considered to be a family member. Furthermore, freed from his association with the Mamluk dynasty, Amin and his family are integrated into the Shihabi royal family in which Salmah legitimately has her roots and into which Prince Ghurayb has married. Therefore, Amin Bayk's becoming a whole subject results in a state of copious completeness that surpasses, even compensates for, his dubious Mamluk origins.

Recognition of the distance between the double identities communicates that *Al-Mamluk al-sharid* narrates more than the unification of the fragmented family which is read allegorically as a return to the same sort of national unity that al-Bustani articulated in *Nafir*. In the case of Salmah/Jamilah and Salim/Salam, the narrative itself charts the crucial allegorical movement from an inauthentic identity to the return of displaced but original identities. In the case of Amin Bayk, his journey to subjective fullness is quite literal. Without rejecting his origins, his perseverance, valor, and courage project him forward beyond his Mamluk identity to a new level of success and, in fact, a new sense of selfhood.

The plot highlights the importance of the restoration of identifiable and complete identities for the fictional protagonists. That is, the story does not begin with a portrait of unity, moving to crisis and resolution; rather, the story opens with the crisis well under way towards eventual success and closure. This

is allegorical of the *nahdah* itself. What is less obvious is that narrative closure is not structured by a portrait of the protagonists' pretraumatic bliss: Amin Bayk, Salmah, and Salim living together peacefully in turn-of-the-century Cairo. In fact, references to the preexisting unity and happiness of Salmah and Amin's family, for example, are completely absent from the narrative and left to the imagination of the reader. Therefore, if we are to understand that *Al-Mamluk* narrates a *return* to an original identity or an assumption of a *new* ontological state that exceeds previous fullness, then we are forced to acknowledge that the goals of the fictional protagonists are structured by a reform-minded imagination. That is, the narrative does not disclose the imaginary (in its popular and Lacanian senses) subjective ideal through the demonstration of how identity was full and is then fragmented. Rather, the didactic characters put forth an imaginary ideal that is realized through the assumption and performance of proper roles and identities by all protagonists. In other words, the novel narrates the reestablishment of the Oedipal family and the authority of the father, Amin, not as it was before the family's fragmentation but as it is imagined in the mind of the reader and protagonists. The invocation of Lacan's notion of the imaginary and the Oedipal portrait seems appropriate since *Al-Mamluk* expresses the overarching desire for the recomposition of the subjective ideal image or *imago* that we have seen represented throughout the nahdah.[26]

The Son

This imagination takes its full force not in the besieged father, however, but in the character of Ghurayb, the precocious younger son of Amin and Salmah, who Lacan might say represents a subjective imago rooted in the nahdah imaginary. As we have seen, Ghurayb served as the catalyst for Amin's reclamation of his true identity. Likewise, his actions offer a pretext for the reunification of the family as a whole. Ghurayb's movement from an inauthentic to a genuine identity reflects the general ontological states of the fictional protagonists, all of whom coterminously occupy several identities. Yet, possessing only one name, his position is unique. Instead of a movement of returning to a primary albeit richer identity, his subjective movement is from uncertainty to certitude. Ghurayb's very name indicates an identity in crisis, as the slave Saʿid narrates to us: "We arrived at Gaza and told the people there that we were from Turkey [*bilad al-turk*] in exile [*nafi*]. After a few months, the time came for Jamilah to

give birth. She bore a son and we named him Ghurayb because he was born in exile [*ghurbah*]."²⁷

In addition to the fact that Ghurayb's name carries the memory of his family's fragmentation and flight, Sa'id narrates the birth and naming of the boy in the first person plural, "we." Sa'id's role as surrogate father and husband communicates a state which Zaydan clearly characterizes as anomalous. The first time we encounter Jamilah, Sa'id, and the infant Ghurayb, they mysteriously appear on the doorstep of a monastery in Mount Lebanon. The narrator states, "One of the monks opened the door. The person who was knocking was a tall, black slave in strange clothes. At his side, there was a breath-taking woman wearing black clothes of mourning, and in the hands of the slave, a child. All of them were shaking from the harshness of the cold" (232).

Upon seeing the three of them, "The monks were amazed by the great contrast between the beauty and pure whiteness of Jamilah and the ugly face of her black servant" (233). This racist comment establishes an immediate and significant contrast between Jamilah (whose name means beautiful) and the absence of her true handsome husband, who is also the legitimate father of Ghurayb. The passage presents an abnormal family portrait, which is structured by a qualitative dichotomy (beautiful-ugly, white-black, princess-slave). This mise-en-scène demarcates the starting point of Ghurayb's movement to completeness. The black slave as surrogate father, the absence of Jamilah's husband, and her appearance in mourning apparel are all signals of the fragmentation of the family. This state is confirmed further as we learn of the absence of Jamilah's elder son, Salim (236–37). The foundation of Ghurayb's identity is in question, and throughout virtually the whole story he is unaware of his true identity. Likewise, his Mamluk origins are displaced by his integration into the royal household of Amir Bashir al-Shihabi. Ghurayb assumes that the Amir, in actuality the most prominent Lebanese historical figure of the nineteenth century, is his biological father. Consequently, he is referred to as Prince Ghurayb. Furthermore, like Bashir's sons, he accompanies the Amir to Egypt and on his military campaign in 'Akka.

In this portrait, we are presented with a diptych that is askew. The novel's first tableau illustrates a disjointed family in crisis represented by a slave accompanying a distraught Jamilah (Salma), and holding infant Ghurayb as if he were his own. The second tableau provides the royal Ghurayb, pseudo-son of Amir Bashir, oblivious to his true identity even as his father, dressed in Bedouin attire, saves him in the Egyptian desert from a band of thieves (271–75).

Amin Bayk's subjective movement, as well as those of Jamilah and Salim, is a relatively clean journey from false to true identity. His movement is a return inasmuch as he again becomes Amin Bayk, the legitimate husband of Salmah and father of Salim, while that very identity is itself boosted in the finale by additional signs of (masculine, personal, familial, social, and political) success. In contrast, Ghurayb is marked by the instability of his identity. Born into exile and unable to recognize his true father and brother upon meeting them, he sees Amir Bashir and his sons as his true family. His subjective movement is a shift from uncertainty to certitude, which unfolds his rich true identity. As Amin Bayk's journey is literally a return to his former identity and beyond, the journey of his youngest son demonstrates the *becoming* of an efficacious, fully conscious subject who not only performs the reform virtues that Zaydan propounds but is responsible for the reunification of his own social milieu (his family).

The above analysis provides foundation for several allegorical readings of *Al-Mamluk*. As in Sommer's reading of Latin American romance novels, we see that the subjective movements of the novel's fictional protagonists are allegorical of the striving for the copiousness of national unity and productivity. The reclamation by Amin, Salmah, and Salim of their authentic identities is inseparable from their reunion, just as Arab subjectivity is impotent without the unity of its community. Likewise, the text can be read allegorically as a comment on the nahdah itself, where the native subject through perseverance, virtue, and effort can surpass the questionable aspects of his/her identity (exemplified by Mamluk oppression) while not completely rejecting that very identity.[28] In the case of Ghurayb, his movement towards certainty is allegorical of the assertion of a national patrimony, which involves exertion of effort as well as consciousness. The allegory of the nahdah is clear: Ghurayb, a subject of noble pedigree, rises from an uncertain ontological and subjective state by demonstrating his own inherent virtues, eventually reaching his rightful state of personal and social completion.

We can glean from Zaydan's didactic typological characters the representation of an ideal rooted in the reform imagination and imaginary. His characters find themselves in a state of crisis, exerting personal effort and performing virtuously to resolve their personal and social predicaments. This is the classic nahdah schema. Locating the practice of signifying this ideal abates the threat of accepting such representation uncritically. My use of "subjective movements" and "processes of becoming" are analytical concepts that presuppose

the understanding of representation as a signifying process, particularly by highlighting how representation's intelligibility is structured by binaries. That is, *Al-Mamluk*'s didactic typology presents us with an allegedly stable system of references by which subjective success is signified. While in most of Zaydan's remaining novels the subjective referents are based on a good/evil, hero/villain dichotomy, *Al-Mamluk* is structured by referents that are delimited by interrelated qualitative sequences, like white and black skin, beautiful and ugly, and authentic and inauthentic identities. These binary typologies present a relationship between identity and efficaciousness and demarcate the narrative and semiological structure through which the character's achievement and the story's closure are signified. The constant that binds these two opposing ends (authenticity/presence and inauthenticity/absence) is the subject himself. Therefore, the space between the two binaries is the field upon which representation and narrative come to fruition. Such distance produces the field upon which the public and private subject can become one ideal and effectual native.

This field, we will recall, is circumscribed by the epistemology of rationalist knowledge and the empiricism of history. In *Al-Mamluk*, the subjective movements are inextricable from this historical knowledge, which Zaydan was trying explicitly to impart to his readership. As he tells us in the introduction to *Al-Hajjaj* quoted above, and in the introduction to *Istibdad*, the desire for such knowledge is essential to reform and progress. Historical knowledge is intertwined with fictional romance to encourage or create that desire. On the simplest level, this braid is woven by having fictional characters associate with a historical era and witness and narrate important historical moments and figures. Sommer would agree that erotic and libidinal desire as aroused or invoked by the fictional romance is fused with the desire for knowledge. On a more theoretical level, the protagonist's process of becoming a full subject (the reclamation of his/her original identity) is accomplished through the intervention and benevolence of historical leaders, in the case of *Al-Mamluk*, Amir Bashir and modernizer Muhammad 'Ali. Rather than acting as a conflation of private and public, or libidinal and social desires, the latter intercedes on behalf of the former. That is, the historical characters are pivotal for the successful becoming of the fictional characters. The fictional protagonists' dependency on historical figures for the progression of the narrative, let alone the realization of their becoming, highlights how historical knowledge is essential to subjective formation.

Duality and Ambivalence

As I have stated before, the usual typological rigidity of Zaydan's villains, heroes, and heroines is absent in *Al-Mamluk*. In fact, the novel is without a central villain. The characters' common crisis, the fragmentation of their family, is not the result of the actions of a tyrannical historical character as is usually the case in his other novels. Rather, the protagonists' plight is caused by more ambivalent circumstances. I say ambivalent because the story opens with imagery that conflicts with some of the novel's character portraits, particularly those of the historical leaders Muhammad 'Ali and Amir Bashir. As we have seen in al-Bustani's *Khutbah*, Mubarak's *'Alam al-din*, and al-Muwaylihi's *Hadith*, these leaders are praised by intellectuals and nationalists alike for their initiative in cultural regeneration. In the same vein, Zaydan generally portrays the rulers as possessing virtue in governing, sound characters, and compassion. This is specifically demonstrated through their interaction with the hero and heroine. Despite this, in their first appearances, these two historical figures seem to be the cause of a certain amount of political and social trepidation if not downright fear. In light of this, the initial impression of Muhammad 'Ali and Amir Bashir could easily be construed as little different from oppressive leaders, such as 'Ali Bayk in *Istibdad*.

The absence of an unequivocal villain is relevant because *Al-Mamluk*'s two central historical figures emerge from an ambiguous state of tyranny and decadence as successful, even exemplary figures. Their identities are structured by two poles; one exists outside and the other inside the narrative. The first is that their past, negative political actions lie outside the novel's narrative. The second is that their virtuous rule and character are demonstrated in the narrative itself. What we are presented with is not a doubleness of character that represents a false identity that is coterminous with but temporarily obfuscates the protagonist's true identity, as in the case of the fictional protagonists. Rather, the two portraits of the historical figures present a duality that asserts not the primacy of a true identity but a critical image of decrepitude from which the leader emerges and transforms himself.

To illustrate, let us return to the beginning of the story. It is a snowy evening at a monastery near Amir Bashir's palace at Bayt al-din in Mount Lebanon. Inside, the monks are dining after a hard day's work in the wake of the storm. The Abbot of the monastery informs the monks, "I heard some news today that disturbed me. Two men from the al-Ma'luf family from the village of Baskinta

killed the Greek Catholic Patriarch, Ignatius, near the village of Zuq Makayil. Amir Bashir was infuriated by this and now, as a consequence, he has taken the murderer, and will exact from him the most severe punishment" (231). When one monk responds that the Amir does not care about the murder because he and his princely family, the Shihabis, are not Christian, the Abbot replies:

> "Perhaps you do not know that the Amir has embraced the Christian faith secretly." All of the monks were stunned. One monk said, ... "But how can he be a Christian? We don't see him in church worshipping." The Abbot said, "The Amir has not neglected the duties of prayer as required by our religion. He has reserved a room for this in his palace, which he has made into a church for him to pray in. No one knows this apart from a few individuals whom he has chosen with care." The monk said, "I think that religion is unsettled by this sort of hypocrisy. Worldly interests are not allowed to stand as obstacles on the road to religious salvation." The Abbot cut him off, "Lower your voice for the walls have ears and the vengeance of the Amir is swift and terrifying as we well know." The monk laughed and said, "Where are we and where is the Amir? There are more than two miles between him and us!" The Abbot said, "This does not prevent him from knowing every word and movement here or anywhere else in Lebanon, even though he may be sitting in his palace." As the Abbot finished what he was saying, several knocks were heard at the door. Terror fell upon the hearts of the monks and not one of them was able to rise and open the door. (213–32)

At the door, there are three seeking sanctuary: the mysterious Jamilah, slave Saʿid, and baby Ghurayb, whose story, at least in part, will be told the following morning. After they eat and retire to their rooms, the Abbot returns to the company of his fellow monks, saying, "Thank God that we were saved from the anger of Amir Bashir. I was afraid that the person knocking was one of his spies." A monk said, "How do you not know that the guest who is the slave is not one of his spies?" And he said, "It is impossible that he is, because the two are foreigners (*gharibayn*). Tomorrow morning we will know the truth" (233–34).

The next morning the slave Saʿid tells the Abbot why and how they fled from Egypt. Muhammad ʿAli, renowned *wali* of Egypt, had invited the members of the deposed Mamluk dynasty to a celebration upon his son's victory over the Wahhabis, but the celebration had been a pretense to massacre them en masse. Thinking her husband, a Mamluk nobleman, had been killed, preg-

nant Jamilah, her eldest, Salim, and Saʿid escaped to the Levant. To compound the tragedy, after Jamilah gave birth to the prodigy Ghurayb in Palestine, Salim apparently drowned while playing on the beach unattended. After the conversation ends, "they heard a voice calling into the room and the Abbot went out to find one of Amir Bashir's men who had come to call him to the Amir's palace at Bayt al-din. Terror fell upon the heart of the Abbot" (240). The Abbot's caution is further confirmed when the Amir inquires about the strangers who arrived the night before and insists on meeting them. During this audience, misrepresenting their story, Saʿid explains how they had arrived in Lebanon and mentions that they had hired a guide from the southern Lebanese city of Sidon (Sayda) to bring them to the monastery. The Amir asks, "'Would you recognize him if you saw him another time?' Saʿid said, 'Yes, Lord.' The Amir smiled and Saʿid realized that that man who had brought them to the monastery was in fact the Amir himself. He was amazed by the Amir's vigilance [*sahar*] in maintaining security in his country, and his roaming around in it by himself, especially with the large number of spies he had everywhere" (244).

I have provided this lengthy summary for many reasons, not least of which is because it accurately represents the language and narrative structure of the story as a whole. It demonstrates the lucidity and simplicity of language in Zaydan's use of dialogue, which scholars of the Arabic novel usually criticize nahdah fiction for lacking. The opening two chapters nicely introduce the story and set up the atmosphere of enigma and mystery. Also, we see how the novel's narrative is structured, like a mystery or detective novel, on the disclosure and concealment of certain pieces of information that are crucially linked to the true identities of our main characters.

In the case of al-Amir Bashir, there is no doubleness, no movement between secondary and primary identities. Rather, the character of the prince presents us with a duality. That is, his identity is stable and split along a necessarily qualitative division. For example, he can be described as possessing two mutually exclusive attributes: He is distrustful yet conscientious. This is expressed in the contextual ambiguity of *sahar,* whose root meaning is "to pass the night awake." Either the prince is "vigilant" in maintaining the safety of his fiefdom and its subjects to the extent of self-sacrifice, or he is autocratic and authoritative to the point of paranoia. The monks' introductory conversation regarding the prince's confessional affiliation serves as another unresolved kernel of this ambiguity. The Abbot's testimony that Bashir has converted and is sincerely concerned with the affairs and security of his Christian citizens is succeeded by

the admonition of his fellow monks to be careful of what they say because the prince and his network of spies are ubiquitous.

This initial image of the terror-inspiring lord is contrary to his image in the remainder of the novel, which offers a flattering depiction of him. That is, two poles delimit the character of the prince. The first pole lies outside the narrative, representing the historical figure's past negative conduct. The second pole lies within the narrative itself and demonstrates the leader's social and political virtue. That is, in the narrative, the Amir who appears is one who compassionately cares for Jamilah, Sa'id, and Ghurayb, adopting them as members of his immediate family. His just act of interceding on behalf of Amin for amnesty further reinforces this portrait.

These qualities neatly fit into an allegory of the nation as a family and its leaders as benevolent father. Bashir acts as a culturally exemplary native leader, one who, in a subtle but classically Bustanian way, values cultural and historical knowledge. We are told that he educates Ghurayb at the hand of the historical court poet Butrus Karamah, reminding us that the Prince was well known for patronizing poets including Nasif al-Yaziji, Ilyas 'Iddah, and Amin Jundi, all of whom maintain a special place in the traditional nationalist historiographical narrative of the nahdah. In the same vein, he recognizes the value of Sa'id's erudition and knowledge of languages and subsequently employs him as a scribe. He also takes Ghurayb and his sons, Khalil and Amin, with him to Egypt where, in addition to official business, they tour Cairo's famed historical sights, ironically including the fortress where the Mamluks were massacred (e.g., 257, 259, 262).

The cultural conscientiousness of the prince reminds us of successful historical figures mentioned by al-Bustani in *Khutbah,* particularly the legendary Caliph Harun al-Rashid. The anecdote about the Lebanese Amir disguised as a nocturnal guide underpins this image. The trope of a prince incognito, meandering among his subjects, brings to mind Harun al-Rashid's mythical exploits in *A Thousand and One Nights.* The literary and mythical Caliph is easily fused with the historical figure. As al-Bustani demonstrates, Harun was for reformers an exemplary leader who maintained unity in a fragile empire, patronized the arts and sciences, and encouraged the integration of foreign and non-Islamic forms of knowledge into these disciplines.

In the figure of a Harun-like ruler, we are presented with a duality of the regal prince and the masquerading prince. The regal prince who is wearing a royal, Damascene caftan in the company of the protagonists juxtaposes the disguised

prince who, as guide, is covered by night's darkness and lacks any other description. The likeness between Harun and the Amir potentially elides the duality of Bashir by presenting a double character delineated along a true/false axis. The inauthenticity of the identity of the guide coexists (false guide/true prince). However, the context of the two identities precludes an authenticity/inauthenticity configuration, as we have seen is the case with *Al-Mamluk*'s fictional characters. First, the figure of the guide is one of only allusion, fundamentally remaining outside the novel's narration. More important, inherent to the identity of the guide is that he is *essentially* the prince. No distance exists between the two. No subjective movement or becoming transpires. That is, the guide is never really a guide but always the prince in disguise, surveying his kingdom. This is contrary to the fictional protagonists whose original identities have been displaced by their secondary identities. Their double identities, while coterminous, are true and false. Their simultaneity precludes subjective completion until closure where the inauthentic is finally shed for the reemergence of the authentic. This distinction is pertinent because the split in the figure of Amir Bashir (disguised royal prince) parallels the ambivalence between the tyrannical Bashir of the first pages and the benevolent and wise prince of the remainder. This ambiguity is seen in *Al-Mamluk*'s second prominent historical figure, Muhammad 'Ali of Egypt.

The character of Muhammad 'Ali, while significantly less developed, similarly emerges out of an ambivalent mise-en-scène. The first time he is mentioned in the narrative is during Amir Bashir's visit to Egypt with his sons and Ghurayb. When Ghurayb's stallion bolts with the boy, the royal entourage search in the desert for him. After Ghurayb's biological father, Amin Bayk, has saved him from bandits, they return to the prince's encampment and introduce him to the prince. Here, Amin tells his story to Amir Bashir, which, in classic Zaydanian fashion, is interwoven with historical knowledge (including dates). He corroborates Salmah's story while disclosing additional information. Specifically, he tells Bashir, "When the current wali, Muhammad 'Ali Basha, came to Egypt with his Ottoman troops to expel the French, he and the Sublime Porte became estranged. The wali requested that our princes to help him in the struggle against the French. We were with him hand to hand and assisted him to the limit of our ability. Then, when the *wilayah* of Egypt became his, he renounced us, did not pardon us, and confiscated our properties" (284).

The figure of Muhammad 'Ali is generally stern in the novel but not necessarily negative. However, in this passage, which precedes his first appearance,

the wali is, like Amir Bashir, an ambivalent character. On the one hand, the great Egyptian modernizer is depicted as having freed his country from French occupation.[29] On the other, he betrayed the aristocrats who aided him in this struggle. This betrayal is the catalyst of the story and the trials of our heroes and heroine. The tension created by this ambivalence comes to a head when Amir Bashir testifies on behalf of Amin's virtue and character and asks Muhammad 'Ali to pardon him. The following is Muhammad 'Ali Basha's ironic reply to the Lebanese prince:

> The ruler turned to the Amir, saying, "He [Amin Bayk] reminds me of my son Ibrahim. Respectfully, I declare to you that I have pardoned him. However, I hope that he does not reside in this country. His presence here is not secure after I have shed the blood of family and taken vengeance on his kin because of their relationship to the Mamluk Prince Ilfi, who tried to take Egypt out of my hands and surrender it to the English. This was contrary to my policies and plans. Yet your praise of his character and your acknowledgment of his service have inspired me to forgive him."
> (293)

The narrative presents us with a ruler who is severe, even brutal and autocratic, as a matter of policy, while also respectful and accommodating to his guests. The first and last sentences of the passage are in conflict with the middle sentence. Amin's very presence or appearance is a reminder of Muhammad 'Ali's dreadful deed. Likewise, the former Mamluk's secure residence in Egypt would be an affront to the power that the Egyptian ruler had adeptly if not ruthlessly established. The governor pardons the fugitive Mamluk almost despite himself. The comment about his son, the famous Ibrahim Basha, reveals his personal side, and the pardon confirms that he is a judicious leader who can be influenced by reason and compassion as well as political expediency.

Muhammad 'Ali's modernization policy, for which he was admired by so many *ruwwad al-nahdah,* falls into the same sort of representation of this public prudence. Testimony to his achievement emerges in the passage that immediately follows Amin's pardon. By pardoning Amin, he has now ingratiated himself with Amir Bashir. The wali informs him of his plans to invade the Levant and requests his support. The Amir confidently responds:

> What increases my faith in the success of your efforts in expanding your country's borders is your care in the training of your soldiers in the modern system (*al-nizam al-jadid*) adopted from the system of the

French army. For this, I am the first to celebrate your victory, because the people of Syria and other peoples of the East are unfamiliar with this system. For that reason, no one among them will be able to stand up to your troops. (295)

The Amir bears witness to Muhammad 'Ali's most monumental achievements, the introduction of modern technology and methodology into the Egyptian political and cultural sphere. The profundity of Muhammad 'Ali's innovation, in fact, will dumbfound the entire East, says Bashir. What is interesting is that, as a historian writing fiction, Zaydan makes few value judgments regarding the Egyptian expedition into Syria or the fact that it was tantamount to rebellion against the Ottoman state, as is stated by 'Abd Allah, wali of 'Akka. Nor does he cast any judgments on the Khedive's campaign in the Sudan, let alone Amir Bashir's attempt to disarm the Druzes. The objective portrait of the historical figure portrays an ambitious but orderly and methodical leader who is not devoid of compassion and understanding. Specifically, the key to Muhammad 'Ali's greatness is his insight into the value of the modern method.

Ibrahim Basha, the son of Muhammad 'Ali and the historical leader of the Syrian campaign, represents this new age. He further illustrates compassion and good judgment, without the less desirable attributes of his father. For example, during the Basha's siege of 'Akka, Salam Agha (Salim) defects to the Egyptian forces after he has saved Ghurayb from the gallows. He requests asylum from Ibrahim Basha and volunteers to assist in the Egyptian siege of 'Abd Allah, wali of 'Akka and his former Ottoman master. However, he refuses to provide any privileged logistical information which might have been entrusted to him while in the service of 'Abd Allah. The following takes place at the Egyptian encampment outside the walls of 'Akka:

> Amir Bashir was astonished by Salim's integrity (*shahamah*). As for Ibrahim Basha, he was not surprised at this because he had seen the likes of Salam in the battles of the Peloponnesus. He said to him, "You are originally our soldier and, therefore, if you tell us the secrets of the city, you would be performing a great service." Salam said, "Sorry, my master, but I do not want to be a spy, nor can I give you any information with which I have been entrusted about the city." Ibrahim Basha smiled and said, "Don't worry, Salam. You have returned to me with integrity just as you were with me when in the Peloponnesus." (348)

As it turns out, this is a repeated scene for Ibrahim, who had received Salam into his ranks when he defected to the Ottoman forces during the Greek war of independence. Then too, Salam swore allegiance to Ibrahim's forces without divulging the secrets of his former Greek masters. The fact that Ibrahim Basha values loyal subjects more than demonstrating his power over them is relevant. This rationality and compassion is also expressed in Ibrahim's tolerant political policies in Syria, foremost of which was his extending full rights and privileges to the non-Muslim citizens of Syria.[30] The figure of Ibrahim Basha illustrates the ideal balance between competency, reason, and compassion, which further reflects the rule of his father.

The ambiguity in Amir Bashir and Muhammad ʿAli should not be attributed to the immaturity or a lack of literary skill of Zaydan. If nothing else, the character of Ibrahim Basha demonstrates this. Their duality is more than a binary good/bad, desirable/undesirable, or progressive/backward typology. That is, it is not a pedagogical technique which offers exemplary and nonexemplary models of behavior. Instead, the conflicting characterizations of the historical protagonists establish two subjective poles of social and political failure and success. This axis forms a path for their movement from decrepitude towards progress. The movement between these simultaneous topoi is one more allegory of the process of becoming reformed, an allegory of the nahdah itself. For the fictional protagonists, their movement is from absence to presence, from a state of liminality and incompleteness to a state of fullness and completion. The historical Bashir the Great and Muhammad ʿAli, however, move literally from cultural and political failure to success, from bloodshed and tyranny to progress and understanding. This movement of becoming reformed or rehabilitated is not only an allegory of change or education but the allegory of the nineteenth century itself as presented in al-Muʿallim Butrus's *Khutbah*.

As I mentioned earlier, the plight of the fictional characters is one of private space, despite their participation in public, historical events. They demonstrate personal virtues, such as Amin's courage, Salim's integrity, Ghurayb's precociousness, and Salmah's fidelity. On the literal level, their journey is libidinal and emotional, aiming at the reunification of the family, the ability to become once again productive and self-knowing. This is in contradistinction to the historical characters. Their progress from one position to its antipole entails a realization of a praxis of success within the public realm. They act as political leaders, virtually always in explicitly political capacities. Their failure is public and political (despotism and ruthlessness). Their success, in contrast, bridges

the gap between the public and private. That is, the historical figure's praxis of success is predicated on the just treatment of their citizens on both the political and the personal levels. However, their subjective position is centered on their role as historical and political figures, always rooted in the public sphere. Therefore, their ambivalence of character, the contradiction between their initial despotic and subsequent judicious behavior, serves a crucial allegorical function. Just as the subjective movement of the fictional protagonists signifies a becoming of effectual subjects, the historical characters' movement signifies an essential transformation from decrepitude to efficaciousness. Therefore, we can delimit at least two coexisting allegories within *Al-Mamluk*. In the case of the fictional protagonists, the allegory is of (re)becoming what they originally were and more. In the case of Muhammad 'Ali and Prince Bashir, however, their movement is not a repossession of original selves but rather an allegory of rising out of and rejecting their elementary failure to reform.

Conclusion

In this chapter, I have not represented all of the twists and turns of *Al-Mamluk*'s plot or the few consistent tropes of character developments. The story, for example, does not end with Amin Bayk and his extended family living peacefully in Mount Lebanon. In fact, they accompany the Amir and his entourage into exile in Istanbul after Ibrahim Basha is expelled from Syria by a joint military force of the Great Powers. This conclusion is told, as is the story, with empirical objectivity by Zaydan, who makes no judgments as to whether Amir Bashir or Muhammad 'Ali were traitors or liberators. This ending, however, does not affect the subjective movement of the protagonists. Their characters have reached subjective closure. The fictional characters no longer occupy subjectively or ontologically a state of doubleness. They have shed their inauthentic disguises and live, it is made clear by Zaydan, happily ever after, even in exile. The actions of the historical characters within the text demonstrated their transformation into prudent rulers who have overcome their previous flaws and failure.

My discussion of Doris Sommer's *Foundational Fiction* allowed me to make such national allegorical readings. More important, I wanted to make clear that the distinction between fictional and historical characters is not an arbitrary one and reflects two different movements of becoming reformed subjects. The split between these two sets of characters also corresponds to a distinction

between private and public spaces, between the libidinal and the social. These two sets of protagonists reflect not two subjectivities but two levels of the same subjectivity, a political and a personal, each of which go through their own journeys of becoming efficacious and successful native Arab subjects. Both cases can be read as an allegory of subjective renewal and of the different tactics of the nahdah itself. Furthermore, we see how the "objectivity" of historical knowledge is also arranged by an imagination, or the imaginary, of the renaissance reform mind and that this imago is a clear articulation of its desire, rooted in al-Bustani and his tireless peers.

Epilogue

Towards an Aesthetic of the Colonial Self

> But all the possible alternatives are not in fact realized: there are a good many partial groups, regional compatibilities, and coherent architectures that might have emerged, yet did not do so. In order to account for the choices that were made out of all those that could have been made ... one must describe the specific authorities that guided one's choice.
>
> Michel Foucault, *Archeology of Knowledge*

Fawwaz Trabulsi wrote that Salim al-Bustani was the first Arab intellectual to conceptualize Beirut as the crossroads between East and West.[1] He argues that Beirut, as a natural linchpin between the Orient and Occident, is less of a historical fact than an ideological construct with its roots in the intellectual activity of the city's bourgeoisie. We have seen that Salim is among the most eloquent and prolific intellectuals of this bourgeoisie. However, the concept of Beirut as a cultural and economic link between East and West predates Salim's writings by a generation. By 1852, his father had published a lecture to al-Jam'iyah al-suriyah lil-'ulum wal-funun entitled "Fi madinat Bayrut." Here, al-Mu'allim Butrus presents the history of Beirut starting with its Phoenician roots. He recounts the construction of landmarks such as the city's walls, commercial centers (e.g., qasariyat al-siyaghah, Khan al-wuhush, Hanut al-hayakin), and towers (e.g., Burj al-Kashaf and Burj al-Jadid). While a certain urban morphology is provided, its economic activity, for al-Bustani, is what gives the city its identity. Key to this identity is how since its Phoenician days Beirut acted as an important entrepôt between the Mediterranean world and the Asian hinterland. Indeed, every social and cultural commentary that al-Bustani would write over the subsequent twenty years would mention Beirut's unique role. The city

is *the* example of this hybridity and interconnectedness, functioning as the cultural and economic entrepôt that links Syria to foreign countries. Just as we saw in *Nafir* that Greater Syria and the Arabs are the link between the East and the West, Beirut is a critical cultural and geographical "link among the many links of this great [cultural] chain."[2]

This role of Beirut is central to an understanding of Salim's social vision. In *Al-Huyam fi jinan al-Sham,* the protagonist Suleiman debates with his friend-the-narrator the progress of the city, the development of its cultural infrastructure, and the adoption of a "modern mentality" by its population. In addition, the city is discussed throughout his social commentary in *al-Jinan*. One of his last articles was a commentary on Beirut, entitled "Asbab taqaddum Bayrut wa numiha al-sari'" (Reason for Beirut's progress and its rapid growth).[3] What is noteworthy about this editorial is that despite its title, Beirut is virtually absent from the narrative. Rather, the city acts as a vessel for the discussions of progress and economy in Syria. Thus we see that, for Salim, Beirut is specifically a locus for the discussion of progress—if not necessarily as an emblem of progress itself. Beirut had become something new in the imagination of intellectuals that went beyond economic development. The idea of Beirut as a cosmopolis appeared, a city central to global historic, economic, and cultural continuities. This concept of the cosmopolis corresponds to a new sense of vision, a new way of seeing society and space. It corresponds to a new aesthetic that framed the fiction, poetry, and nonfiction of the day as well as the city's architecture and urban planning.

Some decades later, Shakir al-Khuri affirmed the Bustanis' vision of Beirut. Both Salim and Butrus were his teachers at al-madrasah al-wataniyah. In *Majma' al-masarrat,* al-Khuri offers an account of the city that is sometimes personal and sometimes dispassionate.[4] Particular to al-Khuri's narrative, however, is his concern with the political topography of Beirut and Mount Lebanon. The doctor peppers his narrative with political histories and biographies of the city's notables as well as with information about secular and nonsecular institutions from the Mutasarifiyyah to the Orthodox patriarchy. In this respect, his memoirs resonate with that of Mishaqa and other local chronicles. Khuri does manage, however, to infuse Beirut with an emotional but completely unromantic life. He describes his motives for moving back to Beirut, for example. For al-Khuri, as a young unmarried doctor, Damascus was his paradise, where he lived in unencumbered bachelorhood. His new wife, who was from a notable Beiruti family, insisted on living in the city of her birth, near her family. Subsequently,

Beirut became the city of his daughter's birth and the place where his professional reputation would be established. Actively involved in the city's politics and high society, he became successful in Beirut, pulling himself out of debt and eventually becoming a moneylender himself. Beirut, as dynamic and significant as he might have recognized it, was a place of al-Khuri's maturity, hard work, and success. *Majmaʿ al-masarrat* offers one more *nahdah* success story. Its narrative is not a survey of commercial centers, landmarks, or the arrival of signs of modernity. Rather, al-Khuri's account reveals a new vision of the city itself. This vision communicates that modern Beirut was a living space imbued with a private as well as public investment.

This dual investment sets the stage for Jurji Zaydan's *Mudhakkirat*. His memoirs were written as a letter to his son, Emile, and they remain a brief and unfinished chronicle of his early life in Beirut. In contrast to Shakir al-Khuri and the Bustanis, Zaydan fully animates Beirut, narrating the city's private and public spaces, from quarters to stores, schools, homes, and piazzas. The portrait and language of this text is radically different from his histories and novels. Working in his father's restaurant at the main square of Sahat al-Burj, the young Jurji observed and participated in what he would come to call the base street culture of the city. Al-Burj was filled with "the most degenerate classes" (*ahatt al-tabaqat*), hoodlums (*zuʿran*), layabouts (*kasala*), and indigents (*ahl al-batalah*) who would gamble, drink, start fights, and frequent brothels.[5] These people, he states, would "roam and meander in the streets," eating and drinking, and looking for entertainment and distraction, working only as a last resort, seeing employment as a matter of disgrace (12). It was at al-Burj that the seductive nightly events would transpire: feasts, festivals, and *zajal* competitions. These events were bawdy and boisterous "drinking parties [that] attracted both ignorant and learned men [*al-jahil wal-ʿaqil*]," who would taunt each other and brag of their manly escapades and sexual exploits, "particularly with married women" (25). Storytellers would also frequent al-Burj, recounting epics of ʿAntarah and al-Zir while the immensely popular *karakuz* puppet theatre theater would provide "tawdry and immoral" entertainment for a shameless audience (21).

The stories and bravado of the piazza's braggarts, heroes, and storytellers enthralled Zaydan. However, as a quiet boy, the ingenuity and verve of this raunchy class "made him feel his own inadequacy [*taqsir*]" (27). Indeed, in the first half of his memoirs, the city is the place where licentiousness reigned. Yet Beirut is also the backdrop for the fundamental tension within the text, between

Zaydan's psycho-social inadequacies and desires. In a manner reminiscent of *The Confessions of St. Augustine*, Zaydan narrates the conflict between his contradictory desires for libidinal pleasure, on the one hand, and knowledge and education, on the other. In other words, he portrays a conflict between the tropes of degeneracy and progress. The city unfolds as the landscape for the journey of both self and society, as the space where cultural dynamism quietly surfaces from "the decadent social life centered around Sahat al-Burj." We witness in Zaydan's narrative the increased presence of foreign travelers and educators and English ships with their drunken soldiers on shore leave. The city's gentlemen participated in social activities that variously required them to wear pants (*bantalunat*), fezzes, or Western dress (*al-zayy al-afranji*), along with the *shirwal* and the *qunbaz* (28).

The presence of Western clothes points to a subtle change in the economy of the city. Zaydan left his father's restaurant to work in a European-style clothing shop. Slowly, he moved beyond the rabble surrounding his father's establishment, befriending other clerks who worked in the same *suq*. He became an apprentice at a European-type shoe shop. There, he "was hit by a weakness" that was caused by "a secret compulsion that every boy or juvenile experiences." He "did not find pleasure in it due to my youth," but the other children at work "increased in me the desire [*raghbah*] for it" (19). He goes on to say:

> Working in the shoe shop ... I had come to understand the extent of the damage derived from this habit.... A son of a Beirut notable would frequent al-Duhayk's shoe shop. A friend of the two Duhayk brothers, he would joke with them a lot and discuss many things with them frankly. ... One time, he came and complained of fatigue [*inhilal*] and weakness. When he left the shop one of the brothers said, "Our poor friend. Do you know the reason for his weakness?" The other replied, "No." The first brother said, "The reason is because he plays with his hands." This was the first time I had heard this expression regarding this harmful habit, but I had understood it and committed myself to stop doing it. I did stop and felt an overall improvement in my health.... [Before this period] I had spent my life in a baseness that dominated my intellect. I enjoyed the things that those who were like me enjoyed, and I did not know the meaning of initiative [*iqdam*]. (19–20)

After this point, we recognize a change in the topography of Zaydan's urban narrative. Just as foreign and modern commodities surface, we witness the

emergence of a new class. During this time of Zaydan's youth, he encounters new sorts of texts, al-Yaziji's *Majmaʿ al-bahrayn,* al-Mutannabbi, Ibn Farid, scientific and English textbooks, *al-Muqtataf,* and, not inconsequentially, the translation of Samuel Smile's *Secret of Success (Kitab sirr al-najah.)* Figures like Dr. Iskandar al-Barudi, Francis Nimr, and Ibrahim al-Yaziji begin to frequent his narrative as well as a slew of young students. This new generation of enlightened natives, their texts and productions, circulated throughout the city, but their current was particularly strong around the Syrian Protestant College. Just as Zaydan associates his "baseness" with the riff-raff of street life or the onanism of his peers, his increased association with this new intellectual class introduced him to the new social space of Beirut.

After rejecting his libidinal inclination, "the flame of desire for knowledge was rekindled." Through his own "initiative," Zaydan is drawn into this new social space of Beirut, drawn into student circles, intellectual discussions, and, eventually, the medical faculty of the Syrian Protestant College. He sees misdirected, unsublimated erotic desires as damaging because they inhibit productivity by draining the "ambition" out of the subject. The connection between desire and productivity is explicitly stated by Zaydan and is directly linked to his narration of Beirut as a new dynamic space for cultural and social renewal. That is, the city, like the narrator himself, takes on a dualistic character: culturally and morally corrupt and progressive and enlightened. The alter egos of the city and Zaydan present two poles in the memory of an intellectual as well as the popular memory of Beirut. Rather than being concurrent, these poles resemble the subjective development of the fictional characters in the author's *Al-Mamluk al-sharid.* The antipodes become diachronic borderlines marking a beginning and an end in the venture of realizing a new, modern personal and public success. Testifying to the depth to which the epistemology of modernity had been naturalized, the two poles (progress and degeneracy) frame a new vision of the urban space of Beirut and its relation to its subjects.

While *progress* and *production* preoccupy the vision of the Bustanis and Shakir al-Khuri, there is a level of consciousness absent from their visions of Beirut. Their texts are a plate on which to serve empirical data or a discussion of progress. We see in *Mudhakkirat Jirji Zaydan* something similar to, say, al-Muwaylihi's protagonists wandering through Cairo or Mubarak's hero's introduction to a new vision of Egypt and the outside world. That is, in the narrative of a native son's tour, we can clearly perceive the correlation between the aesthetic of self and the aesthetic of social space. Zaydan's narrative informs us that

Beirut has become what Walter Benjamin called the material space for "collective consciousness" of its people; it is where the narration (and creation) of a modern urban space mirrors the narration of the process of becoming a fully efficable and successful native son.[6]

The consciousness expressed by a new aesthetic of space cannot be removed from the new sense of self. The memoirs of Zaydan, as well as his more subtle fiction, attest to the degree to which the discourse of progress and civilization affects the most personal and libidinal level of the subject. Some may reject my reading of how even libidinal space is informed by reformist discourse. The force of the epistemology of modern Arab subjectivity that I have mapped out in this study could be seen as powerful enough to dictate all possible reactions to historical developments over the past century. Despite the tyranny of the logos of this episteme, Arab intellectuals, activists, reformers, and literati were never passive or uncritical recipients of it. Nor were they duped or coerced into championing priorities that would eventually be used to justify colonial rule or lead to conditions of their underdevelopment. Rather, relationships between intellectuals, movements, and this episteme form a rhizome as complicated and knotted as the texts that we encountered in this research. Partha Chatterjee demonstrates that Bengali intellectuals accepted certain epistemological and colonialist-informed premises for reform, while also formulating hybrid alternatives to colonial paradigms.[7] In Southwest Asia, intellectuals like al-Muʿallim Butrus, al-Tahtawi, ʿAbduh, and Zaydan arduously worked out specific paths for subjective presence. From Iraq to Egypt to Morocco, intellectuals were not struggling with an imported, foreign, and oppressive episteme as if it were a foreign intruder enslaving them in the thought of a conqueror master. To the contrary, with fathomless ambition, initiative, and energy, these thinkers molded, crafted, and hybridized multiple visions of self, society, and space. In short, they claimed proprietorship over the concepts and problematics of modernity. The modernity that many see as absent in the Arab world was in fact institutionalized through their intellectual activity, political praxis, and writing practices. Their efforts crystallized the desire for and identification with a new public and private self and society that was part and parcel of the modern age. Other cultural productions such as photography, theater, architecture, and even early film corroborate their vision. In communicating this vision, we have seen that the narrative of reform rested on a process of signification whose syllogistic gaps are veiled in order to convey the naturalness of its endpoint, that is, "civilization and progress."

The particularities of this vision could be reduced to an examination of the process of mystification, an examination of how the humanist and positivist notions of universal "Man" are naturalized. Homi Bhabha discusses this question of mystification, which "brings us to the ambivalence of the presence of authority, peculiarly visible in its colonial articulation. For if transparency signifies discursive closure—[such as] intention, image, author—it does so through a disclosure of its rules of recognition—those social texts of epistemic, ethnocentric, nationalist intelligibility which cohere in the address of authority of the 'present,' the voice of modernity."[8]

The radically new forms of fiction during the nineteenth century did just this; these writing practices inscribed an authority of the episteme of modernity. New and old writing practices naturalized the formulas for progress and civilization that were painstakingly worked out by the likes of al-Bustani, al-Nadim, al-Muwaylihi, and Zaydan. The paradigms that they formulated attempted to postulate a social and cultural identity that refuted Western assertions of superiority. We have seen, however, that their suppositions rested on the centrality of the mastery of positivist knowledge and a syllogistic reasoning that concluded their contemporary inability to be the producers of such knowledge. Later, the romantic movement, starting with Jubran along with conservatives such as al-Manfaluti, reinscribed the terms of presence and absence by shifting to metaphysical and spiritual criteria. However, works such as Jubran's *Al-Ajnihah al-mutakassirah*, Haykal's *Zaynab*, and later Haqqi's *Qindil Umm Hashim* or Taymur's *Al-Nida' al-majhul* stressed the superiority of Arab spirituality and constituted a reaction to the positivist, rationalist discourse on identity. However, even these reactions were bound negatively to the vision and ideals of modernity. Despite this rejection of the progress paradigm by the Arab Romantics, we refer to Bhabha's passage, which makes visible the authority that even these ideologues were addressing. The ubiquity and longevity of the positivist epistemology codified by their predecessors confirms the naturalization of discourses of progress and civilization within the "Arab mind." Despite the apparent hegemony of this logos, we know that neither this epistemology nor this vision of self was seamless and fully reified, since it has undergone a series of changes and recodings since its original inscription.

Even by the 1950s, Arab intellectuals such as Adonis and Abdallah Laroui, among others, were attempting to redefine the criteria for social, cultural, and national success (and failure) by pointing to how the qualities of modernity have existed historically in Arab cultural productions. The literary and intellec-

tual productions of the nineteenth century were the *habitus* for these thinkers. From that intellectual space, they confronted postcolonialism in many ways like previous thinkers engaged colonialism, experiencing many of the same discursive issues that were being discussed before imperialist control. The invocation of Bourdieu's *habitus* is not my own but that of Vivek Dhareshwar who reminds us that "the interpolation of the colonial subject qua subject takes place within the colonial *habitus*—the symbolic structures embedded in the colonial institutions and practices that subject the colonized to an internalization of the asymmetries, both material and ideological, between the metropolis and colony."⁹

In the case of the Arab world, the foundation of this *habitus* could not have been poured without the epistemological and narrative groundwork that "pioneers of the Arab renaissance" engineered. I am not saying that this was an intentional and conscious conspiracy devised by the West in preparation for military invasion and colonial rule. Rather, the topography of the colonial site was the consequence of the reorganization of capital and power within the Ottoman Empire. Not unique to South West Asia, its landscape was the effect of the modern era from which Western imperialism cannot be divorced. As evinced through this research, the process of subjectification was institutionalized preceding colonial rule. It unfolded autonomously through the project of native education, the circulation of scientific-literary journals, the reworking of classical and the innovation of new literary genres, and the expansion of various local, national and Empire-wide reform movements. Through a tireless effort to enact a masterful subject, the hegemony of modernity was instituted.

This study has followed the lead of Abdelkebir al-Khatibi, who shows that the domination of the epistemology of modernity does not mean that it was beyond confrontation, ambivalence, and subversion.¹⁰ Through his "double-critique," al-Khatibi was one of the earliest Arab intellectuals to break the hegemony of the epistemology of modernity through his Derridean critique of identity and colonialism. He shows us that the concepts of modernity and national selfhood are not stable, unwavering, or confident and that they have never been "happy" in the nineteenth and twentieth centuries. Within this tradition, Homi Bhabha contributes to our understanding that the colonial epistemology and its appropriate discourses of education, reform, human and civil rights, economy, and gender are riddled with ambivalences and "slippages," which became fields of contestation between the colonizer and the colonized.

I hope that it is superfluous to reiterate that in no way am I asserting that the Arabs were or are inferior to the West, or that European culture was or is more efficient or cognizant. Much to the contrary, my critique is one that aims to set the platform for new political and cultural practices as well as to reveal the slipperiness of naturalized cultural referents and social equations. Following Fanon, this study aspires "not to give back to national culture," in this case Arab national culture, "its former value." Rather, it "aims at a fundamentally different set of relations" between men and women. This work's political, intellectual, and academic goals are, then, not only to facilitate "the disappearance of colonialism" in its many discursive, epistemological, political, social, and material forms, but also to facilitate the disappearance of colonized man and woman, subjects who find themselves, their failure, success, desires, and future in the colonizer's vision of progress and civilization.[11]

Notes

Introduction

1. *Time International,* July 8, 2002.

2. For example, Issa Boullata's *Trends and Issues in Contemporary Arab Thought* (Albany: State University of New York Press, 1990) summarizes a conference of Arab intellectuals and participation stances.

3. See Peter Gran, *Islamic Roots of Capitalism.*

4. See Khaled Fahmy, *All the Pasha's Men: Mehmet Ali, His Army, and the Making of Modern Egypt* (Cambridge: Cambridge University Press, 1997). Mehmet Ali was Muhammad Ali's Turkish name.

5. In addition to Ranajit Guha and Gayatri Chakravorty Spivak, eds., *Selected Subaltern Studies* (New York: Oxford University Press, 1988), see Guha's more recent *Dominance without Hegemony* (Cambridge: Harvard University Press, 1997).

6. Homi K. Bhabha, "Signs Taken for Wonders," in *The Location of Culture,* 107–8.

7. Bernard Lewis, *What Went Wrong: Western Impact and the Middle Eastern Response* (New York: Oxford University Press, 2001).

8. Bernard Lewis, *The Middle East and the West* (New York: Harper and Row, 1964), 70.

9. C. Ernest Dawn, *From Ottomanism to Arabism* (Urbana: University of Illinois Press, 1973); Sylvia Haim, "The Arab Awakening: A Source for the Historian?" *Welt des Islams* 2 (1953); and Zeine Zeine, *The Emergence of Arab Nationalism* (Beirut: Imprimerie catholique, 1966).

10. William Cleveland, "The Arab Nationalism of George Antonius Reconsidered," in *Rethinking Nationalism in the Arab Middle East,* ed. James Jankowski and Israel Gershoni (New York: Columbia University Press, 1997), 66–86; but also his *Making of an Arab Nationalist* (Princeton: Princeton University Press, 1971), and *Islam against the West* (Austin: University of Texas Press, 1985); Rashid Khalidi, "Abd al-Ghani al-'Uraysi and *al-Mufid,*" in *Intellectual Life in the Arab East,* ed. Marwan Buheiry (Beirut: American University Press, 1981), and "Arab Nationalism in Syria," in *Nationalism in a Non-Nationalist State,* ed. W. Haddad and W. Oschenwald (Columbus: Ohio State University Press, 1977); Philip Khoury, *Syria and the French Mandate* (Cambridge: Cambridge

University Press, 1983); and Hasan Kayali, *Arabs and Young Turks: Ottomanism, Arabism, and Islamism in the Ottoman Empire, 1908–1918* (Berkeley: University of California Press, 1997). For a fine introduction to the dominant debate on Arabism and its historiography, see Rashid Khalidi, Lisa Anderson, and Reeva Simons, eds., *The Origins of Arab Nationalism* (New York: Columbia University Press, 1991).

11. Hourani, *The Emergence of the Modern Middle East*, 193.

12. Ibid., 206.

13. C. Ernest Dawn, "The Origins of Arab Nationalism," in *The Origins of Arab Nationalism*, ed. Khalidi, Anderson, and Simons, 10. See also his monograph, *From Ottomanism to Arabism*.

14. See the introduction to Mohammed Arkoun, *Lectures du Coran*. Also, despite its teleological fixation on the messianic qualities of historicism, his groundbreaking second edition of *La pensée arabe* (Paris: PUF, 1979) is a provocative inquiry into the fixation of modern Arab thought on classical philosophical and religious epistemologies.

15. Among their many works, see Laroui, *La crise des intellectuels arabes: traditionalisme ou historicisme?*; Muhammad 'Abid al-Jabiri, *Al-Turath wal-hadathah* (Tradition and modernity) (Beirut: al-Markaz al-thaqafi al-'arabi, 1992); 'Aziz al-'Azmah, *Al-Kitabah al-tarikhiyah wa-al-m'arifah al-tarikhiyah* (Historical writing and historical knowledge) (Beirut: Dar al-tali'ah, 1983) and *Islam and Modernities* (London: Verso, 1993); 'Ali Harb, *Mudakhalat* (Interventions) (Beirut: Dar al-hadathah, 1985); *Naqd al-nuss* (Critique of the text) (Beirut: al-Markaz al-thaqafi al-'arabi, 1993) and *Naqd al-haqiqah* (Critique of the truth) (Beirut: al-Markaz al-thaqafi al-'arabi, 1993); and George Tarabishi's controversial critique of al-Jabiri in *Naqd al-naqd al-'aql* (Critique of the Critique of Reason) (London: Dar al-saqi, 1996). Issa Boullata reviews several of the views of contemporary Arab intellectuals in *Trends and Issues in Contemporary Arab Thought*.

16. For the best articulation of this view, see al-Jabiri, *Al-Turath wal-hadathah*.

17. Sharabi, *Arab Intellectuals and the West*, 10. See also Sharabi, *Neopatriarchy*, which lucidly makes such assertions. For a critical discussion of the work of Sharabi, see my article "Failure, Modernity, and the Works of Hisham Sharabi," *Critique: Journal for Critical Studies of the Middle East* 10 (spring 1997): 39–54.

18. Sadiq Jalal al-'Azm, *Al-Naqd al-dhati b'ad al-hazimah* (Self-critique after the disaster) (Beirut: Dar al-tali'ah, 1969), 51.

19. Ibid., 18, 51.

20. Fouad Ajami, *The Arab Predicament* (New York: Cambridge University Press, 1981). For another less antagonistic example of Bassam Tibi's work, see *Arab Nationalism: A Critical Enquiry* (1971; reprint, New York: St. Martin's Press, 1981).

21. Musa, *Tarbiyat Salamah Musa*, 7.

22. See ʿAbd Allah al-Nadim, *Al-Tankit wal-tabkit*, 92. The quote is, however, taken from ʿAbd al-ʿAlim al-Qabbani, *Nishʾat al-sahafah al-ʿarabiyah bil-Iskandariyah, 1873–1982*, 96.

23. Foucault, *Language, Counter-Memory, Practice*, 131.

Chapter One

1. Frantz Fanon's *Wretched of the Earth* was first published as *Les Damnés de la terre*, which appeared with a preface by Jean-Paul Sartre. It was translated into English by Constance Farrington.

2. The renowned Maronite College of Rome, established by Pope Gregory XIII in 1584, produced many prominent clerical scholars, notably Jabraʾil al-Sahyuni (1577–1648), Ibrahim al-Haqilani (1605–64), Yusuf al-Samʿani (1687–1768), and Patriarch Istifan al-Duwayhi (1630–1704).

3. A. L. Tibawi, "The American Missionaries in Beirut and al-Muʿallim Butrus al-Bustani," *Middle Eastern Affairs*, St. Antony's Papers, no. 16 (Carbondale: Southern Illinois University Press, 1962); John W. Jandora, "Butrus al-Bustani: Ideas, Endeavors, and Influence." Jandora's 1981 dissertation produced two published articles, "Butrus al-Bustani, Arab Consciousness, and Arabic Revival," *Muslim World* 74, no. 2 (1984): 71–84, and "Al-Bustani's Daʾirat al-Maʿarif," *Muslim World* 76, no. 2 (1986): 86–92.

4. Jessup, *Fifty-three Years in Syria*, 484.

5. Butrus al-Bustani, *Qissat Asʿad al-Shidyaq* (1860; reprint, Beirut: Dar al-Hamraʾ, 1992).

6. See Reverend Habib Badr, "Mission to the 'Nominal Christians' (1819–1848)," Ph.D. diss., Princeton Theological Seminary, 1992. I also thank Badr for providing me with a copy of "Why Was There No 'Native Minister' in Beirut in 1848? A Historiographical Problem," paper presented February 2, 1992, Princeton Theological Seminary.

7. See letters from Cornelius Van Dyck to Anderson, August 17, 1850; William Thomson to Anderson, September 2, 1850; Eli Smith to Anderson, June 17, 1851; and the personal letters between al-Bustani and Eli Smith in "Personal Correspondence," ABCFM archives, Houghton Library, Harvard University.

8. An article on the visit of the governor of Beirut to the school expresses how the school fit with the ideological ideals of the Tanzimat, although perhaps not its implementation, as the school was a private venture by al-Bustani. See "Ziyarat Sʿadat ʿAbd al-Hadi Basha mutasarrif Beirut lil-madrasah al-wataniyah" (The honorable governor of Beirut: Abd al-Hadi's visit to the National School), in *al-Jinan* 1 (1870): 70–71. For a more technical article on the school's workings, principles, expectations, tuition, organization, etc., see "al-Madrasah al-wataniyah" in *al-Jinan* 4 (1883): 626–29.

9. Butrus al-Bustani, "al-Jinan" in *al-Jinan* 1 (1870): 1.

10. Suleiman was a notable figure in politics and literary studies. For his comparisons

of Arabic and Greek verse, see Wajih Fanus, "Sulayman al-Bustani and Comparative Literary Studies in Arabic," *Journal for Arabic Literature* 17 (1987): 105–19. For his translation of the *Iliad*, see *Iliyadhat Humirus* (Cairo: Dar al-hilal, 1904).

11. Page numbers for excerpts from *Khutbah* are given in the text. The lecture is also included in the most recent reprint of *A'mal al-jam'iyah al-suriyah lil-'ulum wal-funun, 1847–1852*, compiled by Yusuf Qizma Khuri. Qizma Khuri lists foreign and native members of al-Jam'iyah al-suriyah (17).

12. Jandora, "Butrus al-Bustani: Ideas, Endeavors, and Influence," 47–48.

13. See Michael Chamberlain, *Knowledge and Social Practice in Medieval Damascus* (Cambridge: Cambridge University Press, 1994), and George Makdisi, *The Rise of Colleges* (Edinburgh: Edinburgh University Press, 1981).

14. See Butrus al-Bustani, *Da'irat al-ma'arif*, 11 vols. (Beirut: n.p., 1876), 1:5.

15. Ibid., 1:2.

16. Hourani, *Arabic Thought*, 100–101.

17. For example, see the opening in Hay'at Tahrir's bulletin, "Al-Tarbiyah al-qawiyah" (National education), in their organ *'Alam al-ghadd* (Baghdad) 1, no 7 (February 16, 1945): 1–2.

18. Lacan, "The See-Saw of Desire," in *The Seminar of Jacques Lacan*, 1:163–75.

19. Lacan, *The Four Fundamental Concepts of Psycho-Analysis*, 144.

20. Al-Jabiri suggests that the catalyst for self-reflection and self-formation but not self-criticism was the presence of two exterior Others to the Arabs, the Turks and the Europeans. The popularity of the constitutional and reform movements as well as the Committee for Union and Progress (CUP) among Arab reformers does not necessarily indicate that the Turks were intrinsically Other to the Arabs. Rather, their alleged position as Other emerged at the end of the century as a consequence of several political developments, including the abrogation of the Ottoman constitution and increased censorship and centralized control of the Arab provinces by Sultan 'Abd al-Halim.

21. Lacan shows how the Self-Same becomes the primary identification for the subject. There is an interesting discussion between him and several eminent psychoanalysts regarding the formation of this process in "Ego-ideal and Ideal-ego," in *Seminar of Jacques Lacan*, 1:129–48.

22. See G. W. F. Hegel's *Philosophy of History*, trans. M. A. Sibree (New York: Wiley, 1900). Of particular interest is his discussion of how history and reason are inextricably linked in creating a rational state and society and his section on "The Course of the World's History."

23. For an example of this, see Jacques Derrida's comment on the signification of truth and women's subjectivity in *Spurs: Nietzsche's Styles*, trans. Barbara Harlow (Chicago: University of Chicago Press, 1979), 59.

24. Hegel, *Phenomenology of Spirit*, e.g., 169–70, 179–92.

25. Ibid., 184.

26. See Fanon's inspiring *Black Skins, White Masks* (New York: Grove Press, 1967) and *The Wretched of the Earth*; see also Albert Memmi, *The Colonizer and the Colonized* (New York: Orion, 1965).

27. While his son Salim would be responsible for writing the opening commentaries and editorials of *al-Jinan*, these early editorials seem to indicate the senior al-Bustani's authorship. See "Man nahnu?" in *al-Jinan* 1 (1870): 161–62.

28. Ibid. See also his article "al-Sinaʿah" (Industry) in *al-Jinan* 1 (1870): 49–51.

29. See Homi Bhabha's seminal "Mimicry and Man: The Ambivalence of Colonial Discourse" in *The Location of Culture*.

30. For a fine discussion on early translations especially involving Bulaq, see Ibrahim Abu-Lughod, *Arab Rediscovery of Europe*.

31. The author commends the American missionary press, which was in Malta before it relocated to Beirut. Despite its concern for printing religious books, this press "has the power to spread knowledge (*maʿarif*) and civilization (*tammadun*) in this country in a short time" (34).

32. Samir Amin sees the Arab renaissance as a time of struggle with the encroaching West. See *The Arab Nation*, trans. Michael Pallis (London: Zed Press, 1978).

Chapter Two

1. For a fine brief introduction to the development of the concept of the Arab nation, see Yordan Peev, "Developpement et particularites de l'idee de la 'nation arabe' (deuxieme moite du XIX–debut du Xxe)," *Quaderni di Studi Arabi* 5/6 (1987/88): 616–27. While Azoury's book was preceded by the works of al-Kawakabi, Najib Azoury was the first to express the ideal in an organized, methodical manner; see his *Les Reveil de la nation arabe* (Paris: n.p., 1905).

2. Benedict Anderson, *Imagined Communities* (New York: Verso, 1983).

3. Mikha'il Mishaqah, *Al-Jawab ʿala iqtirah al-ahbab*, written in 1873, was published by Asad Rustum as *Muntakhabat min al-jawab ʿala iqtirah al-ahbab* (Beirut: Wizarat al-tarbiyah al-wataniyah, 1955). Rustum's source, however, is incomplete. Wheeler Thackston has adroitly pieced together a more complete narrative of Mishaqah's writings in his inappropriately titled translation of the chronicle-memoir, *Murder, Mayhem, Pillage, and Plunder* (Albany: State University of New York Press, 1988). Two more comprehensive accounts of the civil unrest can be found in Malcolm Kerr's *Lebanon in the Last Years of Feudalism: A Contemporary Account by Antun Dahir al-Aqiqi* (Beirut: AUB, 1959) and Iskander bin Yaqub Abkarius, *The Lebanon in Turmoil: Syria and the Powers in 1860*, trans. J. F. Scheltema (New Haven: Yale University Press, 1920).

4. Leila Tarazi Fawaz has documented the violence in Mount Lebanon and Damascus, asserting that concurrent social and economic transformations eroded the traditional power structure and motivated the civil and interconfessional discontent. See *An*

Occasion for War (London: I. B. Tauris, 1994). More recently, Ussama Makdisi examines the historical and political developments of sectarianism within Lebanon, understanding it "as an expression of a new form of local politics and knowledge that arose in a climate of a transition and reform and that laid the foundation for a (later) discourse of national secularism." Contrarily, this present research demonstrates that the sectarian and secular discourses were coterminous, at least in their epistemological infancy. More important, however, Makdisi's research marks how both discourses are products of modernity. Ussama Makdisi, *Culture of Sectarianism*, 6.

5. Al-Muʿallim Butrus al-Bustani edited a collection of the papers that were presented at the society's meetings. Written by American missionaries and native intellectuals, the compilation included six articles by al-Bustani, as well as an article by Mishaqah himself on superstition, "Fi saʿd wal-nahas wal-ʿayn," republished in Qizma Khuri, *Aʿmal al-jamʿiyah al-suriyah lil-ʿulum wal-funun*, 63–68.

6. Thackston, *Murder, Mayhem, Pillage, and Plunder*, 244. Rustum's *Muntakhabat* curiously ends immediately before Mishaqah's account of the war of 1860.

7. Ibid.

8. For a truncated analysis of *Nafir suriyah*, see my article "Unpacking Arab Subjectivity," *Journal of Arab Studies* 30 (spring 1998): 87–109.

9. See Kamal Salibi, *The Modern History of Lebanon* (New York: Frederick A. Praeger, 1965), 145.

10. See Antonius, *The Arab Awakening*, 49–50.

11. *Hadiqat al-akhbar* (Garden of news), established in Beirut in 1856, was the first weekly newspaper in Arabic published by a native in Greater Syria. Its founder and editor was Khalil Khuri, also the author of poetry and social criticism in *al-ʿAsr al-jadid* (The new age) and *al-Nashaʾid al-fuʾadiyah* (The heartfelt anthem) and founder of al-Matbaʿah al-suriyah (Syrian press). In 1831, *Takvim-I Vekayi* was the first state newspaper published by the Sublime Port in Istanbul in Turkish, Arabic, and French.

12. Foucault, *The Archeology of Knowledge*, 56.

13. Ibid., 66.

14. See Asʿad Trad, "Ulfah wa ittihad," *al-Jinan* (Beirut) 1 (1870): 304–5, 340–44. Later, al-Bustani's son, Salim, develops the idiom in "al-Ulfah wal-ittihad wal-taʿqqul wa la siyyama fi al-wilayat al-ʿarabiyah" (Concord, unity, and reason in the Arab provinces), *al-Jinan* 7 (1876): 649–52. For more on modes of translating and transcribing concepts fundamental to discursive formations, see Foucault, *Archaeology of Knowledge*, 58–63

15. Hussein al-Marsafi, *Risalat al-kalim al-thaman* (1881; reprint, Cairo: Matbaʿat al-jamhur, 1903).

16. Tibawi, "American Missionaries," 165.

17. Youssef Choueiri, *Arab History and the Nation-State*, 33–34.

18. Hourani, *Arabic Thought*, 101.

19. Hourani, *Islam in European Thought*, 171.

20. See *wataniyat* X as a thematic summary of *Nafir*. Also, al-Bustani stresses how a

merit-based secular society (IX, 50; X, 56) and unbiased enforcement of the law (X, 59) facilitate a "civilized" nation. All citations from *Nafir* are as given in the form of tract (*wataniyah*) number in roman numerals, followed by the page number found in the 1990 edition. All translations are my own.

21. See Slovo Zizek, *Tarrying with the Negative* (London: Verso, 1993), 46–47. See *wayaniyat* VII, VIII, IX, and X for discussion regarding punishment and the law.

22. For an example, see Mustafa Kamal's articles in 'Abd al-Latif Hamzah, *Adab al-maqalah al-sahafiyah fi Misr*, 8 vols. (Cairo: Dar al-fikr al-'arabi, n.d.), 5:115; originally in Kamal's newspaper *al-Liwa'*, January 2, 1900.

23. Makdisi discusses the competing visions and contradictions within the political program of the Ottoman leadership in Lebanon as early as the 1840s, mapping out coterminous imperial desires to promote "compatriotism and equality" but also the control of Istanbul. He also discusses the appearance of parochial nationalisms by those like Bishop Nicholas Murad. Makdisi, *Culture of Sectarianism*, 80–85.

24. The foundation for Marsafi's *Eight Words* rests on the work al-Tahtawi's social commentaries and the milieu that the sheikh and his peers practically institutionalized. For a brief discussion of some of the buzzwords in his paradigm for a modern Egpyt, see Ezzat Orany, "'Nation,' 'patrie,' 'citoyen' chez Rifa'a al-Tahtawi et Khayr al-din al-Tounisi," in *Melanges de l'Institut Dominicain d'Etudes Orientales du Caire* 16 (1983): 163–90.

25. See Austin, *How to Do Things with Words*, e.g., 3, 6–8, 42.

26. See Derrida, "Signature Event Context," *Glyph* (Baltimore) 1 (1977).

27. Austin, *How to Do Things with Words*, 136.

28. Ibid., 142, 145.

29. The notion of "procedures of intervention" refers to the systemization of disparate and preexisting methodologies and discourses of the production of knowledge and social order into a new coherent and proactive method for understanding the world (for understanding the social, self, and cultural as objects). Foucault, *Archaeology of Knowledge*, 58–59. For more on the performative, see Austin, *How to Do Things with Words*, 109–10.

30. As quoted in Tzvetan Todorov, *Mikhail Bakhtin: The Dialogical Principle*, trans. Wlad Godzich (Minneapolis: University of Minnesota Press, 1984), 60.

31. See Bakhtin, *The Dialogic Imagination*, 279, 291.

32. See "Hubb al-watan min al-iman" in *al-Jinan* 1 (1870): 302–3. As I stated, the concept was a pillar of the Tanzimat, but because of its resonance with a similar Islamic invocation, it was found throughout the Muslim world. Firoozeh Kashani-Sabet shows that a similar equation involving love of the nation, civilization, and national unity existed in the process of the formation of Iranian national subjectivity at the turn of the century. See her "Frontier Phenomenon: Perceptions of the Land in Iranian Nationalism," *Critique* 10 (spring 1997): 30–36.

33. The idiom was the motto for the Ottoman newspaper, *Hurriyat*. Salim al-Bustani

invokes it many times, posing it in diametric opposition to fanaticism (*t'assub*). For an example, see his editorial, "'Ijabat dawaʿi hubb al-watan wa nabdh al-inshiqaq wal-tʿassub," *al-Jinan* 9 (1878): 511–13.

34. Al-Tahtawi, *Manahij*, 10. For a rare but brief discussion of *Manahij* in English, see J. M. Ahmed, *The Intellectual Origins of Egyptian Nationalism* (London: Oxford University Press, 1960).

35. For example, see Satiʿ al-Husri, "Al-wataniyah wa hubb al-watan" (National and love of the nation), *al-ʿIrfan* 8, no. 5 (1923): 329–35; and Michel ʿAflaq, "Al-Qawmiyah: hubb qabl kull shay'" (Nationalism: Love before everything) in his *Fi sabil al-shʿab* (For the people) (1940; reprint, Beirut, Dar al-taliʿah, 1978), 111–13.

36. Foucault, *Archaeology of Knowledge*, 91.

37. Muhammad al-Muwaylihi, *Hadith ʿIsa ibn Hisham* (Cairo: Matbʿat al-maʿarif, 1907), 74–76. First serialized in the journal *Misbah al-sharq* (1898).

38. See Jacques Derrida, *Of Grammatology* (Baltimore: Johns Hopkins University Press, 1976), 144–45.

39. Al-Bustani states, "Government ... concerns itself with the interests of its citizens; that is, their comfort, the success of their affairs, their progress in knowledge [maʿarif], wealth, and civilization.... He who realizes the strength of the relationship and connection between the government and its citizens agrees with us that the existence of a civilized people [*shʿab mutamaddin*] under an uncivilized government, or likewise the existence of civilized government over an uncivilized people, is impossible because it is necessary that they both share in one of the two conditions" (XI, 68–69).

40. Among the better studies regarding relationship between confessionalism, political economy, and social change during the period are Ussama Makdisi, *Culture of Sectarianism;* Dominique Chevallier, *La société du Mont Liban à l'époque de la révolution industrielle* (Paris: P. Geunther, 1971); and Leila Tarazi Fawaz, *Merchants and Migrants in Nineteenth-Century Beirut* (Cambridge: Harvard University Press, 1983); Akram Khater, *Inventing Home: Emigration, Gender, and the Middle Class in Lebanon, 1870–1920* (Berkeley: University of California Press, 2001); Samir Khalaf, *Persistence and Change in Nineteenth-Century Lebanon* (Beirut: American University of Beirut, 1979); Waddah Shararah, *Fi usul al-taʾifiyah* (Beirut: Dar al-taliʿah); Iliya Harik, *Politics and Change in a Traditional Society, Lebanon* (Princeton: Princeton University Press, 1968); and, often overlooked, I. M. Smilianskaya, *Al-Harakat al-fallahiyah fi Lubnan* (Beirut: Dar al-farabi, 1972). For a brilliant study of sectarian historiography, see Ahmad Beydoun, *Identité confessionelle et temps social chez les historiens libanais contemporains* (Beirut: Université libanaise, 1984).

41. A series of editorials and articles appeared in *al-Jinan* at the end of 1882 and the beginning of 1883 discussing the ʿUrabi revolt, British pacification, and direct intervention in Egypt. These articles are particularly interesting in relation to the discourse of national reform put forward by *Nafir*. While initially sympathetic to ʿUrabi's struggle,

Salim al-Bustani increasingly saw the revolt as self-centered and myopic. The discourse that Salim invokes is directly rooted in his father's work, posing the tension between individual interests (*al-sawalah al-ifradiyah*) and public welfare (*al-sawalah al-'umumiyah*). See, for example, the editorial "Jumlah siyasiyah," *al-Jinan* 13 (1882): 445–47. For one of Salim's more sympathetic articles towards the British in Egypt, see the editorial of two weeks later, "Ihtilal britani fi misr," ibid., 577–79.

42. For an example, see their article, May 30, 1907, in *Le Tunisien*.

43. See Girard, *Deceit, Desire, and the Novel*.

44. See "al-Sharq" (The East), in *al-Jinan* 1 (1870): 15–17.

45. Michel Foucault, "What Is Enlightenment?" in *The Foucault Reader*, ed. Paul Rabinow (New York: Pantheon, 1984), 35.

46. Tsenay Serequeberhan, "The Critique of Eurocentrism and the Practice of African Philosophy," in *Postcolonial African Philosophy: A Critical Reader*, ed. Emmanuel Chukwudi Eze (Cambridge, Mass.: Blackwell, 1997). An equally powerful and more rigorous examination of Kant's race theories can be found in the same book: Emmanuel Chukwudi Eze, "The Color of Race: The Idea of 'Race' in Kant's Anthropology."

47. Butrus al-Bustani, *Khitab fil-hay'ah al-ijtima'iyah wal-muqabalah bayna al-'awa'id al-'arabiyah wal-ifranjiyah* (Beirut: Matb'at al-ma'arif, 1869); it first appeared in 1869 in the publication of the Syrian Scientific Society (al-Jam'iyah al-'ilmiyah al-suriyah), the native-run progeny to the missionary-led Syrian Society for Arts and Sciences (al-Jam'iyah al-suriyah lil-'ulum wal-funun). All citations from *Khitab fil-hay'ah al-ijtima'iyah* will be referred to as *al-Hay'ah* in this study. Quotes have been taken from *Al-Mu'allim Butrus al-Bustani: dirasat wa-watha'iq*, compiled and annotated by John Dayah (Beirut: Manshurat majallat fikr, 1981). Yusuf Qizma Khuri compiled the publications of the Syrian Scientific Society and provided a history of it as well as a list of its founding members. See *A'mal al-jam'iyah al-suriyah*.

48. The necessity of self-criticism in the development of society development is made explicit by al-Bustani, who says, "When Man was incomplete, his customs were incomplete. There were many defects and deficiencies; but then [through social development and self-criticism], he was raised to the loftiest step on the stairway of civilization." In other words, the ability to be a social critic and perfect customs, thereby disregarding those which are obsolete, is a means of empowerment on the road to progress (*al-Hay'ah*, 173).

49. See Rifa'ah Rafi' al-Tahtawi, *Takhlis al-ibriz fi talkis Baris* (Golden extracts in the summary of Paris) (Cairo: al-Bulaq, 1834). Al-Bustani never traveled to Europe or North America. However, his interaction with the foreign community in Beirut, missionary and diplomatic, was extensive, as was his knowledge of European languages. Furthermore, he was certainly familiar with the innumerable accounts written by Arab travelers to Europe, most notably al-Tahtawi but also al-Shidyaq's *Kashf al-mukhabba' 'an funun urubba* (Uncovering the hidden about the arts of Europe) (Istanbul: Matb'at al-amirah

al-sultaniyah, 1867) and Francis Marrash, *Rihlat baris* (The Parisian voyage) (Beirut: al-Matba'ah al-sharafiyah, 1867). Despite their fascinating content and styles, little analytical and critical research has been devoted to most of these texts, and they remain grossly neglected in modern Arabic studies. For the best discussion of Arab travel accounts in general, see Abu-Lughod, *Arab Rediscovery of Europe*, and Leon Zolondek's "Nineteenth-Century Arab Travellers to Europe," *Muslim World* 61 (January 1971): 28–34. For a simplistic but empirical recent look at the most prominent travelers, see Nazik Saba Yared, *Arab Travellers and Western Civilization* (London: Saqi, 1996).

50. Choueiri, *Arab History and the Nation-State*, 32

51. Hourani, *Arabic Thought*, 100–101.

52. *'Asabiyah* and *tamaddun* are two terms taken from Ibn Khaldun's monumental work, which al-Bustani mentions in *Khutbah*. As we have seen, the author deploys Ibn Khaldun's theory of social development where tribal and simple societies gradually grow into complex civil societies, each one maintaining specific qualities. As societies become more sophisticated, they also lose cohesive tribal feelings (*'asabiyah*), becoming decadent and falling into ruin and foreign subjugation. Perhaps it is not ironic that al-Bustani paradoxically promotes cultural sophistication *and* the strengthening of national *'asabiyah*. See Ibn Khaldun, *Muqaddimah* (Beirut: Dar al-jil, n.d.). For the English translation, see Franz Rosenthal, *The Muqaddimah: An Introduction to History* (Princeton: Princeton University Press, 1967). See also two brilliant studies on the reception, significance, and misinterpretation of Ibn Khaldun's work by Aziz al-Azmeh, *Ibn Khaldun in Modern Scholarship: A Study in Orientalism* (London: Third World Centre for Research and Pub., 1981) and *Ibn Khaldun: An Essay in Reinterpretation* (Totowa, N.J.: Frank Cass, 1982)

53. Al-Bustani wrote at length about classical Arab heritage. It is no coincidence that he took interest in poets such as al-Jahiz and al-Mutannabi who expressed strong proto-Arab nationalistic sentiments and are relevant in discussing the *shu'ubi* debate. For example, al-Bustani like his friend al-Shaykh Nasir al-Yaziji edited and republished *Diwan al-Mutanabbi* (Beirut, 1860).

Chapter Three

1. Biographical information regarding Salim's life can be found in Jurji Zaydan, *Tarikh adab al-lughah al-'arabiyah* (History of Arabic literature) (Cairo: al-Hilal, 1913), 4:258–59. See also Salim al-Bustani, *Iftitahiyat majallat al-Jinan al-Bayrutiyah, 1870–1884* (The opening editorials of the Beiruti journal *al-Jinan*), ed. and comp. Yusuf Qizma al-Khuri, 2 vols. (Beirut: Dar al-hamra', 1990). For one of the few extensive biographies and examinations of Salim al-Bustani in English, see Constantine Georgescu, "A Forgotten Pioneer of the Lebanese Nahdah" (Ph.D. diss., New York University, 1978). Matti Moosa, *Origins of Modern Arabic Fiction*, 2d ed. (Boulder, Colo.: Lynne Rienner, 1997), examines Salim's fiction in detail, providing plot summaries of virtually all of his novels but little insightful analysis.

2. See Qizma Khuri, *Iftitahiyat majallat al-Jinan* for these opening articles. Michel Juha, *Salim al-Bustani*, in the misnamed *Silsilat al-a'mal al-majhulah* (Series of unknown works) (London: Riyad al-Rayyis, 1989), has also compiled a number of Salim's articles according to theme (women's rights, culture, education, etc.). The collection is a good basic introduction to Salim's social and political opinions, but the compilation is far less comprehensive than that of Qizma Khuri, who happens to be an impressive archivist. They both contain biographies taken from the sources mentioned above.

3. There were several nineteenth-century societies. Some formed the basis for later clandestine nationalist activities. For more on the useful book club, see Mitchell's brief discussion regarding their role in the education of Egyptian society and the promulgation of reform and nationalistic ethics. Timothy Mitchell, *Colonizing Egypt* (1988; reprint, Berkeley: University of California Press, 1991), 90.

4. In *al-Hay'ah*, Butrus al-Bustani distinguishes societal gradations based on "need," starting from primitive (*al-hallat al-khishnah*) to civilized and advanced (*tamaddun*). Social and moral needs (*ihtiyajat m'ashariyah* and *ihtiyajat adabiyah*) arise from the need to help one's fellow man. Political needs arise from the need for the strength and organization of a group. Leisurely needs (*ihtiyajat ikmaliyah*) arise from the need for refinement and relaxation of the mind (music, food, drink, smoking, etc.): *al-Hay'ah*, 164–66.

5. For a sample of this almost forgotten art, see Salman al-Qatayah, *Nusus min khayal al-zill fi halab* (Texts from the shadow plays of Aleppo) (Damascus: Manshurat ittihad al-kuttab al-'arab, 1977). This study reproduces nineteenth-century *karakuz* plays, written and performed in colloquial Syrian, whose raunchiness and scatological humour are no less than hilarious. Two medieval shadow plays by Ibn Daniyal have recently been reprinted by René Khawam as *L'Amoureux et l'orphelin* and *Le Mariage de l'emir conjonctif* (Paris: L'Esprit des péninsules, 1997); see also Muhammad Ibn Daniyal, *Three Shadow Plays*, ed. Paul Kahle (Cambridge: E. J. W. Gibb Memorial Trust, 1992). These are invaluable resources for a lost and derided popular art form.

6. See Sabry Hafez, *The Genesis of Arabic Narrative Discourse* (London: Saqi Books, 1993), 112. Also, M. M. Badawi, for example, while appreciating Salim's novels as an experiment with new prose narratives, concludes that they are unequivocal failures as novels.

7. See Fredric Jameson, *The Political Unconscious*, 151.

8. In addition to his father's translations of *Pilgrim's Progress* and *Robinson Crusoe*, many interesting texts had been or were being translated during Salim's short life, including Alexandre Dumas, *Comte de Monte Cristo* (by Bisharah Shadid, 1870); Jules Verne, *Cinq semaines en ballon* (Yusuf Sarkis, 1875); and La Fontaine, *Fables* (by Father Rafa'il Zukhur in the early 1800s and later, in 1870, by Muhammad 'Uthman Jalal, who also translated Bernadin de St. Pierre, *Paul et Virginie*, 1872, and Molière's *Tartuffe*, 1873). See Ibrahim Abu-Lughod, *Arab Rediscovery of Europe*, and Jak Tajir, *Harakat al-tarjamah fi misr khilal al-qarn al-tasi' 'ashar* (The translation movement Egypt during

the nineteenth century) (Cairo: n.p., 1945), both of which still offer the best bibliography and accounts of translated fiction and nonfiction

9. Foucault, *Language, Counter-Memory, Practice*, 127.

10. Among the several excellent chapters, particularly relevant to this study are "The Question of Narrative in Contemporary Historical Theory" and "The Context in the Text" in Hayden White, *The Content of Form* (Baltimore: Johns Hopkins University Press, 1987).

11. *Al-Huyam*, 254. All translations from Arabic to English are my own.

12. As a diligent student of current political developments throughout the Ottoman Empire and the West, as well as prolonged interaction with Westerns in Lebanon, Salim was acutely aware of Western prejudice and colonial aspirations in the Middle East. For an example, see his article "al-Mudakhalat al-ajnabiyah fi misr" (Foreign intervention in Egypt), *al-Jinan* 10 (1879): 353–55.

13. His love, Wardah, herself argues against the unhealthy habit when the protagonist first spies on her and her friends in the Damascene park (*al-Huyam*, 59).

14. Salim al-Bustani, "'Ubudiyah dakhaniyah" (Smoking slavery), *al-Jinan* 1 (1870).

15. Salim al-Bustani, "Najib wa Latifah," *al-Jinan* 2 (1871): 601–4. See also his novel *Asma'*, *al-Jinan* 3 (1872) in which characters represent the difference between "true progress" and adopting the superficial trappings of modernity, among them smoking.

16. Amin wrote *Tahrir al-mar'ah* (Women's liberation) (Cairo: Maktabat al-taraqqi' 1899) and *Al-Mar'ah al-jadidah* (The new woman) (Cairo: Dar al-ma'arif, 1900).

17. Butrus al-Bustani's article "Khitab fi t'alim al-nisa'" later appeared in *A'mal al-jam'iyah al-suriyah*, 45–53.

18. See the reprint of "Risalat fil-mar'ah" along with a commentary by Munsif al-Shanufi in "Risalat Ahmad Ibn Abi al-Diyaf fi al-mar{ah}ah" in *Hawliyat al-jam'iyah al-tunisiyah* 5 (1968): 49–109 (as cited by Jarrow). I want to thank Dr. Judith Jarrow for introducing the work of Ibn Abi al-Diyaf to me. For more information on the thinker and the development of women consciousness and writing in Tunisia, see Jarrow's dissertation "The Feminine Literary Voices of Tunisia and the Growth of Emancipation" (University of Utah, 1999).

19. For an example, see "Limadha?" (Why?), *al-Jinan* 2 (1871): 503. Also, for a case study of Arab women's participation in building national identity, see Margot Badran, *Feminists, Islam, and Nation: Gender and the Making of Modern Egypt* (Princeton: Princeton University, 1995).

20. For example, Muhammad Yusuf Najm, *Al-Qissah fil-adab al-'arabi al—hadith* (Fiction in modern Arabic literature) (Beirut: n.p., 1961), 38; M. M. Badawi, *Modern Arabic Literature and the West* (London: Ithaca Press, 1985), 95; Shmuel Moreh, *Studies in Modern Arabic Prose and Poetry*, 92; and Moosa, *Origins*, 125.

21. Jacques Lacan, *The Four Fundamental Concepts of Psycho-Analysis*, 147.
22. For example, see Badawi, *Modern Arabic Literature and the West*, 132.
23. Lacan, "Desire, Life, and Death," in *The Seminar of Jacques Lacan*, 2:223.
24. Lacan, *The Four Fundamental Concepts of Psycho-Analysis*, 192.
25. Muhammad Husayn Haykal, *Zaynab* (1913; reprint, Cairo: Dar al-Hilal, 1953).
26. Ibrahim Mazini, *Ibrahim al-Katib* (1931; reprint, Cairo: Dar al-shʿab, 1970).
27. Najib Mahfuz, *Bidayah wa nihayah* (Beirut: Dar al-qalam, 1949).
28. For an example, see *Al-Huyam*, 94.
29. Tawfiq Hakim, *ʿAwdat al-ruh* (1928; reprint, Cairo: Maktabat al-adab, 1964).
30. Northrop Frye, *Anatomy of Criticism* (Princeton: Princeton University Press, 1957), 304.
31. Frye, *The Secular Script: A Study of the Structure of Romance* (Cambridge: Harvard University Press, 1976), 36.
32. Ibid., 8.
33. Ibid., 11.
34. Ibid., 50.
35. Doris Sommer, "Irresistible Romance," in *Nation and Narration*, ed. Homi Bhabha (New York: Routledge, 1990), 79.
36. Ibid., 81.
37. Ibid., 76.
38. Ibid., 85.
39. Ibid., 86.
40. Nuʿman al-Qasatli, *Al-Fatat al-aminah wa ummuha* (The virtuous girl and her mother), serialized in *al-Jinan* 11 (1880); and *Riwayat Anis* (The story of Anis), serialized in *al-Jinan* 12 (1881). These will be discussed in chapter 4. The short stories of Shihatah al-ʿUbayd are republished from the journal *al-Sufur* in *Dars muʿlim* (Cairo: Dar al-qawmiyah, 1964).
41. *Al-Huyam*, 702. These terms form the nomenclature for reform and are found throughout the writing of Salim and others. For an example, see his article, "al-Ulfah wal-ittihad wal-taʿqqul wa la siyyama fil-wilayat al-ʿarabiyah."
42. No research has yet determined the genealogy of Lebanese, Syrian, and Arab nationalist imagery. However, by 1869, Marun al-Naqqash's plays were posthumously published as *Arzat Lubnan* (Cedars of Lebanon) (Beirut, 1869).
43. Salim al-Bustani, *Salmah*, serialized in *al-Jinan* 9 (1878) and 10 (1879).
44. al-Bustani, *Fatinah*, serialized in *al-Jinan* 8 (1877).
45. al-Bustani, "Zifaf Farid," *al-Jinan* 2 (1871): 447–53.
46. al-Bustani, *Samiyah*, serialized in *al-Jinan* 13 (1882) and 14 (1883).
47. See Timothy Mitchell, *Colonising Egypt*; Margot Badran, *Feminists, Islam, and Nation*; and Beth Baron, *The Women's Awakening in Egypt* (New Haven: Yale University

Press, 1994). While these texts might not explicitly discuss shifts in Egyptian nationalistic discourse, they all define processes of changing conceptions of subjectivity and strategies of writing and praxis under British colonialism.

48. Nathan Brown, *Peasant Politics in Modern Egypt* (New Haven: Yale University Press, 1990), 69.

49. Zachary Lockman, "Imagining the Working Class: Culture, Nationalism, and Class Formation in Egypt, 1899–1914," *Poetics Today* (Tel Aviv) 15, no. 2 (summer 1995): 157–90.

50. Muhammad ʿUmar, *Hadir al-misriyin aw sirr taʾakhkhurihim* (Cairo: Matbaʿat al-Muqtataf, 1902).

51. Lockman, "Imagining the Working Class," 168.

52. See "*Riwayat Fuʾad* by Nuqula Bustris," in *al-Muqtataf* 12 (1887): 127–28.

53. Muhammad Tahir Haqqi, *ʿAdhraʾ Dinshaway* (Cairo, 1906).

54. Butrus Hallaq, "Love and the Birth of Modern Arabic Literature," in *Love and Sexuality in Modern Arabic Literature*, ed. Roger Allen, Hilary Kilpatrick, and Ed De Moor (London: Saqi Books, 1995). Hallaq specifically recalls the work of Philippe Lacoue-Labarthe's *L'absolu littéraire* (Paris: Editions du Seuil, 1978). Jubran Khalil Jubran, "Madjaʿ al-ʿarus" (The Bride's bed) in *Al-Arwah al-mutamarridah* (Rebellious spirits) (New York: al-Muhajir, 1909); and Jubran's *Al-Ajnihah al-mutakassirah* (Broken wing) (New York: (New York: Miraʾat al-gharb, 1912).

55. For more on the motif of death in Jubran's work, see Vincenza Grassi, "Il Tema della morte nelle opere di Gibran Khalil Gibran," in *Oriente Moderno*, 1–3 (1985): 1–38.

56. Roland Barthes, *Writing Degree Zero and Elements of Semiology* (London: Jonathan Cape, 1967), 32.

57. Hallaq, "Love and the Birth of Modern Arabic Literature," 21. See Khalil Hawi, *Kahlil Gibran: His Background, Character, and Works* (Beirut: Arab Institute for Research and Publishing, 1963). See also Moreh, *Studies in Modern Arabic Prose and Poetry*, 123–24; and, more extensively, Sasson Somekh, "Biblical Echoes in Modern Arabic Literature," *Journal of Arabic Literature* 26 (March–June 1995): 186–200. Note that Jubran and other *mahjari* writers were influenced by the liturgies of the Eastern Christian churches and the groundbreaking nineteenth-century translations of the Bible by Butrus al-Bustani and Cornelius Van Dyck (American Protestant Bible, 1865) and Ibrahim al-Yaziji (Jesuit translation, 1876). This assertion seems to be quite justified especially if one reads the prose-poetry of Jubran against even the contemporary *taratil* (chants) of the Maronite church, which, in fact, Marun ʿAbbud mentions in *Ahadith al-quriyah* (Beirut: Dar al-thaqafah, 1968), 117–20.

58. Mustafa Lutfi al-Manfaluti, *Al-ʿAbarat* (Tears) (Cairo: Matbaʿat al-maʿrif, 1915) and *Al-Nazarat* (Reflections) (Cairo, 1910).

59. Laroui, *La crise des intellectuels arabes*, 110.

60. For a discussion of this shift, see Muhammad Husayn Haykal, *Mudhakkirat fil al-*

siyasah al-misriyah (Memoris in Egyptian politics) (Cairo: Dar al-maʿarif, 1978), 20–70. Also, for a good biography, see Charles Adams, *Islam and the Search for Social Order* (Albany: State University of New York Press, 1983).

61. For example, *Salmah* 9 (1878): 239 and 10 (1879): 700.

62. *Salmah* 9 (1878): 378, 734 and 10 (1879): 63.

63. *Salmah* 9 (1878): 270.

64. For an example of Salim's views on personal responsibilities in the political realm, see "al-Siyasah al-ams wal-an wal-ghadd" (The politics of yesterday, today, and tomorrow), *al-Jinan* 1 (1870): 705–8.

65. Salim specifically wrote an editorial, "Ruh al-ʿasr," *al-Jinan* 1 (1870): 385–88. He also mentions this "new spirit" throughout his commentary and novels. For an example, see his novel *Bint al-ʿasr* (Daughter of the age), serialized in *al-Jinan* 6 (1875).

66. For one example, see his article "Innana asbahna fi zaman musawah wa intizam" (We've come to the age of equality and order), *al-Jinan* 9 (1878): 703–4. For studies in English on the rise of Enlightenment ideals, see Ra'if al-Khuri, *Modern Arab Thought: Channels of the French Revolution to the Arab East* (Princeton: Kingston Press, 1983); and Leon Zolondek, "The French Revolution in the Arabic Literature of the Nineteenth Century," *Muslim World* 57 (July 1967): 202–11. For a more localized study of the rise of "the people" in Arab thought, see also Leon Zolondek, "Ash-Shʿab in Arabic Political Literature of the Nineteenth Century," *Die Welt des Islams* 10 (1965): 1–16.

67. Yahya Haqqi, *Qindil Umm Hashim* (Umm Hashim's lamp) (Cairo: Dar al-maʿarif, 1944); Mahmud Taymur, *Al-Nida' al-majhul* (The unknown call) (Beirut: Dar al-maksuf, 1939); and Tayyib Salih, *Mawsim al-hijrah ila al-shamal* (Season of migration to the north) (Cairo: Dar al-hilal, 1969).

68. Salim al-Bustani, "Asbab taqaddum Bayrut wa namaha al-sariʿ" (Reasons for Beirut's progress and speedy growth), *al-Jinan* 15 (1884): 449–50.

Chapter Four

1. The study of Arab nationalism reflects this, especially regarding elite views of national identity. For an example, see the debate in Khalidi, Anderson, and Simons, eds., *The Origins of Arab Nationalism*. For a good example of a completely top-heavy study in a local context, see Engin Akarli's *The Long Peace: Ottoman Lebanon, 1861–1920* (London: Tauris, 1993). A few studies have shown how national or class identities took shape at the turn of the last century. The most notable are Mitchell, *Colonising Egypt*; Joel Beinin and Zachary Lockman, *Workers on the Nile* (Princeton: Princeton University Press, 1987); and Zachary Lockman, *Workers and Working Classes in the Middle East* (Albany: State University of New York Press, 1994).

2. Badawi, *Arabic Literature and the West*; Hafez, *The Genesis of Arabic Narrative Discourse*; Roger Allen, *The Arabic Novel: An Historical and Critical Introduction* (Syracuse, N.Y.: Syracuse University Press, 1982).

3. See Sasson Somekh, *Genre and Language in Modern Arabic Literature* (Wiesbaden: O. Harrossowitz, 1991).

4. Jaroslav Stetkevych, *The Modern Arabic Literary Language* (Chicago: University of Chicago Press, 1970).

5. See Muhammad Husayn Haykal, *Thawrat al-adab*, 3d ed. (1933; reprint, Cairo: Maktabat al-nahdah al-misriyah, 1965), 38.

6. Salamah Musa, *Tarbiyat Salamah Musa*, 42–43.

7. Some of these articles have been collected and published. See Ibrahim al-Yaziji, *Abhath lughawiyah*, ed. Yusuf Qizma al-Khuri (Beirut: Dar al-Hamra', 1993). The original series of articles, written in the 1890s, was first published as *Lughat al-jara'id* (Cairo[?] : Matbaʿat al-Matar, 1900).

8. Hallaq, "Love and the Birth of Modern Arabic Literature."

9. For example, see Yaseen Noraani's examination of elegy and Egyptian national identity, "A Nation Born of Mourning," *Journal of Arabic Literature* 28 (March 1997): 38–67; and Hussein Kadhim's article on the poetic *diwan* of Ahmad Shawqi, "Poetics of Postcolonialism," *Journal of Arabic Literature* 28 (October 1997): 179–218. While their use of theory is mechanical, they both offer localized examination of the *nahdah* poets.

10. A powerful example is Stephen Greenblatt's *Renaissance Self-Fashioning* (Chicago: University of Chicago Press, 1980).

11. Nuʿman al-Qasatli, *Kitab al-rawdah al-ghanna' fi Dimashq* (Beirut, 1879).

12. *Al-Fatat al-aminah wa ummuha* relates the story of Aminah, whose abusive mother forbids her to marry Thabit. After many tribulations, the mother realizes her error and repents. In the second story, *Riwayat Anis*, the successful Anis loves the beautiful and virtuous Anisah, but Anisah's rival, Nur, the daughter of Anis's business acquaintance, does her best to sabotage their relationship with her accomplices, Talib and La'im, who covet the heroine. The story has a dual plot in which Anis's cousin, Fatimah, and Adib undergo similar trials, including physical abuse. Both couples, however, achieve marital bliss.

13. Nuʿman al-Qasatli, *Murshid wa Fitnah*, serialized in *al-Jinan* 11 and 12 (1880–81).

14. Ibid., 109.

15. Ibid., 159.

16. For example, see the Bedouin obsession with smoking, 217, or poetry and dance, 187–89. For honor codes, see al-Qasatli, *Murshid wa Fitnah*, 152; for gender roles, see ibid., 175; and for superstitions, see ibid., 223 and 249.

17. Salim al-Bustani, "Hadhir wa Laylah," in *al-Jinan* 2 (1871): 165–68.

18. Jirji Jibra'il Balit al-Halabi, "Riwayat rajul dhi amra'atayn" (The story of the man with two wives), *al-Jinan* 2 (1871): 132–40. This may be a translation attributed to the author. All the characters and places have French names, and the author states that he took the story from the French press.

19. Labibah Hashim, "Hasanat al-hubb" (The advantages of love), *al-Diya'* 1 (Beirut) (1898–99): 634–40. The story appeared in a regular column, entitled "Fukahat," in which other stories by Hashim had appeared along with the work of other authors, some of whom remained anonymous. Two other short stories are "al-Fawz b'ad al-fawt" (Victory after the tribulation) in vol. 2 (1899–1900): 568–76; and "al-Hayat al-sa'idah" (Happy life) in vol. 2 (1899–1900): 695–704. The journal itself was edited by Ibrahim al-Yaziji, son of Nasif, translator of the New Testament for the Jesuits, poet, nationalist, and linguist. While he did not write any fiction that we know of, he published shorts stories like "Hikmat al-waalidayn" by Musa Saydah in *al-Diya'* 2 (1898–99): 120–28.

20. For an introduction to the origins of the Arabic short story, see 'Abd al-'Aziz 'Abd al-Majid, *The Modern Arabic Short Story: Its Emergence, Development, and Form* (Cairo: Dar al-ma'arif, 1956).

21. Hafez, *The Genesis of Arabic Narrative Discourse*, 120–29.

22. This short-lived but prominent journal was followed by 'Abd Allah al-Nadim, *Al-Ustadh* (Cairo: Matba'at al-mahrusah, 1882–83; reprint, Cairo: al-Hay'ah al-misriyah al-'ammah lil-kitab, 1994).

23. Among the many occurrences of this idiom, see 'Abd Allah al-Nadim, "Jahl al-'awaqib," in *Al-Tankit wal-tabkit*, 60–61.

24. 'Abd Allah al-Nadim, "'Arabi tafarranaj," in *Al-Tankit wal-tabkit*, 36–37.

25. 'Abd al-'Alim al-Qabbani, *Nish'at al-sahafah al-'arabiyah bil-Iskandariyah, 1873–1982*, 96; taken from *Al-Tankit wal-tabkit*, 92.

26. 'Abd Allah al-Nadim, "Majlis tubbi ala al-musab al-afranji," in *Al-Tankit wal-tabkit*, 37–39.

27. 'Abd Allah al-Nadim, "Al-Nabih wal-fallah," in *Al-Tankit wal-tabkit*, 130–32.

28. 'Abd Allah al-Nadim, "La yusaddiq wa law khalaftu laka," in *Al-Tankit wal-tabkit*, 155–57.

29. See, for example, M. M. Badawi, "The Origins of the Arabic Novel," in *Modern Arabic Literature and the West* (London: Ithaca Press for the Board of the Faculty of Oriental Studies, Oxford University, 1985). This view differs little from H. A. R. Gibb, "Studies in Contemporary Arabic Literature," first published in 1926 in *Bulletin of the School of Oriental and African Studies*, later to appear in *Studies on the Civilization of Islam*, ed. Stanford J. Shaw and William R. Polk (London: Routledge and Kegan Paul, 1962).

30. See Francis Marrash, *Ghabat al-haqq* (The forest of truth) (Aleppo, 1865). See also his preachy *Durr al-sadaf fi ghara'ib al-sudaf* (Strange coincidences in a clam's pearl) (Aleppo, 1873).

31. See Robin Ostle, "The Rise and Development of Lyrical Poetry in Modern Arabic Literature" (Ph.D. diss., Oxford University, 1970) for a good empirical introduction. Mutran's poetry was certainly the most innovative. For a study of the unique poetic possibilities in it, see Ostle's "Khalil Mutran: The Precursor of Lyrical Poetry in Mod-

ern Arabic," *Journal of Arabic Literature* 2 (1971): 116–26. See also Nicolas Saade, *Halil Mutran* (Beirut: Université libanaise, 1985).

32. Badiʿ al-zaman al-Hamadhani, *Maqamat Badiʿ al-zaman al-Hamadhani* (Beirut: al-Matbaʿah al-kathulikiyah, 1958). For an English translation, see *The Maqamat of Badi al-Zaman al-Hamadhani*, trans. W. J. Prendergast (London: Curzon Press, 1973). The translation is masterful although Victorian and slavishly loyal to Muhammad ʿAbduh's nineteenth-century redaction. ʿAbduh expurgated most of the lurid language and scenes of the original work. The translations included here are my own.

33. A. F. L. Beeston, "Maqamah," in *Cambridge History of Arabic Literature: ʿAbbasid Belles-Lettres*, ed. Julia Ashtiany (Cambridge: Cambridge University Press, 1990), 125–35. See also his "Genesis of the 'Maqamat' Genre," *Journal of Arabic Literature* 2 (1971): 1–12.

34. Two fruitful studies that demonstrate this are Ayman Bakr, *Sard fi maqamat al-Hamadhani* (Cairo: Dar al-hay'ah al-misriyah, 1997); and Mustafa al-Shaka'ah, *Badiʿ al-zaman al-Hamadhani: raʿid al-qissat al-ʿarabiyah* (Cairo: n.p., 1975).

35. James Monroe, *The Art of Badiʿ az-Zaman al-Hamadhani as Picaresque Narrative* (Beirut: American University of Beirut Press, 1983), 28–30, 86–91.

36. Ibid., 20–26.

37. Ibid., 27.

38. Vladimir Propp, *Morphology of the Folktale* (Bloomington: Research Center, Indiana University, 1958); Abdelfattah Kilito, *Les séances: récits et codes culturels chez Hamadhani et Hariri* (Paris: Sindbad, 1983).

39. For a biography of al-Yaziji, see ʿIsa Mikha'il Saba, *Al-Sheikh Nasir al-Yaziji* (Beirut: Dar al-maʿrif, 1954). Also, for a dated discussion of his work, see Henri Pérès, "Les premières manifestations de la renaissance arabe: Nasif al-Yazigi et Faris al-Shidyaq," *Annales de l'institute d'études orientales de la faculté d'Alger* 1 (1934–35): 233–56.

40. The text is traditionally associated with the reawakening of interest in high literature. Examples of this assertion are found in Roger Allen, *The Arabic Novel* (Syracuse, N.Y.: Syracuse University Press, 1995), 14; and Moreh, *Studies in Modern Arabic Prose and Poetry*, 118.

41. Nasif al-Yaziji, *Majmaʿ al-bahrayn* (Beirut: Dar Bayrut, 1966), 9.

42. Many neo-classical maqamat followed, most notable of which is ʿAbd Allah Fikri's *Al-Maqamah al-fikriyah* (Cairo: Matbaʿat al-madaris, 1873).

43. Nasif al-Yaziji, *Kitab Fakihat al-nudama' fi murasalat al-udaba'* (another translation could be: The fruit of friends in the correspondence of litterateurs) (Beirut[?]: n.p., n.d), 35–37. I believe that this edition is the same as that published in Beirut by al-Matbaʿat al-mukhallisiyah, 1866.

44. Ibid., e.g., 36 and 53.

45. While Christian Arab maqamat have still to be studied at length, for an overview of Jewish Arab maqamat, see Rina Drori, "Hebrew Literature's Relations with Arabic,"

The Encyclopedia of Arabic Literature, ed. Julie Scott Meisami and Paul Starkey (New York: Routledge, 1998).

46. Gilles Deleuze and Felix Guattari, *A Thousand Plateaus* (Minneapolis: University of Minnesota Press, 1987), e.g., 101–3. See also their *Kafka: Toward a Minor Literature* (Minneapolis: University of Minnesota Press, 1986).

47. A few biographies have been written, containing much repetition of each other's findings. See 'Imad Salih, *Ahmad Faris al-Shidyaq* (Beirut: Sharikat al-matba'at, n.d.); Ahmad 'Arafat al-Dawi, *Dirasah fi adab Ahmad Faris al-Shidyaq* (Amman: Wizarat al-thaqafah, 1994); Marun 'Abbud, *Saqr Lubnan* (Beirut: Dar al-Kashshaf, 1950).

48. Pérès, in "Les premières manifestations de la renaissance arabe," states that *Al-Saq* was influenced by Rabelais.

49. The first maqamah is introduced by a brief explanation of his intent. See al-Shidyaq, *Al-Saq,* 141. For genres, see, e.g., *al-ritha'* (lamentation) of a child, 606–9, or *madh* (panegyric) of Subhi Bey of Istanbul, 664–65. For styles, see, e.g., the opening pages of book 1, ibid., 78.

50. An intimidating text, *Al-Saq* remains understudied. The aforementioned biographies offer interesting information regarding al-Shidyaq and the composition of *Al-Saq.* Nazik Saba Yared, *Arab Travellers and Western Civilization,* is only a descriptive study but offers examples from *Al-Saq* in English.

51. Al-Fariyaq replies by relating the story of how he lost his donkey (ibid., 354).

52. Several travel accounts had been written in Arabic by this time, the best known of which is al-Tahtawi, *Takhlis al-ibriz,* which still warrants close, critical study. However, these travelogues are explicitly nonfictional and, unlike *Al-Saq,* they maintain the pretense of offering an objective view of the phenomena they recount.

53. Al-Shidyaq fled Lebanon after he converted to Protestantism. His brother, As'ad, was the first Protestant convert in Lebanon; he was imprisoned and starved to death by the Maronite Patriarch. See al-Bustani, *Qissat As'ad al-Shidyaq.*

54. For an example of this diversity, see chapter 8, on Tanta, chapter 9, which provides ancient Egyptian myths for the seasons, and chapter 20, on the Arabs.

55. Muhammad al-Muwaylihi, *Hadith 'Isa ibn Hisham aw fatrah min al-zaman* (Cairo: Matba'at al-ma'arif, 1907). Roger Allen has made a masterful English translation of al-Muwaylihi's challenging text, entitled *A Period of Time,* St. Antony's Monographs no. 27 (Reading: Ithaca Press, 1992). Equally important is Allen's extended study of *Hadith 'Isa ibn Hisham* in the introduction. All translations in this chapter are mine.

56. For example, Ibrahim al-Muwaylihi, *Mir'at al-'alam* (Mirror of the World), serialized in his *Misbah al-Sharq* (1899).

57. Hafiz Ibrahim, *Layal Satih* (Satih's Night) (Cairo: Maktabat al-adab, 1898).

58. Ahmad Shawqi, *Riwayat Ladiyas* (Cairo: Maktabat al-adab wal-mu'ayyid, 1898). Shawqi also wrote *'Adhra' al-Hind* (The maiden of India), which Ibrahim al-Yaziji reviewed critically in his *al-Bayan* (Cairo) 1 (1897): 536.

59. See Farah Antun, *Urushalim al-jadidah* (New Jerusalem) (Alexandria: Matbaʿat al-Jamiʿah, 1904); *Maryam qabla al-tawbah* (Mary before her submission), serialized in *al-Jamiʿah* (1906); *Hubb hatta al-mawt* in *al-Jamiʿah* (1899); *Wahsh Wahsh Wahsh* (Alexandria, 1903)—some of the motifs of which seem to anticipate Taymur's *Al-Nidaʾ al-majhul;* Yaʿqub Sarruf, *Amir Lubnan* (Cairo: Matbaʿat al-muqtataf, [1906?]).

60. Jamil Nakhlah al-Mudawwar, *Hadarat al-Islam fi dar al-salam,* 2d ed. (Cairo: al-Matbaʿah al-amiriyah, 1937).

61. Niqula al-Haddad, *Al-ʿAyn bil-ʿayn* (Cairo, 1901?). See also his *Hawwa al-jadidah* (Cairo: 1906); 2d ed. (Cairo: al- Matbaʿah al-salafiyah, 1919), which predates but is uncannily similar to Mahmud Tahir Lashin, *Hawwa bila Adam* (1934).

62. Muhammad Lutfi Jumʿah's social realist book, *Wadi al-humum* (Cairo: Matbaʿat al-nil, 1905), followed by his *Maqamat layali al-ruh al-haʾir* (Cairo: Maktabat al-taʿlif, 1912); Tahir al-Haqqi, *ʿAdhraʾ Dinshaway.*

Chapter Five

1. Nikki Keddie, *Sayyid Jamal ad-Din "al-Afghani": A Political Biography* (Berkeley: University of California Press, 1972).

2. Reprinted as *Al-ʿUrwah al-wuthqa* (The firm grip), ed. Salah al-din al-Bustani (Cairo: Dar al-ʿArab, 1957).

3. Alexandre Kojève, *Introduction to the Reading of Hegel* (Ithaca, N.Y.: Cornell University Press, 1969), 23.

4 Ibid., 229–30.

5. This debate originally appeared in *Journal des débats* (Paris), March 30 and May 18, 1883, and is commented on briefly in Hourani, *Arabic Thought in the Liberal Age,* and Nikki Keddie, *An Islamic Response to Imperialism* (Los Angeles: University of California Press, 1968), where al-Afghani's reply is translated.

6. See Antuniyus Shibli, ed., *Al-Shidyaq wal-Yaziji* (Junieh: n.p., 1950). The articles by al-Shidyaq are also included in the compilation of his articles from his periodical *al-Jawaʾib,* entitled *Kanz al-raghaʾib* (Istanbul: Matbaʿat al-Jawaʾib, 1871).

7. Renan, "L'islamisme et la science," in *Oeuvres complètes de Ernest Renan,* 1:946. Subsequent page numbers will be cited in the text. All translations are my own. For the same articulations, see *Averroès et l'Averroïsme,* in ibid., vol. 3, and *L'avenir de la science,* in ibid., vol. 6.

8. Ibid., 1:951; see also his rhetorical questions, 1:947.

9. Kojève, *Introduction to the Reading of Hegel,* 229.

10. Ibid., 64.

11. Ibid., 65.

12. Karl Marx, *Capital,* 3 vols. (New York: International Publishers, 1967), 1:391–92.

13. "Réponse de Jamal ad-din al-Afghani à Renan," 179. Translations of al-Afghani's article are my own. Subsequent page numbers will be cited in the text.

14. Sigmund Freud, *Civilization and Its Discontents* (New York: Norton, 1961), 11; originally published as *Das Unbehagen in Der Kultur* (Vienna: Internationaler psycho-analytischer Verlag, 1930).

15. Al-Afghani, *Réfutation des matérialistes*, 962.

16. Ibid., 963.

17. Ibid., 961.

18. See Fathi Zaghlul, *Ruh al-ijtima'* (Cairo: Matba'at al-sh'ab, 1909) and Le Bon's *Psychologie des foules* (Paris: Felix Alcan, 1895). Timothy Mitchell discusses these books at length in his *Colonising Egypt*.

19. For a brief biography and selection of his work, see Michel Juha, ed., *Farah Antun* (London: Riyad al-Rayyis, 1998); and *Farah Antun, Hayatuhu, adabuhu, muqtatafat min atharihi* (Beirut: Maktabat al-sadir, 1950); and Husayn Munasirah, *Farah Antun* (Amman: Dar karmil, 1994).

20. Rashid Rida, *Tarikh ustadh al-imam al-shaykh Muhammad 'Abduh*, 3 vols. (Cairo: Matba'at al-manar, 1906–31). Ali Shalash has compiled several articles by 'Abduh from various sources and published them in Riad el-Rayyes's Unknown Works series. See *Muhammad 'Abduh* (London: Riad el-Rayyes, 1987). This collection is interesting because it offers some alternative readings to the 'Abduh corpus that Rida's work has galvanized.

21. See Rashid Rida, *Tarikh ustadh 'Abduh*, 805–16.

22. Antun, *Ibn Rushd wa falsafatuhu*, 6. All translations are mine.

23. Ibid., 2.

24. Antun discusses the role of the Eastern Christians in the larger Ottomanist project (ibid., 179). He also equates knowledge, rationality, and freedom with the victory of socialism (ibid., 169). Subsequent page numbers for *Ibn Rushd* will be cited in the text.

25. Friedrich Nietzsche, *The Use and Abuse of History*, trans. Adrian Collins (New York: Macmillan, 1957), 52.

Chapter Six

1. See Hilary Kilpatrick, "The Arabic Novel: A Single Tradition?" *Journal of Arabic Literature* 5 (1974): 93–107.

2. For example, *al-Hilal* 2 (1893–94) printed letters to the editor from, among other places, Cairo, Beirut, Alexandria, Aleppo, Damascus, São Paolo, Basra, Baghdad, Helwan, Najd, Mosul, and cities in North America; from Nasirah, Jaffa, Nablus, and Jenin in Palestine; from Antakya, Mardin, and Urfa in present-day Turkey; and from numerous villages throughout Lebanon, Syria, and Egypt.

3. See Taha Husayn, *Al-Ayyam*, 2 vols. (Cairo: Dar al-ma'arif li-misr, 1962), 2:177; and Najib Mahfuz, *Atahaddathu ilaykum* (Beirut: Dar al-'awdah, 1977).

4. Zaydan himself wrote in the introduction to *Fatat Ghassan* (1897–98) that he

had received encouraging comments regarding his novels after the publication of *Armanusah al-misriyah* in 1896; *al-Hilal* 4 (1895–96): 24. Rafiq al-ʿAzm also praised his fiction but criticized it for its lack of objectivity. See *al-Hilal* 7 (1898–99): 489–92. Rashid Rida, on the other hand, wrote a review of *Fath al-Andalus* criticizing the book for not properly representing Muslims. See *al-Manar* 6 (1903): 391–98. Likewise, Yaʿqub Sarruf, Zaydan's former teacher at the Syrian Protestant College of Beirut, wrote an extensive critique of *Al-Mamluk al-sharid*. See *al-Muqtataf*, 345–49. Also noteworthy is Muhammad Husayn Haykal's discussion of Zaydan's stories in his *Fi awqat al-faragh*, 2d ed. (1925; reprint, Cairo: Maktabat al-nahdah al-misriyah, 1968), 236, 333.

5. Thomas Philipp translates letters from Zaydan to Emile that briefly discuss Zaydan's feelings about the retraction of the university's offer. See *Autobiography of Jurji Zaydan* (Washington D.C.: Three Continents, 1990), 80–82.

6. Rashid Rida, *Intiqad kitab tarikh al-tamaddun al-islami* (Cairo: Dar al-Manar, 1912).

7. *Al-Manar* 17 (1914): 636–40; Lewis Ware, "Jurji Zaydan: The Role of Popular History in the Formation of a New Arab World View" (Ph.D. diss., Princeton University, 1973), 199.

8. Foucault, *Archaeology of Knowledge*, 59.

9. There are quite a few studies of Zaydan's life and work in Arabic, English, French, German, and Russian, varying in quality and polemical tone. The following are the titles of those I managed to find: Nazir ʿAbbud, *Jurji Zaydan: hayatuhu wa aʿmaluhu* (Beirut: Dar al-jil, 1983); Ahmad Husayn Tamswi, *Jurji Zaydan* (Cairo: al-Hay'ah al-misriyah al-ʿammah lil-kitab, 1992); Shawqi Abu Khalil, *Jurji Zaydan fl-mizan* (Damascus: Dar al-fikr, 1981); ʿAbd al-Rahman Ashmawi, *Waqfah maʿa Jirji Zaydan* (Riyad: Maktabat al-Ubaykan, 1993); Thomas Philipp, *Gurgi Zaidan: His Life and Thought*, Beiruter Texte und Studien, vol. 3 (Beirut: for F. Steiner, 1979); and Ware, "Jurji Zaydan." All the information provided here is taken from these sources or Zaydan's autobiography.

10. See *Mudhakkirat Jirji Zaydan*, ed. Salah al-din Munajjid (Beirut: Dar al-kitab al-jadid, 1968). See also *Autobiography of Jurji Zaydan*. Abdallah Cheikh-Moussa offers one of the theoretical examinations of Zaydan's work, particularly his autobiography, in "L'écriture de soi dans les mudakkirat de Gurgi Zaydan," *Bulletin d'études orientales* (Damascus) 37/38 (1985/1986): 23–49.

11. Georg Lukács, *The Historical Novel* (Lincoln: University of Nebraska Press, 1983), 25.

12. See Fredric Jameson, "World Literature in the Age of Multinational Capitalism."

13. See Aijaz Ahmad's response, "Jameson's Rhetoric of Otherness and "National Allegory," *Social Text* 17 (fall 1987), 3–25, 4. See also Madhava Prasad's interesting engagement, "A Theory of Third World Literature," *Social Text* 31/32 (fall 1982).

14. Craig Owen, "The Allegorical Impulse: Toward a Theory of Postmodernism," in

Beyond Recognition (Berkeley: University of California Press, 1992), pt. 1, 52–69, and pt. 2, 70–87. Part 1 is reprinted in *Art after Modernism,* ed. Hal Wallis (Boston: Godine, 1984), 203–35.

15. Paul De Man, *Allegories of Reading* (New Haven: Yale University Press, 1979), 79.

16. This second pattern is common to the bulk of Zaydan's historical novels, such as *Jihad al-Muhibbin* (Cairo: Dar al-Hilal, 1893), *Fatat Ghassan* (Cairo: Dar al-Hilal, 1897–98), and *Al-Inqilab al-'uthmani* (Cairo: Dar al-Hilal, 1911).

17. Among others are *'Adhra' Quraysh* (Cairo: Dar al-Hilal, 1911) and *Abu Muslim al-Khurasani* (Cairo: Dar al-Hilal, 1905), which is the only text dealing with unrequited love and romantic betrayal.

18. Nietzsche, *The Use and Abuse of History,* 13.

19. Ibid., 15.

20. See Zaydan, "al-Hal fil-wujud," *al-Hilal* 22 (1913): 147.

21. Taha Muhsin Badr, *Tatawwur al-riwayah al-'arabiyah al-hadithah* (Cairo: Dar al-ma'arif, 1968), 90, quoting Zaydan's introduction to the historical novel *Al-Hajjaj ibn Yusuf* in *al-Hilal* 10 (1901–2). Zaydan reiterates this in "Al-Riwayah: Asluha wa tarikhuha," *al-Hilal* 11 (1902–3): 39.

22. Jamil Nakhlah al-Mudawwar, *Hadarat al-Islam fi dar al-salam* (Cairo: Matba'at al-muqtataf, 1888).

23. Farah Antun, *Al-Sultan Salah al-din* (1923; reprint, Beirut: Dar Marun 'Abbud, 1981).

24. Zaydan's novel, *Abu Muslim al-Khurasani,* about the advent of the 'Abbasid dynasty, involves themes of family fragmentation, particularly Abu Muslim's betrayal and the execution of the father of his loving admirer, Julinar. However, the principal themes deal with unrequited love and manipulation.

25. See Gilles Deleuze and Felix Guattari, *A Thousand Plateaus* (Minneapolis: University of Minnesota Press, 1987), 291–92.

26. For the significance of the image in the formation of selfhood, see Lacan, "The Mirror Stage as Formative in the Function of the I," *Ecrits,* 2–3.

27. *Al-Mamluk al-sharid* in *Mu'allafat Jirji Zaydan al-kamilah,* vol. 7 (Beirut: Dar al-jil, 1981), 235. The translations included here are my own. Subsequent page numbers will be listed in text.

28. For example, Amin's Mamluk origin is associated with resistance to French occupation, ibid., 282.

29. For a superb critical engagement of the assertion that Muhammad 'Ali was a great modernizer and founder of the Egyptian state, see Khalid Fahmi's *All the Pasha's Men.*

30. While Zaydan makes this point, the limited appearance of the historical character of Hanna al-Buhayri, a Syrian Christian and attaché to Ibrahim and Muhammad 'Ali, is more representative of their liberal policies towards Christian minorities.

Epilogue

1. Fawaz Trabulsi, "Salim al-Bustani wa Bayrut," *Mulhaq al-Nahar*, April 1997.

2. Butrus al-Bustani, "Fi madinat Bayrut," in Qizma Khuri, *A'mal al-jam'iyah al-suriyah lil-'ulum wal-funun, 1847–1852*. Throughout the work of al-Bustani, Beirut was an exemplary case of the East's failure, success, and promise. On the one hand, al-Bustani chastises Beirut's young and old men for their propensity for visiting coffeehouses and playing backgammon and dominos (*al-Hay'ah*, 169). On the other hand, he criticizes the Beiruti preoccupation with business because it leads to the neglect of the cultivation and fulfilment of socio-civic needs. However, he declared that commercial prosperity is "the wheel and the axis on which the city turns" along with the means that the people of Syria must adopt if they are to return to their former status and avoid being subjugated to the West (*al-Hay'ah*, 170).

3. Salim al-Bustani, "Asbab taqaddum Bayrut wa numiha al-sari'," *al-Jinan* 15 (1884): 449–51.

4. Shakir al-Khuri, *Majma' al-masarrat*.

5. Zaydan, *Mudhakkirat Jirji Zaydan*, 12, 17. Subsequent page numbers will be cited in the text.

6. Walter Benjamin, "Paris, Capital of the Nineteenth Century," in *Reflections* (New York: Schocken, 1978), 147.

7. Chatterjee, *The Nation and Its Fragments*, 5–6.

8. Bhabha, "Signs Taken for Wonders," 110.

9. Vivek Dhareshwar, "Toward a NarrativeEpistemology of the Postcolonial Predicament," in *Traveling Theories, Traveling Theorists*, ed. James Clifford and Vivek Dharashwar, *Inscriptions*, vol. 5 (Santa Cruz: Group for the Critical Study of Colonial Discourse and the Center for Cultural Studies, University of California, 1989), 146.

10. See Abdelkebir al-Khatibi's essays in *Maghreb pluriel* (Paris: Deleon, 1983), his autobiography, *Mémoire tatouée* (Paris: Les lettres nouvelle, 1971), and his novel *Amour bilangue* (Montpellier: Fata Morgana, 1983).

11. Fanon, *The Wretched of the Earth*, 246–47.

Selected Bibliography

ʿAbbud, Marun. *Ruwwad al-nahdah al-ʿarabiyah*. Beirut: Dar al-Thaqafah, 1966.
ʿAbduh, Muhammad. *Risalat al-tawhid*. Cairo: Bulaq, 1897.
Abu-Lughod, Ibrahim. *Arab Rediscovery of Europe*. Princeton: Princeton University Press, 1963.
al-Afghani, Jamal al-din. "Réponse de Jamal al-din al-Afghani à Renan." In *Réfutation des materialistes*, ed. A. M. Goichon, 174–85. Paris: Paul Geuthner, 1942.
Allen, Roger. *The Arabic Novel: A Historical and Critical Introduction*. 2d ed. Syracuse, N.Y.: Syracuse University Press, 1995.
Anderson, Benedict. *Imagined Communities*. New York: Verso, 1983.
Antonius, George. *The Arab Awakening*. 1938; reprint, London: Hamish Hamilton, 1961.
Antun, Farah. *Hubb hatta al-mawt*. Serialized in *al-Jamiʿah* (1899).
———. *Ibn Rushd wa falsafatuhu*. Alexandria: Matbaʿat al-Jamiʿah, 1903.
———. *Maryam qabla al-tawbah* (Mary before her submission). Serialized in *al-Jamiʿah* (1906).
———. *Urushalim al-jadidah* (New Jerusalem). Alexandria: Matbaʿat al-Jamiʿah, 1904.
———. *Wahsh Wahsh Wahsh*. Alexandria: Matbaʿat al-Jamiʿah, 1903.
Arkoun, Mohammed. *Lectures du Coran*. Paris: F. Maspero, 1982.
Austin, J. L. S. *How to Do Things with Words*. Cambridge: Harvard University Press, 1962.
Badawi, M. M. *Modern Arabic Literature*. Cambridge: Cambridge University Press, 1992.
———. *A Short History of Modern Arabic Literature*. Oxford: Oxford University Press, 1993.
Badr, Taha Muhsin. *Tatawwur al-riwayah al-ʿarabiyah fi misr, 1870–1938*. 2d ed. Cairo: Dar al-Maʿarif, 1968.
Bakhtin, Mikhail. *The Dialogic Imagination*. Ed. Michael Holquist. Trans. Caryl Emerson and Michael Holquist. Austin: University of Texas Press, 1981.
Barthes, Roland. *Writing Degree Zero; and Elements of Semiology*. London: Jonathan Cape, 1967.
Benjamin, Walter. "Paris, Capital of the Nineteenth Century." *Reflections*. New York: Schocken, 1978.

Bhabha, Homi. *The Location of Culture.* New York: Routledge, 1994
———, ed. *Nation and Narration.* New York: Routledge, 1990.
Bootstrap: Jordan Valley Development Project. Beirut: Near East News Association, 1953.
Brown, Nathan. *Peasant Politics in Modern Egypt.* New Haven: Yale University Press, 1990.
al-Bustani, al-Mu'allim Butrus. "Fi madinat Bayrut." In *A 'mal al-jam'iyah al-suriyah lil-'ulum wal-funun, 1847–1852,* ed. Yusuf Qizma Khuri. Beirut: Dar al-Hamra', 1990.
———. *Khitab al-hay'ah al-ijtima'iyah wal-muqabalah bayna al-awa'id al-'arabiyah wal-ifranjiyah.* In *Al-Mu'allim Butrus al-Bustani: dirasat wa watha'iq,* ed. John Dayah. Beirut: Manshurat majallat fikr, 1981.
———. *Khutbah fi adab al-'arab.* N.p, n.d. [Beirut, 1859].
———. *Nafir suriyah.* Ed. Yusuf Qizma Khuri. Beirut: Dar Fikr lil-abhath wal-nashr, 1990.
———. *Qissat As'ad al-Shidyaq.* 1860; reprint, Beirut: Dar al-Hamra', 1992.
al-Bustani, Fu'ad Afram. *Al-Mu'allim Butrus al-Bustani.* Beirut: al-Matba'ah al-Kathulikiyah, 1929.
al-Bustani, Salim. "Asbab taqaddum Bayrut wa numiha al-sari'." *al-Jinan* 15 (1884): 449–51.
———. *Asma'. al-Jinan* 3 (1872).
———. *Fatinah. al-Jinan* 8 (1877).
———. *Al-Huyam fi jinan al-Sham. al-Jinan* 1 (1870).
———. *Iftitahiyat majallat al-Jinan al-bayrutiyah, 1870–1884.* Compiled by Yusuf Qizma Khuri. Beirut: Dar al-hamra', 1990.
———. "Innana asbahna fi zaman musawah wa intizam." *al-Jinan* 9 (1878): 703–4.
———. "Limadha?" (Why?) *al-Jinan* 2 (1871): 503.
———. "Al-Mudakhalat al-ajnabiyah fi misr" (Foreign intervention in Egypt). *al-Jinan* 10 (1879): 353–55.
———. "Ruh al-'asr" (Spirit of the age). *al-Jinan* 1 (1870): 385–8.
———. *Salmah. al-Jinan* 9 (1878) and 10 (1879).
———. *Samiyah. al-Jinan* 13 (1882) and 14 (1883).
———. "'Ubudiyah dakhaniyah" (Smoking slavery). *al-Jinan* 1 (1870).
———. "Al-Ulfah wal-ittihad wal-ta'qqul wa la-siyyama fi al-wilayat al-'arabiyah." *al-Jinan* 7 (1876): 649–52.
———. *Zenobia. al-Jinan* 4 (1873).
———. "Zifaf Farid" (Farid's Wedding). *al-Jinan* 2 (1871): 447–53.
Chatterjee, Partha. *The Nation and Its Fragments.* Princeton: Princeton University Press, 1993.
Choueiri, Youssef. *Arab History and the Nation-State: A Study in Modern Arab Historiography, 1820–1980.* New York: Routledge, 1989.
Dawn, C. Ernest. "The Origins of Arab Nationalism." In *The Origins of Arab Nationalism,* ed. Rashid Khalidi et al. New York: Columbia University Press, 1991.

Dayah, John. *Al-Muʿallim Butrus al-Bustani: dirasat wa watha'iq*. [Beirut]: Manshurat majallat fikr, 1981.
Deleuze, Gilles, and Felix Guattari. *A Thousand Plateaus*. Minneapolis: University of Minnesota Press, 1987.
De Man, Paul. *Allegories of Reading*. New Haven: Yale University Press, 1979.
Derrida, Jacques. *Of Grammatology*. Baltimore: Johns Hopkins University Press, 1976.
——. *Writing and Difference*. Chicago: University of Chicago Press, 1978.
Dhareshwar, Vivek. "Toward a Narrative Epistemology of the Postcolonial Predicament." *Traveling Theories, Traveling Theorists: Inscriptions*. Vol. 5. Ed. James Clifford and Vivek Dharashwar. Santa Cruz: Group for the Critical Study of Colonial Discourse and the Center for Cultural Studies, University of California, 1989.
Fanon, Frantz. *The Wretched of the Earth*. Trans. Constance Farrington. New York: Grove Press, 1963.
Foucault, Michel. *Archaeology of Knowledge*. New York: Pantheon Books, 1972.
——. *Language, Counter-memory, Practice*. Ed. Donald F. Bouchard. Trans. Donald F. Bouchard and Sherry Simon. Ithaca, N.Y.: Cornell University Press, 1977.
Frye, Northrop. *Anatomy of Criticism*. Princeton: Princeton University Press, 1990.
——, *The Secular Script: A Study of the Structure of Romance*. Cambridge: Harvard University Press, 1976.
Georgescu, Constantine. "A Forgotten Pioneer of the Lebanese Nahdah, Salim al-Bustani." Ph.D. diss., New York University, 1978.
Girard, René. *Deceit, Desire, and the Novel*. Trans. Yvonne Freccero. Baltimore: Johns Hopkins University Press, 1965.
Gran, Peter. *Islamic Roots of Capitalism*. Austin: University of Texas Press, 1979.
Hafez, Sabry. *The Genesis of Arabic Narrative Discourse*. London: Saqi Books, 1993.
Hakim, Tawfiq. *ʿAwdat al-ruh*. 1928; reprint, Cairo: Maktabat al-adab, 1964.
Hallaq, Butrus. "Love and the Birth of Modern Arabic Literature." In *Love and Sexuality in Modern Arabic Literature*, ed. R. Allen, H. Kilpatrick, and E. De Moor. London: Saqi Books, 1995.
al-Hamadhani, Badiʿ al-Zaman. *Maqamat Badiʿ al-Zaman al-Hamadhani*. Beirut: al-Matbaʿah al-Kathulikiyah, 1958.
Haqqi, M. Tahir. *ʿAdhra' Dinshaway*. Introduction by Yahya Haqqi. 1906; reprint, Cairo: al-Maktabat al-ʿarabiyah, 1964.
Haqqi, Yahya. *Qindil Umm Hashim*. Cairo: Dar al-maʿarif, 1944.
Hashim, Labibah. "Hasanat al-hubb." *al-Diya'* 2 (1898–99): 634–40.
Haykal, Muhammad Husayn. *Thawrat al-adab*. 1933; reprint, 3d ed. Cairo: Maktabat al-nahdah al-misriyah, 1965.
——. *Zaynab*. 1913; reprint, Cairo: Dar al-Hilal, 1953.
Hegel, G. W. F. *Introductory Lectures on Aethetics*. Ed. Michael Inwood, trans. Bernard Bosanquet. London: Penguin Books, 1993. First published as *The Introduction to Hegel's Philosophy of Fine Art*. London: K. Paul, Trench, 1886.

———. *Phenomenology of Spirit*. Trans. A. V. Miller. New York: Oxford University Press, 1977.
Hourani, Albert. *Arabic Thought in the Liberal Age, 1798–1939*. 1962; reprint, New York: Cambridge University Press, 1983.
———. *The Emergence of the Modern Middle East*. London: Macmillan Press; Oxford: in association with St. Antony's College, 1981.
———. *Islam in European Thought*. New York: Cambridge University Press, 1991.
al-Jabiri, Muhammad ʿAbid. *Masaʾalat al-hawiyah: al-ʿurubah wal-islam wal-gharb* (The question of identity: Arabism, Islam, and the West). Beirut: Markaz dirasat al-wahdah al-ʿarabiyah, 1995.
———. *Nahnu wal-turath* (We and tradition). Beirut: al-Markaz al-thaqafi al-ʿarabi, 1993.
———. *Naqd al-ʿaql al-ʿarabi* (Criticism of the Arab intellect). Beirut: Markaz dirasat al-wahdah al-ʿarabiyah, 1991. Introduction reprinted as *Arab-Islamic Philosophy: A Contemporary Critique*. Austin: Center for Middle Eastern Studies, University of Texas at Austin, 1999.
Jameson, Fredric. *The Political Unconscious*. Ithaca, N.Y.: Cornell University Press, 1981.
———. "World Literature in the Age of Multinational Capitalism." *Social Text* 15 (fall 1986): 65–88.
Jandora, John W. "Butrus al-Bustani: Ideas, Endeavors, and Influence." Ph.D. diss., University of Chicago, 1981.
Jessup, Henry H. *Fifty-three Years in Syria*. New York: Fleming H. Revell, 1910.
Jubran, Jubran Khalil (Kahlil Gibran). *Al-Ajnihah al-mutakassirah* (Broken wings). New York: Miraʿat al-gharb, 1912.
———. *Al-Arwah al-mutamarridah* (Spirits rebellious). 1909; reprint, Cairo: Dar al-ʿarab, 1991.
Kayali, Hasan. *Arabs and Young Turks: Ottomanism, Arabism, and Islamism in the Ottoman Empire, 1908–1918*. Berkeley: University of California Press, 1997.
Khalidi, Rashid. "Ottomanism and Arabism in Syria before 1914: A Reassessment." In *The Origins of Arab Nationalism*, ed. Rashid Khalidi et al. New York: Columbia University Press, 1991.
Kojève, Alexandre. *Introduction to the Reading of Hegel*. Ithaca, N.Y.: Cornell University Press, 1969. Originally published as *Introduction à la lecture de Hegel* (Paris: Gallimard, 1947).
al-Khuri, Khalil Effendi. *Al-ʿAsr al-jadid* (The modern age). Beirut: al-Matbaʿah al-suriyah, 1863.
al-Khuri, Shakir. *Majmaʿ al-masarrat*. Beirut: Dar al-ittihad, 1908.
Lacan, Jacques. *Ecrits: A Selection*. Trans. Alan Sheridan. New York: Norton, 1977.
———. "Fonction et champ de la parole et du langue." *Ecrits*. Paris: Edition du Seuil, 1966.

———. *The Four Fundamental Concepts of Psycho-analysis*. Ed. Jacques-Alain Miller. Trans. Alan Sheridan. New York: Norton, 1978.

———. *The Seminar of Jacques Lacan: Freud's Papers on Technique*. Ed. Jacques-Alain Miller. Trans. John Forrester. Book 1. New York: Norton, 1991.

———. *The Seminar of Jacques Lacan: The Ego in Freud's Theory and in the Technique of Psychoanalysis*. Ed. Jacques-Alain Miller. Trans. John Forrester. Book 2. New York: Norton, 1991.

Laroui, Abdallah. *La crise des intellectuels arabes: traditionalisme ou historicisme?* Paris: Maspero, 1974.

Lockman, Zachary. "Imagining the Working Class: Culture, Nationalism, and Class Formation in Egypt, 1899–1914." *Poetics Today* (Tel Aviv) 15, no. 2 (summer 1995): 157–90.

Lucás, Georg. *The Historical Novel*. Trans. Hannah and Stanley Mitchell. 1962; reprint, Lincoln: University of Nebraska Press, 1983.

Mahfuz, Najib. *Bidayah wa nihayah*. Beirut: Dar al-qalm, 1949.

Makdisi, Ussama. *Culture of Sectarianism*. Berkeley: University of California Press, 2000.

Mazini, Ibrahim. *Ibrahim al-Katib*. 1931; reprint, Cairo: Dar al-Shaʿb, 1970.

Mitchell, Timothy. *Colonising Egypt*. Berkeley: University of California Press, 1991.

Moosa, Matti. *Origins of Modern Arabic Fiction*. Boulder, Colo.: Lynne Rienner, 1997.

Moreh, Shmuel. *Studies in Modern Arabic Prose and Poetry*. Leiden: E. J. Brill, 1988.

Mubarak, ʿAli. *ʿAlam al-din*. Alexandria: Matbaʿat jaridat al-mahrusah, 1882; reprint, Cairo: Maktabat al-adab, 1993.

Musa, Salamah. *Tarbiyat Salamah Musa* (The education of Salamah Musa). Cairo: Muʿassasat al-khariji, 1962.

al-Muwaylihi, Muhammad. *Hadith ʿIsa ibn Hisham aw fatrah min al-zaman*. Cairo: Matbaʿat al-maʿarif, 1907.

al-Nadim, Abd Allah. *Al-Tankit wal-tabkit*. Maktabat al-baladiyah al-iskandariyah, n.d.

Najm, Muhammad. *Al-qissah fil-adab al-ʿarabi al-hadith*. Beirut: Manshurat al-maktabah al-ahliyah, 1961.

Nimr, Francis, and Yaʿqub Sarruf, eds. "Al-marhum al-Muʿallim Butrus al-Bustani." *al-Muqtataf* 8 (1883): 1–7.

al-Qabbani, ʿAbd al-ʿAlim. *Nishʾat al-sahafah al-ʿarabiyah bil-Iskandariyah, 1873–1982* (Activity of Arab journalism in Alexandria). Cairo: al-Hayʾah al-misriyah al-ʿammah lil-kitab, 1973.

al-Qasatli, Nuʿman. *Al-fatat al-aminah wa ummuha*. *al-Jinan* 11 (1880).

———. *Murshid wa-Fitnah*. *al-Jinan* 11 (1880) and 12 (1881).

———. *Riwayat Anis*. *al-Jinan* 12 1881.

Qizma Khuri, Yusuf, ed. *Aʿmal al-jamʿiyah al-ʿilmiyah al-suriyah, 1868–1869*. Beirut: Dar al-Hamraʾ, 1990.

———. *Aʿmal al-jamʿiyah al-suriyah lil-ʿulum wal-funun, 1847–1852*. Beirut: Dar al-Hamraʾ, 1990.

———. *Rajul sabiq li-'asrihi: al-Mu'allim Butrus al-Bustani*. Amman: Ta'sis al-ma'had al-malaki lil-dirasat al-diniyah; Beirut: Bisan, 1994.

Renan, Ernest. "L'islamisme et la science." *Oeuvres complètes de Ernest Renan*. 10 vols. Paris: Calmann Levy, 1947. 1:945–65.

Rida, Muhammad Rashid. *Tarikh al-ustadh al-imam al-shaykh Muhammad 'Abduh*. 3 vols. Cairo: Matba'at al-manar, 1906–31.

Sharabi, Hisham. *Arab Intellectuals and the West*. Baltimore: Johns Hopkins University Press, 1970.

———. *Neopatriarchy*. Oxford: Oxford University Press, 1988.

Sheehi, Stephen. "Desire for the Self, Desire for the West." *Jouvert: Electronic Journal for Postcolonial Studies* 3, no. 3 (1999).

———. "Doubleness and Duality: Allegories of Becoming in Jurji Zaydan's *Al-Mamluk al-sharid*." *Journal of Arabic Literature* (Leiden) 30 (spring 1999).

———. "Inscribing the Arab Self." *British Journal of the Middle East* 27 (spring 2000): 7–24.

al-Shidyaq, Ahmad Faris. *Al-Saq 'ala al-saq fi ma huwa al-Fariyaq*. 1855; reprint, Beirut: Maktabat al-hayah, [1966].

Somekh, Sasson. *Genre and Language in Modern Arabic Literature*. Wiesbaden: O. Harrossowitz, 1991.

Sommer, Doris. *Foundational Fictions: The National Romances of Latin America*. Berkeley: University of California Press, 1991.

———. "Irresistible Romance." In *Nation and Narration*, ed. Homi Bhabha. London: Routledge, 1990.

al-Tahtawi, Rifa'ah Rafi'. *Manahij al-albab al-misriyah fi manahij al-adab al-'asriyah*. 1869; 2d ed., Cairo: Matb'at sharikat al-ragha'ib, 1912.

Tarabulsi, Fawaz. "Salim al-Bustani wa Bayrut." *Mulhaq al-nahar*, April 1997.

Tarrazi, Phillipe de, Viscount. *Tarikh al-sihafah al-'arabiyah*. 4 vols. Beirut: al-Matba'ah al-adabiyah, 1913–33.

Tibawi, A. L. "The American Missionaries in Beirut and al-Mu'allim Butrus al-Bustani." *Middle Eastern Affairs*. St. Antony's Papers, no. 16. Carbondale, Ill.: Southern Illinois Press, 1962.

al-Tunisi, Khayr al-din. *Aqwam al-masalik fi ma'arifat ahwal al-mamalik*. 1867; reprint, Beirut: Dar al-tali'ah, 1978.

al-'Ubayd, Shihatah. *Dars al-Mu'allim*. Cairo: Dar al-qawmiyah, 1964.

Van Dyck, Cornelius. "Reminiscences of the Syria Mission, 1839–1850." Typescript, no. 13. Archives of the Near Eastern Seminary for Theology, Beirut.

White, Hayden. *The Content of Form*. Baltimore: Johns Hopkins University Press, 1987.

Yaghi, 'Abd al-Rahman. *al-Juhud al-riwayah min Salim al-Bustani ila Najib Mahfuz*. Beirut: Dar al-'awdah, 1972.

al-Yaziji, Nasif. *Fakihat al-nudama' fi murasalat al-udaba'* Beirut: n.p., n.d.
———. *Majma' al-bahrayn*. Beirut: Dar Bayrut, 1966.
Zaydan, Jurji. *Abu Muslim al-Khurasani*. Cairo: Dar al-Hilal, 1905.
———. *'Adhra' Quraysh*. Cairo: Dar al-Hilal, 1911.
———. *The Autobiography of Jurji Zaidan*. Trans. Thomas Philipp. Washington D.C.: Three Continents, 1990.
———. *Fatat Ghassan*. Cairo: Dar al-Hilal, 1897–98.
———. *Al-Inqilab al-'uthmani*. Cairo: Dar al-Hilal, 1911.
———. *Jihad al-Muhibbin*. Cairo: Dar al-Hilal, 1893.
———. *Al-Mamluk al-sharid*. In vol. 7, *Mu'allafat Jurji Zaydan al-kamilah*. Beirut: Dar al-jil, 1981.
———. "Al-Mu'allim Butrus al-Bustani." *al-Hilal* 3 (1894).
———. *Mudhakkirat Jurji Zaydan*. Ed. Salah al-Din al-Munajjid. Beirut: Dar al-kitab al-jadid, 1968.
———. *Shajarat al-durr*. Cairo: Dar al-Hilal, 1932; originally published in *al-Hilal* 23 (1914–15).
———. *Tarajim mashahir al-sharq fil-qarn al-tasi' 'ashar*. 2 vols. Cairo: Dar al-Hilal, 1912; Beirut: Dar al-maktabah al-hayah, [1970].
———. *Tarikh adab al-lughah al-'arabiyah*. 4 vols. Cairo: Dar al-Hilal, 1911.
———. *Tarikh al-'amm*. Cairo: Dar al-Hilal, 1890.
———. *Tarikh al-tammudun al-islami*. 5 vols. Cairo: Dar al-Hilal, 1901–6.

Index

Abbasids, 7, 8, 26, 35, 116, 119, 133, 139, 140, 156, 170; and the trope of success, 26–28, 28–31, 37
'Abd al-Majid, Sultan, 43; Gulhane Hatti-Hamayun and, 19; Tanzimat and, 41
'Abd al-Hamid, Sultan, 94, 101, 162, 202n20
'Abduh, Muhammad, 14, 27, 28, 37, 64, 73, 77, 82, 114, 136, 143, 194, 216n32, 219n20; and debate with Antun, 149, 151–152, 153–157, 160
adab al-qawmi, al- (national literature), 90
'Adhra' al-Dinshaway. See Haqqi, Muhammad Tahir.
al-Afghani, Jamal al-din: and debate with Renan, 14, 39, 136, 138, 143, 144–49, 150, 151, 157
Aflaq, Michel, 57
Ahmad, Aijaz, 163–64
Ajami, Fouad, 11
'Alam al-din. See Mubarak, 'Ali.
Allen, Roger, 217n55
American Board of Commissioners for Foreign Missions (ABCFM), 17, 18; native ministers and, 17–18; Rufus Anderson and, 17
Anderson, Benedict, 46, 74
Amin, Qassim, 83, 97, 155; *Tahrir al-mar'ah*, 83
Amin, Samir, 43
'Amr ibn al-'As, 22–23
'Antarah, Story of, 79, 191
Antonius, George: *Arab Awakening*, 8–9, 47–48
Antun, Farah, 14, 28, 37, 58, 112, 133, 155, 163, 170; and debate with Abduh, 150, 151, 152, 153–57, 160; on Eastern Christians, 155–56, 219n24; and *Hubb hata al-Mawt* [Love unto death], 133, 155; and *Maryam qabl al-tawbah* [Mary before the submission], 170
Arab Renaissance. *See al-nahdah*.
'Arif, Muhammad, 78
Arkoun, Mohammad, 10, 74
Arslan, Shakib, 37
al-Asir, Yusuf, al-Shaykh, 17, 76
Austin, J.L.S., 52–53, 57, 73, 142. *See also* constantive statements; performative statements.
Avicenna. *See* Ibn Sina.
'Awadat al-ruh [Return of the spirit]. *See* Hakim, Tawfiq.
'Ayn Waraqah (Maronite seminary), 16, 17, 39
al-'Azm, Sadiq Jalal 3, 10–11
'Azmeh, 'Aziz, 10, 208n52
Azoury, Najib, 203n1

Badawi, M. M., 85, 114–15; on Salim al-Bustani, 209n6
Badran, Margot, 96
al-Balit, Jirji Jibra'il, 112
Baron, Beth, 96
Barthes, Roland, 99
Bakhtin, Mikhail, 54, 79
Bashir al-Shihab, al-Amir, 121; in *Mamluk al-Sharid*, 172, 173, 176, 177, 178, 179–83, 184–86, 187
Benjamin, Walter, 194
Beni Hilal, Epic of, 79
Bhabha, Homi, 6, 40, 195, 196
Bitar, Nadim, 3
Book of Governance. See Nizam al-Mulk.

232 · Index

Bourdieu, Pierre, 196
Brown, Nathan, 96–97
Bulaq Press, 41–42, 43
al-Bustani, Butrus, al-Muʿallim, 13, 15–75, 76, 77, 83, 93, 97, 102, 103, 114, 123, 132, 136, 138, 139, 141, 143, 144, 146, 149, 156, 161, 162, 174, 179, 187, 188, 194, 203n27, 205n20, 206n39, 207n48, 207n29, 222n2; on *asabiyah*, 73, 208n52; and Arabic Bible, 17, 212n57; on Beirut, 41, 64–65, 189–90, 191, 193; biography of, 16–19; comparison between East and West, 69–73; *Daʾirat al-maʿarif*, 18, 19, 21; definition of knowledge, 19–22; on social needs, 208n53, 209n4; on women, 83. See also *Nafir Suriyah*; *Khutbah fi adab al-ʿarab*; *Khitab fil-Hayʿah al-ijtimaʿiyah*.
Bustani, Salim, 18, 64, 76–106, 107, 108, 109, 111, 112, 114, 129, 132, 133, 143, 148, 155, 161, 162, 162, 163, 168, 169–70, 171, 195, 203n27, 204n16, 205–6n33, 207n41, 208n1, 208n2, 210n12, 210n15, 213n64, 213n65; *Asma*, 93, 95; biography of, 76–78, 209n2; on Beirut, 83, 91, 189, 190, 191, 193; *Fatinah*, 94; "Hadhir wa Layla," 111–12; on women, 38; and "Zifaf Farid," 95. See also *al-Huyam fi jinan al-Sham*; *Salma*; *Samiyah*.
al-Bustani, Suleiman, 18, 35, 201–2n10
Bustris, Niquala, *Riwayat Fuʾad* [The story of Fuad], 97

Charlemagne, 33–34, 35
Chatterjee, Partha, 74, 194
Chevallier, Dominique, 63
Choueiri, Youssef 49, 72
Cleveland, William, 8
constative statements, 8, 52–53, 54, 56, 123, 149

Dawn, Ernest, 8, 9
Deleuze, Gilles, 13; and Guattari, Felix, 122, 171
De Man, Paul, 165, 166
Derrida, Jacques, 33, 34, 36, 38–40, 105; on constative statements, 52–53; on the supplement, 60
Dhareshwar, Vivek, 196

Fanon, Franz, 15, 36, 138, 197
Fawaz, Leila, 63, 203n4

Foucault, Michel, 14, 49, 50, 57, 69, 79, 161, 189, 204n14, 205n29
Freud, Sigmund, 137, 148
Frye, Northrop, 90
Fuʾad Pasha, 61

Gran, Peter, 4, 116
Gibran, Gibran Khalil (Kahlil Gibran). See Jubran, Jubran Khalil.
Girard, René, 35, 66
Guattari, Felix. See Deleuze, Gilles.
Gulhane Hatti-Hamayun, 19. See also Abd al-Majid.
Guha, Ranajit, 6

al-Haddad, Niqula, 133
Hadith ʿIsa ibn Hisham. See al-Muwaylihi, Muhammad.
Hafez, Sabry, 79, 112
Haim, Sylvie, 8
Hakim, Tawfiq, *ʿAwadat al-ruh*, 90
Hallaq, Butrus, 96, 99, 109
al-Hamadhani, Ahmad ibn Husayn Abu Fadl (Badiʿ al-zaman), 116, 117, 119, 120, 121, 122, 128, 138. See also maqamah.
Haqqi, Muhammad Tahir, *ʿAdhraʾ al-Dinshaway*, 97, 133
Haqqi, Yahya, *Qandil Umm Hashim*, 105, 135, 195
Harb, ʿAli, 10
Harik, Iliya, 63
Hariri, Abu Muhammad al-Qasim ibn ʿAli, 117, 119, 120, 121, 122
Harun al-Rashid (caliph): 182, 183; sponsor of knowledge, 29–30
Hashim, Labibah, 13, 83, 112, 114, 215n19
al-Hayʿah al-ijtimaʿiyah. See *Khitab fil-hayʿah al-ijtimaʿiyah wal-muqabalah bayn al-ʿawaʾid al-ʿarabiyah wal-ifranjiyah*
Hayat al-tahrir (Liberation Society), 23
Haykal, Muhammad Husayn, 88, 90, 99, 101, 107, 134, 195, 220n4; *Zaynab*, 88, 90, 99, 107, 160
Hegel, G.W.F., 50, 60, 69, 75, 101, 137, 142, 158, 164; concept of history, 31, 34, 42, 46, 65, 202n22; dialectics of self-formation, 24, 26; dialogue, 35, 36, 66, 68, 135, 138,

144, 148, 157; and master-slave dialectic, 46, 66
al-Hilal, 12, 77, 112, 159, 161, 167, 169, 219n2
historical romance, 76, 78, 93, 94, 103, 108, 125, 132, 133, 134, 162–69, 170, 171. *See also* Sommer, Doris; Lukacs, Georg.
Hourani, Albert, 15, 49, 72, 76; on *The Arab Awakening*, 9, 48
hubb al-watan. See love of the nation.
Husayn, Taha, 159
Husri, Sati' al-, 57
al-Huyam fi jinan al-Sham [Passion in a Damascene garden], 78, 79–93, 94, 95, 101, 103, 104–5, 110, 129, 138, 168, 169–70, 190

Ibn Abi al-Diyaf, Ahmad: *Risalah fil-mar'ah* [Treatise on woman], 83
Ibn Khaldun, 143, 208n52
Ibn Rushd (Averroes), 140, 145, 148, 149, 150, 156
Ibn Sina (Avicenna), 30, 139, 149
Ibrahim, Hafiz, 115, 133; *Layali Satih* [Satih's night], 133
Ibrahim Pasha, in Syria, 16, 18, 121, 184, 185–86
Ishaq, Adib, 58, 83, 136, 143

al-Jabiri, Muhammad 'Abid, 10, 26–27, 34, 70, 202n20
al-Jahiz, 117, 120
Jameson, Fredric, 79; on national allegory, 102, 163–64, 166
al-Jam'iyah al-'ilmiyah al-suriyah (Syrian Scientific Society), 78, 207n47
Jam'iyat al-ma'arif li-nashr al-kutub al-nafi'ah (Society of Knowledge for the Dissemination of Useful Books), 78
Jam'iyah al-suriyah lil-funun wal-'ulum (Syrian Society for the Arts and Sciences), 17, 19, 44, 47, 78, 189, 207n47
Jandora, John, 16
al-Jananah, 18
Japheth (Yafath). *See* Noah, children of.
al-Jinan, founding of, 18, 37, 77, 78, 109, 111, 112, 139, 162, 190, 206n41
Jubran, Jubran Khalil, 99, 133, 134, 212n57; *al-Ajnihah al-mutakassirah* [Broken wings], 99, 195, 133; *al-Arwah al-mutamarridah* [Rebellious spirits], 99; "Yuhanna al-majnun" [Jonathan the madman], 99
Jum'ah, Muhammad Lutfi, 133
al-Junaynah, 18

Kant, Immanuel, 69, 143, 153; and the noumenal, 34, 39, 43, 99; and race, 69, 206n41
karakuz, 79, 209n5
Kawakibi, 'Abdel-Rahman, 58, 73
Kayali, Hasan, 8
Khalidi, Rashid, 8
Khatar, Akram, 63
al-Khatibi, Abdelkebir, 196
Khayr al-din al-Tunisi, 37, 77, 83; *Aqwam al-masalik* [The straightest path], 53, 55, 58, 76, 77
Khitab fil-hay'ah al-ijtima'iyah wal-muqabalah bayn al-'awa'id al-'arabiyah wal-ifranjiyah [Discourse on society and the comparisons between Arab and European customs], 68–74, 207n47, 209n4, 222n2
Khoury, Phillip, 8
al-Khuri, Khalil, 40–41, 43, 121, 204n11; *Hadiqat al-akhbar* [The garden of news] 40, 204n11; *Matba'ah Suriyah* [The Syrian press] 40–41
Khuri, Shakir, 190–91
Khutbah fi adab al-'Arab [Discourse on Arab culture], 19–45, 46, 47, 48, 52, 53, 54, 55, 58, 59, 65, 72, 101, 139, 156, 179, 182, 187, 208n52; Andalusia, 31–32; the figure of Charlemagne in, 33–34, 35; image of the Abbasids in, 28–31; image of the Umayyads in, 24–26; and nomenclature of reform, 24–25, 46
Kilito, Abdalfattah, 117
Kilpatrick, Hilary, 159
Kojeve, Alexandre, 137–38, 142
Kurd Ali, Muhammad, 9, 37, 160; and *al-Muqtabas*, 112

Lacan, Jacques: on desire, 86, 135, 137, 175, 202n21; and ideal-ego, 27, 50, 60, 66, 76, 85, 86, 88; on misrecognition, 24
Laroui, Abdallah, 100, 195
Lewis, Bernard, 2, 7–8

library of Alexandria, burning of, 22–23, 24
love of the nation (*hubb al-watan*), 56–57, 59, 61, 73, 77, 91, 138, 205n32, 205–6n33
Lockman, Zachary, 96, 97, 213n1
Lukacs, Georg, 103, 104, 163

al-madrasah al-hadathah (The modern school), 88
al-Madrasah al-wataniyah (The national school), 18, 76, 190, 201n8
Mahfuz, Najib, 159; *al-Bidayah wal- nihayah*, 89
al-Mumluk al-sharid [The fugitive Mamluk]. See Zaydan, Jurji.
Ma'mun (caliph), 33, 34, 35, 36
al-Manar, 77, 152
al-Manfaluti, Mustafa Lutfi, 82, 99, 100, 195
Mansur, Ja'far (caliph), 28–29, 30, 30–31, 58; Jirjis Ibn Bakhtishu' al-Nishapuri and, 28–29, 156
maqamah, 79, 116–22, 123, 124, 127, 128, 129, 130, 132, 133, 145, 216–217n45. See also al-Hamadhani; al-Hariri; al-Muwaylihi; al-Yaziji.
Maqdisi, Ussama, 63, 204n4, 205n23
Marrash, Francis, 58, 208n49; and *Ghabat at-haqq*, 115
Marsafi, Hussein: *Risalat al-kalim al-thani* [Treatise on eight words], 49, 205n24
Mazini, Ibrahim, and *Ibrahim al-Katib* [Ibrahim the Scribner], 88
Memmi, Albert, 36, 138
al-Mishaqah, Mikha'il, 62, 190, 203n3
Mitchell, Timothy, 96, 213n1
Monroe, James, 116
al-Mu'allim Butrus. See al-Bustani, Butrus.
Mubarak, 'Ali, 125–27, 128, 131, 137, 143; and *'Alam al-din*, 125–27, 128, 130, 138, 171, 179, 193
Mudawwar, Jamil Nakhlah, 133, 170
Muhammad 'Ali Pasha, 128, 221n29; as historical figure, 34, 35, 41, 58; in *al-Mamluk al-sharid*, 172, 178, 179, 180, 183–87
Muhit al-Muhit [The circumference of the ocean] (Arabic dictionary), 18
al-Muqtataf, 77, 112, 133, 183
Mutran, Khalil, 115, 215n31
al-Muwaylihi, Ibrahim, 128, 133

al-Muwaylihi, Muhammad, 58; and *Hadith 'Isa ibn Hisham*, 125, 127–33, 137, 138, 143, 150, 163, 179, 193, 195, 217n6
Musa, Salamah, 11–12, 108
Mustansir (caliph), 29, 30

al-Nadim, 'Abd Allah, 12, 82, 83, 112–14, 136, 137, 143, 153, 163, 171, 195; on women, 83; "'Arabi tafarranaj" [The Europeanized Arab], 113; "La yusaddiq wa khalaftu laka" [Don't believe unless I've sworn to you], 114; "Majlis tubbi 'ala musab al-afranji" [Medical meeting about the European disease], 113; "al-Nabih wal-fallah" [The noble and the peasant], 113
Nafir Suriyah [Clarion of Syria], 18, 45, 46, 47–68, 70, 72, 73, 101, 102, 138, 141, 153, 174, 190, 191, 205n20, 206–7n4. See also al-Bustani, Butrus.
al-nahdah (Arab Renaissance), 3, 9, 12, 14, 35, 43, 46, 51, 68, 77, 98, 111, 114, 115, 120, 125, 156, 174, 175, 177, 181, 182, 186, 187
Napoleon, 5
Nimr, Francis, 77, 193
Nietzsche, Friedrich, 158, 168
Nizam al-Mulk, and *The Book of Governance*, 20–21
Noah: children of, 45; Japheth (Yafath) and Shem (Sam), 32–33, 35, 45, 70, 72

performative statements, 8, 52–53, 54, 55, 56, 149, 161, 175

Qandil Umm Hashim [The saint's lamp]. See Haqqi, Yahya.
al-Qassimi, Tahir, 28
al-Qasatli, Nu'man, 78, 83, 91, 109–12, 133, 137, 171: *al-Fatat al-Aminah*, 109, 214n12; *Mursid wa Fithah*, 110–11; on women, 83; *Riwayat Anis*, 109, 214n12
Qays wa Layla, 117

Renan, Ernest, and debate with al-Afghani, 14, 136, 138, 139–41, 144–49, 150, 151, 157
Rida, Rashid, al-Shaykh, 77, 82, 151, 152, 154, 160, 220n4; and debate with Antun, 151, 152, 154, 160, 220n4

romance novel, 78, 89, 90, 91, 94, 103–4, 105 108, 110, 125, 132
romanticism, 100, 101, 102, 109, 110, 132, 133, 134

Saghiyah, Hazim, 3
Said, Edward, 7
Salih, al-Tayib, 105
Salibi, Kamal, 47
Salma, 94–95, 96, 98, 99, 101–3, 104, 105, 107, 111, 128, 169–70
Samiyah, 95–96, 98, 99, 101, 105, 111
Sannuʿ, Yaʿqub, 83, 136
Sarruf, Yaʿqub, 64, 77, 108, 112, 134, 163, 220n4
September 11, 2001, 1, 2, 3
Serequeberhan, Tsenay, 69
Sharabi, Hisham, 3, 10, 11, 70
Shawqi, Ahmad, 83, 115, 133, 170
Shem (Sam). *See* Noah, children of.
al-Shidyaq, Asʿad, 17
al-Shidyaq, Ahmad Faris, 16, 72, 76, 83, 128, 136, 139, 153, 207n49, 217n53; *Saq ʿala al-saq* [Thigh over thigh], 122–25, 217n49; debate with al-Yaziji, 218n6
Shumayyil, Shibli, 153, 163
shuʿubi debate, 7–8, 26, 117, 139, 160, 208n52
Smith, Eli, 16
Society of Knowledge for the Dissemination of Useful Books. *See* Jamʿiyat al- maʿarif li-nashr al-kutub al-nafiʿah.
Somekh, Sasson, 108
Sommer, Doris, 90–91, 93, 167–68, 177, 178, 187
Syrian Scientific Society. *See* al-Jamʿiyah al-ʿilmiyah al-suriyah.
Syrian Society for the Arts and Sciences. *See* Jamʿiyah al-suriyah lil-funun wal-ʿulum.

al-Tahtawi, Rifaʾah Rafiʿ, 28, 37, 47, 71, 72, 76, 77, 83, 97, 114, 132, 194, 205n24, 207n49, 217n52; *Manahij al-albab al-misriyah*, 52, 55, 57, 58
Tahrir al-marʾah [The liberation of women]. *See* Amin, Qassim.
Tanukhi, Abu ʿAli al-Muhassin: *Faraj bʿad al-shiddah*, 79, 116
Tanzimat, 5, 19, 48, 49, 107

Tarabish, George, 10
Taymur, Mahmud, 105, 195
Taymuriyah, ʿAishah, 83
A Thousand and One Nights (Alf laylah wa laylah), 79
Tibawi, Abdal Latif, 16, 49
Trabulsi, Fawaz, 189
al-Tunisi, Khayr al-din. *See* Khayr al-din al-Tunisi.

al-ʿUbayd, Shahatah, 91
ʿUmar ibn al-Khattab (caliph), 22, 57, 129; and burning of Alexandria library, 22
Umayyad Dynasty: in contrast to Abbasids, 26, 29; ignorance and, 22–24, 27
ʿUmar, Muhammad, 97
ʿUrabi Revolt, 5, 49, 113, 161, 206–7n41

Van Dyck, Cornelius, 16, 17, 18
Voltaire: *Candide*, 86

White, Haydan, 79

al-Yaziji, Ibrahim, 109, 112, 139, 193, 215n19
al-Yaziji, Nasif, al-Shaykh, 17, 76, 109, 119–22, 127, 128, 132, 145, 152, 153, 159, 171; and the Arabic Bible, 17, 212n57; and *Majmaʿ al-bahrain*, 119–22, 132, 171, 182
Young Tunisians, 64

Zaghlul, Fathi, 97, 150
Zaydan, Jurji, 11, 14, 28, 37, 77, 128, 133, 134, 143, 155, 168, 169, 170, 176, 177, 178, 185, 186, 187, 219–20n4, 220n5, 220n9, 220n10, 221n16, 221n24, 221n30; on Beirut, 191–94; biography of, 159–62; *Istibdad al-Mamalik* [Mamluk oppression], 170–71, 178, 179; *al-Istiqlal al-ʿUthmani* [Ottoman independence], 162, 166; *Mamluk al-sharid* [The fugitive Mamluk], 166, 167, 169–87; *Mudhakkirat* [Memoirs], 191–94; *Zenobia*, 170
Zeine, Zeine, 8
Zizek, Slovo, 50, 60
Zurayk, Constantine, 3

Stephen Sheehi is assistant professor in the Civilization Sequence Program at the American University of Beirut.

www.ingramcontent.com/pod-product-compliance
Lightning Source LLC
Chambersburg PA
CBHW020859180526
45163CB00007B/2560